The English Miniature

The English Miniature

John Murdoch
Jim Murrell
Patrick J. Noon
Roy Strong

YALE UNIVERSITY PRESS
NEW HAVEN AND LONDON
1981

The Art Gallery of Ontario gratefully
acknowledges the generous support of the
A. Sarlos Foundation and HCI Holdings Limited.

Designed by Faith Brabenec Hart
Filmset in Monophoto Bembo and
printed in Great Britain by
Jolly & Barber Limited, Rugby

Published in Great Britain, Europe, Africa
and Asia (except Japan) by Yale University Press
Limited, London. Distributed in Australia and
New Zealand by Book & Film Services, Artarmon,
N.S.W., Australia; and in Japan by Harper & Row,
Publishers, Tokyo Office.

Library of Congress Cataloging in Publication Data

Main entry under title:
The English miniature.

Includes index.
1. Portrait miniatures, English – addresses,
essays, lectures. 2. Water-color painting, English
– addresses, essays, lectures. I. Murdoch, John,
1945–.
ND2202.G7E5 757'.7'0942 81–70055
ISBN 0–300–02769–9
ISBN 0–300–02778–8 (pbk.)

Preface

THIS BOOK is published to coincide with the exhibition of the same name drawn entirely from the collections of the Victoria and Albert Museum and shown in North America between December 1981 and September 1982. The exhibition was conceived by Roy Strong and Ted Pillsbury in conversation at the opening of the Yale Center for British Art in 1977. Their intention was to bring in front of a wide public an important part of British culture and to show something of the value of studying it in a university attuned to interdisciplinary research. The exhibition contains some of the great masterpieces of northern renaissance art, some of the most important documents of the English nation state at its formation, and some of the most characteristic images of its aristocratic and citizen élite over three hundred years. The intention is to persuade people to look seriously at the miniature tradition as one of the main expressive media of a major European culture, and to get away from the muddled and breathless chatter which still sometimes passes for history in this field.

The book treats the art of limning, the art of painting miniatures, as a highly specific technical and cultural phenomenon, and it is perhaps helpful to remember that the term 'miniature' itself refers to the technical base of the art (from Latin *minium*, red lead). All the early literature defines the limning tradition in terms of technique, and from what Roy Strong writes of its transmission from the workshops of illuminators of the Ghent–Bruges school, it is clear that the technical 'mystery' was maintained fairly strictly until the late seventeenth century. It was that strictness, and the taut association of the art with a particular nationalist royalism, that made the art of such significance in British history. The term 'miniature' in this sense thus has no necessary connection with the idea of smallness, and no connection with art forms such as enamelling, oil or watercolour painting in small, in which the products resemble the miniature only in scale. Since there was naturally much mutual influence between different portrait media we have included reference to others where necessary, but only it is hoped in such a way as to define more closely the limning tradition. Thus Petitot for example emerges in these pages as an important influence on the Coopers, and the oil 'miniature' appears not at all: the latter type being a fairly short lived and almost exclusively continental art of the commercial reproductive sector, of political and social significance quite separate from that of the limning. And

thus Patrick Noon discusses the suppression of the native limning tradition by the enamel in the early eighteenth century, the disappearance of the distinctive techniques, and the re-establishment of an apparently authentic limning tradition, using ivory and a necessarily adapted brushwork, in the historicizing Lens school. By the eighteenth and nineteenth centuries miniature painting had spread out, both as the art of the disseminated governing class through London and the provincial capitals, and as a discipline, so that it encompassed in some usage even cut paper silhouettes and tinted photographs. The evolution of the term, and the development of the art away from its originally exclusive court base towards a wide popular appeal, is one of the points of this book.

The debts of anyone working in the field are to the great Basil Long, and to his successors at the Victoria and Albert Museum, Carl Winter and Graham Reynolds, who presided authoritatively over the central definition and representation of the art in the British national collection. Others, such as the unsung heroine of the Walpole Society in elder days, Mrs A. J. K. Esdaile (who transcribed the Vertue notebooks), Erna Auerbach, the Dutch scholar Dr A. Staring, and more recently Sir Oliver Millar, Elizabeth Walsh, Richard Jeffree and Daphne Foskett, have published documents vital to any progress in writing history. The cataloguers of the great auction houses have published large numbers of reproductions of miniatures and have thus added enormously to the collective of knowledge. The specific obligations of each contributor are acknowledged conventionally in the text and notes which follow, but it is surely right to mention here the special dependence of this history on the work of Jim Murrell, whose studies in the technology of limning have been essential in defining the craft base of the art, and of Mary Edmond, whose work on family relationships and domiciles has enabled us to distinguish the very narrow sociological character of the limning tradition with a precision otherwise impossible. Finally (as these acknowledgements verge increasingly on the personal) I should like to thank my immediate colleagues at the Victoria and Albert Museum, Roy Strong and Michael Kauffmann, for a regime in which projects like this can prosper; Lionel Lambourne, Julian Litten, Anne Buddle, Sally Chappell for the sort of support one has come to expect at the V&A; less immediately, the staff of the Yale Center for British Art, the administrative cool of Patrick Noon and Tim Goodhue; the imagination and flair of Kathy Lochnan in Toronto; without whose various contributions this book and exhibition would have been much less fun to work on.

JOHN MURDOCH

Contents

1

‒‒•∙⊰⊱∙•‒‒

The Craft of The Miniaturist

THE PAINTING of portrait miniatures in watercolour is a peculiarly English art form, for no other country supported a continuous and flourishing school of artists working in this *métier* during the period of almost four hundred years which is covered by this book. Technically, this art is unrelated to any other, except in its earliest phase when it was developed from the methods of the Flemish book illustrators. With the waning of the manuscript illumination studios, and the further technical development of the portrait miniature, even that tenuous link was broken. The materials and techniques employed were, throughout their development, highly specialized and were invariably treated separately in more general treatises and manuals on painting methods. When Richard Haydocke made his English translation of G. P. Lomazzo's *Trattata dell'arte de la pittura* in 1598,[1] he noted the omission of any discussion of portrait miniature painting, which he considered to be of the utmost importance, and asked Nicholas Hilliard to supply the deficiency.[2] A few years later Hilliard responded to Haydocke's plea by producing the first essay devoted to the art of the portrait miniature – 'A Treatise concerning the Arte of Limning'.

Hilliard's treatise is a moving and revelatory document; not so much a logically developed thesis on the art and its craft, but rather the outpouring of a complex creative spirit – a condensation of the experience, joys and disappointments of a lifetime. For the student of painting techniques it is infuriatingly rambling, discursive and sometimes contradictory, but for anyone who wishes to have any understanding of Hilliard the artist and the man it is essential reading. Twenty years later Edward Norgate wrote his first manuscript on miniature painting,[3] and followed this in 1649 with a second.[4] Norgate's writings were carefully and logically organized and set a pattern for the other manuscripts and books on the subject which followed. Hilliard's concept of miniature painting as 'a thing apart from all other *Painting* or *drawing*'[5] was reinforced in the years between the early seventeenth century and the twentieth by a steady flow of manuscripts and printed manuals solely devoted to the art. These works, together with artists' letters, memoranda and fee books, as well as detailed examinations of the miniatures have provided us with a valuable and constantly growing knowledge of the materials and methods of the art at all periods.[6]

In the absence of any documentation of the early development

of the methods of the miniaturists, a description of the techniques of those artists working before 1570 relies almost entirely on scrupulous examination of the miniatures themselves. In the absence of signatures, it is necessary to group and attribute miniatures of this period on stylistic, circumstantial and technical evidence. In comparison with the later work of Hilliard and others these early miniatures are remarkable for their economy and simplicity in the use of materials and techniques. It is possible to use Hilliard's descriptions of the simpler methods of the art and the recipes contained in the earliest English printed book on the techniques of illumination[7] to supplement the information which is provided by microscopy, infra-red and ultra-violet examinations, and the use of X-radiography.[8]

When the miniature was removed from the security of the bound book which was seldom opened (and then only with the utmost reverence), it was essential that the vellum should have additional support. In the second and third quarters of the sixteenth century miniature portraits were invariably painted on small discs of very fine parchment (vellum) which were attached with starch paste to sheets of pasteboard which were usually cut from playing cards. During the sixteenth and early seventeenth centuries various methods were proposed for the construction of these vellum and card 'tablets', as they were normally described. Commonly, the white side of the card, which was not printed with the cyphers of the playing card suits, was very smoothly burnished before the piece of vellum was stuck to it with starch. The tablet was then placed under pressure between the leaves of a book until it was nearly dry, when it was removed, placed face-down on a smooth grinding stone, and burnished at the back to ensure an intimate union between vellum and card.[9]

Miniaturists before Hilliard may have used glair (a clear, watery liquid made by beating or sponging white of egg) as a binding medium for a few of the pigments used, but there is no doubt that gum arabic would have been used for the majority.[10] During the late medieval period there had been some argument amongst the illuminators over the relative merits of glair and gum arabic. Glair was the ancient, traditional material. By the sixteenth century gum arabic was in the ascendant,[11] and although it is possible that glair was used for binding a few pigments in the miniatures of Hornebolte, Holbein and Teerlinc, it is not mentioned by Hilliard or the authors of subsequent treatises. The minimal differences in the working qualities of glair and gum are of little importance to us; they are both clear watercolour binders and are easily miscible with water both before and after they have dried. At the time glair was frequently dried and pulverised for convenient use, just as gum arabic was crushed from its lump form for the same reason.

In the sixteenth century it was no longer necessary for the artist or his apprentice to prepare crude pigments in the studio; most could be purchased in lump form from the apothecary's shop.[12] We do not know for certain which pigments were used by the early miniaturists, but the palette was simpler than that recom-

mended by Hilliard and his successors, and was mainly limited to inorganic pigments. X-radiography has shown that there were two types of white, one of which was white lead. The other is very pervious to X-rays, and is probably similar to the ceruse which was later used by Hilliard. There is visual evidence (confirmed by infra-red examination) that two carbon black pigments were used. They were probably the blacks made from lamp soot (which we now know as lamp black) and from burning the bones or horns of animals in an air-tight crucible. The latter pigment is now known as ivory black, and it was certainly made on occasion by calcining off-cuts and shavings of ivory. The reds were probably limited to vermilion and red lead, while the yellows were varieties of ochre, although massicot (lead-tin yellow) and orpiment (yellow sulph-ide of arsenic) may have been used on occasion. The rich blue used for painting the backgrounds was a copper carbonate, almost certainly the natural one which was described at that time as blue bice (made from the mineral azurite). The rare blue, ultramarine (made from lapis lazuli), was not available in England at the time; indeed it was not regularly used for painting the backgrounds of miniatures until after 1600. In some of the miniatures there is a bluish-green which may well be green bice (a pigment derived from the mineral malachite). Powdered gold and silver were also used as pigments. Each of these pigments, when reduced to a very fine powder, would have been mixed with the optimum propor-tion of gum arabic or glair and water in order to make the particles adhere to each other and to the vellum without producing a glossy paint mixture. The aim was to produce a matt colour while retaining the purity of hue of the pigment.

Such an arid description of the materials and mixtures of early miniature painting has little value unless it can be related to the way in which the miniature was painted and, more important, to its final appearance. This can only be explained in terms of technique. The most significant techniques which were used in early minia-tures were those which were directly derived from the methods of the sixteenth-century school of book illustrators who flourished in and around Ghent and Bruges. One work which exemplifies the technical and stylistic link between Flemish book painting and the works of the early English portrait miniaturists is the portrait of Henry VIII in the Fitzwilliam Museum (pl. 45), painted in 1525–6 by Lucas Hornebolte, who had been brought to England by the

1. Attributed to the Hornebolte studio, Detail of a gold over ochre illuminated border from a Book of Hours (fol. 8v – see pl. 44), c. 1525–30. British Library Add. MS. 35314.

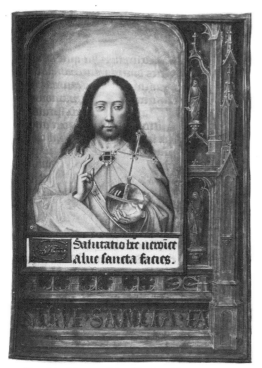

2. Flemish, Hours of the Virgin, *Christ in Majesty* (fol. 8), *c.* 1500, 238 × 165 mm. British Library Add. MS. 35315. The features are modelled with hatches of transparent red and grey over a pink carnation in the same technique used by Hornebolte in his portraits.

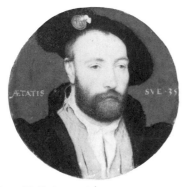

3. Hans Holbein, *Unknown Man*, *c.* 1540, dia. 46 mm. Yale Center for British Art. This shows Holbein's essentially graphic use of the brush in painting the features.

king. It was one of his earliest attempts at painting a portrait which was not part of the pictorial embellishment of a book. Although the portrait is contained within a circle, the miniature is rectangular, so that the corners form spandrels containing stylized angels painted with gold over brown ochre against a flat background of vermilion. This motif and technique echoes numerous similar border decorations in the Biblical illustrations of the Ghent–Bruges school.

Another link with the Flemish book illumination tradition which can be seen in this and other miniatures by Hornebolte is the treatment of the flesh, a technique which was to continue to be of prime importance in English miniature painting. The features were modelled with touches of transparent watercolour over a smooth, opaque, coloured ground. Later miniaturists were to describe this ground as the carnation, and they normally used very pale mixtures of colour for the purpose. In contrast, Hornebolte's carnations were usually of a warm pink hue, the transparent modelling being carried out in hatches of red and grey. An identical treatment can be seen in the features of the larger figures in the manuscripts of the Ghent–Bruges school. The use of the carnation technique for painting the flesh became so characteristic of English miniature painting that its roots in Flemish illustration were soon forgotten and in the middle of the seventeenth century Norgate was able to write, in chauvinistic ignorance: 'the English, as they are incomparably the best Limners in Europe, so is their way the more excellent, and Masterlike painting upon solid and substantial body of colour, much more worthy imitation then the other slight and washing way'.[13]

The smoothly laid, brilliant blue backgrounds which Hornebolte used in his miniature portraits also had their counterparts in Flemish book decoration, and they were to become virtually *de rigueur* in miniature painting for fifty years after his death in 1544. The technique used to arrive at the polished smoothness of these grounds will be discussed later. The representation of gold jewellery in Hornebolte's works was achieved by painting the object with dark ochre and then heightening it with gold paint. This technique had its origins in the borders of *trompe-l'oeil* jewels which frequently appear in late Flemish manuscripts. Hornebolte's use of a band of gold paint to encircle his portraits was a feature which was to become standard in miniature painting, although it is interesting to note that the earlier miniaturists, unlike Hilliard and his followers, were wont to paint the gold thinly over the bare vellum.

Hans Holbein's techniques and materials were identical with these, which supports Karel van Mander's assertion that he was instructed in the methods of miniature painting by Hornebolte.[14] The only difference between their work is that of stylistic approach, which can be seen clearly by comparing the treatment of the features by the two artists. Where Hornebolte's treatment is lovingly naturalistic, revealing his Flemish delight in forms gently modelled in soft diffused light, Holbein's is formal and organizational, the emphasis being on firm modelling and crisp contours. Hornebolte's transparent hatching of the features over the carna-

tion is free, generalized and non-directional, with the modelling softly blurred, while Holbein's hatching is essentially graphic, the strokes following the forms, organizing and simplifying them in order to achieve firm contours with severely limited internal modelling.

After Holbein's death in 1543 and Hornebolte's in 1544 the Flemish tradition in portrait miniature painting was sustained in England by the somewhat meagre talent of Levina Teerlinc. Her ability to render the features of her sitters in a sweet and naturalistic way was always marred by her ineptitude in drawing the figure. Apart from her deficiency in drawing there is no difference in technique between Teerlinc's miniatures and those of Lucas Horne-bolte. As the daughter of Simon Benninck, who in collaboration with Lucas Hornebolte's father, Gerard Horenbout, produced some of the major masterpieces of late Flemish illustration,[15] it is only to be expected that her work should reflect something of her father's manner. Benninck's looser, more washy treatment of the features may be seen in his self-portrait (col. pl. 1c). In the few examples of Teerlinc's work which have escaped the prettifying attentions of the restorer's brush, the modelling of the features can be seen to have been carried out over the carnation with free, transparent washes with a broad brush, rather than with small hatching strokes (col. pl. 1b). Teerlinc and the anonymous and mediocre miniaturists who were working at that time provided little encouragement for the potential patron or for the aspiring miniaturist, and it was well for the perpetuation of the art that the young Hilliard looked back for his inspiration to the miniatures of Hans Holbein.[16] We do not know for certain from whom Hilliard learned the basic techniques of miniature painting, and it seems impossible that they were acquired, as he seems to claim, empirically in attempts to emulate Holbein's work. It is more likely that he had some instruction from a painter trained in the Flemish tradition, who must, as Roy Strong will argue, have been Levina Teerlinc. On the basis of such studio instruction, his works of the early 1570s demonstrate a complete mastery of the traditional methods.

For Hilliard's closest stylistic affinity with the work of Holbein we must look to these few miniatures from the early 1570s, painted before his visit to France. Although in 1600 Hilliard was still prepared to pay lip-service to his devotion to Holbein's example, he had long been working in a highly stylized way which emphasized the decorative possibilities of the miniature and which was largely due to his technical creativity in finding surrogates for the metals, jewels and the texture of materials depicted in his works, rather than merely imitating them with paint. All this was a far cry from the painterly simplicity of Holbein's works. However, there is one aspect of Hilliard's work which is consistent with, and which has a superficial resemblance to, Holbein's approach, and this is the linear treatment of the features. It is possible that we may interpret Hilliard's statement as meaning that he had always imitated Holbein's linear treatment of the features. However, if

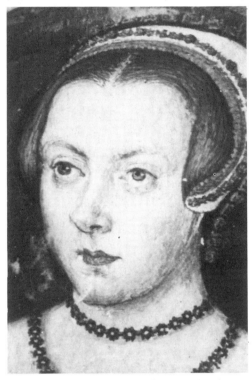

4. Levina Teerlinc, *Unknown Woman* (detail – see pl. 58), *c.* 1550, dia. 48 mm. Yale Center for British Art. Teerlinc's face painting was looser and more washy than that of her predecessors.

5. Nicholas Hilliard, *A Man, said to be Oliver St John, first Baron Bletso*, 1571, dia. 45 mm. Welbeck Abbey. An early Hilliard, painted when he was still under the influence of Holbein.

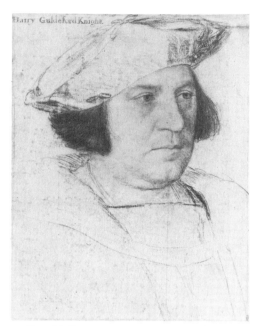

Harry Guildeford Knight.

6. Hans Holbein, *Sir Henry Guildford* (drawing), 1527, 388 × 298 mm. Royal Library, Windsor. This clearly shows Holbein's drawing procedure of extending the modelling of the internal forms to arrive at a related and firm contour.

this is the case, then the imitation was not entirely accurate. Both Holbein and Hilliard did indeed paint the face with strong contours and limited internal modelling, but their approach to this end was diametrically opposed, with the result that their treatment of the features was quite different in emphasis. Holbein's transparent hatching over the carnation was purely an extension of his drawing technique and is typical of that graphic approach, shared by other great renaissance draughtsmen, where the internal forms are gently delineated and extended until they reach the turning-point of the planes of the features where they disappear from view. A firm contour, strictly related to the internal modelling, is thus established. It is easier to appreciate Holbein's method by studying the drawings from the 'great booke',[17] rather than by reference to the miniatures. It is most unlikely that Hilliard had the opportunity to see the drawings, and it must be assumed that his own approach to the drawing of the head was based on what he imagined he had seen in Holbein's miniatures. It is evident from his treatise that Hilliard approached the delineation of the features in the reverse order,[18] first drawing the outlines carefully in proportion and then relating the internal features such as the eyes, nose and lips to this predetermined framework, before adding the faint internal modelling in regular hatches in imitation of those of the engraver Albrecht Dürer.[19] Hilliard's line emphatically precedes the internal forms, rather than arising from them, and the result is that the image becomes more two-dimensional and conventionalized. Where Hilliard's profiles present an almost abstract series of perfect curves which contain the similarly abstracted internal forms, Holbein's method results in contours of great sensitivity and complexity, which result from the modelling of the interior forms and suggest the volume and articulation of the head.

There is no doubt that Hilliard was the most creative of all miniaturists in the invention of new painting techniques. His original attitude to the representation of materials is most aptly demonstrated by his use of gold. Where the earlier miniaturists had been content to use it as a powdered pigment, Hilliard, with his goldsmith's background, insisted on using it as a metal. He painted the encircling lines around the edges of his works and his inscriptions with thick gold powder mixed with a minimal amount of gum and subsequently burnished them with the polished teeth of small animals, so that the soft gold particles would merge together, presenting a continuous surface of gleaming metal. The gold mounts of jewels were first painted with yellow ochre or the bright yellow made by crushing the gall stones of the ox, and these pigments were frequently built up in relief, to imitate the moulding of the mount, before the gold paint was applied and burnished to produce miniaturized counterfeits for the mounts into which the jewels were set. Powdered silver was used in a similar way for painting armour and jewellery, while diamonds were counterfeited by drawing and shading the cut of the stone over an area of burnished silver. Burnished silver was also used for the highlights of pearls, the main body of the pearl being raised with a thick blob

of white. All too often the glittering splendour of Hilliard's minia-
tures have been marred by the deterioration of the silver, which has
tarnished until it is completely black.

When Hilliard discussed the technique for reproducing gem
stones he seems to have been reluctant to publish his secret and he
excused himself from describing the method in the following
passage. 'A word, I praye yo, tuchinge the making of those
beautifull rubies or other stones, how you soe artefically doe
them, that being never so littel they seme precious *Stones* naturall,
cleere and perspicious; soe that (by your favor) is no parte of
limming, wherefore requier it not, it appertaineth merly to ane
other arte; And though I use it in my limming, it is but as a mayson
or joyner, when he hath done his worke, and cane also paynt or
guilde his freeses and needfull parts thereof.'[20] Later in the treatise
Hilliard relented, but gave a very inadequate, and even misleading,
description of the technique. 'Other stones must be glased upon
the Silver with their proper cullors with some varnish etc.'[21] The
making of these precious stones continued to be shrouded in
mystery, for in his first treatise Norgate described it as a 'secret',
and although he set out the method in some detail the materials
were translated into 'Herogliphicall and Cabalistick Caracters'.[22]
These 'caracters' were in fact a simple code, using a transposed alpha-
bet, which could hardly defeat the most amateur cryptographer,
but when William Sanderson published his plagiarism of the
treatise in 1658 he repeated the instructions in code form.[23] By
that time Norgate had written his second treatise and had set out
the method in plain language.[24] Somewhat earlier another writer
expounded the method very fully and commented: 'had I not
unlocked a company of obscure and misticall caracters and taken
oute these jewells, I could not have presented them unto your
view'.[25] Perhaps we should be less surprised by the occasional
secrecy of the artists of this period than by the generosity with
which so many of them committed their knowledge to paper, or
communicated their methods to amateurs such as Norgate and Sir
Theodore Turquet de Mayerne.[26] The previous generation had
been less forthcoming. One early seventeenth-century artist, who
recorded many recipes for various types of painting, commented
on his teacher's reluctance so much as to reveal the nature of his
pigments in a paragraph headed 'Deceyte of Coullers': 'Redd oker
my Master bidd me call browne of Spaine that men should not
knowe what it was rugo plummi; I shall call for red leade and white
plumm I should call for white leade and chalke I should call it
Spanish white. Because all men should not know what he meante
or what Coullers they were.'[27]

The method used for creating the minute counterfeit coloured
stones on the surface of the miniature was to mix the appropriate
transparent pigment (e.g., crimson lake for rubies, verdigris for
emeralds, lapis lazuli for sapphires, etc.) with a small amount of
turpentine resin. This mixture was then taken up with a heated
metal point and laid and modelled over a burnished silver ground.
So convincing are these minute imitation jewels that in one minia-

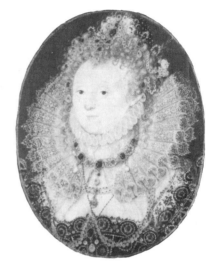

7. Nicholas Hilliard, *Queen Elizabeth*, *c.* 1600,
65 × 49 mm. V&A P1–1974. The demand for
Hilliard's jewel painting techniques was never
greater than when he was painting the Queen.

8–9. John Hoskins, *Unknown Lady* (photomicro-
graphs of ruby and pearl), *c.* 1625, 55 × 43 mm.
V&A P32–1941. These jewels are painted in the
technique invented by Hilliard in the 1570s.

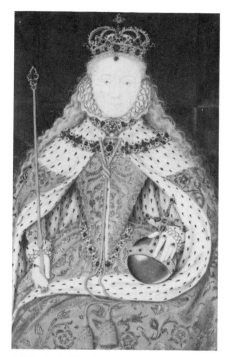

10. Nicholas Hilliard, *Queen Elizabeth in Robes of State*, c. 1590, 91 × 56 mm. Welbeck Abbey. This is a historicizing work which Hilliard copied from an earlier painting by another hand.

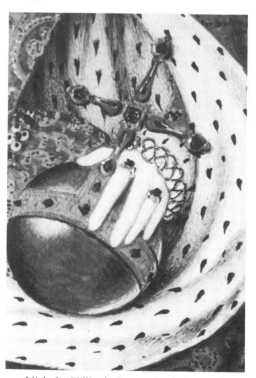

11. Nicholas Hilliard, *Queen Elizabeth in Robes of State* (detail of pl. 10), showing a genuine table-cut diamond in the centre of the orb surrounded by surrogate jewels painted over silver with resin-bound colours.

ture in which Hilliard also set a genuine table-cut diamond, the real stone is not immediately distinguishable from the counterfeits which surround it.[28] It was noted that in his first tentative mention of this technique Hilliard said that it was 'no parte of limning . . . It apperteineth merly to ane other arte.' It would be of some interest to establish from which art Hilliard derived this very specialized and personal method. As we can, without fear of contradiction, limit his other activities to those of the goldsmith and the easel painter, we are presented with a limited number of techniques from which Hilliard's production of imitation jewels may have derived. From the practice of goldsmithing Hilliard may have improvized the basis for his jewel painting method from the techniques of enamelling or *verres eglomisées*, but it seems more likely that the method was an adaptation of an easel painting technique which was frequently used by Hans Holbein, who painted certain areas of drapery by glazing with transparent resinous paints over a ground of silver leaf.

Hilliard emphasized the starched crispness of the lace of ruffs by drawing their complicated tracery with a very full brush of white lead, virtually dribbling the paint onto the surface. Under magnification this lace work has the appearance of the decoration piped with icing-sugar by a confectioner. We are indebted to Norgate for his descriptions of many of the early techniques, and it is he who first explained how the smooth, brilliant blue backgrounds were painted. The blue bice pigment made from azurite is very difficult to work as a watercolour, especially if it is to be laid with the smoothness which is apparent in the work of miniaturists from Hornebolte onward. Artists overcame this problem by using a 'wet-in-wet' technique. First the contour of the figure would be outlined using a fine brush and a watery mixture of the blue, before using a larger brush to sweep the same mixture of colour over the whole area which was to be occupied by the background. While this underlayer was still wet, another brush loaded with a thicker mixture of the colour would be used to apply the top layer, by which means it would 'lye eaven smoth as glasse, and the wetting of the Carde over before with the thinn Collour makes the rest that yow lay after to settle even and hansomly which otherwise, would lye in heapes like unto drifte Sand'.[29] Towards the end of the sixteenth century Hilliard invented a new type of formalized background which imitated folded crimson satin (col. pl. 4d&e), painted in a technique which was still being used by John Hoskins in the 1620s. The method employed was again 'wet-in-wet', not because the red lake paint used was difficult to work, but because this technique so accurately conveyed the sudden but soft transitions of the tones of folded glossy material. First the background was washed all over with a pale mixture of lake and then, while this was still wet, a thicker, darker mixture of the colour was painted into those areas which were to represent the shadows.[30] Ever innovative, Hilliard adopted a new method for gaining this effect in the early years of the seventeenth century which not only gave a crisper appearance, but was also quicker to accomplish. He would

lay the whole of the background area with dark, transparent crimson lake and then, while it was still wet, he would drag a dry brush over the lines of the folds of the curtain, thus taking off the wet paint and producing the highlights.[31]

One of the most subtle of Hilliard's innovations was his method of washing and decanting his white pigment in order to produce three grades of particle size, the finest of which was used for painting satin, the next for linen, and the coarsest for mixing the carnation for the features.[32] The carnations used by Hilliard and Oliver were much paler in hue than those of the preceding miniaturists, and Norgate records that they would have a number of vellum-covered cards prepared with various carnation hues so that when they commenced a miniature it was only necessary to select one which approximated to the complexion of the sitter.[33] The laying of the carnation was critical to the success of the portrait and considerable care had to be taken in mixing and applying it. It was essential that the carnation chosen was as pale as the lightest tones of the complexion, for 'though it bee never soe fayre, yett in working yow may darken or shadow it as deepe as yow please, but if it bee layde on to darke yow cann never heighten it or make it lighter, ffor in Lymning Pictures yow must never heighten, but worke them down to theire Just Collour'.[34] Speed was essential in order that the carnation should dry perfectly smoothly and that the moisture should not affect the vellum, causing it to cockle. It was also important that the carnation should cover a greater area of the vellum than would be occupied by the head, for if less was laid it would be impossible to patch it later with the requisite smoothness. The carnation was mainly composed of white paint with traces of other colours and it was diluted with water. It was then rapidly swept over the vellum with two or three strokes of a large brush. If the application was successful it would dry to a perfectly smooth, even layer. Once the contours of the head had been established, using very faint colour, the excess carnation was removed by wiping it away with a damp brush. Sadly, the features of many of Hilliard's portraits have faded because of his predilection for red lakes for the transparent modelling, which are very fugitive in light.

The special effects by means of which Hilliard had so brilliantly changed the concept of the miniature from its earlier status of a painting 'in little' to that of a highly stylized jewel-like object, whose rich variety of colours and metals became a perfect complement to the jewelled lockets in which so many miniatures were set, did not long outlive the man. When Isaac Oliver became independent of Hilliard around 1597, he gradually abandoned the decorative techniques of his master in favour of the greater realism demanded by his devotion to the new styles of painting of Holland and, later, Italy. Hilliard's techniques were briefly revived in the 1620s by John Hoskins (col. pl. 19b), but he was soon forced to abandon them because of the increasing demand for miniatures in the manner of van Dyck.

Although Hilliard never abandoned his disciplined hatching

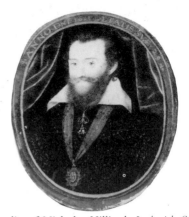

12. Studio of Nicholas Hilliard, *Ludovick Stuart, Duke of Lennox and Richmond*, c. 1610, 52 × 43 mm. Welbeck Abbey. This miniature illustrates Hilliard's later method of painting crimson satin backgrounds when the lights were lifted from the wet lake paint with a dry brush.

technique for modelling the features, it is quite clear from the treatises and from the works of other artists that most other miniaturists had already eschewed that meticulous method in favour of a freer and more naturalistic treatment of the flesh. Norgate's first treatise includes detailed instructions for modelling and colouring the features over the carnation which derive from the looser brushwork of Isaac Oliver and his son Peter and which reflect the practices of the artists of the first half of the seventeenth century. The features were first 'dead-coloured': roughly and boldly laying in all the colours and shadows of the face 'after the manner of washing or hatching, drawing your pencell along with faynte and gentle strokes . . . not carriage to be exacte and Curious, but rather bould and Judicious.'[35] This 'dead-colouring' was later smoothed and closed up by working over with a smaller brush, filling the gaps between the broad strokes and gradually lowering the tones in the shadows with soft and faint touches, to achieve a finely wrought finish, with the shadows worked subtly into the lights so as to give an effect of smooth roundness to the face.[36]

It is striking that Norgate advocated the addition of white to all but the very deepest shadows of the features.[37] The amounts added were very small and did not make the colours opaque, but rather had the effect of making them appear softer and gave a blended effect to the brushwork. It is evident that this innovation was first used by Isaac Oliver in his later work and was adopted by all the artists of the early seventeenth century, with the exception of Hilliard and his studio.

In one passage, Norgate mildly condemned the use of stippling, saying that the colour should be applied by 'rather washing and wipeing it then with stips or pricks to pinke and punch it as some affect to doe'.[38] It seems likely that in writing that passage he had in mind the methods of continental miniaturists and it probably never occurred to him that the description could easily fit the brushwork of earlier works by his hero Isaac Oliver.

The treatises written during the first half of the seventeenth century are partly retrospective, dwelling as they do on the techniques of Hilliard and Oliver, but they also provide a wealth of information on the subjects of materials, equipment and studio management, which can have changed little since the first half of the sixteenth century, and which were to see few further changes in the following two hundred years. It is appropriate at this point, therefore, to discuss briefly these more prosaic aspects of the miniaturist's work.

Although the range of pigments used by Hilliard and later painters was much larger than that employed by the early sixteenth-century miniaturists, it is evident from the manuscripts that they were extremely fastidious in their choice of colours and rejected many which were considered to be acceptable in other types of painting. In the late sixteenth and early seventeenth centuries twenty-five to thirty-five different pigments were in use, some of them synthetic, but the majority derived from natural

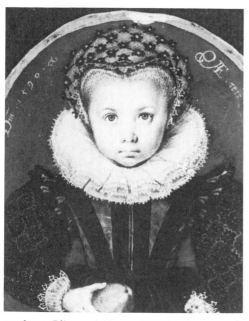

13. Isaac Oliver, *A Young Girl* (detail – see col. pl. 11b), 1590, 54 × 41 mm. V&A P145–1910. Oliver's occasional use of a dotted stipple in modelling the features can clearly be seen in this work.

sources. Earths, such as the ochres and umbers, were used as well as metal salts such as the minerals azurite, malachite, lapis lazuli, and some manufactured colours such as vermilion, white lead, red lead, masticot (lead-tin yellow), and copper blues and greens. Another range of colours was made by using the staining properties of certain materials such as insects, plants and resins to colour white materials to produce transparent pigments such as the lakes (crimson reds) and the 'pinks' (a series of colours ranging from yellow to brown). Other dyestuffs used as pigments included the blues indigo and litmus, and even woad, although the latter was frowned upon by the majority of artists. Although the raw pigments could be obtained commercially, it was necessary to spend many hours preparing them to a sufficient fineness and purity suitable for miniature painting. The mode of preparation varied according to the inherent properties of the individual pigments. Some could be prepared by grinding with water on a smooth stone of hard material, such as porphyry, until the particles were minute and of even size. Other pigments were vulnerable to the grinding process, as it spoiled the beauty of their hues, making them dirty or grey. The method used for the preparation of such pigments was even more time-consuming than grinding, and was known as washing. The pigment was crushed and then stirred with water in a vessel, any scum that floated to the surface being removed until the pigment was thoroughly cleansed. After this the colour was stirred with the water and when the coarser particles had sunk to the bottom the finer pigment which remained in suspension was poured off. This process was repeated four or more times until the very finest particles had been separated. Only a very small proportion of the original pigment would be fine enough for miniature painting, and 'if a handfull of Red Lead yeild a shell or two of good Colour it is enough so it be fine'.[39] The whites, ceruse and white lead, were not only ground, but were also washed to remove any impurities.[40] The pigments were finally dried and stored in boxes or papers.[41] When required for painting, a little of the powdered pigment would be put into a clean mussel shell and the artist, using his index finger, would mix it with water and a little pulverized gum arabic ready for use.[42] Later artists rejected shells for their colours in favour of turned ivory boxes, which usually had threaded lids. John Hoskins was probably the first miniaturist to use an ivory palette in place of the pieces of mother-of-pearl previously used. His palette was described as being concave like the mother-of-pearl palettes, but later artists were content with flat sheets of ivory.[43] Some pigments, such as the red lakes, absorbed so much gum that they had a tendency to crack when dry. This unpleasant characteristic was countered by adding a little powdered sugar candy to the colour while it was wet in the shell. Being hygroscopic, the sugar candy attracted sufficient moisture to keep the gum in a plastic condition.[44] Occasionally the artist would quite literally have to put something of himself into his work, for if the watercolour was difficult to apply to a vellum which had become greasy where it had been touched with sweaty fingers, the

difficulty was overcome by adding a little human earwax to the paint.[45]

The fine brushes (known at the time as pencils) used for painting miniatures could be purchased from the London brushmakers, who had a fine reputation, or they could be made by the artist himself. There is a popular myth which suggests that the brushes used for miniature painting must have been very thin and sharp, perhaps even composed of a single hair. On the contrary, the criterion for miniature pencils was that they should have a good body of hair descending to a reasonably sharp point. Brushes which were too sharply pointed would have produced scratchy, unpleasant results, while the single hair would not carry any paint and would be quite incapable of making a mark. Miniaturists' brushes were made from the hair of caliber[46] or squirrel tails. The hairs were cut, shaped into groups and tied by hand before they were inserted into the quills of water fowl of the appropriate size. These quills were then mounted on sticks of brasil wood or ivory of the same size and shape as writing pens.[47]

Having provided himself with a painting tablet, brushes, colours and a palette, there were yet a few more necessaries to be found before the artist could begin to paint. He had need of a table at which to work, and upon which to place the working desk. This desk, or easel, usually consisted of a box with drawers for colours, brushes, etc., and a baize-covered hinged board at the top which could be raised to various angles. The tablet would be attached to this board and for normal working purposes it would be adjusted to an angle of forty-five degrees or more. For laying certain types of wash the board could be adjusted until it was horizontal.[48] It was also necessary to have at hand two pots of water: one for wetting the brush before taking up the colours, and the other for washing the brushes before mixing a new colour. If gold and silver were used, brushes were set aside for that purpose, and smooth animal teeth for burnishing the metallic pigments were mounted upon wooden handles. Large brushes were also necessary: one for sweeping away any dust which had settled on the miniature, and the other for carrying out the same operation on the shells of dry colour. It was also useful to have a penknife or a pair of tweezers to take off any hairs or dust which might have stuck to the miniature while the paint was wet. Finally, sheets of blotting paper were used for testing the flow of colour from the brush, and as hand rests to protect the miniature from the fingers during painting.[49]

Cleanliness was of great importance to the miniaturist. Not only was it essential that his clothes should be free of dust and his hands clean, but also that the room in which he worked should be 'free from dust and Smoake and the Sulphrous aire of Sea cole'.[50] Sea coal, mined in the north and shipped on the coastal sea lane to London, rapidly replaced wood as a domestic and industrial fuel in the sixteenth century. It was Hilliard who first noted the connection between sulphurous pollution and the deterioration of some pigments: 'the culers themsellves may not endure some ayers, especially in the sulphirous ayre of seacole'.[51] All the minia-

14. Samuel Cooper, *The Duchess of Cleveland* (unfinished), 95 × 70 mm. V&A 446–1892. Here we can see the first indication in faint colour of the features over the carnation.

turists who wrote on the subject were insistent that the working room should have ideal lighting conditions. The window should face north to give the most consistent light throughout the day, and it should be high and large to admit a diffused light that would cast the minimum of shadow from a high angle. The working desk was placed in relation to the window so that the light fell from left to right.[52] This was a matter of simple convenience; if the light fell from the right the shadow of the artist's painting hand would fall across his work. As a result, in the majority of miniatures we see the sitter lit from the left, with *his* left side in shadow. It is interesting as a corollary that in the work of Holbein, an artist whom we know to have been left-handed, the light most frequently falls from the right.

According to Norgate, it took at least three sittings and a minimum of seven working hours to complete a portrait miniature. The first sitting, which occupied between two and four hours, was spent in making the first faint drawing of the features over the carnation, and dead-colouring them, before washing in the hair broadly using a middle tone. Remaining time could be spent in closing up any gaps in the dead-colouring.[53] The second sitting was the longest and could occupy from three to six hours, depending on the needs of the artist and the patience of the sitter. The first part of this sitting was spent in particularizing the features, 'driving and sweetning the same Collours one into another, to the end that noething be left in your worke with a Harde edge or uneven heape or patch of Collours, but all soe swepte and driven one into another with the poynte of somewhat a sharper pencell then yow used at first, as that your Shadowes may lye softe and smothe'.[54] After an hour or two the background, the ground for the collar or ruff, and the middle tone of the costume could be laid in. The deeper tones of the background and costume would have had the effect of making the features appear pallid and lifeless, and it was necessary to work over them again, paying particular attention to the dark tones and accents. Attention would also have to be paid to the hair, darkening the shadows and adding opaque heightening touches. The use of opaque colour in the hair was a seventeenth-century innovation; for Hilliard and Oliver, in their works before 1600, had used pale, transparent colour over the carnation to stand for the lights of the hair. By this time the sitter would be 'gone, or weary with Sitting, (as commonly they are)',[55] and the artist would be left to close up and polish his work on the face, and lay in the costume and jewellery according to the forms and shadows which he had already marked out. In effect, he could carry out any finishing which did not require direct observation from life. The final sitting was the shortest and took from two to three hours to complete. In this period the artist would work carefully and with the closest observation from life, bringing expression to the features with deft touches of the brush and finalizing the costume and jewellery, which had already been broadly worked, with that attention which could only result from the close scrutiny of reality.[56]

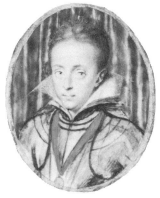

15. Isaac Oliver, *Charles I as Prince of Wales*, after 1611, 51 × 40 mm. Welbeck Abbey. Although this is a pattern for use in reproducing replicas, it approximates to the progress the artist would have made at the end of the second sitting.

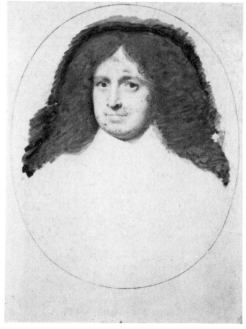

16. Samuel Cooper, *A Man* (unfinished), c. 1665, 95 × 70 mm. V&A 449–1892. This miniature has been painted as far as the end of the second sitting, but remains incomplete.

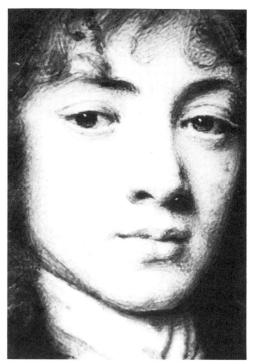

17. Samuel Cooper, *Young Man* (detail), *c.* 1665, 65 × 53 mm. Welbeck Abbey. This demonstrates Cooper's more adventurous approach to the handling of the brush.

18. Samuel Cooper, *Unknown Man* (detail), 1665, 70 × 60 mm. Collection José A. Gomis. This late work is probably the most freely painted of all Cooper's miniatures.

In his second treatise Norgate varied his description of the sequence of the three sittings very little, and still emphasized the use of Hilliard's methods for painting jewels and metals, in spite of the fact that by the middle of the seventeenth century those techniques were redundant. This retrospective attitude to the techniques of miniature painting serves to underline the fact that Norgate was not a professional miniaturist but more of a compiler of recipes who, in the absence of his earlier treatise written for Mayerne and described in his later work as having 'broke forth and bene a wanderer',[57] had to have recourse to the notes which he had made before 1620 in order to compose the second version for the Earl of Arundel.[58] By the time Norgate penned his second treatise there had been significant changes of emphasis in the art of miniature painting. These were brought about by the decline of the decorative techniques of the Tudor period and by the demand for a new type of portraiture based on the styles of Daniel Mytens and, later, van Dyck.

* * *

It is not easy to describe the subtle change which occurred in the usage and mixing of watercolour paint during this period because of the paucity of descriptive terms which are available for this branch of the arts. In the absence of precise language, the following definitions are offered. As a generic term, watercolour indicates *any* paint which is bound with a water-soluble binder, such as gum arabic. As a specific term, however, it now means a water-soluble paint applied transparently over a reflective surface such as white paper. For the present purpose the term *body-colour* is taken to mean a water-soluble paint which owes its opacity to the minimal amount of binder which is added to it, while *gouache* describes a water-soluble paint which is rendered more opaque, and less brilliant in hue, by the addition of white pigment.

During the sixteenth century the emphasis had been on the use of body-colour which was normally made from pure, unmixed pigment, the only transparent watercolour in use being that which was used to model the features over the carnation and the occasional diapering of patterns over the body-colour of the costume. With the adoption of a more realistic and duller tonal range during the second quarter of the seventeenth century, gouache replaced body-colour and there was a much greater tendency to mix primary, and even secondary, colours in order to produce more subtle hues. Another tendency was for the small amounts of white which had been added to the transparent modelling colours of the features to be increased until, in the second half of the century, it was not unusual for opaque gouache colour to be used in the heightening and even the half-tones of the flesh, a complete reversal of the transparent face-painting methods of the sixteenth century. The tentative beginnings of this new approach to the portrait miniature can be seen in the works of Peter Oliver and

John Hoskins (col. pl. 20) during the 1630s, but the more dramatic innovations in technique awaited the arrival on the scene of the mature Samuel Cooper whose work between 1640 and 1670 revolutionized attitudes to the handling of paint.[59] Where previous artists had used the smooth, subtle and anonymous handling which had originated in the early sixteenth century, Cooper employed a broad and vigorous brushwork which added to the drama and movement of his compositions. It was he, too, who first exploited to the full the use of really opaque colour in the features, for although it is evident in his unfinished works that he began the flesh painting with transparent or near-transparent hatches and drawing, he would work back over his shadows and half-tones with bold, opaque strokes, simplifying the forms and broadening the effect of light.[60] Cooper was equally free and inventive in the treatment of the hair and backgrounds of his works, alternating loose washes and hatches of gouache with passages of transparent watercolour.

When one studies miniatures painted by Cooper after the middle of the century one is aware of a painter who had a complete mastery over the materials of his craft and who, in his chosen *métier*, rivals Frans Hals in his virtuosity, and Rembrandt in his sensitivity to the nuances of expression which can be conveyed by the subtle and skilful handling of paint. The individuality of the artists of the second half of the seventeenth century was expressed in their diversity in handling the brush rather than in any variety in their painting techniques. Cooper's followers, Thomas Flatman and Susanna Penelope Rosse, worked in a similar gouache technique, but their treatment of the features, although freely hatched, appears scratchy in comparison with that of Cooper and suggests that they used brushes which were too fine and which produced a mean and scribbled effect. On the other hand their treatment of the costume and background is smooth and almost too meticulously wrought in comparison with the freedom with which Cooper approached the same areas of the miniature.

In the mid-seventeenth century there was only one artist whose handling of the paint was more rugged than that of Cooper. It is unlikely that Richard Gibson had instruction from a professional miniature painter, and his face-painting technique is much closer to that of an easel painter. The features of his sitters are modelled with broad diagonal hatches and the half-tones and lights are built up with thickly dragged impasto (col. pl. 24a). He extended the same breadth and thickness of paint to his rendering of the hair and costume.[61] The late work of Peter Cross is interesting for its absence of hatching. Cross achieved a soft *sfumato* effect in his miniatures by rejecting linearism completely and by executing the features and hair of his miniatures with a soft, dotted stipple. Nothing similar had been attempted in English miniature painting since the unusual *Head of Christ*, a unique miniature by Isaac Oliver (col. pl. 12c). Unlike Oliver's work, however, which was executed in an almost monochrome red-brown, the features of Peter Cross's miniatures were dotted in almost primary colours (red, blue,

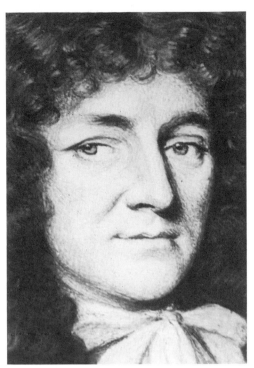

19. Thomas Flatman, *Thomas Gregory* (detail – see pl. 163), *c.* 1680, 63 × 51 mm. V&A Evans 24. Flatman's modelling of the features was scratchy in comparison with the breadth of Cooper.

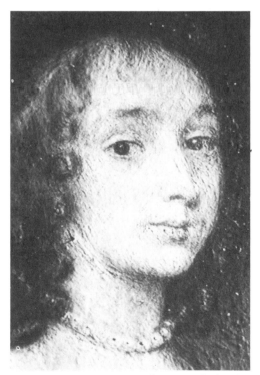

20. Richard Gibson, *Mrs William Russell* (detail in raking light), ?*c.* 1650, 49 × 41 mm. V&A Evans 37. This shows Gibson's impasted brushwork which is related more closely to the methods of easel painting.

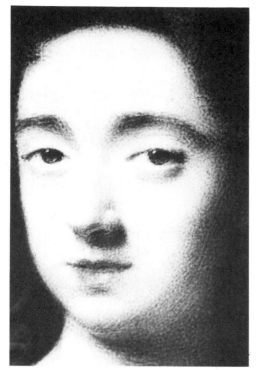

21. Peter Cross, *A Daughter of Sir Edward Villiers* (detail), 1684, 81 × 65 mm. Welbeck Abbey. Cross was unique amongst English seventeenth-century miniature painters for his employment of a colourful dotted stipple in his modelling of the features.

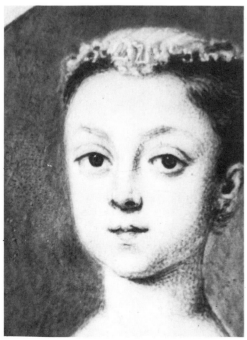

22. Bernard Lens, *A Young Girl* (detail), c. 1720, 48 × 40 mm. V&A Evans 157. Lens adopted a mechanical stipple to overcome the difficulty of painting with watercolour on ivory.

yellow and green) which blend optically to produce a smooth, subtle and atmospheric effect of flesh tones from a normal viewing distance (col. pl. 24c).[62]

<div align="center">★ ★ ★</div>

As we have seen, the development of miniature painting techniques until the beginning of the eighteenth century can be seen as a steady progression from the simple methods of Hornebolte, Holbein and Teerlinc, through the heights of specialized technical brilliance which marked Hilliard's career, to a gradual simplification during the seventeenth century and the final ubiquitous and simple gouache methods of the miniatures painted in about 1700.

Shortly after 1700, however, there was a revolutionary change in the methods of English miniature painting which was to have a profound influence on the future development of the art. The traditional vellum support was quite suddenly superseded by ivory.[63] Ivory was unknown in England as a miniature painting support before 1707, yet few miniatures were to be painted on vellum after 1720. This rapid adoption of the new material is more surprising because it is a far less sympathetic surface upon which to work. In comparison with vellum it was antipathetic to watercolour, being oily, unabsorbent and, in the early years, prepared with a polished, slippery surface that can only have added to the miniaturist's problems. The difficulties inherent in working upon such a surface imply that ivory was adopted for reasons of fashion, and this conclusion is reinforced by the fact that the only real advantage of the new material, which is its luminescence when worked over with transparent colours, was not immediately realized. It might be supposed that the introduction of any such new and different material to an art form would engender automatic and radical responses from painters in terms of technique. On the contrary, artists rarely appreciate immediately the possibilities of a new material, and it is usually a long time before they have adjusted their ideas and techniques sufficiently to be able to make full use of it. The introduction of ivory in miniature painting was no exception to this general rule, and it was almost forty years before artists began to exploit its luminosity and to find techniques with which to work upon it with the transparency it demands.

This is no reflection on the inventiveness of the miniaturists who were involved in the development of ivory as a painting surface. They were attempting to work in one of the most difficult painting techniques ever devised, and it took many years of experimentation to overcome the problems of preparing the surface of the ivory to receive watercolour and to devise paint mixtures in such a way that they would not only work well on the new material, but would have a pleasing appearance.

At first, miniaturists such as Bernard Lens and his sons clung to the familiar methods of vellum painting which were relatively easy to control, but which had an ugly, dry appearance when used on ivory. It is to the credit of these early eighteenth-century painters that they frequently accomplished this compromise fairly

successfully. Their only modification of the earlier methods was that they abandoned the use of a carnation, painting the flesh in transparent colours over the ivory. Every other area was covered with thick layers of matt gouache paint which in broad spaces, such as the background, were unattractive because the ivory was not sufficiently absorbent to allow the paint to dry to the flat, even finishes which had been possible on vellum. In the flesh the transparent colour tended to run into puddles, and the earlier strokes to 'pick up' when later touches were applied. Lens and his sons overcame this problem by adopting a dotted stipple, similar but closer than that which had been used by Peter Cross, which allowed them to proceed cautiously towards the final transparent depth of tone which was necessary. Unfortunately, this type of stippling has a dull mechanical appearance when used for caution rather than effect. The main technical problem at this stage was still to make the ivory and watercolour more compatible, thus freeing the artist from these limitations in the use of the brush.

During the next forty years miniature painting went into something of a decline, possibly due to the waning influence of the baroque, and the emergence of an unpretentious naturalism which was also evident in English easel portraiture in the mid-eighteenth century. Graham Reynolds very aptly described the artists of this period as the 'Modest School', for their works were not only modest in conception and characterization of the sitters, but were also very small in size.[64] In spite of the convenience of the term, however, it should be remembered that these artists were not, in the proper sense of the word, a 'school', but were working independently and were often geographically far removed one from another. In such circumstances, it is remarkable how rapid and universal was the adoption of the 'Modest' manner. Whether the reduction in the size of the miniatures was the result of a national artistic trend, or of the dictates of fashion in costume jewellery, or was simply the choice of the miniaturists themselves, it was obviously more easy to handle watercolour paint on the treacherously slippery ivory on this smaller scale, and the areas which had to be executed with gouache would not appear so unrelievedly boring and ugly. On this smaller scale it was also possible for artists to make their first tentative essays towards new techniques and greater freedom in the handling of the brush. It is tempting to dismiss the Modest School as an insipid interlude in the history of English miniature painting, but if the works of this period are looked at with sympathy and an understanding of the technical problems, they can be seen to have their own special merits and, in addition, great charm. Without the painstaking experiments, and the original solutions to the problems of ivory painting made by artists such as Nathaniel Hone, Samuel Cotes (col. pl. 25f) and Luke Sullivan, the great flowering of the English miniature in the last quarter of the eighteenth century would not have been possible. Nor should we forget that the majority of the masters of the late eighteenth century spent the first part of their careers working in the Modest School manner.

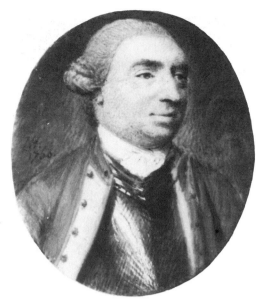

23. Nathaniel Hone, *Richard Lovell Edgeworth*, 1785, 76 × 59 mm. National Portrait Gallery. Plates 23–5 are examples of attempts on the part of members of the 'Modest School' to invigorate the techniques of painting on ivory.

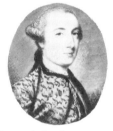

24. Samuel Cotes, *A Gentleman*, 1757, 30 × 27 mm. V&A P8–1929.

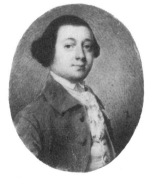

25. Luke Sullivan, *Unknown Man*, 1759, about 45 mm high. Location unknown.

By 1750 a great deal had been done to make watercolour painting on ivory a less difficult and more attractive art. Painters were beginning to emancipate their work from the inhibiting influence of vellum painting techniques. A new freedom of handling was achieved by preparing the ivory with an abrasive to give it a more receptive surface, and by adjusting the paint medium so that it would flow more readily and would not dry into unsightly 'rings'. The early ivories were thick and were evidently purchased from the ivory turner with a polished surface. These were soon replaced with thinly cut ivory, straight from the saw. The saw-marks were first removed by careful scraping and the surface was prepared with a fine 'tooth' by rubbing it with fine glass-paper or Dutch polishing rush before the final finish was applied by grinding the surface with wet pumice powder. The ivory could be degreased by pressing it between sheets of absorbent paper with a hot smoothing iron. Vinegar and garlic were also used to remove the grease, and cuttle-bone was sometimes used for finishing the ivory surface as well as for extracting the grease.[65] The modification of the paint was partly achieved by adding a greater proportion of gum arabic to the pigment, an adjustment which was to have far-reaching secondary effects: the more transparent medium added to a pigment, the greater the transparency and richness of hue of the resulting paint. At first this was probably accidental to the improvement of the working properties of the paint, but artists came eventually to realize the enhancing quality of transparency and the possibility of exploiting the remarkable luminosity of ivory. With the increase in gum arabic it was necessary that sugar candy or honey be added to all the colours to prevent them from cracking and peeling from the ivory. Ox-gall was also used as a wetting agent to convey the colour more neatly from the brush.[66] Because of the improved painting methods it became possible to use the brush more adventurously. More vigorous styles emerged, and the mechanical dotted stipple disappeared, giving way to freer stippling and hatching techniques.

The first artist to realize fully the great potential of miniature painting on ivory was Jeremiah Meyer. He capitalized on the experiments of the Modest School and developed a novel and exciting approach to the miniature, and to him must go the main credit for the renaissance of the art in the late eighteenth century. His brushwork was essentially linear, and developed in a special way the decorative possibilities of painting on ivory. He did not use stipple or conventional hatching, but covered each area of his works with a network of lines of varying length and colour. In the features of a Meyer portrait the lines are long and have a graceful rococo sinuosity and achieve a decorative effect which is unattainable with ordinary hatching methods (col. pl. 30a&b). Each line is of exactly the correct tone, colour and direction to contribute to the modelling and colour of the whole. It was a virtuoso technique, permissive of no alterations or corrections, and it would hardly be unfair to say that no artist following Meyer had the superb skill and confidence as a draughtsman to be able to carry

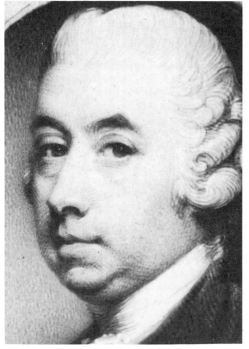

26. Jeremiah Meyer, *Sir William Chambers* (detail), *c.* 1770, 41 × 35 mm. National Portrait Gallery. A fine example of Meyer's calligraphic and decorative rendering of the features.

these methods to the same extreme and beautiful conclusion. Other areas of Meyer's miniatures were executed in pale, transparent washes of colour, and then worked over with transparent lines or long hatching strokes, either to achieve the modelling of the hair and costume or to give a rich textured effect to the smooth area of background. Occasionally he used opaque matt colour in the costume as a textural foil to the transparency of the remainder. The novelty of Meyer's approach was noted by a contemporary critic: 'These Miniatures excell all others in pleasing Expression, Variety of Tints, and Freedom of Execution, being performed by *hatching*, and not by stippling as most Miniatures are.'[67]

The great miniaturists who followed Meyer worked in similar linear or hatching techniques – often more freely, sometimes more minutely, but never with his inimitable combination of controlled freedom, decoration and absolute mastery of the brush. Richard Crosse (col. pl. 31), Richard Cosway (col. pl. 34) and George Engleheart (col. pl. 35e) were the most important of the linear artists who followed Meyer's example, and they each found a personal solution to the challenge posed by the master's brilliant concept of calligraphic modelling and transparency. Richard Crosse also worked very transparently, using a rhythmic line in painting the hair similar to that adopted by Meyer, but falling back on a tighter, more controllable stippling in the features (col. pl. 30c&d). Cosway, who was by no means a brilliant draughtsman, worked carefully with stipple in the features, but adopted a roman-

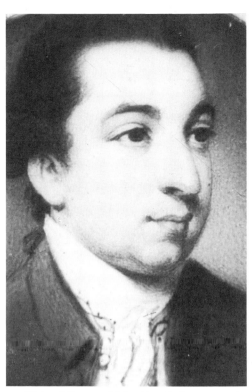

27. Richard Crosse, *A Man* (detail), ?*c.* 1770, 35 × 30 mm. V&A Evans 93. A refined linear treatment of the features, but less confident than that of Meyer.

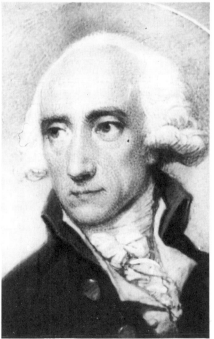

28. Richard Cosway, *Warren Hastings* (detail), 1787, 38 × 30 mm. National Portrait Gallery. This shows Cosway's hesitant approach to painting the face.

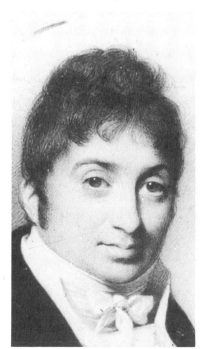

29. George Engleheart, *Unknown Man* (detail), *c.* 1795, about 90 mm high. Location unknown. An example of Engleheart's free hatching of the features combined with a searching attempt to capture the forms of the face.

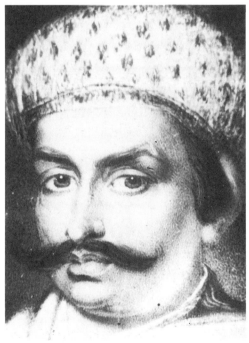

30. Ozias Humphry, *Hyden Beg Kahn* (detail), 1786, 97 × 77 mm. V&A Evans 142. Although Humphrey was a free and confident draughtsman, he usually finished his miniatures with careful stippling.

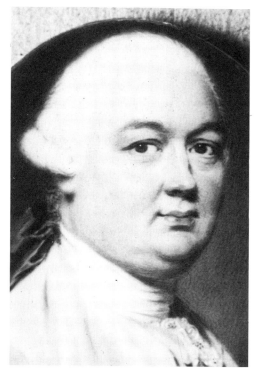

31. John Smart, *James Bruce* (detail), 1776, 36 × 30 mm. National Portrait Gallery. Smart painted the skin rather than the underlying forms, working patiently with layer after layer of very faint, gummy stipples.

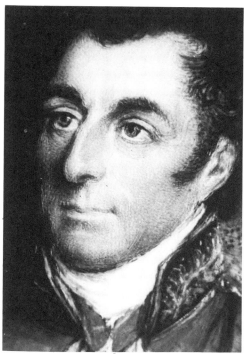

32. William Grimaldi, *The Duke of Wellington* (detail), 1814, 171 × 146 mm. Collection José A. Gomis. This shows the use of a scraper to scratch highlights and half-tones into the dry paint.

tic sketchiness in his linear handling of hair, costumes and background which, with its areas of ivory completely uncovered with paint, exploited to the full the interdependent qualities of transparent watercolour and the luminous ivory ground. In many of his miniatures Cosway abandoned the use of colour to the extent that they are virtually drawings in a blue-grey monochrome with pale tints of pink in the features, and freely washed blue in the sky backgrounds (col. pl. 34b&d).

Engleheart similarly graduated from a loose hatched technique, with a broad and fluid linear treatment of hair, costume and background, which owed much to Cosway's example, to a solemn and searching exploration of form, by way of a tight and ordered hatching technique. On the other hand, exceptions to this dominant linearism occur in the works of Ozias Humphry (col. pl. 37a) and John Smart (col. pl. 32d&f), who both worked with tight stipples to achieve minute modulations of form, without sacrificing any transparency. Smart's brushwork was incredibly smooth and blended, so that without relatively high magnification it is difficult to descry the individual touches. He achieved this effect by working with stipples in very faint layers of gummy colour, gradually working the painting up, layer upon layer, until he arrived at an almost miraculously smooth finish. Such revived technical self-confidence was reflected in the size of the miniatures, which had grown from the average of one and a quarter inches, common in the mid-century, to as much as three and a quarter inches in the last quarter of the century.

Apart from the plethora of individual calligraphic stippling and hatching styles, there were very few specialized painting methods in use at the end of the eighteenth century. However, there was one technique which deserves mention because it was so widely employed. This was the method for painting men's coats where the textural quality of matt gouache was contrasted with the transparency of the head and background. These coats were smoothly floated with very matt gouache or body-colour, and the shadows were frequently hatched with gum arabic solution alone.[68] The effect of the addition of gum was to alter the refractive index of the dry, floated colour, darkening it in the hatched shadow areas. It was far more difficult to float such even layers of colour on ivory than it had been on vellum, and the very competent craftsman William Wood proudly noted his first successful achievement of this feat in his journal.[69] Wood also stated, on a number of occasions, that he had 'breathed on' his miniatures during the finishing stages, without offering any explanation for what, at first sight, seems to be an extraordinary procedure. However, experiments have shown that when watercolour is applied to ivory in the very hygroscopic, gummy mixtures which were in use at that time, if one breathes on an earlier application of paint it will be softened sufficiently to allow later touches to melt into it, giving a much smoother finish. It is tempting to conclude that John Smart used this technique to attain the seemingly impossible glossy smoothness of his backgrounds. Some artists used a scraper or a penknife to scratch highlights in the dried paint, especially in the

hair, while it is evident from observation that others made softer lights by scribing with the wooden end of the brush while the paint was still semi-liquid.

One writer categorized the various types of brushwork as 'floating', 'washing', 'handling', and 'marking'.[70] Floating was the term applied to the peculiar dry application of men's coats which has been described above. Washing alluded to the first broad laying-in of the miniature (which in the seventeenth century would have been described as the dead-colouring). Handling described the type of brushwork (either stippling or hatching) used to close up the washing in the features and other parts of the miniature, while marking consisted of those last spirited marks and accents which gave vitality to the features.

Viewed in retrospect, it is remarkable how little the materials and apparatus of the miniature painter had changed in the years between 1525 and 1800 (or even 1850). Painting easels remained much the same, and the brushes used were little different except that during the nineteenth century red sable was in use, although many artists still preferred the traditional squirrel hair.[71] Metal ferrules replaced quills for many purposes, but the miniaturists seem to have preferred the old method for their fine brushes. Artists used ivory for their palettes and, by this time, almost universally kept their colours in turned ivory pots. By the end of the eighteenth century the artist was relieved of some of the tedium of routine studio work by the emergence of reliable purveyors of ground pigments, and the availability of cake watercolours prepared by the artist's colourman – compacted blocks of pigment ground with a very small amount of gum or isinglas, which had

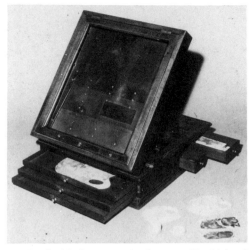

33. Easel with drawers and palettes used by Richard Crosse. V&A.

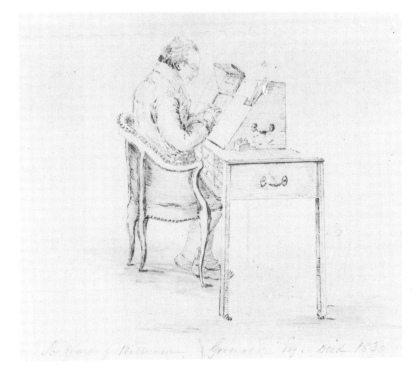

34. Mary Grimaldi after Louisa Edmeads, *William Grimaldi at his Painting Desk*, 193 × 222 mm. National Portrait Gallery.

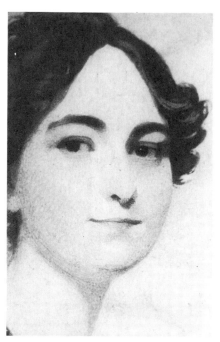 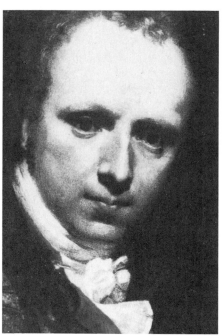 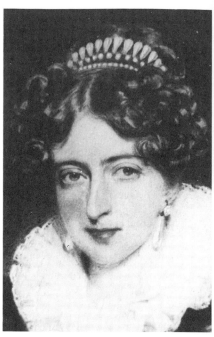

35. Andrew Robertson, *A Young Woman* (detail), *c.* 1810, about 102 mm high. Private Collection. A commissioned portrait in Robertson's 'commercial' manner; compare the 'artistic' style of his self-portrait (pl. 36).

36. Andrew Robertson, *Self-Portrait* (detail), 1801, 171 × 143 mm. Aberdeen Art Gallery. Robertson's miniatures were carefully worked with very fine stipples with the intention that when they were viewed from a distance the forms would appear to have been achieved with a broad brush.

37. Sir William Charles Ross, *Mrs E. G. Lardner* (detail), 1825, 82 mm high. National Portrait Gallery. Ross continued to work in Robertson's fine stippled manner, but he added his own distinctive genius as a draughtsman.

only to be wetted and rubbed out on the palette to be ready for use. Although a number of new pigments had been introduced over the years, it cannot seriously be argued that any of them had a great impact on the appearance of miniature paintings. A classic example was the widespread introduction of zinc white in the early years of the nineteenth century to replace white lead, which had the unpleasant quality of blackening in a polluted atmosphere. This happened at a time when artists were eschewing the use of *any* white in their works, preferring to use the whiteness of the ivory for the lights. The majority of the basic colours used for miniature painting in the nineteenth century were very similar to those which had been used three hundred years earlier.

The development of miniature painting in the nineteenth century was dominated by the figure of Andrew Robertson (col. pl. 36b). His work epitomized a new approach to miniature painting which was largely a reaction to the formulae and slightness of much late eighteenth-century work. Robertson said of Cosway's miniatures: 'they are very pretty things, but not pictures. No nature, colouring, or force. They are too much like each other to be like the originals and if a man has courage to deviate from the model, we all know how easy it is to paint pretty things, when he can paint smooth without torturing it into the likeness of a bad subject.'[72] He further expanded on his attitude in a letter: 'oval miniatures but toys . . . I should like to aspire to paint *pictures*, and

in the exhibition this year, oval miniatures have disappeared, as they are not so much worn.'[73] Robertson's ambition was to paint miniatures which had the depth of tone and colour – 'the force' – of oil paintings. He was a consummate artist and draughtsman and it is no small tribute to his success in his self-appointed aim that one of his early works completely deceived Richard Cosway, who found it difficult to believe that it was painted with watercolour on ivory.[74]

Robertson's method was to proceed with faint transparent colours, first in washes, then hatches and finally stipple, to achieve his closely wrought modelling and very high finish, using more gum at the last to enrich the colours and give glossiness to the surface. He even used a proprietory spirit varnish on some of his miniatures. It took a great deal of time to complete the painting of a miniature to such a high finish and Robertson estimated that he needed some twenty-three hours of sittings, as well as ten or twelve hours of work on the background.[75] With the possible exception of John Smart, no eighteenth-century miniaturist can have spent so much

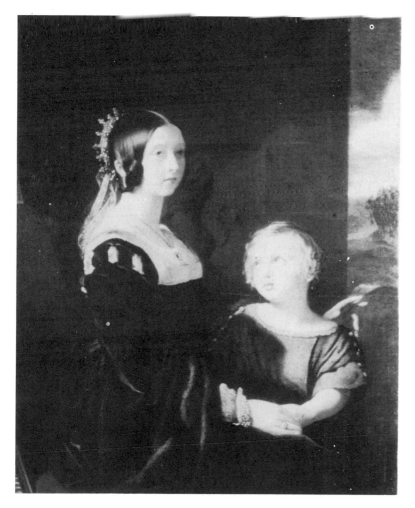

38. Robert Thorburn, *Queen Victoria with Edward Prince of Wales*, c. 1845, 324 × 260 mm. Royal Collection. This very large miniature is worked in a scrupulously fine stipple technique.

39. Alfred Tidey, *Sir John Conroy* (detail), 1836, 152 × 114 mm. National Portrait Gallery. Tidey was influenced by Ross and for some time worked in collaboration with him.

time and labour on a work. Robertson was extremely particular over the composition, accuracy of form and the colour harmonies in his work and would frequently take out areas of his miniatures in order to repaint them to meet his high standards.[76] In one miniature he painted and finished at least six backgrounds before he was satisfied. Later, Alfred Tidey was to be assailed by doubts over the arrangement of the *Boy with White Mice* (col. pl. 38b), and extensively repainted it in order to produce a more satisfactory composition.[77]

This meticulous approach to the miniature was adopted and even furthered by Robertson's most influential pupil, William Charles Ross, in whose works the tones were worked to great depth and the paint finished with liberal applications of gum arabic to a varnish-like surface (col. pl. 36f). The great acclaim which Ross's work received ensured that his manner and technique would set standards for the remainder of the nineteenth century.

With the re-introduction of the rectangular cabinet miniature at the beginning of the century, the size of miniatures was limited to the largest piece of ivory which could be cut like a thin plank along the axis of a tusk. By 1840 this limitation had been overcome by the invention of a method for cutting sheets like veneer from around the circumference of the tusk and subsequently unrolling and flattening them. These sheets could be as large as 30 by 150 inches,[78] and Ross and other mid-nineteenth-century miniaturists were able to paint very large full-lengths and group portraits. There were no further significant developments of technique during the nineteenth century. The work of such artists as William Egley (col. pl. 38a), Alfred Tidey and Annie Dixon (col. pl. 36c) was purely reflective of the techniques of their paradigm, Sir William Charles Ross.

Robertson's faith in the rightness of his approach to miniature painting had been justified and his lesson had prevailed long after his death. In 1814 he had written:

> I begin now to be proud of my pupils – not one, to whom I have even occasionally given advice, has failed of success, and the last exhibition it happened singularly enough, what I had never thought of looking for in former exhibitions, nor then, till I was struck by it, that everyone, with the exception of Chalon [col. pl. 36d], who distinguished themselves in miniature were more or less my pupils and consider themselves so, for my only having set them properly about the art and lent them pictures to copy – and that one, Chalon, told me that the very first year I exhibited . . . his master Artaud took him up to them and prognosticated that, their style would be followed and prevail.[79]

2

—••**⊱)(⊰**••—

From Manuscript to Miniature

WRITING at the close of the reign of Elizabeth I, Nicholas Hilliard looked back across the century and described what had become one of the supreme aesthetic expressions of his own age, the art of limning.[1] It is, he writes, 'a kind of gentle painting, of less subjection than any other . . . it is secret.'[2] 'A Treatise concerning the Arte of Limning', which he never finished, goes on to provide a vivid picture of the artist in his studio and lists the methods whereby he attained his effects and thereby created a portrait miniature. It is a discursive, rambling document, the work of an old man, besprinkled with a little learning, mostly lifted from others and in particular from Haydocke's translation of Lomazzo's *Trattato*, and a fair amount of name-dropping. He refers to conversations with the queen and Sir Philip Sidney. He discusses the problem of depicting the tall handsome figure of Sir Christopher Hatton. And, more surprisingly, there are references to interchange with the great French poet Pierre Ronsard. But the mainstay of the document is technical. It is an account of how to do it. He discusses colours one by one. 'Of whites', he writes, 'white lead is the best, picked out and grinded, and dried on a chalk stone in trenches made in stone for that purpose, and afterwards grinded again.'[3] Or, to take a technical point: 'when you begin your picture, choose your carnations too fair, for in working you may make it as brown as you will, but being chosen too brown you shall never work it fair enough'.[4] In other words it is a discourse on the practical processes needed to be mastered by anyone painting portrait miniatures. Hilliard did not invent these. He was taught them. He, in turn, taught others, including his son and Isaac Oliver. From Karel van Mander we learn that Holbein was taught them by Lucas Hornebolte. What emerges are fragments of a family tree stretching into the seventeenth century and back to the reign of Henry VIII, some pieces of which we know and others of which are missing. It is this technical line of descent, however, that bridges the gaps unfilled by documentary evidence, for it establishes beyond a shadow of doubt that the Elizabethan art of limning is lineally descended from the manuscript workshops of Ghent and Bruges during the golden age of the Dukes of Burgundy. And it is with these that we must begin.

THE ROYAL LIBRARY AND ITS ILLUMINATORS

Tudor court culture was essentially neo–Burgundian.[5] The court of the Dukes of Burgundy was the richest and most magnificent in Northern Europe, enjoying a dual economic and cultural ascendancy that spread as far as the humanist centres of Florence and Ferrara. That it was potent in late fifteenth-century England is explained by the commercial and dynastic links that bound the two countries together. The early Tudor renaissance was directly Burgundian in spirit whether we examine its manifestation in letters, in court festivals or in the visual arts.[6] Its essence was a revivified cult of chivalry that was in England to outlast the sixteenth century and was still to be a dominant force in the ideology of the Jacobean age. It was a pattern already established by Edward IV, but it was to reach its zenith under the first rulers of the new dynasty. For Henry VII, the emergence of a Tudor court style was epitomized by one event, the building of a palace at Sheen, begun in 1497 and carried through with great speed so as to be fit to welcome the Spanish Infanta, Catherine of Aragon, the bride of Arthur Prince of Wales, in 1501. This was to be the apogee of Henry VII's foreign policy. The bride was received with a series of lavish spectacles deliberately designed to outshine the pageants, tilts and tourneys of the Dukes of Burgundy. Most found their setting in the new palace which was in the main built of brick in the Low Countries style and had long covered galleries surrounding newfangled gardens, another Burgundian feature. Its interior was hung with the most opulent of Flemish tapestries, its windows were glazed or inset with Flemish glass, and French jewels and plate glittered by the light of a thousand candles. Henry VII named the palace forthwith Richmond, not only after the earldom that he had borne before he became king but because the palace symbolized the Rich Mount of England created by Tudor rule.

Henry VII initiated what was to become the dominant feature of the reigns of Henry VII and Henry VIII, the recruitment of poets, chroniclers, artists and craftsmen from abroad, nearly all from Flanders with only a sprinkling from Italy.[7] The payrolls are heavy with annuities to this army of foreign talent, a phenomenon that was to last until the close of the first decade of Elizabeth's reign. Its influence on the whole bias of Tudor court culture was to be profound, especially in the visual arts. The emergence and subsequent development of the art of limning belongs within this mainstream and it should not be, as it usually is, considered in isolation from the central developments of the period. For the true origins of the art of Hilliard and Oliver lie where logic should have located them long ago, within the work of the atelier of the illuminators attached to the old Tudor Royal Library.

Of all Henry VII's innovations in emulation of the Dukes of Burgundy, the foundation of the Royal Library was to be the most important.[8] Edward IV, whose exile had been spent at the Burgundian court, had collected and commissioned manuscripts from

40. (facing page) Flemish, *Prince Arthur studies a Manuscript and attends Mass*, Illumination from *Grace entière sur le fait du gouvernment d'un Prince*, c. 1500. British Library.

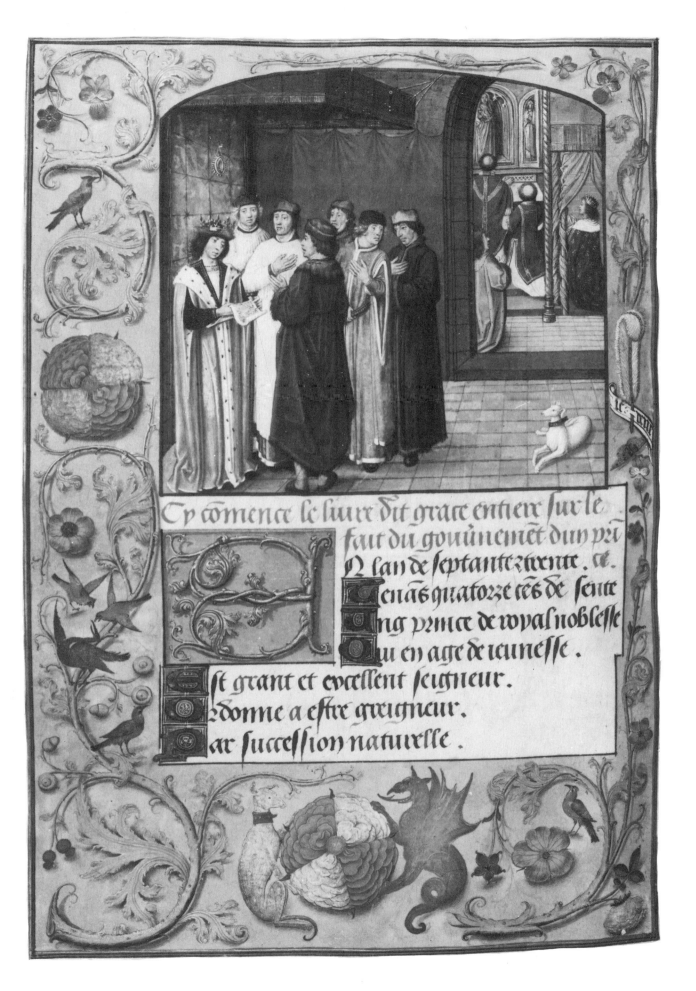

Cy comence le liure dit grace enteir sur le
fait du gouuneme̅t duy pri
N lan de septante xxxvinte, et.
enas quatorze ce̅s de sente
ng prince de royal noblesse
u en age de ieunesse.
st grant et excellent seigneur.
e donne a estre greigneur.
ar succession naturelle.

Flanders, and these travelled with him in the usual migratory manner. But in 1492, seven years after his accession, Henry VII was to appoint a Fleming as the first Royal Librarian and the books came to rest within a library. The librarian's name was Quentin Poulet, a native of Lille, whose prime duty was to establish an atelier – and he proceeded to enlist a group of miniaturists from the Low Countries who were exponents, albeit feeble ones, of the prevailing Ghent–Bruges school of illuminators. In 1501 this workshop with its scribes and illuminators moved into the newly completed palace of Richmond. Their task was to produce manuscripts for the Royal Library. These were rarely in English or Latin but in French Burgundian – volumes of Froissart, Alain Chartier or Christine de Pisan together with French translations of the classics.

The illuminations of these books descend from the style established by the Master of Mary of Burgundy and reflect vividly the work of the two leading families of the Ghent–Bruges school, the Horneboltes and the Bennincks. There is no study as yet of the history of illumination in early Tudor England but it needs to be written, as it clearly formed a far more important part of royal patronage than, for example, panel painting. From the point of

41. Flemish, Illumination from *Imaginacion de la vraye noblesse*, 1496. British Library.

42. Flemish, Illumination from a Bible for Henry VIII and Catherine of Aragon, *c.* 1509. Script by Peter Meghen. The Marquess of Salisbury, Hatfield House.

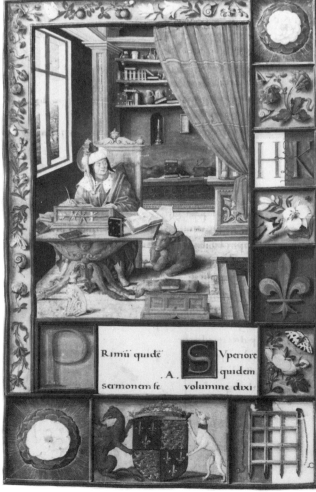

view of the history of portrait miniature painting it is not difficult to demonstrate that it is out of the traditions of this atelier that the art was to spring. Its work under Henry VII tended to conform to a formula. In, for instance, the *Imaginacion de la vraye noblesse*, dated 1496, the miniature and its text are framed by a typical border of naturalistically observed flowers arranged like botanical specimens. In a miniature in the court poet Bernard André's *Grace entière sur le fait du gouvernment d'un Prince*, Arthur Prince of Wales studies a paper which has been presented to him and is also seen kneeling at mass in the background. The likeness is clearly a portrait one, for the portrait tradition was strong within the Ghent–Bruges school. These manuscripts already contain all the ingredients from which the art of Hilliard was to spring.

LUCAS HORNEBOLTE (*c.* 1490/5–1544)

Nothing was to disturb the activities of this Royal Library atelier at the accession of Henry VIII in 1509. If anything, the new king's prodigality resulted in an increase in its activities. Quentin Poulet was succeeded by an enterprising man, Giles Duwes, who remained in charge of the Library until his death in 1535. In the manuscripts that were produced there was a marked emphasis on the heraldic symbols of the Tudor dynasty in the decoration of borders. Thomas More's Latin epigrams celebrating Henry's coronation is a typical instance, with its margins scattered with red and white roses symbolizing the union of the houses of York and Lancaster, Catherine of Aragon's pomegranate and the Beaufort portcullis.[9] The effect is repeated in the Bible illuminated for the use of Henry and Catherine.[10] The scribe was Peter Meghen, a one-eyed Brabantine who also acted as a courier for Erasmus, Colet, Warham and More. The script is no longer Gothic but humanist, although the illuminations and borders are still in the Ghent–Bruges tradition, thick with Tudor roses, fleurs-de-lis, portcullises and the royal arms interspersed with naturalistic flowers. For the first fifteen years of the new reign the workshop continued in this manner, but about 1525 something happened which led to Giles Duwes's greatest coup, the attraction into the service of Henry VIII of the entire Hornebolte family, one of the two families who were the prime exponents of the Ghent–Bruges school.[11]

No explanation has ever been produced for the sudden arrival of the Horneboltes, but it could be a very easy one. The generation of illuminators recruited from the Low Countries by Henry VII in the 1490s must have been extremely old by 1525. Surely death must have prompted the importation of these highly talented artists, because their demise in turn was to prompt exactly the same operation in the middle of the 1540s. For the first two Tudors, artists in the main were people recruited from abroad, and Henry VIII imported on a massive scale. The Horneboltes were, there-

fore, a great prize. Gerard Horenbout, the father, had occupied an important post as court painter to the Regent of the Netherlands, Mary of Hungary. He had added miniatures to the celebrated Grimani Breviary and executed the Book of Hours of Bona of Savoy for Margaret of Austria. Henry VIII had to pay dearly for him in the form of an annuity of £20. Gerard, it is generally accepted, was set to work at once illuminating an Epistolary and a Lectionary intended for use in Cardinal Wolsey's foundation, re-established after his fall by the king as Christ Church.[12] Gerard in fact disappeared after about 1531, having either died or returned to the Low Countries. But his two children remained.

One was Susanna, whom we know was also an illuminator because Dürer saw and admired a *Salvator Mundi* by her in 1521. Presumably she worked in the royal atelier in England but no one so far has been able to single out anything definitely by her. Her brother Lucas was also an illuminator, and again no manuscript by him has yet been attributed although it would be logical to associate him with one of the most splendid of royal manuscripts from the 1530s, Henry VIII's Psalter with its portrait images of the king. These are totally within the Ghent–Bruges, Royal Library tradition. But the true point of departure for the reconstitution of

43. Attributed to Lucas Hornebolte, Illumination from Henry VIII's Psalter, *c.* 1540. British Library.

44. Attributed to the Hornebolte studio, Crucifixion with a gold over ochre illuminated border from a Book of Hours (fol. 8v), *c.* 1525–30. British Library Add. MS. 35314.

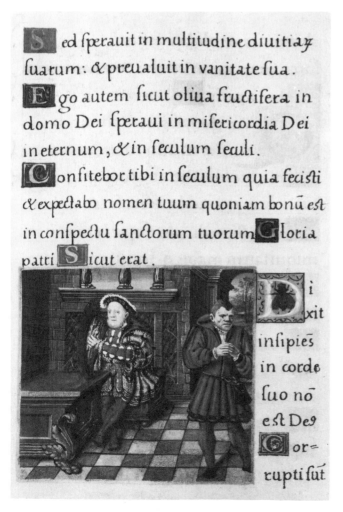

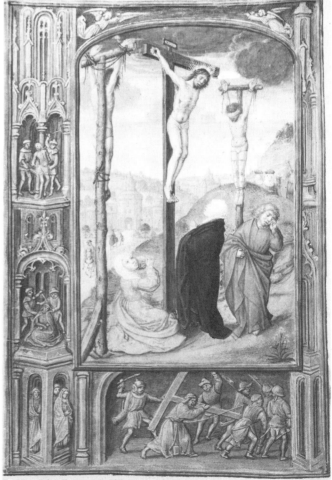

his oeuvre is the fact recorded by van Mander that he taught Hans Holbein how to paint portrait miniatures.

Lucas Hornebolte is such a lost figure in the history of British art that it is time to place him back into the centre of the stage of the early Tudor court. He was paid an annuity of well over £60, more than twice that the king awarded to Holbein. In 1531 he is referred to as king's painter and three years later he received a grant for life of the actual title of king's painter, a post he held until his death in 1544. The surviving documentary evidence so far tells us that he painted portrait miniatures, that he worked on the interior decoration of Whitehall Palace and that he was a painter. In other words he operated within a wide sphere of artistic creativity typical of Flemish artists who worked for the Burgundian court who could turn their hands to anything from designs for banners to stained glass, from panel portraits to illuminated manuscripts. There is indeed a body of panel portraits of Henry VIII and others from the 1530s which, although they are not of any great quality, should be the products of his studio.[13] Henry VIII we know had a high opinion of him. In the Book of the Court of Augmentations his patent reads as follows: 'For a long time I have been acquainted not only by reports from others but also from personal knowledge with the science and experience in the pictorial art of Lucas Hornebolte.'[14]

And it is with him that the portrait miniature starts together with the whole tradition of what was to be called the art of limning, stretching from master to pupil from the England of the 1520s down into the middle of the seventeenth century. Although in ignorance of the Tudor Royal Library and its atelier, the Danish historian of the miniature Colding was absolutely right when he pointed out in 1953 that technically and stylistically an illuminated Tudor Book of Hours and a miniature of Henry VIII now in the Fitzwilliam Museum, Cambridge, painted in the year 1525–6, the king's thirty-fifth year, were identical. Colding then went on to say that all that was needed was to isolate a group of early miniatures seemingly in the Holbein manner but not by him to reconstruct Hornebolte's oeuvre.

In assembling such a group, the Fitzwilliam *Henry VIII* remains the vital touchstone, for the circular portrait image is set into a border in the spandrels of which angels cense the king – angels delineated with lines of gold over an ochre ground in a manner that can be exactly paralleled in manuscripts by the Ghent–Bruges school. And here in this miniature the technique, which was to descend into the Stuart age unchanged, is already fully formed. All Hornebolte's miniatures are on vellum mounted onto card. Whether circular or rectangular in shape the surface is always bounded by a line of gold painted directly over the vellum. The face is invariably painted over the carnation. The sitter's hair is worked in dark lines over a middle tone, often heightened with opaque colour, the costume being built up in the same way. Powder is used for the gold highlights on the costume or over ochre for the jewels. And always the background is a brilliant

45. Lucas Hornebolte, *Henry VIII*, c. 1525–6, 53 × 48 mm. Fitzwilliam Museum.

46. Lucas Hornebolte, *Henry VIII*, 1525, dia. 48 mm. Duke of Buccleuch.

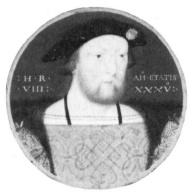

47. Lucas Hornebolte, *Henry VIII*, c. 1525–6, dia. 48 mm. Royal Collection.

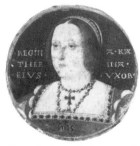

48. Lucas Hornebolte, *Catherine of Aragon*, c. 1525–6, dia. 38 mm. National Portrait Gallery.

opaque pigment, blue bice floated over the vellum. Technically there is absolutely no difference between executing an illuminated page and a detached miniature, except that the latter was mounted onto card. Detached miniatures were already being executed in fifteenth-century Flanders, the so-called cabinet miniatures, some of which were portraits.[15] What cannot be established so far is whether Lucas Hornebolte ever executed detached miniatures before he came to England. One would suspect that he did, but this should in no way detract from what seems to have been an original idea which caught on.

Hornebolte was never a great portraitist. His work is purely derivative within the Flemish tradition and he adhered to an unchanging formula. The sitters bask under a soft diffused light, their features indicated without any use of sharp line or dramatic chiaroscuro. As in the case of most portrait painters there tends to be a family resemblance between his sitters, for they share a puffy, pouchy quality about the eyes, and they all have bright rosebud lips which pout slightly. The other most distinctive feature is his calligraphy which sometimes includes a back to front letter *N* and often seems unworked-out, resulting in contractions or a sudden cramping to get it all in. In spite of all this it must be remembered that virtually all these miniatures, save a few variants and repetitions, are portraits *ad vivum*, observed from the sitter. The limner painted only what he saw before him with no preliminary drawings. This establishes Hornebolte's likenesses of the court of Henry VIII as the most important prior to Holbein's record of its final decade.

Almost inevitably the work of Holbein does form a watershed and Hornebolte's miniatures fall neatly into two groups, before and after that event. The first group is by far the largest, covering the years 1525 to 1535, and within even that most were painted before the beginning of the divorce proceedings in 1529. Three miniatures of Henry VIII by Hornebolte were given to Charles I by Theophilus Howard, second Earl of Suffolk, and are recorded by Abraham van der Doort, albeit as anonymous, among the royal miniatures in the Cabinet Room of Whitehall Palace in 1639. All date from 1525. Two are repetitions, the first as the inventory states 'without a Beard in a black Capp, and a little gold Cheine about his neck, in an Ashcullor'd wrought doublet in a furr'd Cloake and purple sleeves'.[16] The second is smaller with the same dress but crimson sleeves.[17] The third, however, records Henry age thirty-five, and shows him with a beard. Van der Doort annotates what must be another description of this miniature with the remark 'but meanlie done',[18] an observation far from the truth for this is a portrait from life.

To these years belong three miniatures of Catherine of Aragon. The one in the National Portrait Gallery carries an inscription which presupposes that it is a pendant to one of the king, conceivably to one of those already discussed because the sizes tally.[19] A second of her is certainly a repetition, this time in a Spanish hood,[20] but the third is without doubt *ad vivum*, a miniature of the

utmost importance, long known but its significance unrecognized. The formula is that of Flemish painters of the period, with the hands arranged before her waist. She is depicted feeding a pet marmoset, a large stalwart lady whose looks have already gone, fully explaining the king's roving eye and matching exactly a description of her in 1531 as 'somwhat stout and has always a smile on her countenance'.[21] That Hornebolte was no flatterer is reinforced by the miniature of Catherine's touchingly plain daughter Mary at about the age of ten wearing an enormous jewel pinned to her bodice inscribed in English *Emperor*,[22] refering to her uncle Charles V, of whom Hornebolte also painted a portrait (col. pl. 1a), but this time after an oil painting in the Royal Collection.

Other miniatures by him from these years are all in the same vein, but that Holbein made his imprint there can be no doubt. Cut off in remote England and never having experienced the achievements of Italian renaissance art, Hornebolte must have been quite amazed by the virtuosity of Holbein. Two miniatures establish the point. The first is the *Henry VIII* at Welbeck which without doubt is a superb *ad vivum* likeness, but it is one virtually identical with Holbein's magisterial portrait of the king in the Thyssen collection and as he conceived him initially in the great wall-painting for the Privy Chamber of Whitehall Palace. So powerful is Holbein's influence that it is difficult to see any immediate connection with Hornebolte's earlier portraits of Henry. We can reinforce this by a second example, the *Jane Seymour* at Sudeley Castle, which again depends on Holbein's famous portraits of the queen.[23]

The two or three dozen miniatures that survive and are now attributable to Hornebolte cannot have been anything other than a sideline, products of a studio that was active over a far wider sphere of artistic activity. But with them he established an art form that had a potent appeal for the Tudor court. And court is the operative word. The miniatures that have emerged so far by Hornebolte were obviously regarded from the outset as something quite special pertaining to the Crown. The sitters never range outside of the king, his many queens, the princesses and prince, with one or two of unidentified but very high ranking sitters who may well also turn out to be connected closely with the royal family. Hornebolte was employed by the Crown at a very high salary and therefore was not available for commissions by anyone. It is in this rarified atmosphere that the portrait miniature was born, a fitting aspect of the cult of monarchy that was to reach its apogee in Hilliard's manifold images of the divine Gloriana.

HANS HOLBEIN (1497–1543)

It was sometime just before 1536 that Hans Holbein entered the service of Henry VIII as king's painter, and there begins the celebrated series of portraits of king and court that have obliterated from the visual memory of posterity the images of Hornebolte and

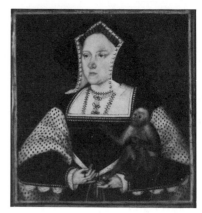

49. Lucas Hornebolte, *Catherine of Aragon, c.* 1525–6, 55 × 48 mm. Duke of Buccleuch.

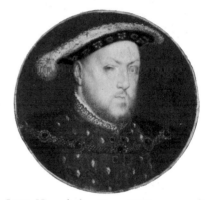

50. Lucas Hornebolte, *Henry VIII, c.* 1537, dia. 49 mm. Welbeck Abbey.

COLOUR PLATE 1 (following page)

a. (top left) Lucas Hornebolte, *The Emperor Charles V, c.* 1525, dia. 42 mm. V&A P22–1942.
b. (top right) Levina Teerlinc, *Katherine Grey, Countess of Hertford, c.* 1555–60, dia. 33 mm. V&A P10–1979.
c. (bottom) Simon Benninck, *Self-Portrait*, 1558, 81 × 53 mm. V&A P159–1910.

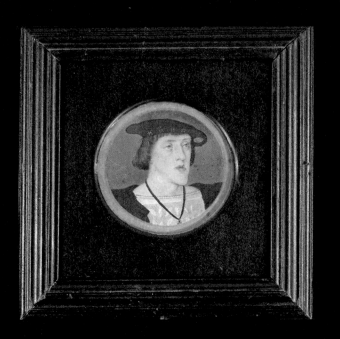

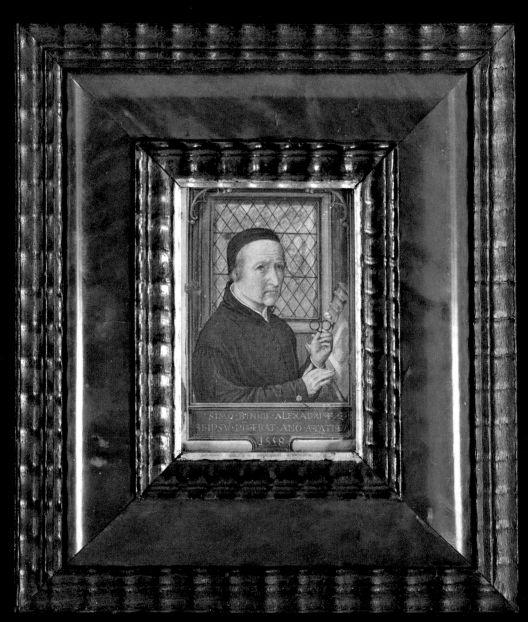

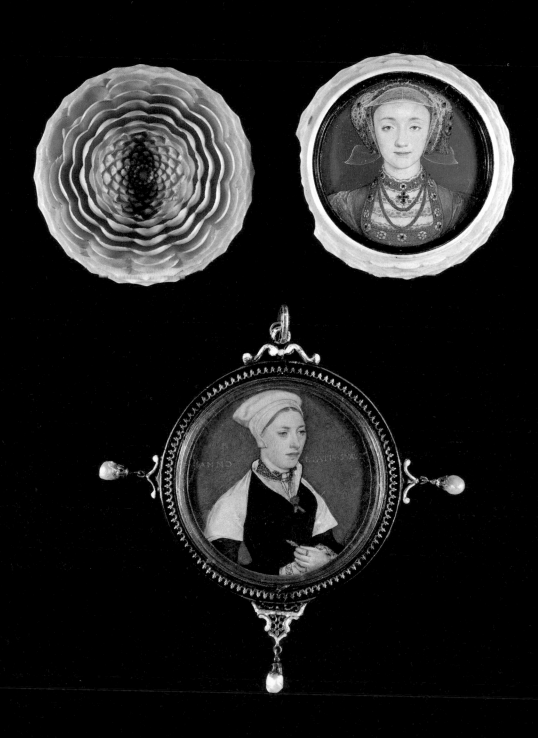

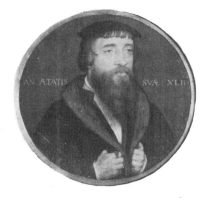
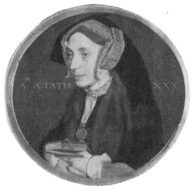

51. (above left) Hans Holbein, *William Roper*, *c.* 1536, dia. 46 mm. Metropolitan Museum of Art, New York.

52. (above right) Hans Holbein, *Margaret More, Mrs Roper*, *c.* 1536, dia. 46 mm. Metropolitan Museum of Art, New York.

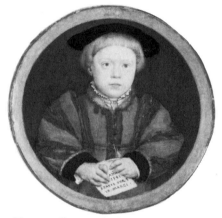

53. Hans Holbein, *Charles Brandon*, 1541, dia. 55 mm. Royal Collection.

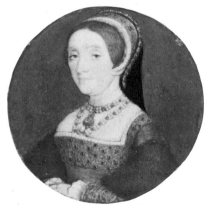

54. Hans Holbein, *A Woman, said to be Catherine Howard*, *c.* 1540, dia. 53 mm. Duke of Buccleuch.

the neo-Burgundians who had dominated the first thirty years of the reign.[24] If Hornebolte had everything to assimilate from Holbein, Holbein had only one thing to learn from Hornebolte, the actual technical process of painting miniatures. However dissimilar Holbein's miniatures may strike the onlooker, the difference remains one of style and composition but not of actual technical process. Like those of Hornebolte, Holbein's miniatures are also painted on vellum stuck onto card. They are also painted in transparent grey and red, sometimes brown, over an opaque carnation ground. The floated blue bice background, the use of powdered gold unburnished over ochre for the jewellery and the gold direct onto the vellum for the encircling line holding the circumference are all Hornebolte techniques.

The result, however, is a series of portrait miniatures wholly different in character. We pass from sitters observed in the aureole of a late Gothic sunset to those recorded in the cold light of a renaissance morning. There is a preoccupation with mass and form bound within rigid defining lines and an analytical rendering of both features and dress which stems from someone familiar with the ideals of renaissance scientific observation. These grave and often beguiling images have authority and dignity. Holbein's compositions render the minute surface that they cover monumental. The art of the portrait miniature is lifted suddenly onto a higher plane, fed by Holbein into the mainstream of renaissance art.

Not surprisingly it is not a large oeuvre and can never have been anything other than a sideline covering a very brief period from about 1534 to his death in 1543. Early on come ones of survivors from happier days: Sir Thomas More's daughter Margaret and her husband William Roper of Well Hall. Mrs Roper is in her thirtieth year which dates the miniature precisely to 1536. Both have a boldness of concept far superior to the niggling of Hornebolte. Unlike Hornebolte, Holbein nearly always included, as he did in his large-scale portraits, his sitter's hands, which he deployed to elaborate his statement as to character – William Roper foursquare tugging at his coat while his wife, in sharp contrast, timid and sad after untold woes, clutches her prayer book. This originality in composition is amplified by others: those of the children of Charles Brandon, Duke of Suffolk, one of the boy Henry dated

1535 (which dates Hornebolte's tuition of Holbein) and the other of Charles dated 1541; two of a grand court lady, usually identified as Catherine Howard; and above all the miraculous *Mrs Pemberton* (col. pl. 2b), probably painted about 1536.[25]

These are all too familiar, but the miniatures which are most illuminating are those which shed light onto Holbein's actual process of executing them. Hornebolte painted his miniatures direct from the sitter seated before him straight onto the vellum, at the most retaining a pattern of the head in case of repetitions. Holbein's sequence was a far different one, for he applied to miniature painting exactly the same procedures that he adopted when making a portrait on any other scale. In other words Holbein started with something totally unheard of as part of the art of limning, a drawing from life. No fewer than four miniatures survive whereby we can trace this procedure. One is the miniature of Henry's fourth queen, Anne of Cleves (col. pl. 2a), the preliminary drawing for which lurks beneath the surface of the large-scale portrait, on paper, in the Louvre. No doubt a miniature enabled him to produce a likeness with speed of the prospective bride without the laborious and long process of constructing an oil painting on panel. A second is of Lord Abergavenny,[26] for which the portrait drawing, once part of the famous series at Windsor, is now at Wilton, and another is of Lady Audley for which the original study is still in the Royal Collection. Holbein began any portrait on whatever scale with a drawing on paper, first defining in chalk the form, moving on by degrees to etching in those decisive outlines which are such a feature of the drawings. His visual memory must have been quite phenomenal, for from these drawings, often with notes and a few additional indications of details of dress or jewellery, he was able to construct his completed portrait.

In the final instance, the miniature of his patron Thomas Cromwell, Earl of Essex, into whose orbit he drifted before entering royal service in the mid-1530s,[27] the original drawing is lost. So too is the original large-scale oil painting, but many versions exist (of which the best is in the Frick Collection), and we can suspect the presence of a portrait drawing in the studio to have been the fount of the likenesses, whether large or small. This process, aligned to the genius of the artist, lifted the art of the portrait miniature onto another level, a fact which Hilliard, writing in the reign of Elizabeth, recognized when he wrote that Holbein's manner of limning he had 'ever tried to imitate'.

Holbein's will was proved on 29 November 1543. Six months later, on 27 May, Hornebolte's will was proved. Almost overnight the Tudor court had lost its two leading artists. Great must have been the panic that these two losses precipitated because there was no sign of lack of royal patronage. Indeed in 1537 Henry VIII had embarked on his magnificent folly, Nonsuch, designed to eclipse Francis I's Château de Chambord. As a successor to Holbein the king succeeded in attracting to his service William Scrots, court painter to the Regent of the Netherlands, Mary of Hungary. Scrots

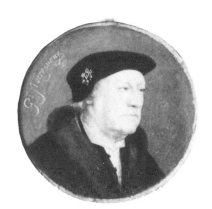

55. Hans Holbein, *Lord Abergavenny*, c. 1535, dia. 49 mm. Duke of Buccleuch.

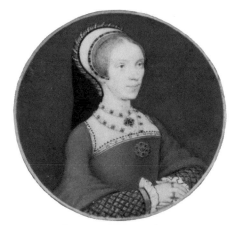

56. Hans Holbein, *Elizabeth Lady Audley*, c. 1540, dia. 56 mm. Royal Collection.

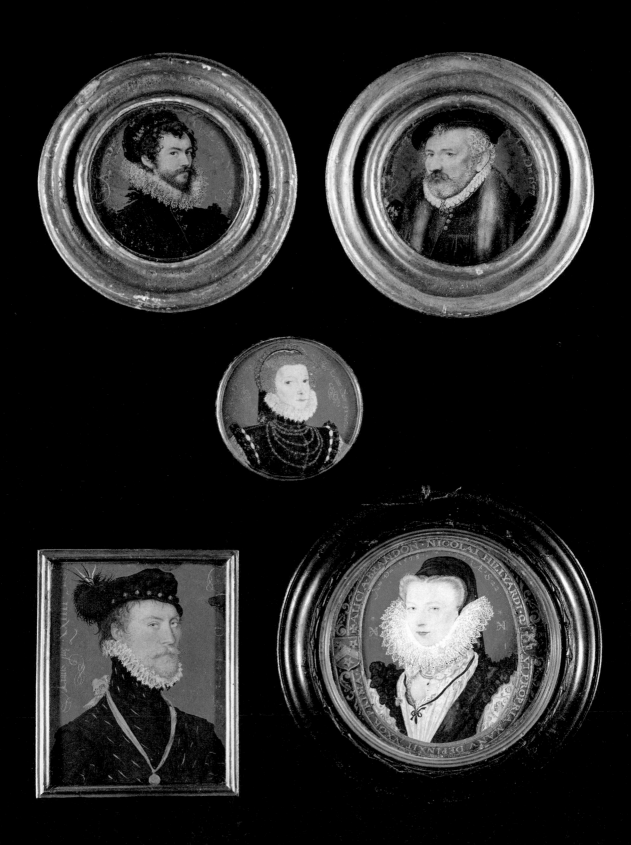

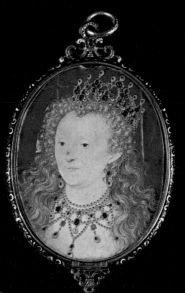

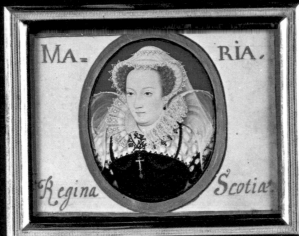

MA = RIA.

Regina Scotiæ.

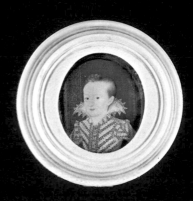

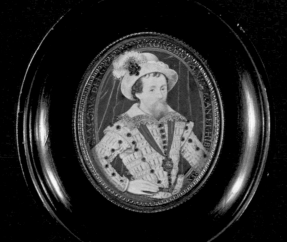

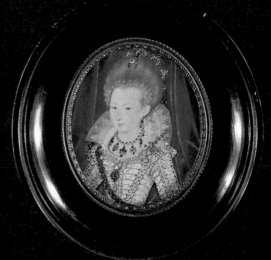

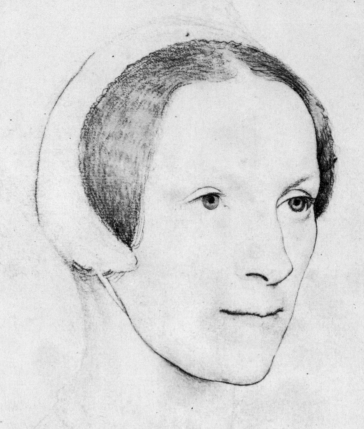

The Lady Audley.

was to serve Henry and especially his son, Edward VI, until he died or left England in 1553. A successor to Lucas Hornebolte, however, presented more serious problems.

LEVINA TEERLINC (?1483–1576)

As was the case in 1525 there was a repetition of the procedures established whereby the Tudor court enlisted a new miniaturist. Hornebolte taught Holbein but there is no evidence that he instructed any native-born painter to succeed him. Miniaturists and illuminators, like other artists, were people recruited from abroad. Inevitably, therefore, attention this time focussed on the remaining family of the Ghent–Bruges school, the Bennincks.[28] The founder of that dynasty was Alexander or Sanders Benninck who had migrated with his family from Zealand and settled in Flanders in the late fifteenth century. He was an important illuminator and one of the first to substitute for the conventional foliage and floriations on plain vellum, borders of natural flowers and foliage on a ground of yellow pigment heightened with gold. Greater fame was to surround his son Simon, whose abilities were even eulogized by Vasari. He was also a portraitist as, for instance, is revealed in the series of miniatures of emperors in the manuscript he illuminated of the Order of the Golden Fleece. Benninck eventually settled in Bruges in 1519 and married twice. By his first wife he had five daughters, the eldest of whom, Levina, he trained as an illuminator. Levina married George Teerlinc of Blanckenberg and it was she who, at the close of 1546, crossed to England to enter the service of Henry VIII. The line of communication to her would have been easy because interchange between the Bennincks and the Horneboltes went back as far as 1519 when Gerard Horenbout worked with Sanders Benninck on the Grimani Codex. What we must imagine, therefore, is a repetition of the recruitment operation of the 1490s and 1520s.

Levina Teerlinc has so far figured as an unknown quantity in the history of miniature painting but any examination of the evidence (of which there is no lack) will quickly establish that there is absolutely no reason for this.[29] She arrived in England in 1546 and died in 1576. She enjoyed from the outset a handsome annuity of £40, less than that awarded to Hornebolte but more than that given to Holbein. Her husband was made a Gentleman Pensioner and she was always referred to as a 'gentlewoman', indicating a status far superior to that of tradesman or artificer, the category normally assigned to an artist. In October 1551 she was sent with her husband to the Princess Elizabeth 'to drawe out her picture'. Five years later, on New Year's Day 1556, she reflected the rhythm of religious change by presenting Mary I with 'a smale picture of the Trynitie'. Between 1559 and 1576 the surviving New Year's Gift lists provide an abundance of material, as she annually presented the young Elizabeth I with portraits of herself: 'the Quene's picture finly painted Upon a Card' (1559); 'a certayne Journey of

COLOUR PLATE 4 (preceding colour page)

Nicholas Hilliard

a. (top) *Elizabeth I* and jewelled setting (gold, enamel, rubies and table-cut diamonds), *c.* 1600, 62 × 47 mm. V&A 4404–1857.
b. (middle left) *Mary Queen of Scots, c.* 1578, 51 × 40 mm. V&A P24–1975.
c. (middle right) *Charles I as Duke of York, c.* 1605–9, 33 × 27 mm. V&A P10–1947.
d. (bottom left) *James I, c.* 1604–9, 53 × 43 mm. V&A P3–1937.
e. (bottom right) *Elizabeth of Bohemia, c.* 1612, 54 × 45 mm. V&A P4–1937.

57. (facing page) Hans Holbein, *Elizabeth Lady Audley* (drawing), *c.* 1540. Royal Collection.

COLOUR PLATE 5 (following page)

Nicholas Hilliard

a. (top left) *Man clutching a Hand in the Clouds,* 1588, 60 × 50 mm. V&A P21–1942.
b. (top right) *Young Man with Bonnet and Feather, c.* 1585–90, 51 × 41 mm. V&A P4–1974.
c. (middle) *Frances Howard, Duchess of Richmond and Lennox, c.* 1605–10, 32 × 26 mm. V&A P15–1941.
d. (bottom left) *A Woman, said to be Mrs Holland,* 1593, 58 × 48 mm. V&A P134–1910.
e. (bottom right) *Unknown Woman,* 1602, 60 × 46 mm. V&A P26–1975.

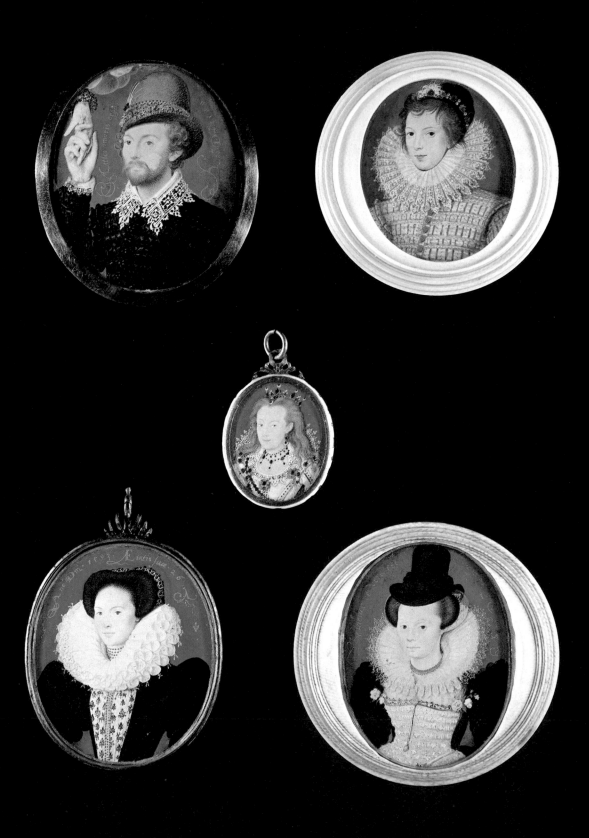

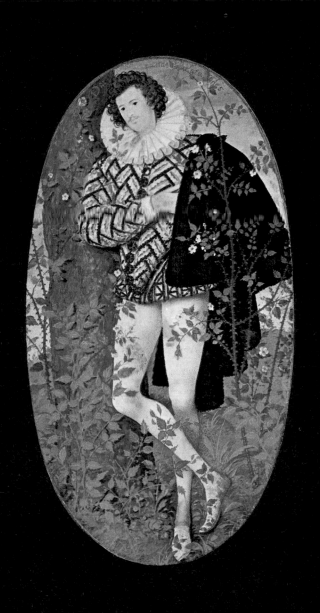

the Quenes Majestie and the Trayne fynely wrought upon a Carde' (1564); or 'the Quenes picture upon a Carde' (1576).[29]

She went on working for thirty years and was actually still painting portraits of Elizabeth I four years after Hilliard's earliest likeness of the queen. No one yet has ever attempted to assemble an oeuvre.[30] This is because very few miniatures from the period have so far come to light, but those which have do, it can be argued, provide a scattered but coherent picture of the work of one artist over a long period of time. That there are so few miniatures and that the period of time is so long has puzzled scholars, but it must be remembered that miniatures still pertained only to members of the royal family and to those closely related to it. In the second place Levina Teerlinc was a gentlewoman. She was far grander than the Horneboltes. The endless annual presentation miniatures on New Year's Day might well have represented the sum total of her work for any one year. With a large annuity she had no need for the commissions that were to be the life-blood of the impoverished Hilliard. Bearing these points in mind we can begin to assemble a nucleus of material which on stylistic, technical and iconographic grounds must be by her.

The documents make it clear that she specialized not only in portraits but in secular subject miniatures, a totally new departure for a Tudor court miniaturist and regrettably one not to be sustained by her successors. The earliest identifiable miniature is in a tentative style and was formerly assigned to Hornebolte. It is of a young woman which, on grounds of costume, must have been painted soon after her arrival. As an object it establishes immediately that she was working as one would expect within the Ghent–Bruges technical tradition. It is painted on vellum stuck onto card, the features and hair are worked over a carnation ground, the background is blue bice and there is an encircling gold line. The format is circular. Although the lettering with its reversed letter *N* derives from Hornebolte, the drawing is far weaker and tentative, and the figure is provided with a pair of matchstick arms which were to become almost her signature. The painting of the face is thin and transparent, watered-down Hornebolte, genteel, slightly fussy and poles apart from the boldness and monumentality of conception introduced by Holbein. The work of Levina Teerlinc is a step back, the maintenance of a tradition rather than the re-invigoration of it into new directions.

This is corroborated by a second miniature in the same vein, one of Lady Katherine Grey, sister to Lady Jane (col. pl. 1b), and likewise brought up as a Tudor princess. It again is a thinly painted piece, papery in feeling, with the customary slender arms. And just as the young girl painted ten years before reflects the influence of large-scale portraiture by Master John, as evidenced in his portrait of Mary I (1544)[31] in the National Portrait Gallery, so in this miniature, *c.* 1555, we catch the direct impact of Hans Eworth who used this formula for his female sitters time and again.[32] One final miniature rounds out her portrait style. It is one of Elizabeth I dating from the mid-1560s, and although the features are repainted

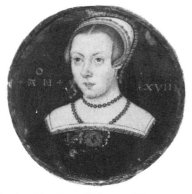

58. Levina Teerlinc, *Unknown Woman, c.* 1550, dia. 48 mm. Yale Center for British Art.

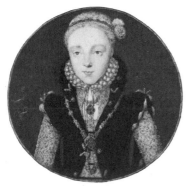

59. Levina Teerlinc, *Elizabeth I, c.* 1565, dia. 46 mm. Royal Collection.

there is enough of the original left for us to conclude that there
were no sudden late innovations.[33] The format is still the same and
the influence is still that of Eworth.

Levina was at best an indifferent draughtsman, but this did not
impede her ambition to embark on complex compositions far
beyond her limited capabilities. The miniature depicting an Eliza-
bethan Maundy ceremony provides us with a unique glimpse of
court pageantry clearly observed from the life. It must have been
one of her New Year's Gift miniatures to the queen for she,
wearing an apron and with her train borne up by a gentlewoman,
is the centre of attention in the foreground. Poor people sit in rows
waiting for their feet to be washed, while the background is made
up of choristers, members of the chapel royal, courtiers and gentle-
men pensioners. The miniature has all the characteristics of Teer-
linc's spidery style and, in addition, it raises the question – did she
as was the case with her predecessors illuminate books? Certainly
she was trained as an illuminator and there is a group of manu-
scripts that could be assigned to her. One dating from about 1555,
*Certain prayers to be used by the quenes heignes in the consecration of the
crampe rynges*, is technically right and stylistically marries exactly
into the *Elizabethan Maundy*.[34] An illumination from the manu-
script depicts Mary laying her hands on the neck of a man suffering
from cramp or epilepsy. It is a tableau observed from life, at least
initially, and the people, the queen, clerk of the Closet and chap-
lain are portraits. Even although the printed book was taking over,
the tradition linking portrait miniatures and the Royal Library was
still alive into Mary's reign.

Levina Teerlinc will never emerge as an artist of major impor-
tance. She is rather a technical life-line taking the tradition of
portrait miniature painting on well into the England of the 1570s.
Almost more than any other Tudor artist, however, she was to
disappear into total oblivion, so much so that not even a garbled
memory of her name remained by the reign of Charles I. Could it
be male prejudice? One wonders, bearing in mind Hilliard's cele-
brated statement that 'none should medle with limning but
gentlemen alone' – a reference certainly to class, but also possibly
with sexist overtones. By the time that Hilliard came to write his
treatise, the cornerstone for our knowledge of the technical tradi-
tion, he was the undisputed master of his age and writing in a
fervour of patriotism. Although he is fulsome in his tributes to
Holbein, he never refers to either Hornebolte or Teerlinc and yet
he was their successor rather than Holbein's. And it is this problem
that we must tackle before we move on to a consideration of the
apogee of the miniature from the 1580s onwards.

Nicholas Hilliard (1547–1619)

If we are to accept the postulated birthdate of Teerlinc, she would
have been eighty in 1563 and ninety-three when she died in 1576.
Both ages are startling in terms of the sixteenth century. Even if

60. Levina Teerlinc, *An Elizabethan Maundy, c.* 1565,
70 × 64 mm. (originally rectangular). Countess
Beauchamp, Madresfield Court.

COLOUR PLATE 7 (following page)

Nicholas Hilliard, *Henry Percy, ninth Earl of
Northumberland, c.* 1595, 257 × 172 mm. Rijks-
museum.

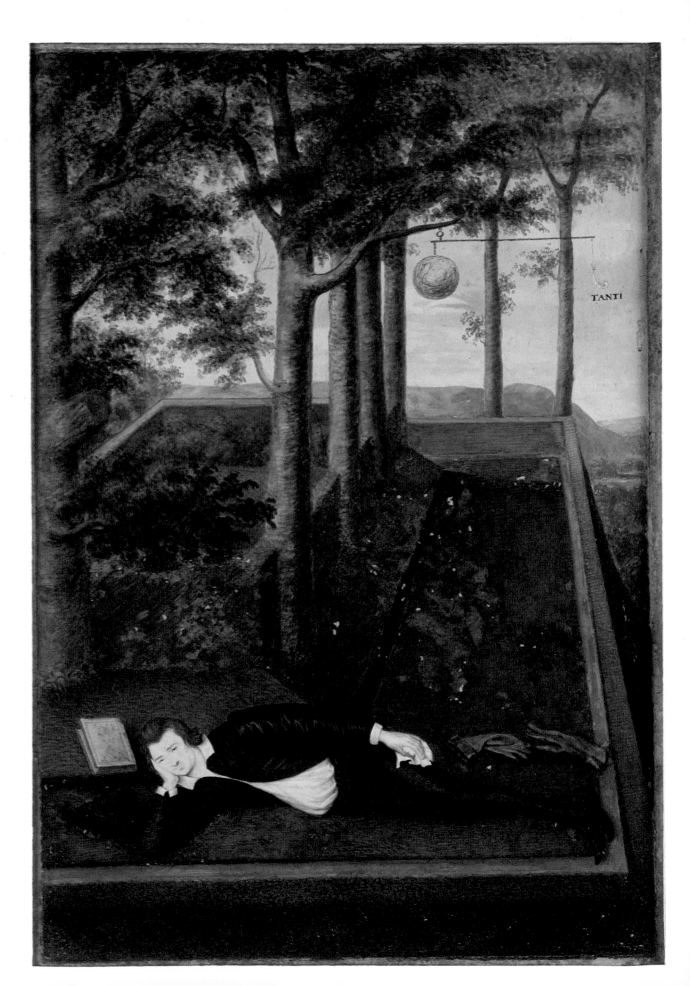

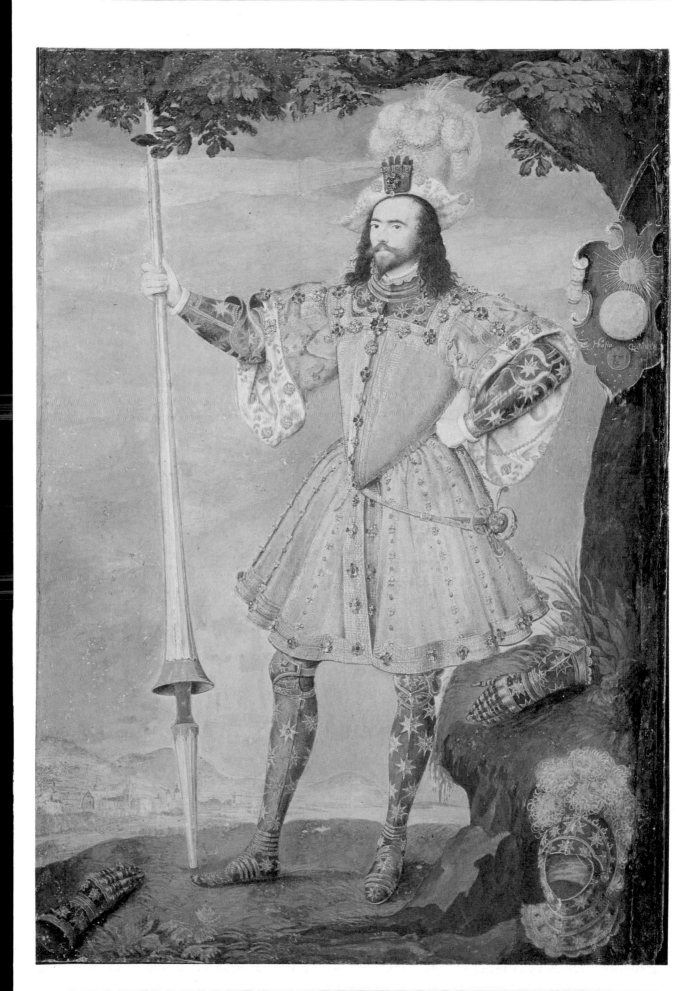

COLOUR PLATE 8 (preceding page)

Nicholas Hilliard, *George Clifford, third Earl of Cumberland, as the Knight of Pendragon Castle, c.* 1590, 258 × 178 mm. National Maritime Museum.

she was sixty in 1563 she was still old, and understandably thought must have begun to have been given to her successor. In that year the ministers of Elizabeth I drafted a proclamation forbidding the manufacture of her portraits until an artist could be found to make some form of approved pattern.[35] We do not know whether this proclamation was ever issued but what it does establish is that Elizabeth and her ministers were looking around for a court painter in the middle of the 1560s. All the evidence would suggest that the usual pattern of recruitment was not followed. For the first time no one was to be imported from abroad and, more significantly, no one was to be placed on a payroll. Crown finances had to be placed back on an even keel, and the prodigal expenditure of Henry VIII on art and artists was to come to an end. Royal patronage was now in full retreat never to return until a new century and a new dynasty. The effects of this decision were extremely important across the whole spectrum of the arts, for they explain the direction taken by the miniature after 1570.

Nicholas Hilliard was born in Exeter in 1547, the son of a well-to-do goldsmith of reformist bent.[36] Under Mary I the young Nicholas had gone into exile to Geneva with the future Sir Thomas Bodley, another Exeter man. It is not known when he returned to England but the mass influx of exiles was immediately after the accession of Elizabeth and soon enough to affect decisively the Parliament of 1559. In November 1562 he was apprenticed to a London goldsmith, Robert Brandon, a leading member of his influential Company and jeweller to the new queen. There was nothing unusual in this relationship and Hilliard served the customary seven years' apprenticeship, becoming a freeman of the Company in July 1569. He, in turn, set up as a goldsmith and the earliest reference we have to his work comes in 1571 when 'a booke of portraitures' is referred to as being in his hands. From the same year comes the earliest certain miniature, one of a man called Oliver St John, first Baron Bletso. In it he emerges as an artist with total control, his style fully formed, assured in his interpretation of character, with complete technical mastery. No one has ever explained how this came about.

Hilliard was trained as a goldsmith and a jeweller. What is unusual is that he painted miniatures, an art which like the others had to be learned by apprenticeship. He, in his turn, taught Isaac Oliver, Rowland Lockey, and his own son, Laurence. The only fact that Hilliard never tells us is who taught him. The nearest he gets to it in his *Treatise* is his reference to the 'cunning strangers' recruited by Henry VIII which leads on to his well-known statement: 'Holbein's manner of limning I have ever imitated and hold it for the best.'[37] Stylistically this, of course, is correct. His miniatures are inspired by the monumentality and boldness of Holbein, they embody a return to the linear, to the delineation of form by means of line achieved by a use of colour. But Hilliard did not technically paint miniatures like Holbein. The latter as we have seen began with a drawing and scaled it down. Hilliard, in contrast, followed the tradition of the Ghent–Bruges school. He painted

61. Nicholas Hilliard, *A Man, said to be Oliver St John, first Baron Bletso*, 1571; dia. 45 mm. Welbeck Abbey.

directly from life what he actually saw before him without any preliminary studies. There was surely no one in England that he could have learned this process from except Levina Teerlinc. The hypothesis must be posed that, as a result of the 1563 portrait crisis, it was decided to train someone up as court portraitist. The queen's jeweller had a bright boy, who had already shown an interest in miniatures (two schoolboy efforts dated 1560 survive),[38] who should be taught to paint miniatures by Levina Teerlinc but also to paint panel pictures under the instruction of an artist of the type of the Master of the Countess of Warwick. Without a scenario of this kind the emergence of Hilliard is inexplicable.

As far as the queen was concerned she had got what she wanted, a court painter without paying for one. Hilliard's life indeed can almost be written in economic terms as a result of this. Initially his career got off to a flying start. In 1573 Elizabeth granted him the reversion of the lease of the rectory and church of Clive in Somerset for his 'good, true and loyal service'. Three years later he cemented his success by marrying his master's daughter, Alice Brandon. Then the clouds began to gather. A few months later we find him *en route* to the French court, 'with no other intent than to increase his knowledge by this voyage, and upon hope to get a piece of money of the lords and ladies here for his better maintenance in England at his return'.[39] That seems to have proved abortive, for after his reappearance in England sometime between the autumn of 1578 and the spring of 1579 he turns up along with a group who promptly 'lost all their charges' by dabbling in goldmining in Scotland. In the early 1580s this was succeeded by an attempt to corner production of portraits of the queen jointly with the Serjeant Painter, George Gower, but this also ended in failure. By then Hilliard had almost completed his large family of four sons and three daughters.

Even allowing for the fact that money matters tend to generate papers, Hilliard always surfaces in financial straits. In 1591 both he and his children went unmentioned in his father-in-law's will, though it made provision direct for Alice, reflecting accurately her father's opinion of his son-in-law. In 1595 Essex, then at the zenith of his glory, produced no less than £140 to redeem the mortgage on Hilliard's house, an event followed by a long struggle by the artist to secure the renewal of the lease from the wealthy Goldsmiths' Company. In 1613 he finally left this house, which was in Gutter Lane off Cheapside, and moved to another in the parish of St Martin-in-the-Fields. Once more he revived the project for a monopoly over royal portraiture, this time with success, but by 1617 he was almost too old to enjoy it and it in no way prevented a sojourn in Ludgate prison as a result of standing surety for another man's debt. A solitary engraving by Delaram after Hilliard, who based it on his miniature of Elizabeth I now at Ham House, bears witness that the monopoly did in fact momentarily work.[40] On 7 January 1619 he was buried in the church of St Martin-in-the-Fields. His will reveals that he was far from being a rich man: 20 shillings to the poor of the parish, household goods to the value of

COLOUR PLATE 9 (following page)

a. (top) *The Heneage ('Armada') Jewel*, containing a portrait of Elizabeth I by Nicholas Hilliard (gold and enamel with diamonds and rubies), c. 1600, overall height 70 mm. V&A M81–1935.
b. (middle) *The Gresley Jewel*, containing portraits of Sir Thomas Gresley and his bride Catherine Walsingham by Nicholas Hilliard (gold and enamel with rubies, emeralds, pearls and onyx), c. 1580–5 (Lady Gresley), c. 1590 (Sir Thomas), overall height 69 mm. Pennington–Mellor–Munthe Trust.
c. (bottom) *The Ark Locket*, containing a portrait of James I from the studio of Nicholas Hilliard (gold and enamel), c. 1605–10, overall height 30 mm. V&A M92–1975.

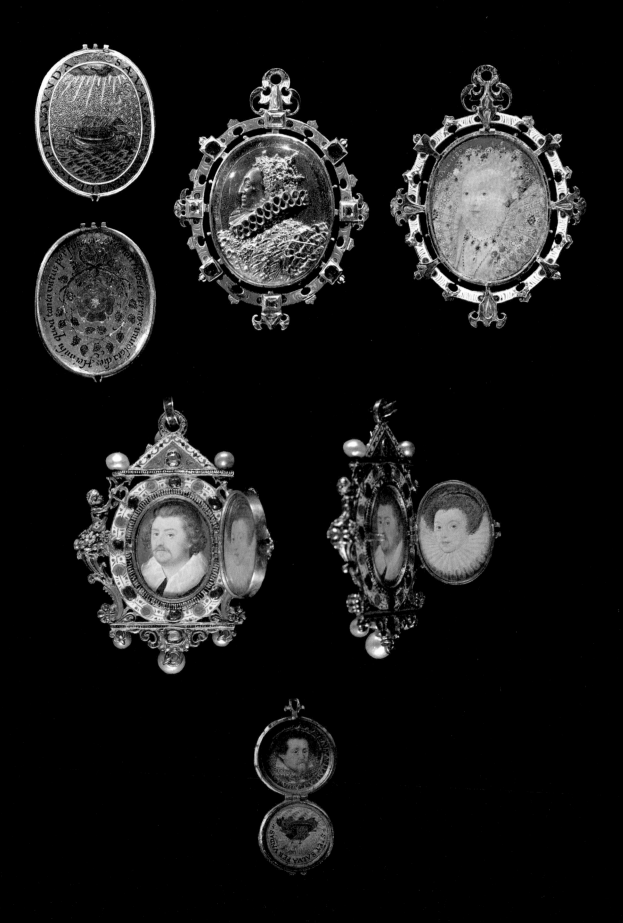

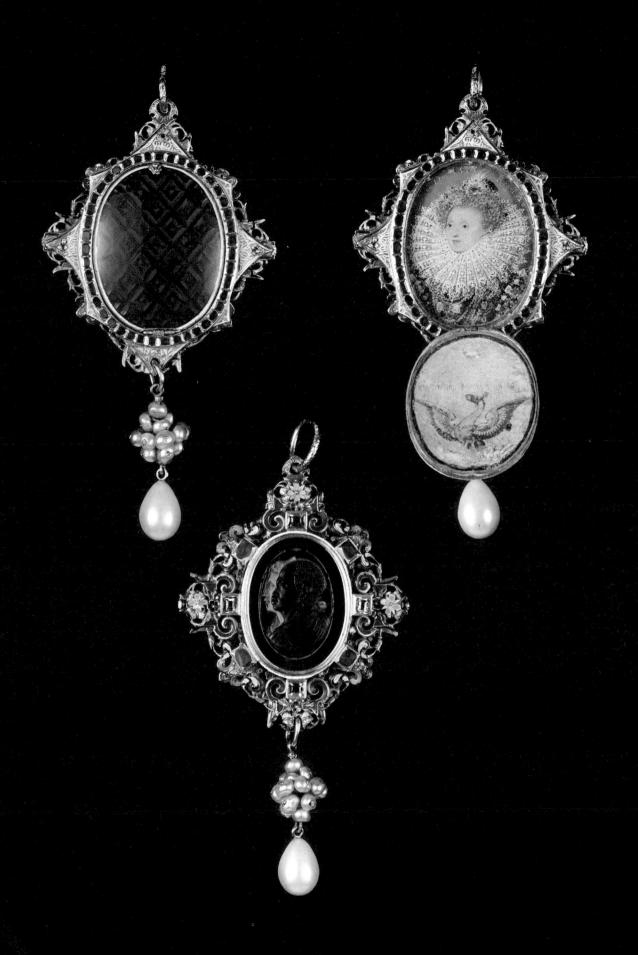

The Drake Jewel, containing a portrait of Elizabeth I by Nicholas Hilliard (gold and enamel with diamonds, rubies, pearls and sardonyx), 1586–7, overall height 117 mm. Private Collection.

62. Nicholas Hilliard, *Elizabeth I, c.* 1587–8, 44 × 37 mm. V&A P23–1975.

£10 for the servant who had nursed him and the remainder to his son Laurence.

That Hilliard's life can be presented in terms of money is important. Hilliard, unlike his predecessors, had no fixed income. He depended for his livelihood on fees and commissions. Although he produced miniatures and jewels in abundance for both Elizabeth I and James I, he never figured on an annual payroll until Robert Cecil achieved it for him, and then the annuity went direct to his debtors. As a result of this, miniatures ceased, therefore, for the first time to be exclusively rarified attributes of the royal family and those close to it produced by royal artists. A portrait miniature was available from 1570 onwards to anyone who could meet the bill. Hence the dazzling panorama of Crown and court, town and country, that make Hilliard's portraits such a microcosm of the Elizabethan world. Side by side with the votive images of Gloriana set into gem-encrusted cases, there are miniatures such as that of a citizen's wife in a plain turned ivory box, shyly peering at us, modestly dressed with a high-crowned hat and a ruff stuck with sprigs of wild flowers (col. pl. 5e). A sitter from this class of society would have been unthinkable before 1570. We have witnessed the democratization of the miniature.

This fact also accounts for the balance in numbers of surviving miniatures. During the whole century 1520–1620, about thirty by Hornebolte, a dozen by Holbein and half a dozen by Teerlinc account for half a century. In sharp contrast, over two hundred miniatures by Hilliard have survived covering forty years. More may emerge by the earlier artists but I doubt very much that the overall pattern of productivity will change. It was conditioned from the outset by these sociological and economic factors.

Hilliard began work in the 1570s utilizing the circular format of his predecessors, simple head-and-shoulders studies with a distinc-

tive calligraphic style using an abundance of flourishes to the
capital letters (col. pl. 3c). From the outset his technique was that of
Hörnebolte, but his application of it was by way of Holbein. The
definition of form is achieved by means of line. There is a vigour
and a thrust to his brushwork which, under intense magnification,
is amazingly free, making it more reminiscent of the work of
Impressionist painters centuries later than the smooth controlled
surfaces of the mannerist masters. In his *Treatise* he explains the
importance of learning by way of copying Dürer's engravings and
certainly this is the clue to his brushwork which is hatching done in
the manner of an engraver working across a plate.

Hilliard painted exactly what he saw. The force of that elemen-
tary observation can only truly be grasped when it is realized that
every one of his numerous portraits of the queen shares this
quality.[41] The head may be a repetition but the hair, dress and
jewels never. He must have had a lay figure dressed by the queen's
tirewomen to copy for he has delineated with his brush the reality
of the wardrobe of Elizabeth Tudor. Every jewelled headdress,
gigantic carcanet, embroidered and bespangled dress and sleeves,
every little jewel pinned to her ruff or sparkling in her hair actually
existed.

An early miniature of a lady, *c.* 1575–80, which was probably
kept in the studio as a demonstration piece, gives us a detailed
glimpse of how he built up his portraits. He began with a graphite
drawing, parts of which are still visible through the dress. The
opaque carnation ground was then applied over the area of the hair
and face, and the hatching in red and brown which would ulti-
mately have defined the features was begun but not finished. A
wash of yellow was applied to the hair, but further modelling was
to have come. The background of blue bice has been floated and
the ruff worked up in transparent grey over a white ground with
the lace embossed in thick white. Lines of brown and black direct
onto the surface of the vellum indicate the general disposition of
the costume. The whole is given its quality by his unerring placing
of the figure within the compass of the vellum and his unfailing
response to almost any sitter, above all women.

The miniature is also unusual in being an oval. Although oc-
casionally he returned to the old circular format, from about 1577
onwards Hilliard evolved the oval as the ideal shape for the portrait
miniature. Not only did it permit a glimpse of more costume, it
allowed from time to time the insertion of a hand. Even more it
subtly emphasized the private informal nature of the image and
removed it from any immediate association with the medal or
coin. This transition seems to have occurred during his visit to
France. There is an *Unknown Man* dated 1577 which is an oval and
in 1578 he painted his wife (col. pl. 3e) and executed his two wood-
cut portraits of the Duke and Duchess of Nevers using the same
shape. For his own self-portrait (col. pl. 3a) and the portrait of his
father (col. pl. 3b), both from 1577, he was still working within a
circle, so we can pin-point the date of the change exactly.[42]

That Hilliard was familiar with French court portraiture before

63. Nicholas Hilliard, *Unknown Woman, c.* 1575–
80, 39 × 33 mm. V&A P8–1947.

he crossed the Channel is generally recognized, but the experience of actually seeing the work of Clouet in quantity and the decor of the Valois palaces, above all Fontainebleau, in their pristine glory must have been profound. Of course the French chalk drawings reinforced his concern with recording the elusive fleeting glances of his sitters, those 'lively graces, witty smilings, and these stolen glances which suddenly like lightening pass, and another countenance taketh place'.[43] The famous *Young Man among Roses* (col. pl. 6) stands posed in a manner lifted direct from a stucco figure amongst the plaster decoration of Fontainebleau, and the presentation of him sinuous amidst a bower of blossoms certainly suggests the influence of the Maître de Flore. On his return this elegant, almost effete sophistication of the court of Henri III, familiar to us through the paintings of Antoine Caron and the Valois Tapestries, was a recurring inspiration. The portrait of Sir Walter Raleigh in the National Portrait Gallery[44] and the youth formerly in the Radnor collection (col. pl. 5b) could, for instance, as equally be likenesses of *mignons* in attendance upon the last Valois king as Elizabethan courtiers.

By the early 1580s the aesthetic he represented swept all before it and decisively affected the direction of large-scale painting, which he also practised. The iconic 'Phoenix' and 'Pelican' portraits of Elizabeth I (National Portrait Gallery and Walker Art Gallery respectively) must virtually certainly be by him,[45] but in the 1580s this style, flat, two dimensional and decorative, was to influence the queen's Serjeant Painter, George Gower, into producing a long series of formalized icons of court ladies, in which the accent is on the detailed rendering of every item of dress and in which the face (unlike Hilliard) was to become almost incidental. Other artists including Robert Peake, William Segar, William Larkin and Gilbert Jackson were to ensure the vitality of this aesthetic down to the Civil War.[46]

Towards the end of the 1580s, however, a new line suddenly appears, the large-scale miniature. It is difficult to divine what prompted this. The legendary idyll of the *Young Man among Roses* (col. pl. 6)[47] must be amongst the earliest. The *Young Man* is an extraordinary elongated oval shape which suggests that it was composed for some particular setting but its successors are all rectangular. All fit tightly into the decade *c.* 1585 to *c.* 1595. Where sitters are identifiable they are ones noted for their wealth and extravagance, for such miniatures must have been costly and taken a long period to execute. Others are of Leicester's son, Robert Dudley, Duke of Northumberland, George Clifford, third Earl of Cumberland (col. pl. 8), Robert Devereux, second Earl of Essex, Sir Anthony Mildmay and Henry Percy, ninth Earl of Northumberland (col. pl. 7).[48] Some of these extend the format to such a size that they strike one less as miniatures than as precursors of the English watercolour school. The *Mildmay, Essex* and *Dudley* stick to the conventions of the grand Elizabethan full-length with curtains and chair to hand, all tight within an enclosed space. The *Cumberland* and *Northumberland* strike out by having the figure

64. Nicholas Hilliard, *Sir Walter Raleigh, c.* 1585, 48 × 39 mm. National Portrait Gallery.

65. (facing page) Nicholas Hilliard, *Sir Anthony Mildmay, c.* 1590–3, 235 × 175 mm. Cleveland Museum of Art.

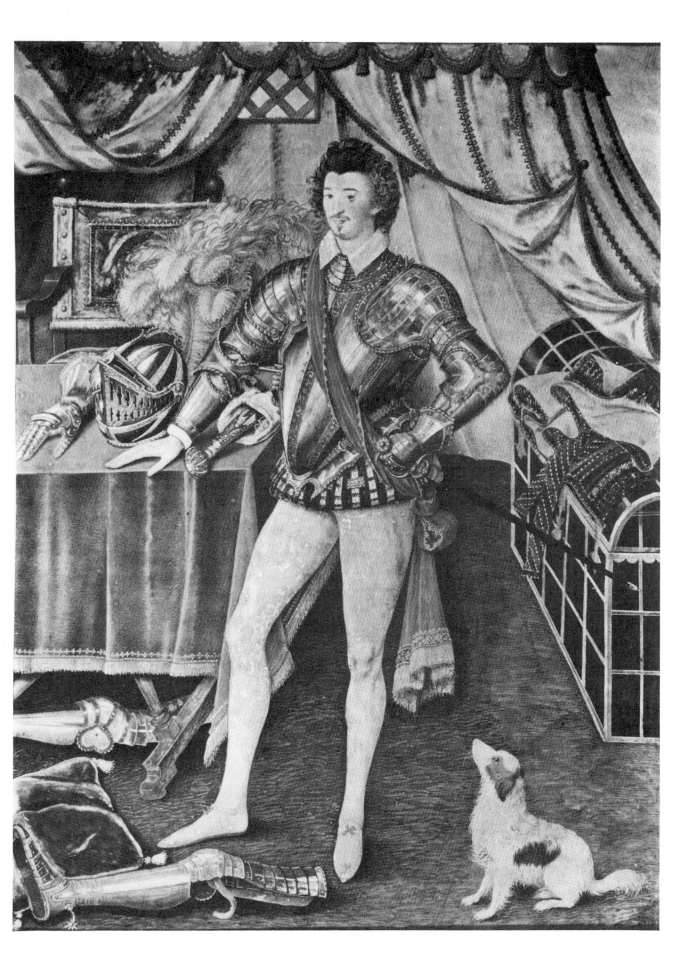

66. Nicholas Hilliard, *Sir Henry Slingsby*, 1595, 84 × 63 mm. Fitzwilliam Museum.

67. Nicholas Hilliard, *Elizabeth I* (drawing), *c.* 1585, 137 × 116 mm. V&A P9–1943.

placed within a landscape, albeit an emblematic one, possibly reflecting Hilliard's awareness of the innovations in portraiture by Marcus Gheeraerts the Younger during the 1590s. But miraculous though these miniatures are there lurks behind them a basic uncertainty. The format has extended itself beyond the artist's control. They reveal Hilliard's essential limitations. He has absolutely no grasp (as Oliver had) of renaissance scientific perspective whether in its mathematical or aeriel sense. Chairs, tables and trunks are tipped up at impossible angles and converging lines (meaning distance) in fact never actually meet at a vanishing point. One of these full-lengths remains unfinished, reflecting perhaps his disillusionment with the formula to which after about 1595 he never returned.

The early 1590s do, however, witness a change of style in his brushwork under the impact of his pupil Oliver. The so-called *Mrs Holland* (col. pl. 5d) pin-points it to the year 1593. From that date onwards Hilliard tightened up his brushwork, above all in the rendering of the hair, which henceforth is no longer a torrent of strokes but a carefully composed arrangement of lines of the brush. In addition the almost monotonously blue backgrounds of the

1570s and 1580s give way to the folded velvet curtain, usually crimson, executed in a new wet-in-wet technique, a feature datable to *c.* 1594–5 in portraits such as *Sir Henry Slingsby*. Rarely was he ever bored in his response to his sitters, certainly never in the case of a woman.

Drawing was only required in the case of a design for a project. There is and should be no corpus of Hilliard drawings. The two certain surviving ones connect with royal commissions. Both are of Elizabeth, although the first up until now has remained unidentified. It is a formal presentation of the queen in a pose that suggests that it is one of the studies leading up to the Second Great Seal (1584–6) for which Hilliard was paid for the preparation of several patterns. The second is a design for a Great Seal of Ireland from the 1590s, but it was never used.[49] Both are reminders that Hilliard was still an artist who, like the Horneboltes, ran a workshop in the old Burgundian tradition, able to turn his hand across the spectrum. Occasional references establish that he continued to

68. An impression in white wax of the second Great Seal of England, designed by Nicholas Hilliard, *c.* 1585, dia. 153 mm; attached to royal Letters Patent allowing Henry Southworth to alienate parts of the manor of Potter Hanworth in Lincolnshire, dated 2 March 1594. V&A P48–1980.

paint panel pictures. The Lumley Inventory of 1590 lists a 'conyng perspective of death and a woman'. In 1584 he presented Elizabeth with a New Year's Gift of 'a faire Table being pyctores conteyning the history of the fyve wise virgins and the fyve foolysshe virgins'.[50] As late as 1600 he promised to paint the Goldsmiths' Company a 'faire picture in greate of her Ma^tie'.[51] We know that he was active as the designer if not the sculptor of medals, among them probably the Dangers Averted series and those commemorating the peace with Spain in 1604. His connection with engravers also suggests that he drew portraits for them. In 1571 there is mention of a book of portraits being delivered to Jan Rutlinger the engraver,[52] and in 1617 Francis Delaram's portrait of Elizabeth I states that it is after Hilliard. And Hilliard too continued to illuminate documents because the dazzling portrait of Elizabeth I on the Mildmay College charter of 1584 can surely be by no other.[53]

With the advent of the new reign in 1603 it has been customary to cast Hilliard into the role of an artist in decline overshadowed by a more brilliant pupil, Isaac Oliver, who attracted the patronage of the avant-garde in the persons of Anne of Denmark and her precocious son, Henry Prince of Wales. Our judgment has, however, been adversely affected by the superfluity of mechanical portraits of the king, produced not only by Hilliard himself but by his studio and his followers. These have to be placed as a group into a special category and considered as such because any serious examination of Hilliard's other late work will rapidly eliminate a pronouncement on failing power, diminishing enthusiasm or an inability to adapt to the demands of a new age. Up until his seventieth year, if a sitter really interested him, he was to respond with all his customary bravura of technique and interpretation of character. Nor can one say either that inventiveness vanished. Although infinitely less chameleon-like than Oliver, he continued to evolve new poses and even introduced, in a final phase, borders of simulated 'jewels' as a brilliant decorative foil to the portrait subtleties enclosed.

The mass-produced images of the royal family need as indicated to be discussed as a single group. Hilliard could never respond to either James or Anne as he had to Elizabeth. James I's portraits[54] tell us all we need to know of this weary saga and we need only miniatures to capture what we might describe as the upper and lower end of the market. The former (col. pl. 4d) comes from an early group painted sometime between 1604, when he was proclaimed King of Great Britain, a fact recorded on the encircling inscription, and 1609, when he sat again. The face is mechanical but the dress, as in the case of Elizabeth, is observed from life, still with a degree of pleasure as his brush responds to the grey hat with its curling white and blue ostrich plumes or the slashed doublet with its diamond buttons. But the joy that went into recording Elizabeth's fantastic wardrobe has vanished. We no longer contemplate sparks from a goddess, but witness the tidying up of a corpulent middle-aged Scotsman. Yet even if the passion is missing there is novelty in the placing of the figure, arms akimbo, jutting

69. Follower of Nicholas Hilliard. *James I*, c. 1604–9, 57 × 44 mm. V&A P25–1975.

through the inscription. Contrast this, however, with a workshop production of *c.* 1604–9. The overall impression is limp and lifeless. The spirit has gone.

Such miniatures have obscured the fact that the embers continued to be stirred by other members of the royal family. The beautiful rendering of the *Charles I as Duke of York* (col. pl. 4c), between the ages of five and nine, gives the prince a pertness that other likenesses deny. The embroidered border of the hanging behind the sitter is deliberately used to emphasize the tiny upright figure. This same freshness is apparent in his lyrical rendering of Charles's sister Elizabeth as a girl of about ten to fifteen (col. pl. 4e). Silhouetted against the luscious folds of a crimson velvet curtain Hilliard was clearly entranced by her. The magic and response continued unabated to the end, as any examination of miniatures of sitters other than the royal family confirms. Perhaps the most astounding of these is the one of a grand lady, wrongly called *Mary Queen of Scots* and previously ascribed to the 1580s. Wrapped in an ermine-lined cape and embowered within a widow's cap and veil of lace and lawn, she lies arranged in a bed of state whose curtain is just visible to one side, the whole being encircled by one of his jewelled borders simulating pearls, sapphires, emeralds and rubies. The contrived richness of the frame is designed to emphasize the portrait within, an essay, apart from the pale carnation, entirely in white and silver executed with a dazzling virtuosity that makes this miniature the counterpart of Oliver's *Woman, said to be Frances Howard* (col. pl. 13). It is as though Hilliard was trying to outshine his pupil in his use of a restrained colour range, eschewing his usual brilliant palette which he confines to the border. In 1616 he repeated the formula in a portrait of a lovesick young man attired in black toying with the tassels of his collar, *Encore vn (astre) luit pour moy.*[55] In the 'jewelled' border his decorative instincts rampage while the portrait within is as severe as Oliver's most austere interpretations of melancholic man. Painted three years before his death, the economy of the composition, with its unerring use of broad blocks of white, black and blue, could never be cited as evidence of declining powers. And these two miniatures are not alone. Fashion may well have passed him by but Hilliard remained vibrant to the last.

ROWLAND LOCKEY (*c.* 1565/7–1616) AND LAURENCE HILLIARD (1581/2–1647/8)

Hilliard's work was always of supreme quality. Even at his least inspired the brilliance and vigour of the brushwork never wholly evaporated. In reversing the traditional assessment of his work after 1603 we would have to accept that as a man in his sixties he produced much less than he did twenty years before and that there must have been a pupil active to account for the considerable body of miniatures that survive which are in his manner and technical tradition but are not by him. And these are not merely variants of

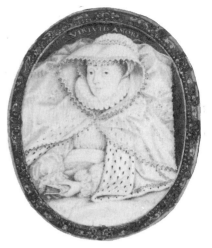

70. Nicholas Hilliard, *Unknown Woman*, *c.* 1615, 63 × 52 mm. Welbeck Abbey.

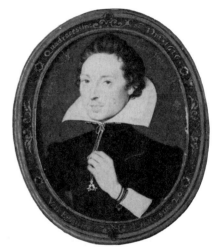

71. Nicholas Hilliard, *Unknown Man*, 1616, 62 × 51 mm. Welbeck Abbey.

royal portraits but quite independently observed *ad vivum* like-
nesses by someone working in the style of Hilliard as he practised it
before his tightening up of manner *c.* 1593.

In other words we are looking for a painter trained by Hilliard in
the 1580s. There is no evidence that Hilliard presided over a large
atelier. In fact everything in the history of miniature painting
under the Tudors and Stuarts points to the opposite, to a 'mystery'
in the medieval sense with secret recipes and tricks covertly passed
to the initiated resulting in a slender line of descent kept, if possible,
within the family. In Hilliard's case we know that he definitely
trained three other people in the art of limning. One was Isaac
Oliver, who was to establish an independent style almost at once
from the time he left his master's instruction. The second was his
son Laurence who only began his formal training in the very last
years of the century and certainly cannot have been practising as an
artist in his own right before 1605. The third was Rowland
Lockey.[56]

Lockey was apprenticed to Hilliard for a term of eight years
from 1581. In 1589 he emerged as a fully qualified goldsmith but he
was also a limner and a painter of large-scale portraits. In other
words he was very much in his master's mould. His large-scale
paintings from the evidence of documented and attributed works
establish him in the main as an indifferent copyist, certainly a
painter with no originality of concept, rather someone content to
work within the established conventions of the major artists of the
day, in this instance a watered-down Gheeraerts. From 1609 to
1612 we know that he was engaged in the mass manufacture of
portraits for Sir William Cavendish's long gallery at Hardwick.
But what of the miniatures? Some twenty years before, in 1592, we
find him working in tandem with Hilliard for Bess of Hardwick.
The latter was paid £3 in all for 'a gratter and a lesser' miniature
while Lockey received 40 shillings for one or two others. The
accounts are confused, but there is no confusion when Richard
Haydocke describes him in 1598 as expert in 'oil and limning in
some measure' or, and here we touch upon the key document,
when William Burton the antiquary eulogizes Hilliard's 'expert
scholler, Mr Rowland Lockey (one whom I know very well when
he dwelt in Fleet-Street), who was both skilful in limning and in
oil-works and perspectives'.

Armed with this evidence we are confronted with a miniaturist
in the Hilliard manner active from *c.* 1590 to 1616. No one has so
far faced up to the consequences of this, which is surprising because
Burton goes on to provide us with the vital clue we need. When in
1590 Holbein's cartoon of the family of Sir Thomas More came
onto the market it was purchased by his grandson, Thomas More
II, a recusant, who commissioned a series of copies. One was a
direct large-scale copy, dated 1590, which, signed by Lockey, still
survives. A second, not signed, but dated 1593, was described by
Burton when in the painter's studio and incorporated into the
original group Sir Thomas More's descendants. This is now in the
National Portrait Gallery. A third was a miniature (col. pl. 16)

which remained in the descent of the More family until it passed to the Sotheby collection at Ecton Hall in 1705. This work surely should enable us to reconstruct some form of oeuvre around Lockey. We only have to look through the archway to the right into the garden with its view of the Thames and London beyond to know what Burton meant when he referred to Lockey as a painter of perspectives. It is, however, the portrait group on the same side of the miniature of Thomas More II and his family that we need to study. Technically it is pure Hilliard and the light palette range is unresponsive to the new mood of introspective gloom of the 1590s. It is the Hilliard of the 1580s living on but, and here is the touchstone for Lockey, without the vigour and strength of characterization and drawing. The brushstrokes are often weak and indecisive and there is no sense of the structure beneath.

The Bess of Hardwick payment reveals that Hilliard and Lockey were working together closely in the early 1590s. In the small world of Elizabethan London Gutter Lane was no distance from Fleet Street. It can surely be no coincidence that from 1595 onwards and particularly after 1600 there begins to emerge a substantial number of Hilliardesque renderings first of Elizabeth I and subsequently of James I and his family. It is thus amongst the endless repetitions of portraits of James I that we should seek initially to expand Lockey's work. Examples in the Royal Collection,[57] for instance, painted during the first ten years of the reign and before Laurence could have been active, are pure derivatives of Hilliard but weak in drawing and execution. Surely these are by Lockey? They, of course, presuppose that Hilliard made his face patterns available to him but that was the normal procedure for the manufacture of royal likenesses.

Over-concern with transforming him into a convenient tip for too many indifferent royal portraits, however, would be misleading, for he was an independent artist in his own right and side by side with these convenient money spinners he would have painted *ad vivum*. Working from the More group we should make the leap and group others by him. One instance is a portrait of Henry Prince of Wales, dated 1608, wearing silver armour. It is the same suit as in Hilliard's incisive rendering of a few years earlier but there the comparison ends. It is a charming decorative piece, the face and hair in the same weak style as the likenesses of his father. The composition is uncertain and the inscription is virtually lost against the looped up wet-in-wet technique crimson velvet curtain. To this miniature we might add one of his brother Charles as Duke of York from about 1611, when he was made Knight of the Garter, painted in the same feeble manner.[58] Into this group perhaps one can draw in the so-called *Earl of Pembroke* dated 1612[59] and the so-called *Countess of Pembroke* of about the same date. Both are pure Hilliard in the Elizabethan manner and both are works of a fully formed artist rather than the tentative gropings of a young man as they would have to be if they were by Laurence. More imaginative thinking about Lockey is certainly desirable although it would be dangerous to develop him into a blanket label.[60]

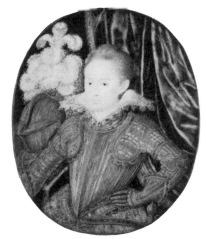

72. Attributed to Rowland Lockey, *Henry Prince of Wales*, 1608, 61 × 50 mm. Royal Collection.

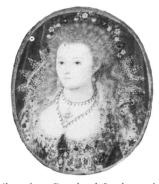

73. Attributed to Rowland Lockey, *A Woman, said to be the Countess of Pembroke*, c. 1610, 45 × 37 mm. Duke of Buccleuch.

74. Laurence Hilliard, *Unknown Man aged 31*, 1638, 38 × 32 mm. Countess Beauchamp, Madresfield Court.

75. Laurence Hilliard, *Charles I*, c. 1635, 49 × 42 mm. Duke of Buccleuch.

76. Isaac Oliver, *A Woman aged 20*, 1587, 55 × 44 mm. Duke of Buccleuch.

Laurence Hilliard, however, is quite another matter.[61] He was Nicholas's fourth son and the only one with a flair for painting. He finished his training as a goldsmith in 1605 and in 1608 received the office of 'his Majesty's limner' in reversion after his father's death. Laurence kept his style alive into the Civil War. No corpus of his work in any number has ever been assembled. For this indifferent artist it would be an uninspiring labour, as the earliest signed miniature, dated 1622, reveals, depicting a man in a weak flat style. Other miniatures by him are dated 1636, 1638 and 1640[62] and to these we could add a series in the same manner. They show no advance. He never includes the hands and as time passes we witness his struggle to come to terms with the age of van Dyck. The signed miniature of Charles I in the Buccleuch collection epitomizes his failure. There is no means whereby the technique and vision of the Elizabethan world could ever be adapted. The premises of both are totally at variance. Laurence only presents a problem in his youngest years. How soon did he help his father? When did he start to execute miniatures on his own? Is it to him that we can assign the feeblest of the repetitions of James I? These are the problems for future research.

ISAAC OLIVER (*d.* 1617)

Oliver has become a somewhat neglected artist.[63] Earlier periods held him in far higher esteem than Hilliard, whose reassessment has depended not only on the progress of art historical scholarship and the cult of the Elizabethan age but on the rise of the modernist movement with its final abandonment of the aesthetic principles that have largely governed the structure of a picture's surface since the renaissance. Oliver has therefore suffered a dramatic eclipse comparable to that of Samuel Cooper as our taste for more than a generation has spurned anything that smacks of the old academic tradition. With the reappraisal of the latter and with the advent of the new realists, Isaac Oliver is ready to be restored to the pantheon as one of the most important painters this country has ever produced. If the post-war generation was ready to rediscover Hilliard, the present one is ripe for the subtlety, shadowed gloom and introspective melancholy of Oliver.

The facts about his life place him from the outset into a far more international context than Hilliard. Oliver was brought to London in 1568 as a child by his father, Pierre Olivier, a Huguenot goldsmith. Richard Haydocke stated during Hilliard's lifetime that Oliver was 'his scholar for limning', a fact which can be corroborated on technical grounds. No evidence, however, survives of a formal apprenticeship by way of the Goldsmiths' Company, but then Oliver, unlike Lockey, was never trained as a goldsmith. He must have begun his training under Hilliard about 1580 because his earliest miniature is dated 1587, an unusual three-quarter length of a citizen's wife in a peaked hat and apron, accomplished and yet

unformed.[64] He was still only twenty-two but had already for-
mulated the monogram that he was to use on most of his minia-
tures, consisting of an *I* laid across an *O* with four dots surrounding
it. Only rarely did he sign in full and then at times with the
addition *françois*, evidence that he was proud of his French birth.
Everything in fact points to continental contacts via the exile
Protestant community. Although there is no definite evidence that
he went to the Low Countries at the close of the 1580s, there is a
strong possibility. His second wife was Sara, sister of Marcus
Gheeraerts the Younger, the leading fashionable portrait painter of
the 1590s, and niece of another painter, John de Critz, later Serjeant
Painter to James I. This places him very firmly into the tight
Anglo-Flemish community and into the milieu of the portrait
studios. His third marriage, to Elizabeth Harding in 1606, brought
him into a family of court musicians.

About the only other important fact we know about Oliver is
that he was in Venice in 1596 because it is recorded in a con-
temporary hand on the reverse of a miniature giving the date 13
May. The sitter is identified (in another hand) as a certain Sir
Arundel Talbot (col. pl. 12a), although no one has ever found any
trace of such a person.[65] There is, however, another piece of
evidence already long-published but not so far referred to that
clinches this Italian tour. In van der Doort's catalogue of Charles I's
collection a subject miniature is listed by Oliver of 'our Lady St
Katharine and manie Angells' which the king had purchased from
the artist. It is described as 'a bigg piece in limning wch was first
done in Italy and since over don and touched' by Oliver.[66] The
picture, it is stated, was a copy of a Veronese, thus providing us
with evidence that he was already executing large-scale copies of
oil paintings in the middle of the 1590s at a far earlier date than is
usually believed. This type of miniature, with religious subject
matter, is normally seen as a Jacobean development. Oliver's most
ambitious essay in it, the *Entombment*, though unfinished, also
passed into the Royal Collection.

In the new reign Oliver was appointed limner to Anne of
Denmark who, unlike her husband, had a marked taste for the
visual arts, one which she transmitted to her son Henry Prince of
Wales, who patronized him extensively during the years 1610 to
1612 when he died. Oliver's portraits of both mother (col. pl. 12d)
and son are by far the most important records that we have and
embody new concepts and moods in royal portraiture. Oliver was
to die in 1617, two years before Hilliard.

There are no surviving writings by Oliver, but a phrase in his
will perhaps gives us a greater feeling of his ambiance. In it he
bequeaths to his son Peter 'all my drawings allready finished and
unfinished and lymning pictures, be they historyes, storyes, or any
thing of limning whatsoever of my owne hande worke or yet
unfinished'.[67] The words that leap from the page are 'drawings',
'histories' and 'storyes', all three things which place him im-
mediately in a different context from Hilliard. Let us start with the
drawings. A considerable number of drawings exist signed by Isaac

Oliver.[68] They derive almost without exception from engravings by mannerist artists such as Parmigianino or Spranger, and depict typical sinuous elongated figures of saints, a madonna and child or a lady plucking at a stringed instrument. The puzzle is that they have no connection with finished works. Within the limning tradition this should be no reason for surprise because preliminary studies had no place in the process of creation. Holbein, as we have seen, was the exception. His drawings were preliminary studies for portraits on any scale but this was a fact unknown to his successors. So Oliver's drawings are not part of a process of creation; instead they seem to have been conceived as works of art in their own right. In this aspect Oliver needs to be considered in tandem with Inigo Jones, who was more or less his contemporary and who went to Italy at exactly the same time and simultaneously began to use drawing as an essential tool whereby to convey his ideas. Jones's drawings are slightly different. They are *aides-mémoires* of things seen, practice sheets to keep his hand in or sketches for specific projects, be it a scene, a costume or a building. Drawing was a means whereby he developed his first thoughts and concepts and a method whereby he presented these in more finished form to the patron. Bearing in mind that Oliver died in 1617, just two years after Jones's return from his more important Italian tour with the Arundels, his drawings assume an even greater importance. Some could have been executed while Elizabeth was still alive and certainly during the first decade of the new reign. Compared with Jones, Oliver was an enormously accomplished draughtsman, making the early masque designs awkward in comparison.

The will never refers to anything except limning so that it would be useful at this point finally to dispose of the possibility that Oliver accepted commissions for oil paintings as did Hilliard. Apart from the will all contemporary sources corroborate that he only painted miniatures, indeed they cite him precisely within that context. In Haydocke's listing he refers to Lockey 'for Oyl and Lim:' as against Oliver for 'Limming' only. In the same manner Henry Peacham in 1612 in *The Gentleman's Exercise* alludes to Hilliard and Oliver 'for the countenance in small' as against Robert Peake and Marcus Gheeraerts 'for oyle colours'. The idea that Oliver ever painted large scale comes from a misreading of documents by Auerbach. The one in question occurs in the accounts of Henry Prince of Wales: It reads as follows: 'Mr. Isacke for three Pictures 32 *l*. one greate Picture 34 *l*. three other Pictures 30 *l*. one greate and two little pictures 40 *l*.'[69] If, however, the actual accounts are consulted this entry will be found to occur in the midst of a series of payments to those from whom the prince purchased pictures for his own fast-growing collection at St James's Palace. In other words Oliver was also a picture-dealer and the prince's taste was for Dutch pictures in particular. The miniaturist with his connections with the Low Countries, to which he could even have travelled to and fro, would have been a natural source.

When it comes to his work Oliver was a chameleon, not, however, in either his technique or style, but in his surprising

77. Isaac Oliver, *The Adoration of the Magi* (drawing), *c.* 1615, 229 × 168 mm, British Museum

variations in scale and in the eclectic sources that inspired his compositions. He was an artist at once highly idiosyncratic and, simultaneously, susceptible to outside influences. The usual division of his work into before and after his Italian visit is too simple. There is still no full scholarly treatment of the miniaturist, but it is clear that he was a far more intellectual and complicated figure than Hilliard. His initial stylistic statement, however, made at the opening of the 1590s remained absolutely unchanged until his death. It is the variations and sudden surprises that break through that pattern which present the problems and defy a neat categorization into periods. The main drift can be summed up in any one of his portrait miniatures of a man (col. pl. 12b) or lady painted during the last decade of Elizabeth's reign. So little of the costume is shown in the case of the men that they could often have been painted either before or after his visit to Italy. The first observation to be made is that, although he is at the end of the technical line of descent from the Horneboltes, there the resemblance stops. In the case of Hilliard we can still turn the clock back aesthetically to the later Middle Ages. Ironically it is, of the two, Oliver whose approach to miniatures was closer to the Holbein tradition, for his

visual premise springs from the world of the large-scale portrait.
He approached the miniature from a tradition of portraiture
which stemmed from such artists as Antonio Mor via Key to a
final flowering with Pourbus before the baroque of Rubens.
Oliver did not have to visit the Low Countries to know of this,
although he probably did. Religious persecution had ensured a
wave of exile artists arriving in England from the 1560s onwards.
Of these Cornelius Ketel worked within that style throughout the
1570s before returning to Amsterdam in about 1581.[70] It was a
style, the exact antithesis of the high Elizabethan manner, which
was to reach its apogee in the insular England of the 1580s. In
contrast it aimed at a three-dimensional realism of presentation of
the sitter making use of dramatic chiaroscuro and a sombre palette
range. The sitter is presented within space created by means of
perspective and light and shade. And these are precisely the effects
aimed at by Oliver, ones which make him often unhappy with
calligraphic inscriptions which began to disappear from his minia-
tures because they destroyed the renaissance pictorial unities.
Oliver's sitters are not lit by sun from the front, they are illumined
by candlelight from one side, shadows being used to emphasize the
sculptural quality of the head, and the effect is heightened by a far
tighter handling of the brushstrokes with a use of wash, stipple and
fine lines far different from the broader free calligraphic manner of
Hilliard. Although there are exceptions, colour is restrained, mov-
ing from brown to black, puce to sepia, grey to silver, and white
with rare touches of gold. With Oliver we move from the after-
noon into eventide. And the overall impact of these miniatures is at
once more introspective, more subtle; doubt replaces assertion,
muted sadness jocund gaiety. We leave *L'Allegro* of Hilliard to
encounter *Il Penseroso* of Oliver.

Here is an artist of great stature but one who must not be viewed
in isolation, for the style he represents in its initial phase went
hand-in-hand with that promoted by his brother-in-law, Marcus
Gheeraerts the Younger.[71] During the last decade he too pro-
duced pictures of great sensitivity and the Ditchley portrait of
Elizabeth I or the Woburn Abbey portrait of Robert Devereux,
Earl of Essex, should be viewed side by side with Oliver's own
interpretations of these sitters.[72]

Throughout his career Oliver produced a series of brilliant small
head-and-shoulders portraits, but it is the exceptions in his work
which reveal the true stature of the man. One is his masterpiece
from the 1590s, the large circular miniature formerly called *Frances
Howard* (col. pl. 13). Formerly dated 1610–15 the lady is in fact
wearing sleeves of a cut and hair of a style not traceable after 1603
and more likely to be before 1600. Its size and shape alone make it
an extraordinary object to have been painted in late Elizabethan
England. The miniature is a love token, the lady's hand is placed,
like that of Hilliard's famous young man (col. pl. 6), on her heart.
She is attired in an elaborate form of undress, minus the formal ruff
and troublant jewels in her hair, but encircled instead by a wired
lace cap from which billowing gauzes surround her. An embroid-

ered mantle is looped across the front. If an allowance is made for the fading of the carnation the contrast even now between the flesh tints and tonality of the rest of the portrait is astounding, moving from grey into grey-black with touches of white and tiny highlights of gold and silver. As we look into this mysterious presentation of a great lady, for rich and grand she must have been, we are looking at a concept that could not have sprung from the insulated England of the 1580s. It belongs to the late 1590s when, after years of religious wars, the continent and Italy were becoming once more accessible to visitors from the Protestant north. Such an experience alone can explain the phenomenon of this enigmatic half-smiling Elizabethan court lady emerging from the surrounding gloom. She must be placed at the end of a line of descent that leads back via the Milanese school to Leonardo. We are contemplating the *Mona Lisa* of Elizabethan art.

And yet fifteen years later Oliver was capable of going into total reverse. What could form a sharper contrast than his full-length (col. pl. 14) of Richard Sackville, third Earl of Dorset? Technically miraculous, it is a formal presentation of the prodigally extravagant aristocrat who was to leave Knole mortgaged to the hilt. The clothes he wears are actually listed in an inventory of his rich attire[73] and so splendid is the miniature that pure ultramarine has been used for painting the trunk hose. But the references here are no longer international, they are insular. They allude directly to the art of the Jacobean court artist William Larkin,[74] one whose portraits Oliver was actually paid to copy. Larkin's work is the final blaze of glory of the Elizabethan aesthetic, flat, formalized mosaics of colour with an emphasis on every detail of dress, embroidery and jewellery.

No two miniatures could better sum up the paradox of Oliver, and this initial statement can so easily be elaborated. As the apostle of the avant-garde he produced a whole series of miniatures *c.* 1610–15 of sitters in profile *à l'antique*. One is of Anne of Denmark in a shimmering masque headdress; another, manufactured in quantity, is of her son attired in antique armour with a looped mantle, his head silhouetted against a classical shell niche.[75] These reflect accurately the court's preoccupation with renewed contact with the main fount of the classical revival, Italy, in the shape of the masque designs of Inigo Jones. Prince Henry in the *Masque of Oberon* (1610) made his entry in what was the first *à l'antique* triumph ever staged in a court spectacle in England.[76] Simultaneously Jones was adding a classical loggia and clock tower to Hatfield. Oliver had been quick to respond, no doubt under the impulse of the patron, to the new classicizing tendencies.

The pressures behind Oliver were, therefore, international. He was an ideal artist for the mannerist courts, combining mystery of presentation and courtly elegance with minuteness of scale. Such courts assiduously cultivated and collected every manifestation of the miracles of nature and of man's ability to harness and subject them. Oliver's miniatures fit neatly into the hermetic world of the late renaissance court with its obsession with marvels, be they the

78. Isaac Oliver, *Anne of Denmark*, *c.* 1610–12, about 51 × 41 mm. Royal Collection.

79. Isaac Oliver, *Henry Prince of Wales*, *c.* 1610–12. Fitzwilliam Museum.

miraculous hydraulics of grotto automata, the ability to conjure up facsimiles of earth and heaven on stage or distil the enigma of the human character and soul within the compass of a piece of vellum the size of a medal.

THE PORTRAIT AS IMPRESA

The early portrait miniatures are all portraits, neither more, nor less. They record the features of the sitter and, in the main, add their age and the date of the portrait. But from the 1580s onwards the miniature took off in another direction as a vehicle for late renaissance esoteric imagery. Such imagery, familiar to us through a vast outpouring of literature on emblems and devices, was central to the make-up of the mannerist psyche in which the pictured symbol occupied a role as means of communication midway between the written and spoken word. In the case of the portrait miniature it took a form parallel to that of the medal, in which the reverse carried an interlocked image and motto as an expression of the ideals and aspirations of the sitter depicted on the obverse. William Camden, herald and antiquarian, provides a succinct definition of the *impresa* in his *Remaines* (1605):

> An *Impress* (as the Italians call it) is a device in Picture with his Motto or Word, borne by Noble and Learned Personages, to notify some particular conceit of their own, as Emblems . . . do propound some general instruction to all . . . There is required in an *Impress* . . . a correspondency of the picture, which is as the body; and the Motto, which as the soul giveth it life. That is the body must be of fair representation, and the word in some different language, witty, short and answerable thereunto; neither too obscure, nor too plain, and most commended when it is Hemistich, or parcel of a verse.[77]

Elizabethan and Jacobean portrait miniatures could become elaborate personal *imprese* presupposing programmes laid down by the patron and presenting four centuries later some of the most impenetrable problems as to their meaning.

The most famous, besides being almost the earliest instance of this, is Hilliard's *Young Man among Roses* (col. pl. 6), the identity of which I believe to be Robert Devereux, second Earl of Essex.[78] He stands lovesick with hand on heart leaning against the trunk of a tree embowered within the thorny branches of a rose bush. The flowers are those of the white five-petalled rose, the single eglantine emblem of the queen, who cultivated an elaborate horticultural symbolism. The sitter is attired also in her personal colours of black and white worn by her champions in the tiltyard or by masquers in court festivals. Just as the eglantine entraps him with a celebration of regal chastity, the colour of his clothes proclaims her constancy and purity. His own constancy is elaborated in the symbolic tree trunk and in the motto, *Dat poenas laudata fides*, which fulfils Camden's dictum in being lifted from a suitable source, in

this instance Lucan's *De Bello Civili* where it occurs in a speech in which the eunuch Pothinus counsels Pompey's death. Ben Jonson translates this as:

> . . . a praised faith
> Is her own scourge, when it sustains their states
> Whom Fortune hath depressed.

Whether the identity as Essex is accepted or not, the miniature has become more than a mere likeness, it has been transformed into a vehicle for an allegorical message possibly intended for the eyes of none other than the queen herself.

Hilliard's *Henry Percy, ninth Earl of Northumberland* (col. pl. 7) is no less obscure in the complexity and ramifications of its imagery. He is looked down upon, reclining full-length on the grass within the confines of a formal garden. The bird's-eye view and perspective are quite without precedent in Hilliard's art and incidentally beyond him. The garden has two hedges, an outer and an inner from which arise trees from the branches of one of which hangs a balance bearing a sphere or globe or even, it has been adumbrated, a cannon ball, with a feather or quill pen at the other end. And this mysterious enclosure is on a mountain top with a sheer drop downwards beyond the hedge and a view of distant peaks. This is a portrait of the Wizard Earl, the friend of Raleigh, the patron of Thomas Hariot, the man to whom Chapman refers in the preface of his cryptic poem *The Shadow of Night*. George Peele describes him in his poem celebrating the earl's election as a Knight of the Garter in 1593 at precisely the period the miniature was painted:

> Renowned lord, Northumberland's fair flower,
> The Muses' love, patron and favourite,
> That artisans and scholars doest embrace,
> And clothest Mathesis in rich ornament;
> That admirable mathematic skill,
> Familiar with the stars and zodiac,
> To whom the heaven lies open as her book;
> By whose directions undeceivable,
> Leaving our schoolman's vulgar trodden paths,
> And following in the ancient reverend steps
> Of Trismegistus and Pythagoras,
> Through uncouth ways and unaccessible,
> Dost pass into the spacious pleasant fields
> Of divine science and philosophy.[79]

Peele is virtually describing what we see, the earl's ascent by way of 'uncouth ways and unaccessible' to the 'spacious pleasant fields /Of divine science and philosophy'; and that such an ascent of the mind has been made by means of Mathesis, a system that embraced a Pythagorean and numerological approach to the diagram overlaid by the fruits of renaissance occultism.[80] It is not fanciful that Northumberland lies enclosed within the straight lines of a hedge which at first glance might strike one as being rectangular but which, allowing for Hilliard's very poor grasp of perspective, is

80. Isaac Oliver, *Unknown Melancholy Young Man*, c. 1590–5, 125 × 88 mm. Royal Collection.

probably meant to be square. The square is the symbol of wisdom, the attribute of Hermes (in one of his aspects Trismegistus), god of reason and truth.[81] Such should be at least an initial rudimentary approach to unravelling the meaning of this most riddling of portrait miniatures in which 'Northumberland's fair flower' presents himself in the black attire of a meditative melancholic with his clothes dishevelled and his gloves cast to one side.

With the earl's attire we touch upon a thread that leads to a more pervasive theme, melancholy.[82] In the broadest terms, for the subject is a rich and ramifying one, the renaissance resulted in a revaluation of the melancholic humour, in which the Galenic view of it as being inimical was overlaid by the Aristotelian view in which the Saturnian humour was regarded as favourable to the imaginative and intellectual powers. Neoplatonism fused the *furor melancholicus* with the platonic *furor divinis*. Gradually the attributes and attitudes of melancholy were to become indispensable adjuncts of any renaissance man with artistic or intellectual pretensions. It was not, however, until the 1590s that this began to manifest itself in England in the visual arts with a whole series of portraits of Elizabethan and Jacobean gentleman as melancholics. Some of Isaac Oliver's most famous portrait miniatures are entirely essays in

melancholia. The young man seated beneath a tree in the miniature in the Royal Collection is seeking the shade of the greenwood away from the confines of the formal garden of the great house in the distance. This is precisely the way that Democritus of Abdera is depicted on the title-page to that *locus classicus* for the whole movement, Robert Burton's *Anatomy of Melancholy* (1621). In the main the sitter is dressed in black and wears a large broad-brimmed hat and sits with his arms folded:

> See yonder melancholy gentleman,
> Which, hoodwink'd with his hat, alone doth sit!
> Thinke what he thinks, and tell me if you can.[83]

So Sir John Davies apostrophizes a fashionable melancholic gallant. Oliver's ravishing miniature of the black Lord Herbert of Cherbury portrays him also as a melancholy knight stretched out by the side of a trickling brook in the midst of forest. As Sir Thomas Overbury writes, the melancholy man will 'seldome be found without the shade of some grove, in whose bottome a river dwels'.[84]

81. Isaac Oliver, *Lord Herbert of Cherbury*, c. 1610–14. Earl of Powis.

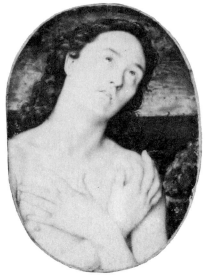

82. Isaac Oliver, *Unknown Melancholy Young Man, called 'The Prodigal Son'*, c. 1595, 72 × 52 mm. Welbeck Abbey.

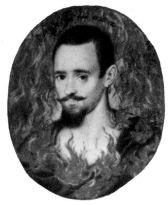

83. Isaac Oliver, *A Man with a background of Flames*, c. 1610, 54 × 45 mm. Ham House.

Melancholy not only afflicts the thinker, it consumes the lover who sighs and laments like Don Armado in *Love's Labour's Lost*. He is advised to 'sigh a note and sing a note . . . with your hat penthouse-like o'er the shop of your eyes, with your arms crossed on your thin-belly, like a rabbit on a spit . . .'[85] The so-called Prodigal Son, in one of Oliver's most enigmatic miniatures, is surely such a lover, his hands crossed, his eyes cast upwards in contemplation of his lady in the same way as in the famous early portrait of John Donne.[86] And, in the distance, a rock rises out of a stormy sea as token of his constancy. Love indeed is a central theme appropriate to such private covert images, whether it is Hilliard's man of 1588 clasping his lady's hand let down from heaven[87] or Oliver's sitter whose head floats amidst a burst of orange and gold flames.[88]

Such miniatures could also be commemorative. Hilliard's full-length of George Clifford, third Earl of Cumberland (col. pl. 8), records him as Queen's Champion in the tiltyard in the attire that he wore at the annual tournament held on her Accession Day, 17 November.[89] Cumberland adopted the pseudonym of Knight of Pendragon Castle, a title combining suitable overtones of ancient British prophecy and lore, arriving at the 1590 tilt aboard 'a dragon laiden with fair spoils'. He stands attired in star-studded celestial armour, his surcoat embroidered with caduceuses and armillary spheres, the queen's glove in his plumed bonnet, clasping his tilting lance. On these occasions it was customary for a knight's squire to present to the queen a shield bearing his *impresa*, and this is precisely what we see hung up on the tree to the right with the device of the earth between the sun and moon with the motto in Spanish, *Hasta quan*. Cumberland, however, was always overshadowed at the tilts by the glamour of Essex and he again commissioned a commemorative miniature on a huge scale. Once more there is the queen's glove present, but this time tied to his right arm, the one with which he would carry his lance. Over marvellous gilded armour he wears an embroidered skirt or bases bearing the *impresa* that the herald Camden records him carrying: 'The late Earl of Essex took a Diamond only amidst his shield, with this about it, "Dum formas minuis." Diamonds, as we all know, are impaired while they are fashioned and pointed.'[90]

These likenesses of knights loyal to Crown remind us of a category on its own, the endless images of Elizabeth I and James I. The habit of wearing these reached a crescendo in the 1590s in the dazzling votive images we associate with Hilliard's rendering of Elizabeth as a young girl.[91] Each miniature was a personal vision of his sovereign by the possessor and each carried within it allusions to her duality within the Spenserian sense, as 'a most royall Queene or Empresse' and 'a most bewtiful and vertuous ladie'. One courtier placed his image within a bejewelled case upon the face of which there is a star-burst in stones concealing the portrait, revealing that his vision is of her as *Stella Britannis*.[92] None, however, is more extraordinary than the so-called Armada Jewel (col. pl. 9a), far better referred to as the Heneage Jewel, for it must date a decade

later than 1588.[93] This miraculous survival gives us an insight into just how integrated ideologically these miniatures could be to their setting. The outside of the case begins by an initial celebration of Elizabeth as the queen with a formal imperial profile image on the obverse together with her titles. On the reverse we progress from her secular to her ecclesiastical authority as governor of the *Ecclesia Anglicana* in the Ark of the Reformed Church sailing safely through the troubled seas. The locket opens to a contemplation of the private world of the heroine of the sonnets, a paean on her as the Lady, as 'Astraea, Queen of Beauty', whose pictured image is mirrored by the rose enamelled on the interior of the lid:

> R ose of the Queen of Loue belou'd;
> E ngland's great Kings divinely mou'd,
> G aue Roses in their banner;
> I t shewed that Beautie's Rose indeed
> N ow in this age should them succeed,
> A nd reign in more sweet manner.[94]

John Davies's graceful acrostics, *Hymnes to Astraea* (1599), are the exact literary equivalent to these final votive images. James was neither to cultivate nor to attract such eulogy which had to await the martyrdom of a king to be reawakened.

FROM PICTURE BOXES TO THE CABINET

Sir James Melville, ambassador of Mary Queen of Scots, provides us with the earliest picture that we have of these portrait miniatures within the social setting of the court. The passage is ushered in by Elizabeth feigning her desire to meet her cousin of Scotland and how, in anticipation of this longed-for event, she would contemplate Mary's portrait:

> She took me to her bed-chamber, and opened a little cabinet, wherein were divers little pictures wrapt within paper, and their names written with her own hand upon the papers. Upon the first that she took up was written, 'My Lord's picture'. I held the candle, and pressed to see that picture so named. She appeared loath to let me see it; yet my importunity prevailed for a sight thereof, and found it to be the earl of Leicester's picture . . . Then she took out the Queen's picture, and kissed it . . . She shewed me also a fair ruby, as great as a tennis-ball.[95]

Melville's anecdote establishes that these early miniatures were regarded as regal objects, so precious that they were kept within the innermost sanctum of the palace, the royal bedchamber. Although he says nothing as to their framing they were carefully wrapped in paper and their status is reflected in the fact that in the same cabinet the queen kept a vast ruby.

What little we know about surviving groups of early miniatures

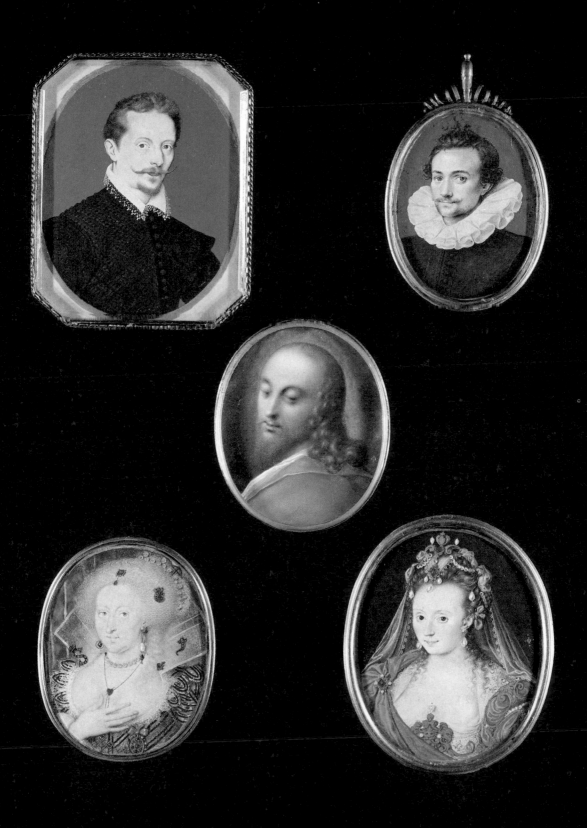

COLOUR PLATE 12 (preceding page)

Isaac Oliver

a. (top left) *A Man called 'Sir Arundel Talbot'*, 1596, 70 × 54 mm. V&A P4–1917.
b. (top right) *A Man in Black, c.* 1590–1600, 51 × 41 mm. V&A P50–1941.
c. (middle) *Head of Christ, c.* 1615–17, 53 × 43 mm. V&A P15–1931.
d. (bottom left) *Anne of Denmark, c.* 1612, 60 × 48 mm. V&A 237–1866.
e. (bottom right) *?Masquer in Ben Jonson's 'Masque of Queens'*, 1609, 64 × 51 mm. V&A P3–1942.

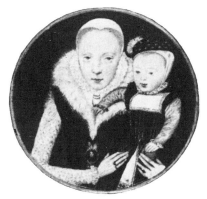

84. Levina Teerlinc, *Katherine Grey, Countess of Hertford, c.* 1562, dia. 51 mm. Duke of Rutland, Belvoir Castle.

suggests that they were always kept together as groups. Theophilus Howard, Earl of Suffolk, presented Charles I with just such a group of very early portrait miniatures in the main of Henry VIII. The group with the longest provenance is the Radnor miniatures which were purchased at the close of the eighteenth century from a descendant of Elizabeth Drury, Lady Stafford, Lady of the Bedchamber and of the Privy Chamber to Elizabeth I. There were seven originally, all in turned ivory cases like draughtsmen kept in a little cabinet with other treasures.[96]

From the very first, miniatures seem to have been inserted into these ivory boxes with crystals placed over to protect them. The earliest and most spectacular of these cases is that containing Holbein's *Anne of Cleves* (col. pl. 2a), with the unfolding petals of a Tudor rose on the lid. This kind of framing remained standard into the Jacobean period and a considerable number of miniatures survive in their original turned ivory boxes. By the 1560s, however, they had begun to be worn. Perhaps the earliest evidence of this is the miniature almost certainly by Levina Teerlinc of Katherine Grey, Countess of Hertford, at Belvoir Castle. She is depicted holding her infant son, which dates the portrait closely to late 1562 or early 1563, and a circular miniature of her husband hangs at the end of a ribbon on her bodice. Next in date comes George Gower's portrait of Lady Walsingham (1572) in which she actually holds open a circular jewelled locket containing her husband's likeness.[97] This is suspended at the end of a riband encircling her waist in lieu of a pomander chain. Picture boxes or jewels which might or might not contain miniatures recur from that date onwards. Of all the picture boxes, that most familiar is Anne of Denmark's with its lid of table-cut diamonds in the bold style that she promoted which, pinned to her bodice by a ribbon, appears in portrait after portrait.

The miniature Lady Walsingham displays must have been by Nicholas Hilliard, so that he would have inherited in the early 1570s this alliance of portrait likeness and jewelled setting. Surviving examples are of exceptional rarity. The Gresley Jewel (col. pl. 9b), which appears in a portrait dated 1585, contains the portraits of Sir Francis Walsingham's cousin Catherine and her husband Sir Thomas Gresley. The exterior of the pendant has an onyx cameo of a negress within a setting of gold enamelled in white, black, opaque pale blue, green, translucent royal blue, red, green and yellow set with rubies, emeralds and pearls. Two golden cupids approximately aim their arrows from either side.[98]

Apart from the Gresley Jewel all other surviving sixteenth-century lockets open to reveal an image of the sovereign. Of these, perhaps the most superb is the Drake Jewel (col. pl. 10) containing a miniature of Elizabeth by Hilliard and once inscribed *Anno Dm 1586 Regni 28*.[99] It is of gold elaborately enamelled and, like the Gresley Jewel, its case bears the head of a negro. But there the resemblance ends, for the Gresley Jewel is inferior in quality to the superbly crisp articulation of the Drake Jewel case. This means that, although Hilliard could and doubtless did make settings for

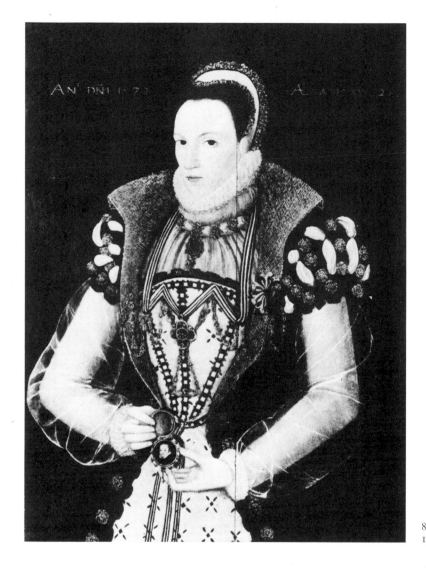

85. George Gower, *Lady Walsingham* (oil on panel), 1572, 839 × 635 mm. Private Collection.

his miniatures, he did not necessarily do so. He could also paint a miniature which would then be set into a case made by another goldsmith. That this was so is abundantly clear from the lockets that contain images of Elizabeth which are clearly from different workshops. This probably arose from the fact that miniatures of the queen were presented often unframed. We know this from a letter by Lord Zouche in 1598 who had just received what was doubtless one of those idealized late images of Gloriana. 'I would', he writes, 'I could have as rich a box to keep it as I esteem the favour great';[100] for he now had to commission a jeweller to make a picture box along the lines of the Armada Jewel. This simple practical procedure would also account for the fact that miniatures in their original cases are often clipped to make them fit.

By the close of Elizabeth's reign the wearing of her portrait whether in miniature or in cameo was *de rigeur*. Nothing was to change this in the new reign, where the accounts tell of mass manufacture and distribution of royal portrait miniatures. But, to a degree, the magic was beginning to evaporate. Two cases con-

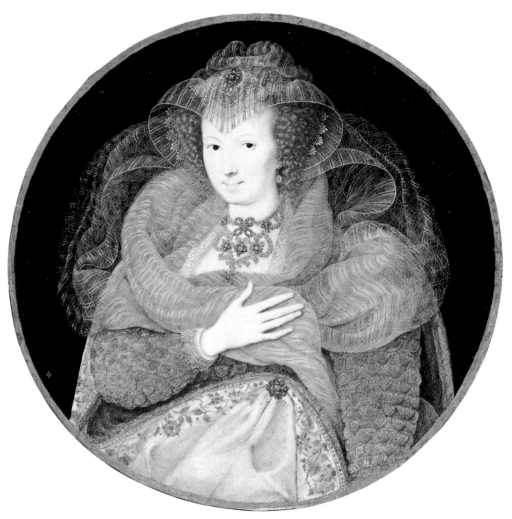

COLOUR PLATE 13. Isaac Oliver, *A Woman, said to be Frances Howard, Countess of Essex and Somerset, c.* 1596–1600, dia. 130 mm. V&A P12–1971.

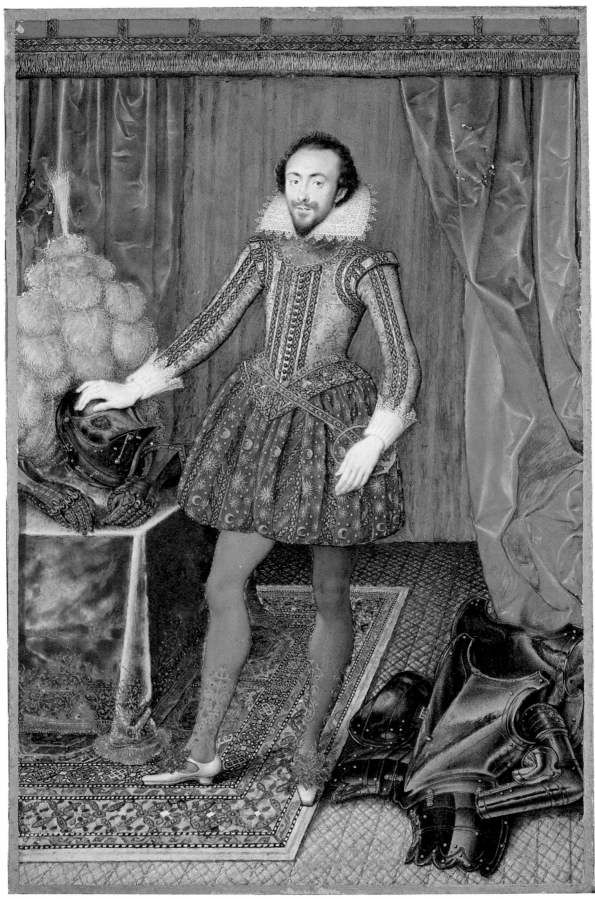

COLOUR PLATE 14. Isaac Oliver, *Richard Sackville, third Earl of Dorset*, 1616, 235×153 mm. V&A 721–1882.

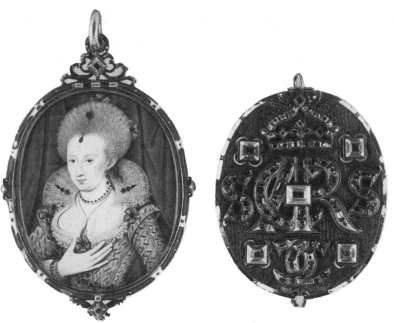

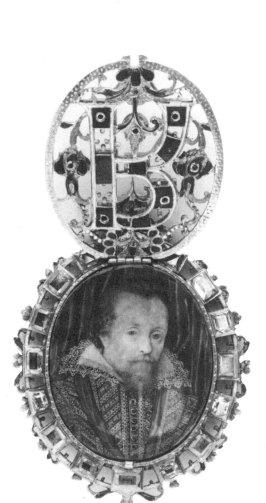

taining portraits of James I survive. One is a humble object, the Ark Locket (col. pl. 9c), in which James the King appears at the centre of a sunburst complemented opposite by a slight updating of the Elizabethan image of the Ark of the Church on the waters. By far the most splendid survivor is the Lyte Jewel in the British Museum, presented by the king to Thomas Lyte on 12 July 1610 and worn by him in his portrait now in the museum at Taunton.[101] It is in the style of Anne of Denmark's picture box, a composition of pierced gold fretwork and table-cut diamonds arranged on the front to form an *R* for Rex. A less splendid locket containing a miniature of Anne herself epitomizes the cult in decline. The case is gold enamelled in white and translucent red and green set with table-cut diamonds. The design is awkward, the reverse bearing two intertwined *A*s for Anne crowned with three *S*s for her mother Sophia of Mecklenburg surrounding it, while the obverse repeats the effect in diamonds, the *S* recurring and *A R C* intertwined for *Anna Regina* and *Christianus Rex*, her brother, of Denmark, plus two more interlocking *C*s.

With the revolution in fashion of the mid to late 1620s the wearing of jewellery of this kind went into eclipse. By the 1630s jewellery for both sexes was restrained to an extreme degree, rendering boxes of this kind outmoded. The miniature was henceforth to find its habitat in that attribute of the seventeenth-century connoisseur and virtuoso, the cabinet.

By the 1630s miniatures were collected and displayed along with other rare works of art on a small scale in cabinet rooms. The Green Closet at Ham House with its allegorical ceiling by Francis Cleyn after Polidoro and its walls hung with green wall-hangings is a unique survival evoking this refined milieu in which Charles I's friend William Murray displayed his small pictures and miniatures, some of which, including a dazzling Hilliard of Elizabeth I, still survive.[102] This evokes in microcosm the splendours of the king's own Cabinet Room at Whitehall Palace referred to as a recent

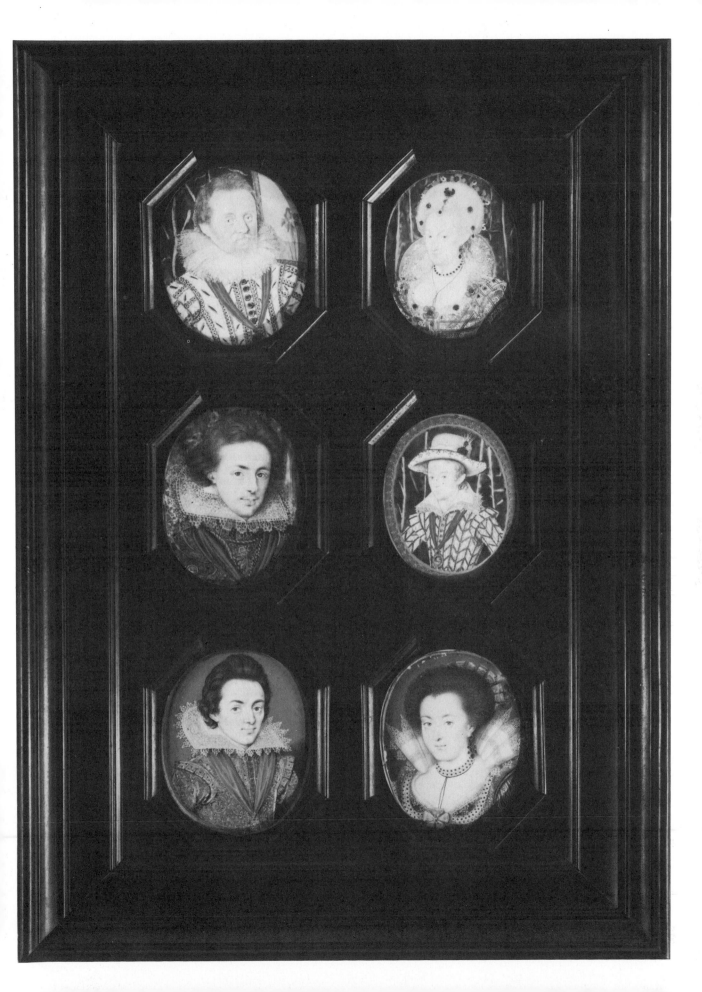

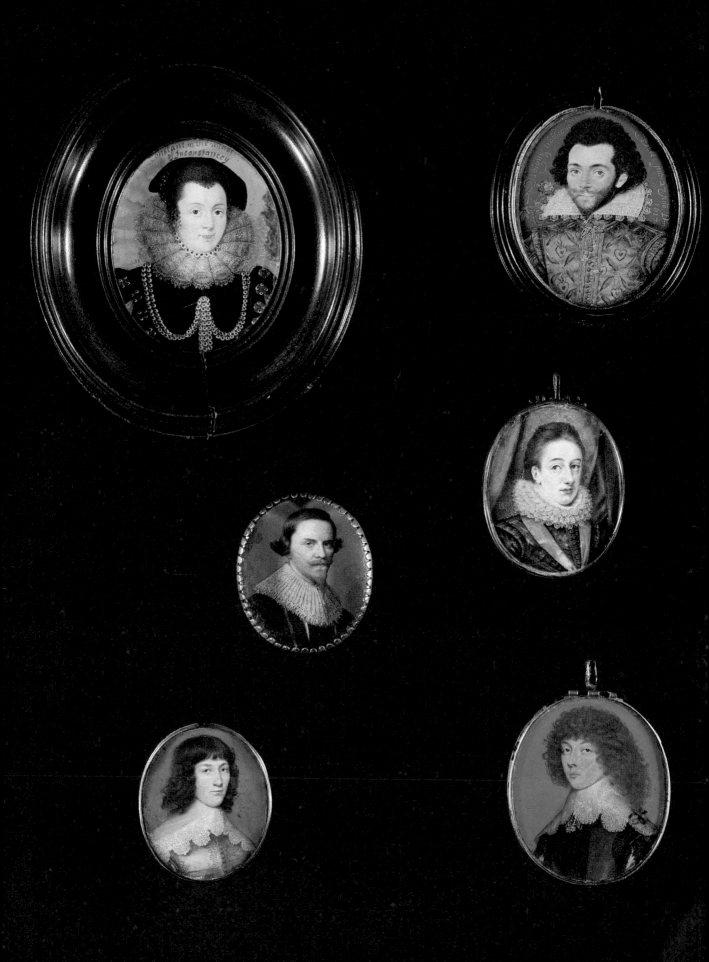

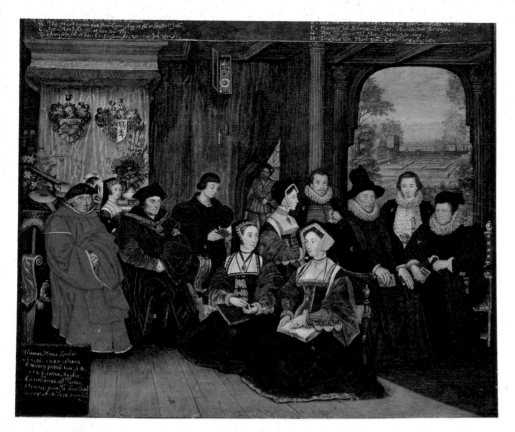

creation by Abraham van der Doort in his inventory compiled at the close of the 1630s.[103] At Whitehall this was the setting for a massive display of small paintings, bronzes by Giovanni Bologna, antique and modern coins and medals, illuminated books, engraved gems and ivories. There were seventy-five miniatures in all, including fourteen by Peter Oliver, thirteen each by Hilliard and Isaac Oliver, eight by Hoskins, and four by Holbein. A considerable number came by way of gift. By far the largest donation was a dozen from the Earl of Suffolk, all early miniatures, but others came from Arundel, Pembroke, Lord Fielding, Sir Henry Vane and Sir James Palmer. Lady Killigrew's gift provides a glimpse of the king making choice from a small group of miniatures of a kind that must have been in the possession of many aristocratic families: 'Item there was presented a Case wth 5 little lim'd pictures to yor Matie by my Lady Killegrew to take/ – Choice thereof and yor Matie pleased to take one onely –.'[104] A number were purchased from Laurence Hilliard, but he apparently gave via Pembroke a splendid jewel made by his father enamelled with the Battle of Bosworth and containing miniatures of Henry VII, Henry VIII, Jane Seymour and Edward VI.

Van der Doort sheds light on both how they were kept and their framing. None were kept on open display but in cupboards to protect them from fading. Special arrangements were made for Isaac Oliver's unfinished *Entombment* and Peter Oliver's large copies of works by Titian, Correggio and Raphael: 'Whereof: IO: lim'd peeces are in – /dowble shutting Cases with locks and /keys and glasses over them . . .' The early Hornebolte miniatures of Henry VIII presented by Suffolk were 'in white tournd Ivory boxes without Christalls'. Isaac Oliver's lovely miniature of Elizabeth of Bohemia as a girl was still 'in a white Ivory Box' but his portrait thought to be of Mrs Sidwell was 'set in a big ebbone frame'. All the miniatures were in separate frames except one group which represented a departure, for the king had framed it as a group of his own progenitors. It survives intact in the Buccleuch collection and consists of miniatures of Henry VII, Henry VIII, Catherine of Aragon, Edward VI and Mary I given by Suffolk, one of Elizabeth I purchased from Laurence Hilliard and two of Elizabeth of York and Anne Boleyn by Hoskins after oil paintings. Such a treatment of miniatures was quite new, and multiple frames of this type, representing the legitimate Tudor–Stuart Protestant tradition, evidently became widespread in great households. Charles I's collection is a kind of finale to the art of limning before the disruption of the Civil War. He had in effect created a museum in miniature of the art of limning that included every artist from those whose names had already vanished into obscurity, like Hornebolte and Teerlinc whose works he possessed unknown to himself in some number, to those precious likenesses of Henrietta Maria that he had commissioned, to the great pieces by Peter Oliver after the choicest and most prized pictures in his collection (col. pl. 18). All, however, was to be as dust in the great sale that epitomized the destruction of a civilization.

3

⸻•⸱∙⫷⫸∙⸱•⸻

The Seventeenth-Century Enlightenment

LIMNING AND THE ELIZABETHAN TRADITION

ART HISTORIANS are accustomed to think of the year 1619, the year in which Nicholas Hilliard died and in which Inigo Jones was commissioned to build the Banqueting House in Whitehall, as the end of the Elizabethan and Jacobean civilization in England.[1] As the negotiations for the Spanish marriage continued in the 1620s, and after the humiliating defeat of the forward Protestant policy in Bohemia in November 1620, the peculiar tone of the embattled, in some ways isolationist and self-conscious culture of the emergent English nation state gave ground to the cosmopolitanism of the Caroline court. Apart from literature, where the vernacular revolution of the sixteenth century held, the arts drew their main inspiration from Italy and the Spanish Netherlands rather than from the northern mannerist tradition associated with Holland and the Germanic states of Protestant Europe. On a wider view, however, it is possible to see that the cultural inventions of the Elizabethan and early Jacobean civilizations remained the determining characteristic of the English political élite, and provided both continuity and a historically progressive impulse through the conflicts of the seventeenth century.

The group of people who represented this culture had institutional points of attachment at the universities, in Parliament, the City companies, and in the historic professions of the Church, law and medicine. They were thus essentially metropolitan, socially, geographically and politically located on the axis of City and court, and they held during the successive swings of state policy and constitutional experiment relatively constant political and cultural values. During the Caroline absolutism, the Wars and Interregnum, these values were maintained partly in London, partly in the outer ring of home counties including the universities, and partly in certain foreign Protestant courts such as that of Elizabeth of Bohemia at The Hague; in 1660 they and their protagonists were adopted and confirmed in their moral hegemony by Charles II. The movement that can be discerned is the Elizabethan–Restoration enlightenment, an outgrowth of the European renaissance, rooted in the hermetic and cabalistic traditions of knowledge and coming to fruition in the rationalized

COLOUR PLATE 17 (following page)

Peter Oliver

a. (top left) *Ludwig Philip, Duke of Simmern, c.* 1615, 49 × 40 mm. V&A P28–1975.
b. (top right) *A Man, said to be William Herbert, third Earl of Pembroke, c.* 1625, 54 × 45 mm. V&A P133–1910.
c. (middle left) *Judith Lanier, Mrs Edward Norgate,* 1617, 54 × 43 mm. V&A P71–1935.
d. (middle right) *Sir Francis Nethersole,* 1619, 51 × 41 mm. V&A P6–1917.
e. (bottom left) *Elizabeth of Bohemia, c.* 1615, 48 × 40 mm. V&A P27–1975.
f. (bottom right) *Venetia Stanley, Lady Digby, c.* 1615–17, 67 × 54 mm. V&A P3–1950.

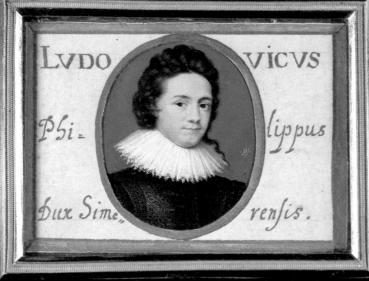

LVDO VICVS
Phi= lippus
Dux Sime„ rensis.

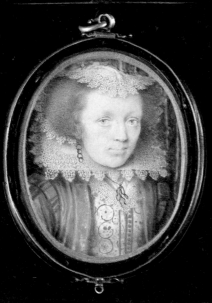

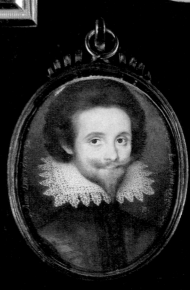

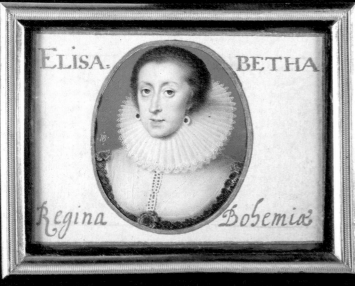

ELISA: BETHA
Regina Bohemiæ

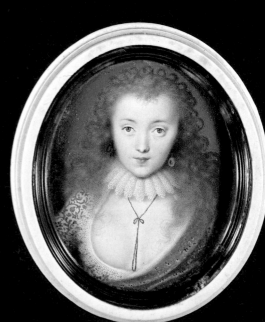

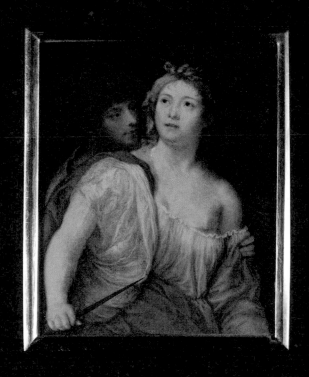

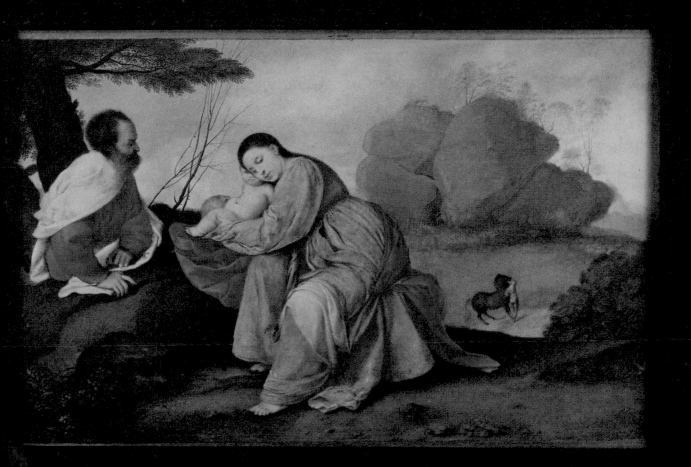

COLOUR PLATE 18 (preceding page)

Peter Oliver
a. (top) *Tarquin and Lucretia, after Titian or Palma Vecchio, c.* 1630, 114×99 mm. V&A 1787–1869.
b. (bottom) *Rest on the Flight into Egypt, after Titian,* 1628, 152×241 mm. V&A 740–1882.

science and art of the late seventeenth and eighteenth centuries.[2] What I am proposing is that this enlightenment, familiar in its progress from Elizabethan Baconianism to the Royal Society, was as importantly an aesthetic movement, tending to distinguish the personality and skills of the artist, and assign to him a special role in the culture. While the Royal Society announced the limitation of the scientist's enquiries to the material and sensible part of creation,[3] the artist found his special interest in the speculative or psychological study of humanity. The portrait painters naturally, because their subject was peculiarly Man, were in the vanguard of this movement, and because it was at the same time a movement that sought validation by precedent and acknowledged its roots in the Elizabethan culture, the limners were especially prominent. The metropolitan limners, in their line of descent from Holbein and Hilliard, via Isaac Oliver who had been the agent of Anne of Denmark and Prince Henry, and Peter Oliver the servant of the Bohemian exiles, were the custodians of the tradition, the possessors of the mystery and of a vast technical expertise that made them, after Hilliard and Isaac Oliver, into connoisseurs or historians of art, and even, through their experience in practical chemistry, a presence in the field of natural philosophy; the literature of art through Hilliard, Peacham and Norgate was disproportionately a literature of limning. What finally can be distinguished is the character of the limning tradition as typical of the English nation state, intellectually central, an art rooted in the Tudor monarchy and mediating into the late seventeenth century a sense of legitimacy, the right sovereignty of reason, good government and established religion.

PETER OLIVER (*c.* 1589–1647)

As the eldest son of his father and direct inheritor of the business, Peter Oliver belongs firmly in the line of descent of miniature painting from the sixteenth into the seventeenth century. He is, however, a somewhat neglected figure, his frequently encountered works and obvious importance being acknowledged in a slightly perfunctory way by historians. It is as though there was something difficult to get to grips with about him, something obscure about his oeuvre or motivation. Why for example did his career apparently tail off in the copying of pictures in the Royal Collection, and why did he apparently attract such a narrow and court based clientele for his portraits? It is easier to understand the shape of his career if his copying is seen against the background of the cult of old masters, and as helping to place their achievement within the encyclopaedic cabinets of the advanced connoisseur-intellectuals. His portraiture accordingly showed a significant concentration on the leading political exponents of the culture to which the limners belonged.

He is usually said to have been born about 1594, but the date was

89. Peter Oliver, *Henry Prince of Wales, c.* 1612, 55×43 mm. V&A P149–1910.

probably earlier than that. There are no birth or baptismal records of him extant, and one of the few pieces of information is the baptismal date of his wife Anne Harding, 11 April 1593.[4] It is unlikely that Peter Oliver was younger, even only a year younger, than his wife. Isaac Oliver and his first wife had probably married in the late 1580s, so Peter as their first child was probably born *c.* 1589 or 1590, making him some three or four years older than his wife. Curiously, Anne Harding was the younger sister of Isaac Oliver's third wife Elizabeth, whose marriage took place in 1606 when Elizabeth was seventeen. If Anne also was seventeen when she married Peter, the date of their marriage would have been 1610. Anne and Elizabeth were daughters of James Harding, a court musician of French extraction, and, like the Olivers therefore, one of that class of immigrant suppliers of professional services to the court who were establishing themselves in the city of London and certain favoured villages upriver.[5] It was through the Hardings that the Olivers became connected with Isleworth, the parish of which Peter was ultimately proud to describe himself as a resident, a 'gentleman of Isleworth'.[6] While they were working, however, the Olivers lived in London, in the parish of St Anne Blackfriars, where Peter was brought up to his father's business. It has long been recognized that, except when there are signatures, it is practically impossible to distinguish the work of Isaac and Peter Oliver between about 1605 and 1617, the period covering Peter's training and early semi-independent works. The confidence with which Isaac in his will assigned Peter to finish his *Burial of Christ* is evidence that they were practised collaborators. Brothers-in-law as well as father and son, the distinction between them as miniaturists is hardly clear before 1617, and even then it was more a matter of date than of style.

What can we tell of Peter Oliver's emergence as a master in his own right? The earliest discernible works seem to be those that belong in the overlap between father and son, when both were working on versions of the same portrait. Thus, the *Henry Prince of Wales* is a variant of the very widespread Isaac Oliver type represented at its finest at Windsor; and the *Venetia Stanley* (col. pl. 17f) is one of a series signed either by Isaac[7] or by Peter[8] or left unsigned.[9] The *Prince Henry* type must have been current *c.* 1612, and the *Venetia Stanley*, to judge from the costume, *c.* 1615–17. In both, Peter Oliver worked with a firm stipple, clearly based on that of his father, but slightly less disciplined and broader so that the overall effect is less focussed. When examined closely, the individual touches are very clearly visible, and in the areas of dense work, as in the shadows and hair lines, they seem almost granular. The effect varies with the complexion of the sitter, but whether carried out in red-gold or dark grey the coarse stipple resolves itself into apparent softness only from a distance.

In the early works after Isaac's death, the granular effect of the paint is clearly visible, especially when the sitter, Sir Francis Nethersole (col. pl. 17d) for example, or Sir Robert Harley,[10] is dark haired. The modelling is none the less extremely subtle, and

COLOUR PLATE 19 (following page)

a. (top left) John Hoskins, *James I, c.* 1620–5, 54 × 44 mm. V&A P27–1954.
b. (top right) John Hoskins, *Unknown Woman, c.* 1620–5, 55 ×43 mm. V&A P32–1941.
c. (middle left) Alexander Cooper, *A Man, perhaps Ferdinand III, c.* 1635–40, dia. 36 mm. V&A P6–1940.
d. (middle right) John Hoskins, *Katherine Howard, Lady d'Aubigny, c.* 1640, 84 ×67 mm. V&A P105–1910.
e. (bottom left) David des Granges, *Charles II, c.* 1648, 48 ×39 mm. Ham House 380.
f. (bottom right) Nathaniel Thach, *Anne of Gonzaga,* 1649, 60 ×48 mm. V&A P2–1969.

90. Isaac Oliver, *Henry Prince of Wales, c.* 1612, about 130 × 102 mm. Royal Collection.

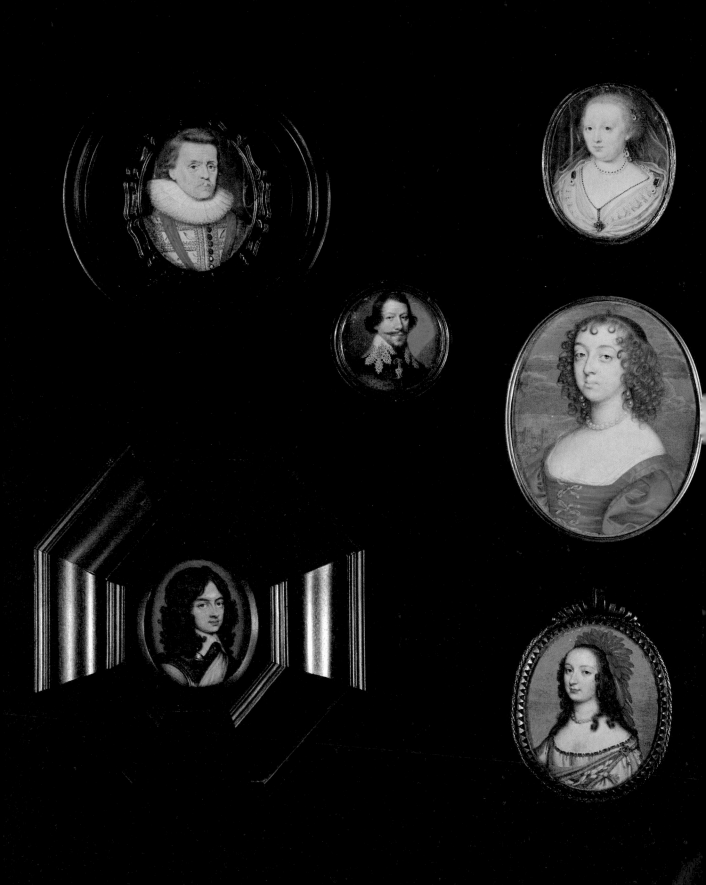

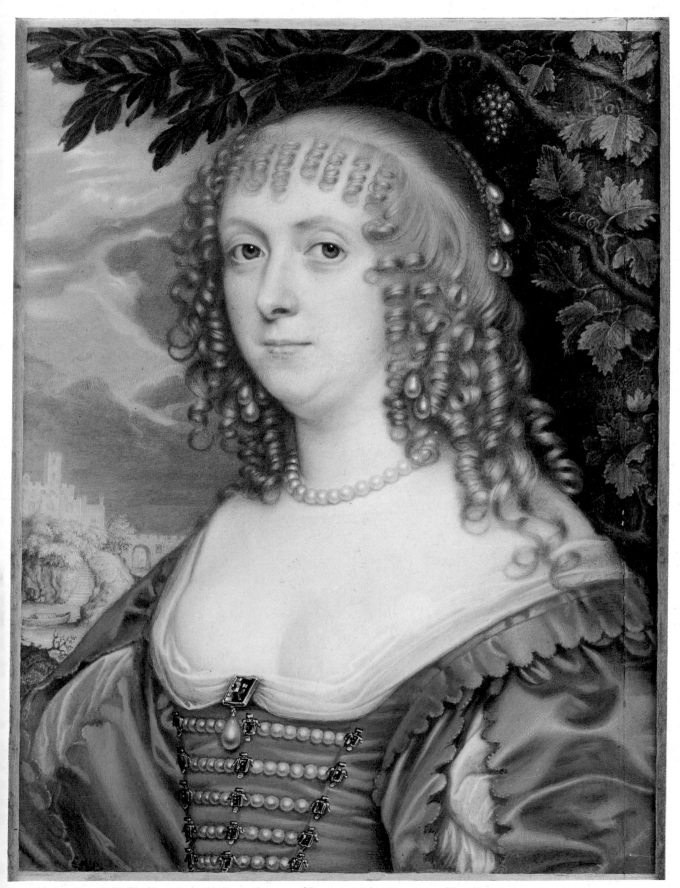

COLOUR PLATE 20 John Hoskins, *Catherine Bruce, Countess of Dysart*, 1638, 229 × 174 mm. Ham House 274.

91. Peter Oliver, *Sir Robert Harley, c.* 1621, 61 × 50 mm. Welbeck Abbey.

92. Peter Oliver, *Child with a Bunch of Flowers,* 1647. Collection V de S.

illusionistically three-dimensional. The character of a man's face is depicted in the muscular set of his jaw, the knotting of his brow, the wrinkles at the corners of his eyes – by the precise representation in other words of features that are within the outlines of the countenance. It is a very anti-linear style, clearly derived from that of Isaac Oliver, but much more developed and completely differentiated in its three-dimensional solidity from the classic Hilliard manner. For Peter Oliver, forms were known by their highlights and shadows, and faces presented to the portraitist a set of complicated inter-reacting formal problems whose resolution could only be effected by smoothing the transitions, not by drawing lines where they didn't actually exist in the sitter's features.

This was the direction in which he continued to develop, encouraged by the example of the pictures he was copying in the collection of the king. Clearly he was perfectly capable of a linear style when occasion demanded, as in his copy of the Raphael *St George,*[11] but the main anti-linear impulse seems to have been from the Venetians Titian and Palma Vecchio in the examples shown here (col. pl. 18). Ultimately, he responded most to the king's Correggios, the *School of Love*[12] and the *Venus, Cupid and a Satyr.*[13] The soft sweet corporeality of the style seems to have led on directly to his last works, and it is difficult to conceive of him painting the *Child with a Bunch of Flowers* in the year of his death without a lively memory of Correggiesque putti. The plastic softness of his earlier copies has here become virtually a mist, the forms emerging into light and disappearing into shadow, across contours dissolved in a haze of stipple.

Oliver's style was in this respect far more extreme than that of any other limner in the 1630s and 1640s, though there are parallels both in the general aspiration to a more fleshy style and in other artists' development of stipple. John Hoskins for example evolved in the same direction, and the similarity goes far to suggest an actual link between the Olivers and Hoskins in Blackfriars at least until the early 1630s when the Hoskins household moved to Covent Garden. Thus, both Peter Oliver and Hoskins painted with the 'granular' shadow stipple in the 1620s, and elaborated the technique in such a way as to obliterate the linear formalism of the older style. Significantly both limners were becoming increasingly committed to the business of copying, Hoskins probably with a bias towards portraits and Oliver evidently towards histories, but it was not the technical requirements of copying as such that conditioned the stipple manner. Rather, the act of copying induced a sense of belonging in a tradition of mastership, and compelled attention to the skills and demonstrable virtuosity of execution within that tradition. In other limners the impulse towards a virtuoso style led in a different direction: in Cooper it led towards the red-brown hatching manner and in Dixon ultimately towards an undisciplined improvising looseness of stroke, but in Oliver and Hoskins it led towards stipple. Peter Oliver went further in this direction than Hoskins partly for the simple reason that Hoskins gave up in the early 1640s, but more deeply because Oliver was

brought up by his father to it; he was brought up in the house of a painter–dealer–historian, an expert agent of the royal connoisseurs, and the expertise that he thereby came to trade on started at a higher level and became more extreme than anyone else's.

The same strain of expertise is reflected in Oliver's standing as the most professional technician of the limner's art in the 1620s. It was his adoption of the 'pink' prepared by Sir Nathaniel Bacon that was quoted as proof of its excellence, that Oliver 'did highly commend it and used none other to his dyeing day. Wherewith and with Indian lake hee made sure expressions of those deepe and glowing shadowes in those Histories hee copied after Titian, that noe oyle painting could appeare more warme and fleshly then those of his hand.'[14] Nathaniel Bacon remains an obscure figure, but from the inscription on his burial monument it is clear that he was known as an expert on plants and colours,[15] that he was probably therefore one of an important class of experimental natural philosophers, ranging from Theodore Turquet de Mayerne to Matthew Snelling and Charles Beale,[16] who intellectualized the traditional technical base and lore of painting and helped thus to bring the art to the leading edge of the culture. The Nathaniel Bacon anecdote is important because it shows Oliver as the expert, not an expert of the kind that knows all the answers, but one who was far down the arcane ways of experiment, eager to hear of the work of others and to use all advances to help his own pursuit of excellence. The expert in the culture that Oliver belonged in was an open-minded experimentalist, fascinated by materials and techniques, constantly in search of improvements and new ways of doing things.

Another example of his inventiveness, or readiness to adapt an existing technology, was his introduction of gessoed cards as a secondary support for miniatures in the 1620s. These cards had been around for a long time.[17] They were a standard drawing surface used in the studios of artists all over Europe, advantageous in a pre-graphite era since the relatively hard and abrasive surface accepted a more distinct mark from a metalpoint stylus than paper or ungrounded vellum. The cards were widely available because of their use in banking and commerce; they were sold in a block or bound together as a tablet, and were used as handy erasable tally books. Oliver saw their advantage in offering a stiff smooth surface, which could be further burnished to receive vellum, and in offering a greater resistance to cockling than the traditional sized-card secondary support. It must have seemed an obvious innovation, but its first recorded use was on the portrait of Sir Kenelm Digby of 1627 in the National Portrait Gallery, and thereafter it was taken up rapidly by the London miniaturists, especially those – Hoskins and Alexander Cooper – in closest touch with Oliver. By the late 1630s it was standard London practice to use the gessoed card, so much so that it was, prima facie, a mark of non-membership in the metropolitan school to use a plain card or, as the French recommended, a copper support. It was Oliver, dominant and authentically descended from the

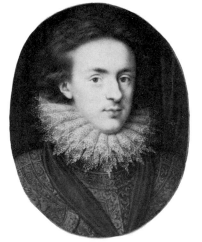

93. Isaac Oliver, *Henry Prince of Wales*, c. 1612, about 62 × 50 mm. Royal Collection.

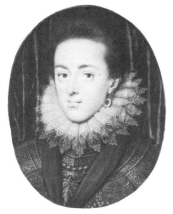

94. Isaac Oliver, *Charles I as Prince*, c. 1612, about 54 × 43 mm. Royal Collection.

Holbein–Hilliard tradition, who set these norms and most clearly represented that tradition of technical innovation, mystery and expertise into the second quarter of the seventeenth century.

It is right to emphasize the Olivers' Englishness, their import-ance and centrality in the limning tradition on the one hand, and their firm social settlement among the professional servants and providers of the Jacobean court culture on the other. It was as settled Englishmen that their relative foreign ease, their familiarity with the European art market for example, probably mattered most. They should be seen as part of the out-reach of the English state, its readiness to absorb the ideas and skills displaced by the Counter-Reformation, and its short-lived putative readiness to become the main protagonist of such values as the champion of Protestantism.

Peter Oliver inherited Isaac's role with Anne of Denmark's children, maybe not his role as dealer and agent, but surely his role as limner. It is difficult to be precise about it, but as we have seen he shared with his father the production of portraits of this group at court at least from *c.* 1612, when he worked on the images of Prince Henry.[18] After Henry's death he transferred the imagery to Prince Charles for whom he developed a series of portraits of the prince with his Garter ribbon, apparently continuing into the late 1620s.[19] These connect circumstantially with the contemporary images of Princess Elizabeth (col. pl. 17e), Frederick V of Bohemia,[20] his brother Ludwig Philip, Duke of Simmern (col. pl. 17a), and Sir Francis Nethersole (col. pl. 17d), Elizabeth's secretary and the political agent of the Protestant Union. It is possible that Peter Oliver actually joined Elizabeth's suite after her marriage to Frederick, and travelled between London and the Palatine court at Heidelburg as part of the intercourse between the centres of Protestant enlightenment. It was from this connection that Peter Oliver's signed portrait oeuvre emerged between about 1615 and 1620, the period covering his father's death and his consequent formation as an independent miniaturist. It set the style that

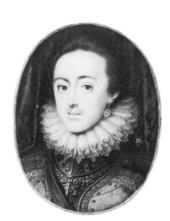

95. Peter Oliver, *Charles I as Prince*, c. 1612, about 50 × 40 mm. Royal Collection.

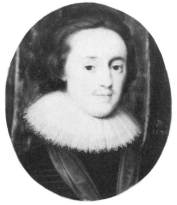

96. Peter Oliver, *Charles I as Prince*, 1621, about 53 × 41 mm. Royal Collection.

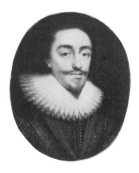

97. Peter Oliver, *Charles I as Prince*, c. 1625, about 39 × 34 mm. Royal Collection.

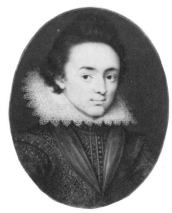

98. Isaac Oliver, *Frederick V of Bohemia*, c. 1613, about 53 × 42 mm. Royal Collection.

characterized his work for the next decade, and by which Charles and Buckingham[21] were co-opted to the heroic, classicizing iconography worked out originally by Isaac Oliver for Prince Henry. For as long as it was possible to see Charles in this light Peter Oliver did so, but increasingly after 1621 his sympathy as the portraitist of Protestant heroes must have focussed on Elizabeth, in exile at The Hague. The flow of images of her continued,[22] part of the machinery of maintaining herself in the political consciousness and of communicating with her supporters, until the connection was handed on to Alexander Cooper. Oliver, finding his puritan-Augustan portrait style increasingly inappropriate to the Caroline court of the late 1620s and the 1630s, left portraiture to Hoskins. He himself, none the less an exponent of limning as a court art, got on with the business of histories in which his and the king's sympathies were palpably harmonious.

Too much of this may seem hypothetical, but it does seem to make sense both of what we fragmentarily know of Oliver's career, and of the significance of limning in the particular circle where he practised. Ineluctably his profession both in its traditional and in its innovatory aspects made him an exponent of the English enlightenment, and he found his artistic niche with those such as Elizabeth of Bohemia who most consistently during his adult life symbolized that culture and its chances of ultimate success. By his continuing relations with Elizabeth in exile, and the continuing adaptive presence of his art at the metropolitan centre, he and the other limners helped to maintain the political viability of the culture they represented, and prevented their art from losing its close association with the Tudor Protestant nationalist tradition.

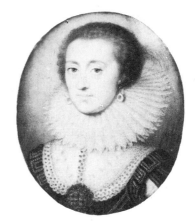

99. Peter Oliver, *Elizabeth of Bohemia*, 1621, about 54 × 44 mm. Royal Collection.

JOHN HOSKINS (*c.* 1590–1664/5) AND HIS SON (1615/20–AFTER 1690)

John Hoskins must have been very close in age to Peter Oliver. He was a child in the last years of Elizabeth, and, having grown up through the reign of James I, was a man made in the mould of the English renaissance enlightenment. We know nothing definitely of his parentage but it is probable that his family had some important connections in the Surrey countryside, the Hoskinses of Oxted, who were themselves linked in a complicated network of relationships with the Coopers of Capel near Dorking.[23] The marriage between Barbara Hoskins, the sister of John, and Richard Cooper in 1607 may have been arranged by the rural heads of the families between the relatively less well off metropolitan scions. Limning, as Hilliard insisted, was an art fit to be practised by gentlemen, and the evidence thus suggests that the great native dynasty of limners in the seventeenth century, the Hoskinses and Coopers, came from the social class to which, other evidence shows, the limners invariably belonged.

John Hoskins was probably married twice. His putative first

wife would have been the mother of John the younger, Cooper's 'Cozen Jack' and the beneficiary of his father's will. He must have been born by about 1620, perhaps as early as 1615. The second child, Christiana, was born on 24 June 1654, and her mother was Sarah who must on these dates have been a second wife. The child was evidently named after her grown-up cousin and probably her godmother, Christiana, Samuel Cooper's wife. She died at the age of six in September 1660, and thus was not mentioned in her father's will which was made on 30 December 1662. John Hoskins died sick and impoverished and was buried at his parish church of St Paul's Covent Garden on 22 February 1664/5. His widow, described as an 'Almswoman', was buried in the same place on 19 February 1668/9.[24]

The decline in Hoskins's fortunes was steep. Profoundly committed by upbringing and sense of professional loyalty to the king, who on 30 April 1640 granted him the enormous annuity of £200, he must have been shocked when the king left London, abandoning his roots in the legitimate parliamentary and professional sources of power. As a man in his mid-forties, he probably did not know quite where else to find patronage. Unlike Cooper or indeed his own son, he seems not to have developed a clientele amongst the parliamentary nobles and other magnates of the Interregnum, but to have remained morally attached to Charles I – a conclusion drawn from the 'late' type of *Charles I*, deriving on costume evidence from a sitting of the late 1630s[25] but probably current well into the 1640s, being adapted as the king aged.[26] Work from Hoskins's own hand, however, is pretty rare after the late 1630s, and it may well be that he suffered some sort of debilitating illness or stroke. There is a very obvious difference in quality between for example the *Catherine Bruce* (col. pl. 20) of 1638 and the *Mrs Henderson* of 1649 at Ham: it is difficult to see how a miniaturist could make a living from work such as the *Mrs Henderson* in a competitive metropolitan market, and the likelihood is that Hoskins had ceased virtually to work by the mid-1640s. It was probably no accident that the royal annuity was paid to him only in the year that it was granted, and it was probably tough but just that the Lords Commissioner of the Treasury took no action on his petition for back payment after the Restoration. As Roy Strong has inferred from the scarcity of work by Levina Teerlinc as compared with the profusion by Nicholas Hilliard,[27] the receipt of a royal pension was less of an inducement to work than the means to gentility. In the 1620s and 1630s, the period of his large output, Hoskins similarly had been driven by commercial pressures which, with the prospect of a pension, he was probably quite glad to escape and which had already compelled him to the role of entrepreneur in his studio. He may thus have been responsible more for winning the new clients of the 1640s with the prestige of his name while his gifted son and perhaps some assistants went on doing much of the actual work from the familiar premises in Covent Garden.

Implicit in this account is the view that the body of Hoskins's

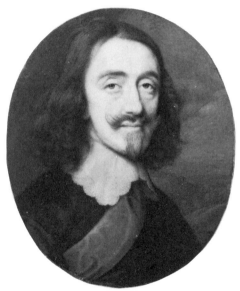

100. John Hoskins, *Charles I*, c. 1635–40, about 73 × 60 mm. Royal Collection.

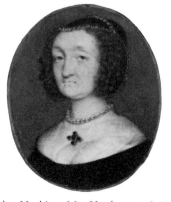

101. John Hoskins, *Mrs Henderson*, 1649, 50 × 41 mm. Ham House.

work which nowadays confronts the historian is in fact by several hands.[28] One of the problems posed by the Hoskins oeuvre has been the concentration on the question as to whether there were one or two *IH* artists, and attempts to sort the extant miniatures into two categories on stylistic grounds, or to apportion the miniatures between them on grounds of signature, have not surprisingly failed. Yet, on a close and impartial survey of the actual objects, it remains impossible to believe that the corpus is a self-consistent whole; and the only plausible explanation of its internal variations is that from the late 1620s Hoskins had several assistants or colleagues in the studio. It is irrational to believe that an artist would change the most fundamental characteristics of his graphic method not only from year to year and from sitter to sitter, but within the run of versions of a particular portrait type. It is reasonably consistent with what we know of the way Hoskins lived, the demand for his work, and the actual miniatures that survive, that during the 1630s the initials *IH* became virtually a trademark covering the activities of a busy studio.[29]

That said, what were the characteristics of the studio – what sort of product did Hoskins's patrons expect? In the 1620s they would have expected an image of the sitter still iconographically and stylistically within the tradition of Elizabethan and Jacobean portraiture. Hoskins was in this respect the inheritor of the Hilliard mantle and, if we are right to attribute a portrait like the so-called *Arnold Breams* (col. pl. 15b) to the late Hilliard studio, then we can see that a portrait like the *Henry Carey, Viscount Falkland* relates to it in solemnity and public formality as well as in close stylistic similarity. Comparison with the signed Peter Oliver portrait of Sir Francis Nethersole (col. pl. 17d) shows an even closer stylistic similarity – the dark granular stipple in the hair lines of jaw and forehead for example – though Oliver even at this stage in his career seems to have offered a more intimate account of his subject: Nethersole 'en vous voyant' seems a quizzical observer of the human comedy. The three portraits are quite distinct and are clearly by different people, but they come from a common stylistic matrix. Hoskins gave his clients an updated version of the traditional English miniature, the evolving continuity of his practice maintaining the norms of the whole English school.

One can point to specific technical continuities, the flooded crimson lake wash for the stock red curtain background, for example, or more interestingly the illusionist treatment of the jewellery in a portrait like the *Unknown Woman* (col. pl. 19b). In the latter case Hoskins deploys the full panoply of resin and powdered metal to create a three-dimensionally glittering illusion of the jewelled costume. Written instructions in this craft were available from the treatises of Hilliard or Norgate, but the confidence and neatness of Hoskins's performance tend to suggest he may have learned at first hand in Hilliard's studio. Very soon Hoskins and the whole English school abandoned this literalism of rendering and adopted a painterly means of simulating precious metals and stones. Gold and silver continued in use, but as pig-

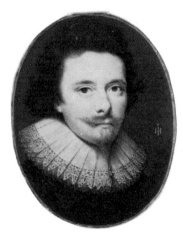

102. John Hoskins, *Henry Carey, Viscount Falkland,* c. 1625, about 57 × 43 mm. Royal Collection.

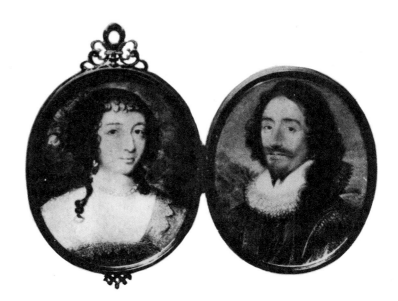

103. John Hoskins, *Charles I and Henrietta Maria, c.* 1627, about 51 × 42 mm. Pierpont Morgan Library.

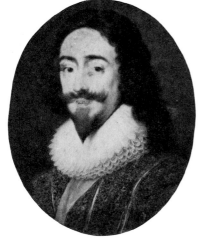

104. John Hoskins, *Charles I, c.* 1627, 62 × 50 mm. V&A P39–1942.

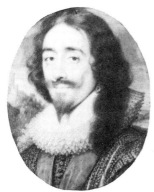

105. John Hoskins, *Charles I, c.* 1627, about 51 × 42 mm. Countess Beauchamp, Madresfield Court.

ments, to provide the lights of a burnished breastplate or the lustre of a pearl. By the end of the century the craft, a direct link with the origins of the art of the limner, had been lost, and the attempt to paint a Hilliardesque jewel by painterly means is now one of the ways of telling an eighteenth or nineteenth-century fake from the real thing.

Hoskins's establishment as the principal limner of the Stuart court was signalled by his employment for the portraiture of the Duke of Buckingham and of Charles at the beginning of his reign. Both the resulting images exist in a considerable number of surviving examples, and from the quantity of the former it is evident that Buckingham, like the king, used portraiture to transmit and express his political persona to followers or correspondents. The king's portrait of this type is modelled on an original by Mytens that was current between about 1629 and 1631, and the miniature versions vary considerably in quality, from the signed image paired with one of the queen in the Pierpont Morgan Library to the unsigned but still probably autograph version in the Victoria and Albert Museum. Perhaps we can deduce from the coherence of the group that Hoskins was still personally responsible for the output of his studio at this date, even when he was merely multiplying an image that was not originally his anyway. The Buckingham group, on the other hand, has so much variation in quality and in the details of handling that one can surely impute the activity of assistants.[30] The version at Windsor indeed is of commandingly high quality but is not obviously by Hoskins. Though the novel and subtle method of illumination, quite foreign to the Hilliard–Oliver tradition, presumably derives from Honthorst, it is difficult to match anywhere else in Hoskins's oeuvre and it seems rather to anticipate Alexander Cooper. The possibility of a Cooper contribution to this group of Buckingham portraits emerges more strongly in versions of the type where the background is unconventionally coloured and marbled. All one can really say, however, is that the Hoskins studio at this date provided the same sort of stylistic matrix as that of Hilliard fifteen years earlier, and that from it the next generation of limners later developed distinctively.

Close in date but very different in other ways is the *Edward Sackville, fourth Earl of Dorset* which may show the activity of the young Samuel Cooper in his uncle's studio. The vigorous brown and red modelling of the face indicates a more profound response to the bravura painting of the Dutch and Flemish masters; the artist does not use the traditional stipple or hatch of the limners to reproduce the effect of the large-scale painting, he imitates the brush work. The model here is of course van Dyck and it seems likely that the main exponent of the van Dyck style in the Hoskins studio – in the specific point of imitating the vigour of the execution – was Samuel Cooper. Certainly it is in his first independent works of the later 1630s that this particularly free red-brown brushwork reappears.

In contrast, *Sir George Heron* (col. pl. 15f) seems normative for Hoskins himself in the 1630s. The face-painting is much softer and achieves a blend of sanguine with blue, yellow and some white heightening over the carnation ground that remains fairly constant in the works of the next decade. The development in Hoskins's style between the 1620s and 1630s is thus evident even in work that bears little mark of van Dyck's influence. His style develops from the relatively crisp and dark Hilliard–Oliver manner towards the polychromatic blended stipple, and it was that which provided the means for him to interpret van Dyck with a soft plasticity quite different from the treatment given to the *Earl of Dorset*. Van Dyck evidently came to dominate Hoskins's output at this time almost

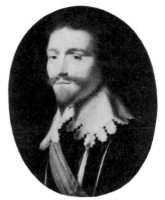

106. Studio of John Hoskins, *George Villiers, first Duke of Buckingham*, c. 1628, about 51 × 40 mm. Royal Collection.

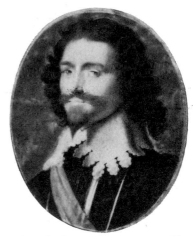

107. Studio of John Hoskins, *George Villiers, first Duke of Buckingham*, c. 1628, about 58 mm high. Christie's, 3 October 1972, lot 116.

108. John Hoskins, *Edward Sackville, fourth Earl of Dorset*, c. 1632, 100 × 81 mm. V&A P104–1910.

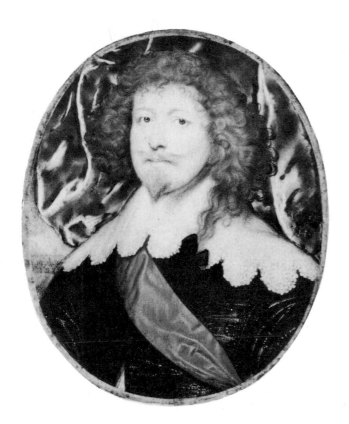

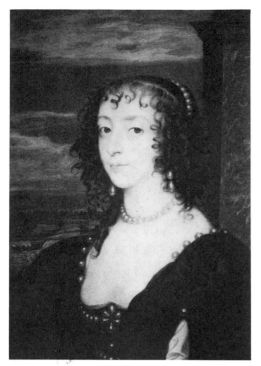

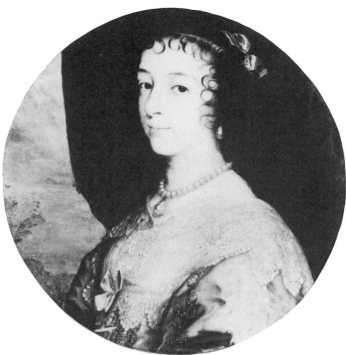

109. (above) John Hoskins, *Henrietta Maria*, 1632. Duke of Devonshire.

110. (above right) John Hoskins, *Henrietta Maria*, 1632, dia. 179 mm. Mauritshuis.

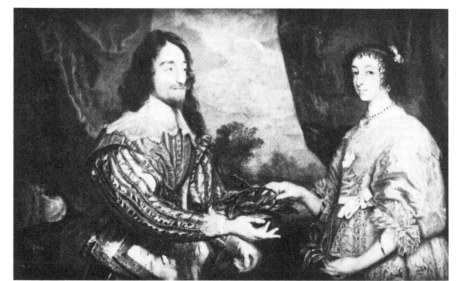

111. John Hoskins, *Charles I and Henrietta Maria*, 1636, 70 ×115 mm. Duke of Northumberland.

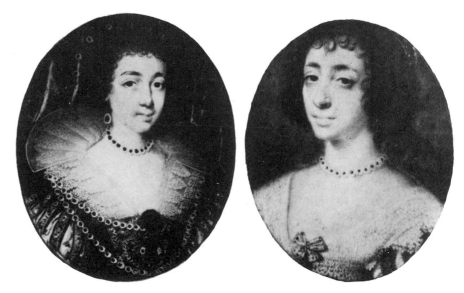

112. John Hoskins, *Henrietta Maria*, c. 1630–5. Mauritshuis.

113. John Hoskins, *Henrietta Maria*, c. 1630–5. Countess Beauchamp, Madresfield Court.

completely, and it is clear that there was some special compatibility between his almost sensual rendering of skin and the van Dyck images of Henrietta Maria and the court ladies. The subtlety of tone is especially clear in his interpretations of the queen's face from van Dyck's double portrait of 1632.

Hoskins himself undoubtedly worked on these miniature variants of the double portrait, which were probably individually commissioned and paid for, after the custom established for Hilliard and Oliver. At least two of the miniatures – the rectangular image of the queen alone, but framed in a paired cabinet with one of the king, and the large round of her alone – are dated the same year as the painting, and the straightforward copy of the whole composition must have followed closely. A further variant, of the queen alone in an oval with a different costume, must also be from the same time, and the impression given by the whole group is of a direct relationship between van Dyck and Hoskins whereby the new van Dyck composition passed at once to Hoskins for reproduction and variation on the queen's order. The relationship was direct enough and Hoskins was confident enough to interpret freely, adding not only an extra quality of soft sensuousness, but changing costumes, varying poses and generally maintaining the vivacity of the image throughout its currency.

The evidence of contemporary correspondence gives ample indication that Hoskins in the 1630s did not limit his autograph work to the royal commissions, and that he was associated in clients' minds with van Dyck. The self-confidence with which he handled his models in this respect, can be seen in the *Catherine Bruce* (col. pl. 20) and the *Katherine Howard* (col. pl. 19d), both freely adapted from van Dyck. Both of them show also how important the landscape element had become in the mature Hoskins portraiture, important enough for Hoskins to adapt a landscape from Hollar for the background of *Frances Cranfield, Countess of Dorset*, another of this group. The *Katherine Howard* also has a significant landscape element, and is, although an oval set in a locket, on the enlarged scale which Hoskins as distinct from Peter Oliver appears to have favoured. The *Katherine Howard* is probably later than the *Catherine Bruce*, and it is not entirely clear whether it derives freely from an actual van Dyck original, or whether it is an independent Hoskins likeness cast in the van Dyckian manner. It is probably one of the latest essays in this dominant courtly mode of the 1630s, and it connects with the non-autograph Hoskins–van Dyck miniature portraits of Beauties such as those at Ham. What marks out the autograph Hoskins, however, in all the van Dyck copies, variants and pastiches that are associated with him, is the subtle and rich blending of colours, pink, yellow and grey, into the basic modelling of the features. It was Hoskins's capacity to make an image that was strikingly, sensuously satisfying – to take the advanced iconography of the van Dyck school and to contain it, adding to its appeal to the senses in an intense small span – that accounts for his primacy while he worked with the connoisseurs of the Caroline court.

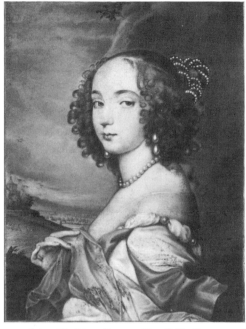

114. John Hoskins, *Frances Cranfield, Countess of Dorset, c.* 1638. Duke of Buccleuch.

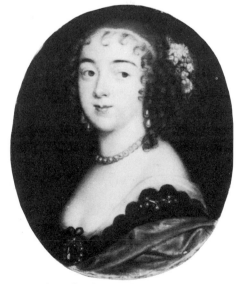

115. Studio of John Hoskins, *Dorothy Sidney, Countess of Sunderland, c.* 1640, 71 × 60 mm. Ham House.

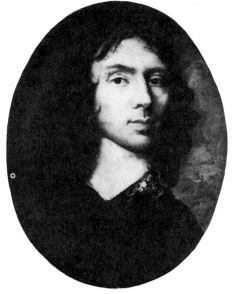

116. John Hoskins the younger, *Probably a Self-Portrait*, 1656, 76 × 57 mm. Duke of Buccleuch.

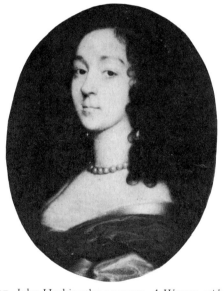

117. John Hoskins the younger, *A Woman said to be Princess Elizabeth*, 1645. Countess Beauchamp, Madresfield Court.

The younger John Hoskins, whose existence (but not his career as a limner) is irreducibly proved by documents and contemporary references, is putatively the artist responsible for the apparently distinct group of miniatures of the period roughly 1645–58. They cluster naturally around the portrait in the Buccleuch collection which is signed and dated 1656, and inscribed 'Ipse' to indicate apparently that it is a self-portrait. If, as already suggested, the younger Hoskins was born about 1620, he could have been the artist and sitter. The portrait is in fact damaged and it can only be used with caution as the basis of stylistic analysis. It can, however, be said that it is worked with a breadth and graphic strength quite unlike the manner of the Hoskins–van Dyck portraits of the 1630s, and convincingly similar to the red-brown draughtsmanship of the group we are attempting to distinguish. The earliest is the so-called *Princess Elizabeth* of 1645, and the series runs more or less continuously to the *Sir John Maynard* of 1657 and the *Unknown Man aged 67* of 1658.[31] The early ones, such as the *General Davison* and the *Soldier aged 27*, both of 1646, are in the Commonwealth 'sad-coloured' mode, with brown backgrounds. They are severe and honest images of proud Christian soldiers, viewed slightly from below.

The same basic pose, the three-quarter face turned to the right, direct gaze and no hands, runs through the whole series. With the *Sir John Wildman* (col. pl. 22a) of 1647, the bright landscape background, established in the elder Hoskins's repertoire in the 1630s, reappears. With landscape, or with a sky background as in the *Lady Mountnorris* of 1648, the figure acquires prominence and dignity from the implicit space behind. The imagery is naturalistic rather than emblematic: the spaciousness not only places the figure in the wide free world, in which he is seen as important, but the close-up view of him imparts a special sense of concentration on his particular features. The portraiture is thus humane and intimate, but its projected character is none the less formidable. As in the *Unknown Man aged 67*, it seems to address the rigorous disciplined face of the puritan at home, the wakeful Christian soul who hears the call of duty as clearly in his conscience as in the outside world. The distinction between public and private in the portrait has disappeared.

Very little serious work has been done on the younger Hoskins, and few of his sitters have been certainly identified. Of those with names traditionally attached, however, there are enough to suggest that Hoskins had a fairly committed parliamentary clientele. For them he worked out a distinctive and naturalistic iconography expressing their status as an individualistic and non-royal élite. The achievement was considerable and must have had its lustre even beside that of Samuel Cooper. Certainly Sanderson, writing for publication just as the series of surviving works by Hoskins was coming to an end, had no doubt of the younger man's standing amongst the limners. Pepys also, ten years later, knew him to be a man 'eminent in his way'. It is plausible that he had earned this respect by having painted during the preceding years the

characteristically Commonwealth portraits here attributed to him.

There are, however, many problems and uncertainties, and despite recently added light on Hoskins's later history he remains a shadowy figure. What was he doing between 1658 and 1668? The Restoration should have been a time of opportunity for him as it was for his cousin Cooper, or for any of the new entrants to the London trade, Gibson, Dixon or Flatman. Are the miniatures he painted after 1658 then simply lost? Or did he have other occupations?

Hoskins married on 7 February 1669/70, almost a year after his mother's death.[32] His wife was Grace Beaumont, elder daughter of Thomas Beaumont, a lay Vicar Choral of Wells Cathedral and probably a surgeon or apothecary, like his father John Beaumont before him. Grace was born in Wells about 1645 and was named after her mother, Thomas Beaumont's second wife. She and John Hoskins had seven children, named in the will of the elder Grace Beaumont dated 1690. John was the residuary legatee and executor of his mother-in-law's estate.

It is probable that the elder and younger Hoskinses in London were connected with the Somerset and Herefordshire based family founded by John Hoskins (1566–1638), the scholar, wit and lawyer, and culminating in the seventeenth century with his grandson Sir John Hoskins (1634–1705), lawyer, philosopher and ultimately president of the Royal Society.[33] His position in the Royal Society was probably supported by his connection through the Hoskinses and Coopers of Oxted in Surrey[34] with the Surrey Greshams who, as a family, had a continuing interest in the endowments of Gresham's College and its salaried professors, the basic caucus of the Royal Society. Behind Gresham's College also were the Mercers, the Company to which many of the Surrey Hoskinses and Coopers and their relations belonged.

The younger Hoskins connection with the Beaumonts of Wells helps additionally to fix his social and intellectual milieu amongst the protagonists of the Royal Society culture. Amongst them his profession as a painter, with expertise in disciplines related to theirs within the traditional scheme of knowledge, would have given him standing. His wife's grandfather had been a surgeon or apothecary, and her father probably likewise; in the next generation there was another surgeon called John Beaumont practising at Stone Easton just outside Wells. He was a distinguished practitioner of the microcosmic studies that underlay his profession, and his wider interests took in also the geocosm. He was elected Fellow of the Royal Society in 1685, the year of Sir John Hoskins's presidency.

He was a friend also of Robert Hooke, with whom in his youth one of the Hoskins miniaturists was also evidently acquainted. Aubrey recorded a visit by Hoskins to Freshwater, Isle of Wight, probably in the late 1640s, during which Hooke observed him drawing: 'John Hoskyns, the painter, being at Freshwater to drawe pictures, Mr. Hooke observed what he did, and, thought he, "why cannot I doe so too?" So he gets him chalke, and ruddle and coale, and grinds them, and puts them on a trencher, got a pencil, and to

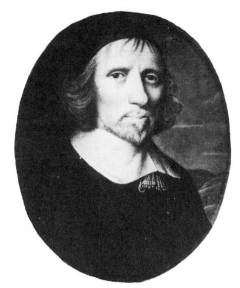

118. John Hoskins the younger, *Unknown Man aged 67*, 1658, 73 × 58 mm. Formerly H. J. Pfungst Collection.

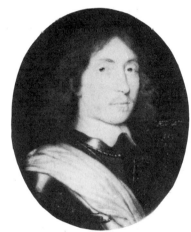

119. John Hoskins the younger, *Soldier aged 27*, 1646. Countess Beauchamp, Madresfield Court.

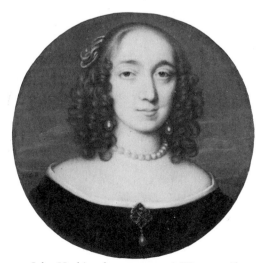

120. John Hoskins the younger, *A Woman said to be Jane Stanhope, later Lady Mountnorris*, 1648, dia. about 65 mm. Christie's, 16 December 1975, lot 45.

worke he went, and made a picture: then he copied (as they hung up in the parlour) the pictures there, which he made like.'[35]

Hooke obviously was very interested in painting well after this incident, and is said to have worked for a time in Peter Lely's[36] studio. Whether Lely in his turn was a friend of Hoskins, as he certainly was of Richard Gibson, is not known. The links, however, in such a network are intricate, and only in sum do they offer a reliable sense of what the younger Hoskins's mind may have been like. He lived amongst people who, although they were interested in painting and were perhaps amateur practitioners of it, did other things as well. He probably did not regard himself as exclusively a miniaturist, and he may have preferred to reinforce his membership of the cultivated class by presenting his talent as an ornament which, the handbooks said, gentlemen should aspire to. Thus it may not be surprising that there is a scarcity of work by him from the Restoration: he may have been employed through his family's extended contacts in the City companies or have had some agency connected with the law or Church. What we know is that he was surrounded by a concert of families well placed to offer opportunities to a bright young relation, and which constituted the same sort of supportive social and intellectual group as emerges with perhaps greater certainty from the biographies of the Beale – Flatman set.[37] The perception of such groups is important not only because it helps to substantiate the growing claim of painters for social status, but because it shows how close to the leading edge of intellectual life the painters, perhaps especially the limners, actually were. It shows how the intellectual community was composed of intricately mingling family, professional and commercial interests, and how the internal communications of a significant sector of it probably worked.

SAMUEL COOPER (?1608–1672)

The career of Samuel Cooper is central in the history of miniatures in the seventeenth century. For one thing he seems to have been much more dedicated to the business of painting miniatures than almost anyone else – the elder Hoskins seems to have stopped in the 1640s, the younger in the late 1650s, Flatman had other heavy commitments, and Dixon ran into problems sometime around the late 1680s, and only Peter Cross seems, like Cooper, to have been a serious professional from apprenticeship to old age, with a large body of works finished and delivered to clients. Lasting reputations in the arts are much more dependent on this solid ability to perform than on the more evanescent qualities of brilliance, and Cooper was certainly able to perform. From the mid-1630s when he painted the *Margaret Lemon*[38] to the month of his death there is a more or less continuous series of dated or dateable portraits, testimony of a formidable industry and a well-organized flow of

business. Across the three central decades of the century, during the Civil War, the Commonwealth and the Restoration, Cooper painted most of the leading courtiers or citizens.[39] In both quantity and prominence, therefore, Cooper's achievement bulks larger in the seventeenth century than anyone else's. But what concerns us here is the claim that he was as an artist central, pre-eminent in brilliance as well as in industry. We should look at the way in which Cooper put together his reputation as the most brilliant limner of his age, and at the culture that valued and encouraged the growth of such reputations.

Cooper emerged from one of the complicated meshes of family and professional relationships on the fringes of the prosperous bourgeoisie that provided practically the whole limning trade in the seventeenth century.[40] He was the son of Richard Cooper and Barbara Hoskins, who were married on 1 September 1607 at the church of St Nicholas Cole Abbey near Blackfriars, where his brother Alexander was baptized two years later, on 11 December 1609.[41] He and Alexander were evidently orphaned when he was sixteen and, according to Richard Graham,[42] then lived with their maternal uncle John Hoskins, presumably in the area of Blackfriars. From 1632 van Dyck also lived in the neighbourhood.

We have seen that much of Hoskins's work from this time consisted of copying and making miniature variants of van Dyck portraits, and we know from all the early histories that Cooper had learnt much from the '*Observations* which he made of the *Works* of van Dyck';[43] Buckeridge adds that he copied many of van Dyck's works 'which made him imitate his stile'.[44] The inference that Hoskins, van Dyck and Cooper had some sort of formalized business arrangement in the early 1630s is well established,[45] and Cooper's personal familiarity with van Dyck is evident anyway from the cypher portrait of Margaret Lemon, van Dyck's mistress. The portrait is a relaxed and masterly essay in a van Dyckian composition and shows in detail the extent of stylistic assimilation between the master painter and the emulative young limner. In his mid-twenties, therefore, when Cooper signed this first surviving work that is definitely his, he had in his immediate background the long continuity of the native tradition synthesized in his uncle's practice, together with the innovative and invigorating influence of the van Dyckian baroque. For him these factors were not remote or abstract, but part of his living urban environment, literally personified by the people with whom he grew up and from whom he learned his art.

From this background Cooper was especially well qualified to be the beneficiary of the culture of connoisseurship and virtuosity that had been growing in London since early in the century. He was probably fascinated by van Dyck's technique. Watching the master work would have aroused a specially vivid sense of access to the fabled brilliance of Rubens's most gifted pupil. The style that Cooper developed in response in the 1630s had certain marked similarities to that of van Dyck. It was much freer than was traditional for the limners, and the palette was naturalistic rather

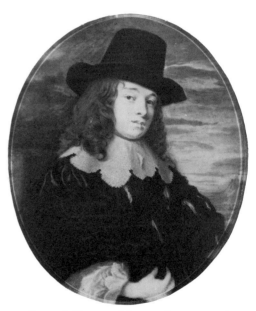

121. Samuel Cooper, *Margaret Lemon*, c. 1637, 120 × 101 mm. Institut Néerlandais, Paris.

than conventional, employing the red-brown flesh colours prac-
tically unblended with white or with moderating colours. The
uncompromising sanguinity and fleshiness of Cooper's faces was
still a slightly shocking feature of his style to Pepys over thirty
years later.[46] Cooper in fact used watercolour not in washes or in
stipples as the limners did, but in the manner of the oil portraitist
working in the final sittings, putting on the glazes and bringing up
the complexion to the colour of life.

Where on the other hand Cooper's early style was most graphic,
his long wiry strokes also recall the hand of van Dyck, more
probably studied from etchings than from drawings in the san-
guine manner of the Flemish school in general. It is extremely
likely that Cooper studied the most remarkable series of portrait
prints available on the market in the early seventeenth century, van
Dyck's *Iconographia*.[47] Cooper's technique, whereby he worked
directly with metalpoint or graphite on to the grounded vellum,
laying out the face first and leaving the background and the
arrangement of the rest of the figure till later, suggests that he
might have known the *Iconographia* images in their first etched
states: in that form they constitute the most dazzling example of
the potency of graphic art to create likeness, and to mirror the
pride and self-confidence of commoners, secure in their belonging
to a cultural and commercial élite. It is probable that Cooper had
access to some at least of the *Iconographia* at Blackfriars, and their
example must have qualified his attitude to the necessity of 'finish-
ing' – completing the background and body in a portrait – to the
end of his life. Cooper probably developed, in common with the
other connoisseurs, his attitude to the sketch as of particular auth-
ority, on the precedent of the *Iconographia* etchings.

Cooper, under this influence, was developing a brilliant showy
style for himself. The stories of Cooper and Hoskins quarrelling[48]
perhaps suggest truly the sort of tensions that the presence of
Cooper, self-conscious, gifted and apeing the manner of van Dyck,
could have generated in his uncle's house. The vital point, how-
ever, is that Cooper would have been aware that he was growing
up in a world where clients valued the artist's brilliance and
expected it to be evident in his work. He knew himself to be
talented, and he developed for himself from the obvious model a
style that demonstrated the speed, accuracy and power of his own
hand. On his own, he established a studio practice and working
routine that took all this into account.

It is very striking that although Cooper was much employed,
and was just as liable as his uncle had been to be courted to
undertake work,[49] he seems to have used assistants only for replicas
of work done originally by himself. There are various possible
reasons for this, one perhaps a conscious reaction against the
practice of Hoskins, a reaction that may have extended itself into a
reluctance to copy from full-size paintings. It became part of his
character as an artist that he did the work he was commissioned to
do himself, and that he worked *ad vivum*, in the presence of the
sitter. The concept of authenticity, applied to the genuineness both

of the sitter's likeness and of the artist's work, thus had a special point for Cooper. On the simplest level there was clearly no question of much studio assistance if the greater part of the work was carried out during the sitting, and so the client could be sure that what he got was a real Cooper, worth, independently of the subject, a good 20 guineas at auction.[50] Similarly, the client and his connections were assured of the accuracy of the likeness if the portrait was painted by a gifted artist who was actually looking closely at his subject while he painted. Hence the ritual of the sitting. Cooper would take his client, even a relatively unimportant one like Pepys's wife, through at least eight sittings, which became an extended platform for the artist to impress his personality – his *style* in a significantly extended sense – on the client. Cooper had a reputation as a witty conversationalist, a linguist and a musician, and Pepys was able to feel the force of all these talents when he went to his wife's third sitting on 10 July 1668: 'now I understand his great skill in musick, his playing and setting to the French lute most excellently; and he speaks French, and indeed is an excellent man'.[51] Cooper was clearly not just a face painter who produced a mechanical likeness of the client – Pepys in fact was hardly satisfied with the likeness as such of his wife's portrait, but he remained delighted with the totality of his experience of Cooper and the more elevated quality of the work.[52] In Pepys's account it emerges that what Cooper was selling was not so much a mere likeness but the magic of genius, the sense of a relationship with a brilliant man and of participation in his creativity. The miniature, enclosed in precious metal and crystal, was the material relic of the moments of its own creation. Its emblematic power came from its actual presence at the moment when, for example, the Lord Protector sat in front of Samuel Cooper, who had conferred on him the special gift of the painter, the privilege of corporeal immortality in the visual dimension. Flatman's lines –

> Strange Rarity! which can the Body save,
> From the coorse usage in a sullen grave,
> Yet never make it Mummie![53]

refer directly to the contemporary sense of magical or alchemical power in painting and its relevance, as a rarity, to the encyclopaedic cabinet of the connoisseur.

A crucial piece of evidence suggestive of the character of the young Samuel Cooper's mind is the connection with Sir Theodore Turquet de Mayerne, the king's physician and a neighbour of the Hoskins household in Covent Garden.[54] Mayerne met Cooper at Hoskins's house in February 1633/4, and Cooper wrote out for him the method of preparing various colours – white lead, bice, masticot, red lead and vermilion. Mayerne kept the document, noting on it that it was 'dedans ce mesme livre escripte de la main de Cupper'. In another of his notebooks Mayerne annotated a summary of his information from Cooper as 'tout le secret de lenlumineur'. Mayerne was evidently a frequent visitor at Hoskins's house, and we know that he visited other painters over

many years as he gathered information on the pigments and dyes used by painters. The results of his labours were collected in the large manuscript volume 'Pictoria, Sculptura et quae Subalternarum artium', containing work done between 1620 and 1646, that is in parallel with his medical work. He was not one of the great seventeenth-century physicians who published prolifically, nor was his work of a sustained theoretical nature. His method, for which he has since been consistently respected by clinicians and co-opted to the pantheon of inductive natural philosophers, was close observation and precise on the spot recording of substances and symptoms. The notes that he took on the materials of painting are in form the equivalent of those on his principal subject. He pursued his researches in both fields with the same methodological rigour. The reason for this was probably that Mayerne's fundamental expertise, which was in chemistry, was the same as that of the painter and colourman. For his commitment to the virtues of chemical remedies against the orthodoxies of the Galenists, Mayerne had been driven from France, and he regarded himself throughout his life as an experimentalist and innovator. It was therefore consistent with his intellectual bent that he should, as an empiricist, draw on the related expertise of the colourman and seek to extend his understanding of a discipline neglected by the orthodoxy of his own.[55] Moreover, Mayerne, as is evident from his writings, was working from a deep basic commitment to the medieval pharmacology and to the comprehensive idea of man and his anatomy as the microcosm of the universe. The entire College of Physicians, whatever their reservations about Robert Fludd, subscribed to the same broad conceptual structure, and Mayerne would have derived confidence from it for his empirical studies in chemistry. Especially he would have recognized a connection between his work and that of the portrait painter, both of whom, within the tri-partite schema of macrocosm, geocosm and microcosm, studied Man and deployed the same range of materials to approach his central mystery, Life. Life, indeed, in the seventeenth-century painter's vocabulary, meant portrait painting, and in Sanderson's account there is a direct equation between Life and Colour: though in landscape or history painting the qualities of freedom or discipline are involved, about portrait painting he says firmly '*Life*; only the *Colour*'.[56] Mayerne I think would have recognized the elegant ellipse, defying logic and subsequent science, by which such statements express the wisdom and insight of adepts.

Mayerne mentions Cooper as though the young man caught his attention as something more than a studio hand grinding colours and passing on the recipe. If Cooper were talking to Mayerne, one of the most advanced practical chemists in Europe, as in any way an expert in such a closely related discipline, it suggests that he had been a fairly deep student of the subject and that he had a grasp of the philosophical structures by virtue of which painters and physicians could be conscious of their common interests. He might, while travelling, have spent some time at one of the European universities like Padua or Montpellier where experimentalism

within the traditional synoptic approach to knowledge was encouraged. If that is right, it contributes significantly to the notion of Cooper as an intellectual, engaged in the business of limning as an activity at the leading edge of human culture.

It may be right to mention here Cooper's portrait of Sir Samuel Morland (col. pl. 22e) which, though it dates from about 1660, is further evidence of his contact with the advanced experimentalist and mechanistic philosophers of the period. Intellectually Morland was a paradigm of the historically conscious Protestant natural philosopher. He first came to prominence in 1658 as the historian of the Waldensian 'heretics' of southern France and Piedmont, whose persecution by the Savoyards in 1655 became a focus of Protestant-evangelical solidarity throughout Europe and occasioned Milton's noble verse 'Avenge, O Lord, thy slaughtered saints'. As a natural philosopher, Morland's special expertise was in hydraulics and acoustics, the fields par excellence of the de Caus Bohemia–Heidelberg connection,[57] but developed by him as theoretical exercises leading to practical human benefits rather than as magical wonders. He is credited with fundamental work in the theory and construction of pumps and water engines, in the development of drum capstans for weighing anchor at sea, of the speaking trumpet and of the arithmetical calculating machine. He was a cryptographer, an architect of military fortifications, and was certainly one of the metropolitan–court élite whose distinctive intellectual interests defined the centre of English culture through the period. Cooper's contact with men like Mayerne and Morland was absolutely of a piece with his friendship with Thomas Hobbes. Cooper's sketch portrait of Hobbes[58] was of course very different in terms of finish and presentation from the Morland: it relates in its stylistic iconography to Flatman's development of unadorned graphic frankness as the proper medium – the Royal Society style – for members of this set.[59] Cooper must therefore have been conscious of its intellectual rationale, and he clearly had one foot in the overtly scientific part of the Royal Society culture, but his use of the sketch style arose and was primarily deployed in the depiction of a different branch of the élite.

After 1642 Cooper's oeuvre presents few problems; from this time 'there is a year-by-year tale of signed and dated miniatures, showing the artist in the full stride of a career which did not falter till his death in 1672'.[60] At the year 1653 there was a change in signature. The early type had the initials separate – *S:C*, with or without a date; the post-1653 type had the initials entwined, again with or without a date. It was exceptional for Cooper to add other information to the face of the miniature – the absence of inscriptions was part of the naturalistic reaction to the Hilliard tradition in the 1620s – but there were instances well on in Cooper's career, as for example in the *Sir William Palmer* of 1657 (col. pl. 22d) where the sitter's age 'Aet.52' was added.

This miniature incidentally is one of the very finest of Cooper's works in the chiaroscuro style, possibly due to an influence from Rembrandt.[61] In the context of the London limners its affiliations

are with the sad-coloured style of the 1640s. With its plain brown background and extreme noble severity of treatment, it is one of the high points of Commonwealth portraiture, a far more appropriate example of the judaizing iconography of the puritan gentry in arms than the *General Ireton*[62] much reproduced but of doubtful authenticity. Among the finished miniatures of the 1650s, the *Palmer* contrasts with the smaller portraits, bright and jewel-like, which show Cooper responding to the contrasting aesthetic of the Petitot enamel. The *Elizabeth Claypole* (col. pl. 22c) of this type provides a rich insight into the extent to which the Cromwell family assimilated their manners to those of the European courts,[63] and it is ironic that one of the very few reasonably certain likenesses of a Cromwell lady is more clearly influenced by Jean Petitot than any other work of Cooper. This portrait was originally framed in one of the gold and enamel jewels particularly associated with the courtly rituals of exchange. It is of a type probably made in the Netherlands, and which occurs on many of Alexander Cooper's Amsterdam or Hague miniatures of the period. The *Elizabeth Claypole* may similarly once have formed part of a chain, and in that form its stylistic links with the continental court miniature would have been emphatic.

A complete contrast is the famous *Oliver Cromwell* of the early 1650s. Legends of Cooper's virtuosity and the high value placed on his work have significantly clustered around this miniature. It is unfinished, and was indeed a sketch intended as the basis of versions produced to order for diplomatic gifts and other reasons of state, certainly not in itself as an object of exchange. The extent to which attention focussed on this particular work as opposed to any of the finished products from it (which were probably jettisoned rapidly by their owners after 1660) shows the great importance that the Cromwells and their descendants, the connoisseurs and the early historians placed on the fact of its originality. Cooper produced work like this, or like the series of sketches in the Royal Collection, in a style that emphasized their immediacy: his drawing and his use of wash are dashing and boldly direct in the way calculated to evoke the moment of creation. The work raises to a higher power the concept of authenticity realized in its normal form in Cooper's finished work. In crude cash, Vertue was told, the *Cromwell* fetched £100 at a time when a standard finished miniature by Cooper cost £20–30. The point was not that there was a special premium attached to the name of Cromwell, because we know from the Terriesi papers that the starting price for the sketches left by Cooper to his wife was £100. The point was that Cooper and seventeenth-century connoisseurship were elevating the sketch to a special status. They were attributing to it a kind of authenticity that came from its qualities of speed, instinctive comprehension and lack of labour or afterthought. They recognized its special power to epitomize the relationship between artist and sitter as achieved not over the conventional span of sittings, but in the flash of mutual regard between men of genius, all that was essentially necessary for illumination, and all that was necessary between

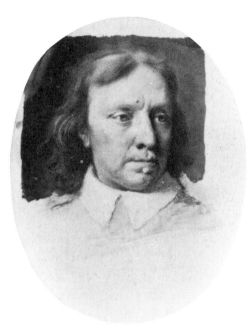

122. Samuel Cooper, *Oliver Cromwell*, c. 1653, 80 × 64 mm. Duke of Buccleuch.

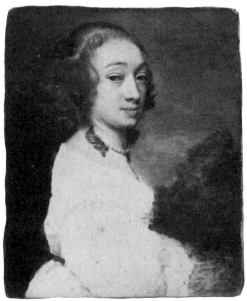

123. Samuel Cooper, *Christiana Cooper*, c. 1645, 91 × 75 mm. Welbeck Abbey.

intimates. Cooper, we may note, left unfinished the portrait of his own wife, painted perhaps about 1650, which clearly develops its affective power from its loose informality, an interesting departure from the long-established tradition of the miniature symbolizing in its finish and small scale the intimate relations between lovers. The importance for this trend in aesthetics of van Dyck's *Iconographia* has already been mentioned: ironically, some of Cooper's heads shared the fate of the *Iconographia* plates, being 'finished' by inferior hands not initiated in the judgment of the connoisseurs.

For most of the main sixteenth and seventeenth-century miniaturists there seems to have been a correspondence with a full-scale painter – thus Hilliard and Gower, Oliver and Gheeraerts, Hoskins and van Dyck, Gibson and Lely, Cross and Wissing. Cooper seems to have been exceptionally independent. In the main body of his work there are no copies. The only portrait that corresponds closely with a full-scale painting is the *Cromwell*, and in that case it seems certain that the Lely image follows the Cooper. There are other instances of the painter following the miniaturist – Oliver Millar once suggested that the portrait by van Dyck or his school of the fourth Earl of Dorset at Knole was after the Hoskins, and certainly the posthumous *Prince Henry* by van Dyck follows the Isaac Oliver at Windsor – but the former of these is dubious and the latter dependent on very special circumstances.[64] The *Cromwell* is the more outstanding, and it emphasizes the character of the Cooper oeuvre as above all *ad vivum*, original and, in the sense that Cooper and his contemporaries were amongst the first to establish in English usage, authentic.

Cooper responded to the Restoration with an enriched style – the flesh painting more full bodied, a subtle blending of the sanguine with a stronger admixture of white on the carnation ground as in the *Morland* (col. pl. 22e). It is a very beautiful style, and when combined with the austere dignity of composition worked out for the Commonwealth sitters, it constitutes Cooper's main initial contribution to the iconography of the Restoration court. At its best it emerges in the portrait of Barbara Villiers,[65] the so-called *Penelope Compton* or in the smaller *Unknown Woman*,[66] in which the low viewpoint and the brightly lit figure against a relatively dark background enforce a sense of continuity with the portraiture of the Interregnum. The portrait of the Duke of York (col. pl. 25a) is similar in pose and the flesh painting is as richly blended, but the effect is less austere: the relief of the features is less marked in a lighting scheme that is less emphatically directional. The use of a sky background also has the important effect of lightening the whole surface of the miniature and making it more colourful, while it maintains the dignity of the sitter, as in the work of the younger Hoskins, by creating space behind. The high point of enrichment, both in the flesh painting and in the costume, is appropriately the portrait of the king of 1665,[67] but the impulse is clearly evident in portraits of the Earl of Romney,[68] of the Duchess of Richmond in men's clothes[69] and of Shaftesbury (col. pl. 23a). Ineluctably the visual emphasis is shifted in these portraits

124. Samuel Cooper, *A Woman, said to be Penelope Compton, Lady Nicholas, c.* 1661, 89 × 70 mm. Duke of Buccleuch.

125. Samuel Cooper, *Henry Sidney, Earl of Romney,* 1669, 82 × 65 mm. Welbeck Abbey.

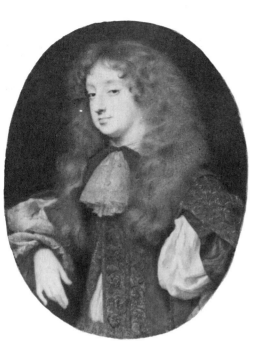

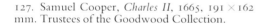

126. Samuel Cooper, *Frances Teresa Stuart, Duchess of Richmond, in Men's Clothes*, 1666, 99 × 73 mm. Royal Collection.

127. Samuel Cooper, *Charles II*, 1665, 191 × 162 mm. Trustees of the Goodwood Collection.

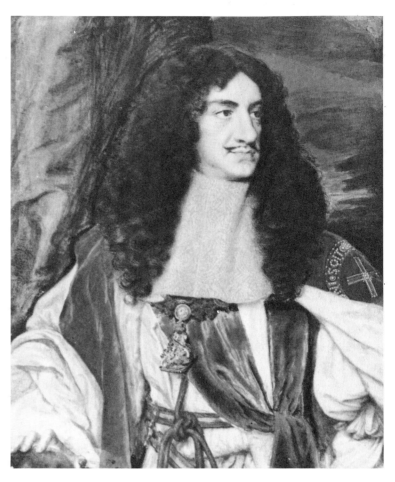

from the individuality of the sitter to his ethos: the spectator is prompted to look at the *vanitas* rather than at the talents for which the puritan sitter must answer to his maker.

At most this was a marginal effect in terms of actual iconography, and it is probably true that such a reading of Cooper's images of courtiers depends greatly on extraneous knowledge of their identity. Many of the portraits exist as multiples, and it is clear that there was a demand for them beyond the immediate circle of the sitter. The traditional function of the miniature in the court culture, as part of the programme of self-presentation and imposition of a uniform ethos, was thus being re-established in the Restoration, and mediated by men like Sanderson to the wider professional élite. The images of Barbara Villiers and Frances Stuart proposed a type and standard of beauty that compelled emulation, and the portraits of Clifford or Lauderdale[70] activated exactly that sense of longing to belong always aroused by images of prosperity and success. Pepys articulated this emulative loyal instinct when he looked over Cooper's portraits of the Beauties, Cabalists[71] and other high functionaries of the regime, and decided he would have a portrait of his wife. Portraiture was a badge of membership amongst the wordly elect.

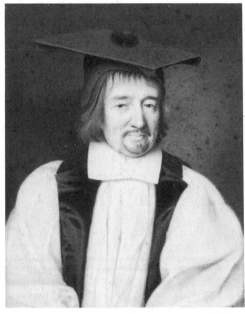

129. Samuel Cooper, *Gilbert Sheldon, Archbishop of Canterbury*, 1667, 111 × 86 mm. Welbeck Abbey.

128. (left) Samuel Cooper, *Charles II*, 1665, 165 × 134 mm. Mauritshuis.

It is among the finished images of this courtly type, including for sufficient reasons the Cromwell repetitions, that a question of copies and studio assistance can come up in the Cooper oeuvre. It is not a question of great importance, but difficult examples occur: the Chequers and the Evans versions of the *Elizabeth Claypole* (col. pl. 22c) are both autograph, and the versions of the 1665 *Charles II* at Goodwood and in the Mauritshuis, or the versions of the *Gilbert Sheldon* at Welbeck and in Baltimore, are like enough for it to be difficult to be sure that Cooper did not himself do all the work. Yet, when they are directly compared, there is a difference in quality. In the case of the *Gilbert Sheldon*, it coincides with the signature: the Baltimore version, which is the finer, is fully signed and dated whereas the inferior Welbeck is not. With the *Charles II*, discrimination is harder because both versions are signed and dated; it is only when seen together that the vigour and directness of the Goodwood version emerges and establishes it presumptively as primary. The moral, as upheld elsewhere, is that Cooper was an *ad vivum* artist. Whether he or an assistant made the copy, the prime version is detectably better because it was made in the presence of the sitter. Cooper evidently needed this stimulus to produce his strongest and most incisive work.

COLOUR PLATE 21 (following page)

David des Granges, *The Marchese del Vasto and his Wife, after Titian*, 1640, 125 × 127 mm. Ham House 394.

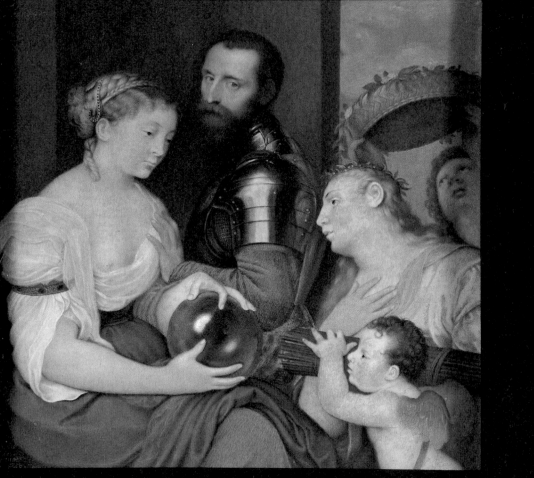

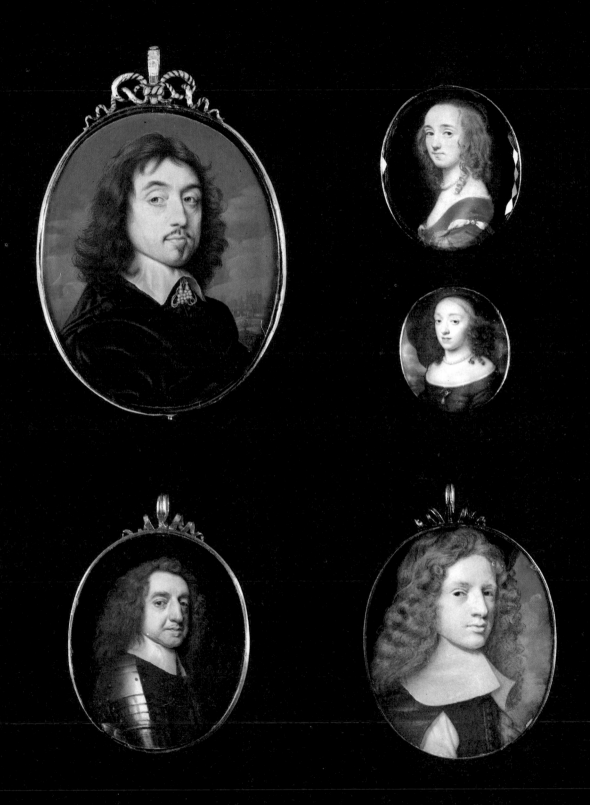

COLOUR PLATE 22 (preceding page)

a. (top left) John Hoskins the younger, *Sir John Wildman*, 1647, 76 × 62 mm. V&A P2–1962.

Samuel Cooper

b. (top right) *Unknown Woman*, c. 1650, 42 × 35 mm. V&A Evans 11.
c. (middle right) *Mrs Elizabeth Claypole*, c. 1653, 32 × 28 mm. V&A Evans 9.
d. (bottom left) *Sir William Palmer*, 1657, 57 × 45 mm. V&A P3–1956.
e. (bottom right) *Sir Samuel Morland*, c. 1660, 60 × 48 mm. V&A 481–1903.

As with the 1665 *Charles II* in its more mechanical repetitions, or with the *Cromwell*, when the type emanates from an original sketch, it is the sketch that bears the virtues of direct contact between the artist and the sitter. Thus, the *Charles II* at Chiddingstone Castle was the most potent of the series that depended on it, the finished piece at Welbeck, a similar one at Woburn Abbey, another in the Wallace Collection, down to the version signed *WP* in the Victoria and Albert Museum.[72] It was this principle in his work which became suddenly very obvious when the sketches left in his studio after Cooper's death became known. The echoes of the excitement and competition, gradually diminishing as Christiana Cooper overplayed her market position in the next ten years or so, were evident in the attempts of the king and of Cosimo III of Tuscany to secure examples of the sketches.

The episode is well known since the publication of the correspondence between Cosimo and his London agent Terriesi.[73] Two points are worth clarification and emphasis. Charles II was perennially short of money; two years after the Treaty of Dover he should have been cautious of admitting people to his payroll, especially prosperous widows of household officers at the full rate of salary when a successor was already appointed. In Christiana Cooper's case, it seems her pension was tied to a deal whereby she handed over 'several pictures or pieces of limning of a very considerable value, which are agreed to be delivered into our hands for our own use'. According to the later Terriesi correspondence the basic asking price for the miniatures left by Cooper was £100 for the best. The deal therefore looks as though it was effectively a way of delaying payment, paying by instalment for something that Charles wanted very much but could not afford outright. The valuation at £100 was between three and five times the going rate for portraits in Cooper's own life. When an artist dies it is normal for the price of his remaining work initially to rise: in Cooper's case the rise was exceptional by any standards and it suggests that the market was taken unawares by the desirability of the objects suddenly on offer. Evidently the ambiguous pension/sale deal between Christiana Cooper and the king did not quite come off – neither was the pension paid nor were the goods handed over – or perhaps both parts of the deal were partially and tardily performed. The upshot was that the Crown, either Charles or James II, acquired at least five and probably more of the sketches, and they became part of the Royal Collection.

The other point is the extent to which the king, or more particularly Cosimo, focussed on aspects of the limnings, their 'unfinished' state, the sitters represented and their certain authorship by Cooper, by which they recognized the special status. Thus Terriesi wrote to the Grand Duke in July 1674 telling him that the miniatures left by Cooper were mostly unfinished, and offering him the chance instead to buy a *Lady Cavendish* for £16 and a *Duke of Richmond* in a gold Box for £40. Cosimo agreed to these but remembered being struck when in Cooper's house by three-quarter length unfinished portraits of the Duchess of Richmond

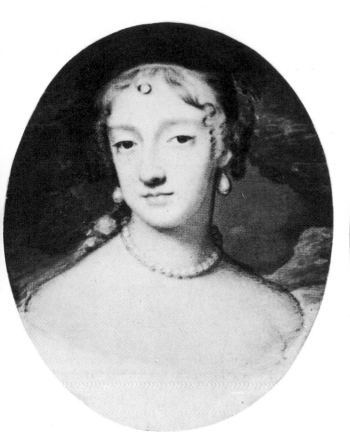
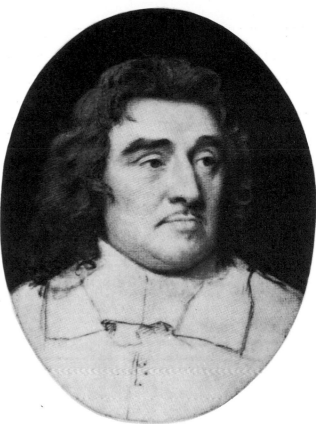

and of General Monck 'well executed with much spirit, and charm'. Nearly two years later, in February 1676/7, Cosimo had had precise information about the portraits available, their relative sizes and the extent to which they were finished. He knew that the heads were complete and that the draperies were merely sketched. He again pressed Terriesi about them, specifying the *Duchess of Richmond* and the *General Monck* again, but adding the *Duke of Monmouth* and the *Duchess of Cleveland*. The prices, still nominally £100, had come down: £50 for the first three and £30 for the *Duchess of Cleveland*. They were still, however, too high in Cosimo's view for 'unfinished' portraits, but none the less the *General Monck*, 'if the head is well finished' and not merely sketched, should be bought. Terriesi at this point heard the rumour that some of the portraits had been 'finished' by one of Cooper's pupils, and Cosimo took fright, instructing his agent to look elsewhere for indubitable works. By February 1679 he had heard that there were portraits by Cooper already in the Royal Collection in London – so perhaps the deal between Charles and Christiana Cooper had born some fruit by this time – and was anxious for details of them. It was four years, however, before Terriesi was finally able to see the works on offer and to send a list of them to his principal, and by this time it was clear that both of them were becoming disillusioned. From the list finally sent it seems clear that the best big pieces, with the vividly finished heads, including the *General Monck* and the *Duchess of Richmond*,

130. Samuel Cooper, *Frances Teresa Stuart, Duchess of Richmond, c.* 1663, 124 × 99 mm. Royal Collection.

131. Samuel Cooper, *George Monck, Duke of Albemarle, c.* 1663, 124 × 99 mm. Royal Collection.

COLOUR PLATE 23 (following page)

Samuel Cooper

a. (top left) *A Man, perhaps Anthony Ashley Cooper, second Earl of Shaftesbury, c.* 1665–70, 84 × 66 mm. V&A P66–1968.
b. (top right) *Henrietta Duchess of Orleans, c.* 1661, 72 × 55 mm. V&A P110–1910.
c. (bottom) *Unknown Woman, c.* 1660–5, 96 × 70 mm. V&A 448–1892.

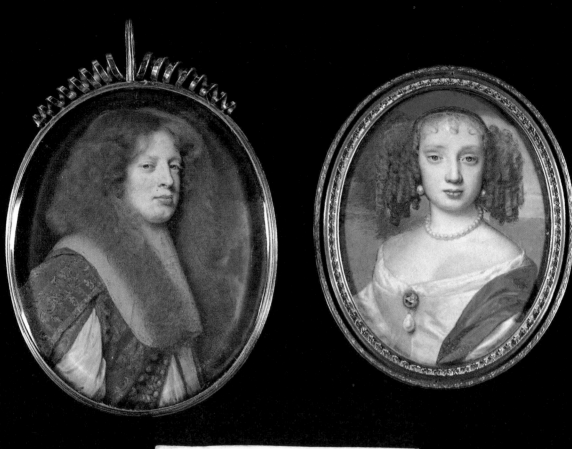

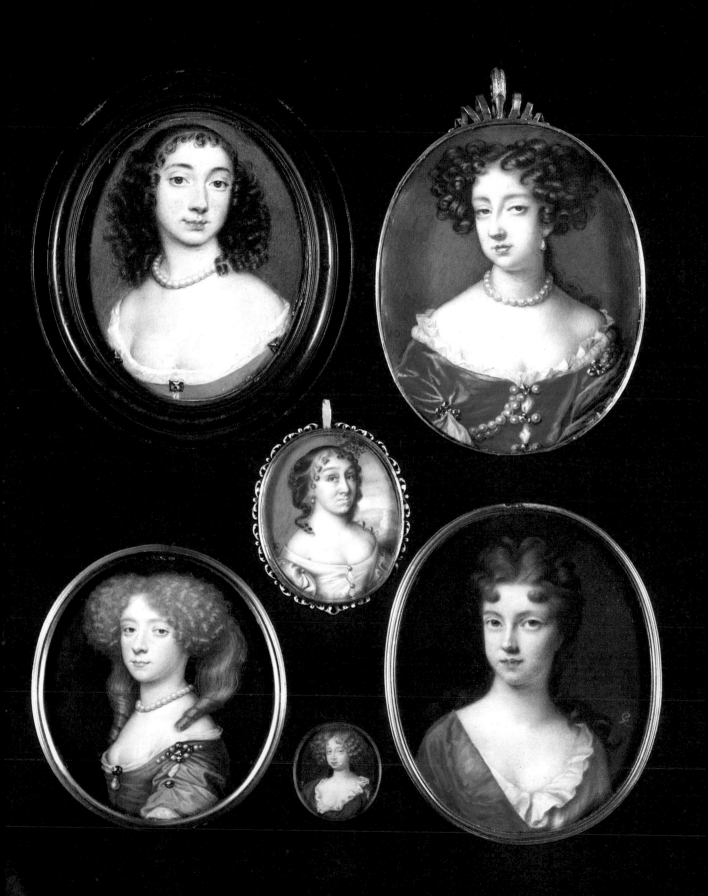

Cosimo's original desiderata, had gone. Negotiations dragged on until the end of 1683 and then lapsed.

From this we can derive the following inferences: that Cosimo was particularly interested in the 'unfinished' portraits that he had himself seen and knew to be vividly realized in the heads; that it mattered to him who the sitters were at least to the extent that they should not be anonymous – vividly realized identity being of the essence; that the portraits had to be by the master himself, with no gratuitous 'finishing' by pupils. In other words the special status of the sketches, as being the very documents of Cooper's contact with his eminent sitters, the brilliant created outcome of a personal encounter, and a fruition of the artist's genius, was what constituted their value. Cosimo was not interested in merely unfinished work or in small sketches: he was deploying at unfortunately long range the discriminating preference of the connoisseur for what was evidently the best work of Cooper's last years. The sketches indubitably to the eye of the connoisseur established whole new standards of primacy and authenticity in limning and had the effect in the 1670s as now of relegating any derivative piece, whether from Cooper's hand or from that of an assistant, to a lower standing. They were, finally, Cooper's most brilliant achievement, his most inventive and surprising contribution to the national iconography.

ALEXANDER COOPER (?1609–?1660)

The surviving certain works of Alexander Cooper do not add up to a very impressive oeuvre. In black and white photographs one of the peculiar excellencies of Alexander Cooper's work – his colour – is suppressed, and only the minor charm emerges. There is apparently nothing of the dynamism and vigour of baroque portrait design, and in comparison with his brother Samuel, Alexander Cooper seems surprisingly timid and conservative.

It is hard to be confident in any judgment, since the oeuvre itself (as well as access to it) is very uncertain. Beyond the corpus of work attested by the *AC* signature, the grounds of attribution are questionable. Graham Reynolds proposed that there were two styles, fine and broad, that ran parallel throughout Cooper's career, and it may indeed be wise to accept such an inclusive criterion.[74] Yet the practice has grown up in recent years of attributing with apparent certainty a fairly wide variety of work which appears to have in common only a certain brightness of colour and a tendency to push the figure back from the edges of the oval. There is through these works admittedly a strain of similarity, and a demonstrable connection in both characteristics with the signed work of Alexander Cooper, but nowhere has the underlying stylistic analysis been publicly set out, and, above all, nowhere has the major question of overlap between the work of Alexander Cooper and the late work of Peter Oliver even been approached. The time to consider the

problem may not yet be ripe – we need more circumstantial information about both Cooper's and Oliver's lives and about their patrons on the continent – but the similarity of style and common connection with the circle of Elizabeth of Bohemia should be borne in mind by anyone concerned with Alexander Cooper or the continental miniatures of *c.* 1630–45.

Cooper is thought to have been in Holland in about 1631,[75] working on the portraiture of Elizabeth of Bohemia, a connection to which he was presumably introduced by Peter Oliver, in whose studio he had learned the limner's art. The evidence for this stay in Holland is the date 1631 engraved on the back of the signed portraits of Elizabeth and Frederick of Bohemia after Honthorst and of their adherent the Earl of Craven.[76] The dates 1632–3 are similarly engraved on the backs of the nine miniatures of members of the Bohemian royal family that were preserved in the Kaiser Friedrich Museum, a relic presumably of diplomatic intercourse between Frederick and Elizabeth, still hoping for restitution to the Calvinist Palatinate, and the rising power of Calvinist Branden-burg, a potential but reluctant supporter of the Protestant Union. The later 1630s are obscure. Sandrart's account places Cooper in Amsterdam on a visit in 1642, when he showed Sandrart portraits of 'very many' of the leaders of the English court.[77] Sandrart's statement is usually taken to suggest that Cooper was back in England during the 1630s or early 1640s, but this is clearly not a necessary inference. Other portraits of the period, perhaps by virtue of the theory that Cooper worked in London in the 1630s, have picked up identifications as English sitters – the Duke of Hamilton, the Earl of Bristol (col. pl. 15c) and the Earl of Car-narvon[78] – but these miniatures are all in one way or another highly dubious and offer no support to any theory. By the time Sandrart was writing, the distinction between the Palatine exiles and the unfortunate Stuarts may have seemed rather remote, and his phrase 'Aulae Anglicanae' could certainly indicate the group of English Bohemians who constituted a real court, albeit in exile, rather than the London court, recently mobilized for war. No portraits of Charles I's courtiers as such survive, whereas those like the *Charles Louis* (col. pl. 15e) and the *Earl of Craven*[79] could well represent the group referred to by Sandrart.

The evidence from the miniatures seems to be that Cooper enjoyed a more or less uninterrupted European patronage in the 1630s. The *William Count of Nassau*, which derives from an ori-ginal by Mierevelt, follows on from the group of Dutch minia-

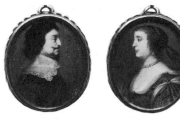

132–3. Alexander Cooper, *Frederick V and Eliza-beth of Bohemia*, *c.* 1632, each about 24 × 20 mm. Countess of Craven.

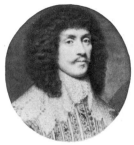

134. Alexander Cooper, *William Craven, Earl of Craven*, *c.* 1632, 37 × 33 mm. Countess of Craven.

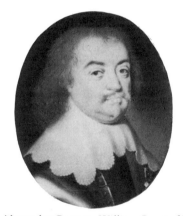

135. Alexander Cooper, *William Count of Nassau*, *c.* 1640, 52 × 41 mm. V&A P35–1933.

136. Alexander Cooper, Chain of portraits of members of the Bohemian royal family. Perhaps Bode Museum, East Berlin.

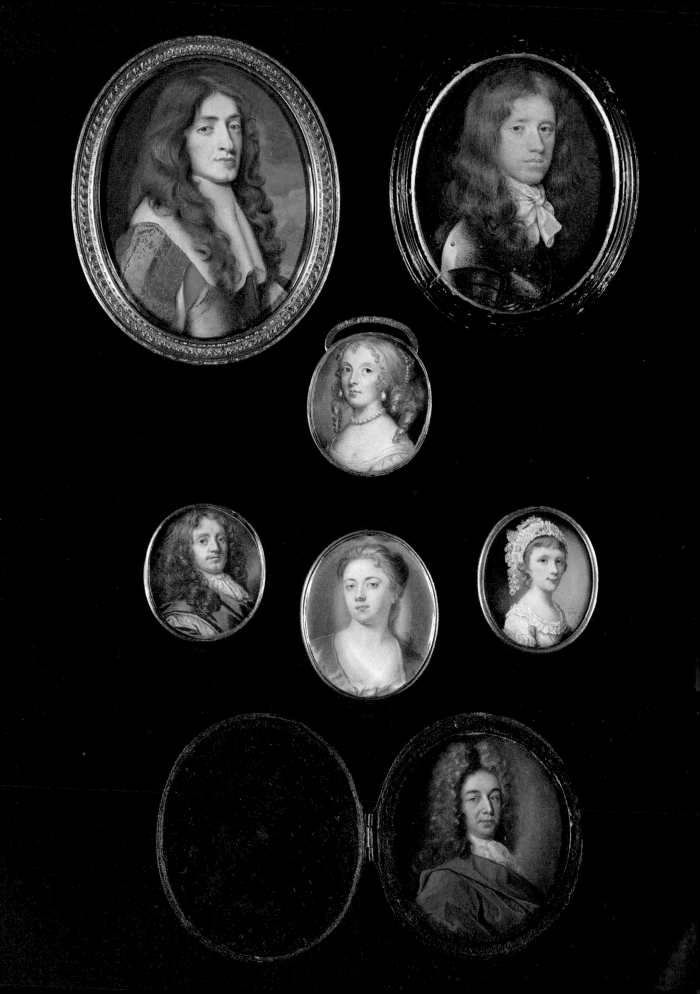

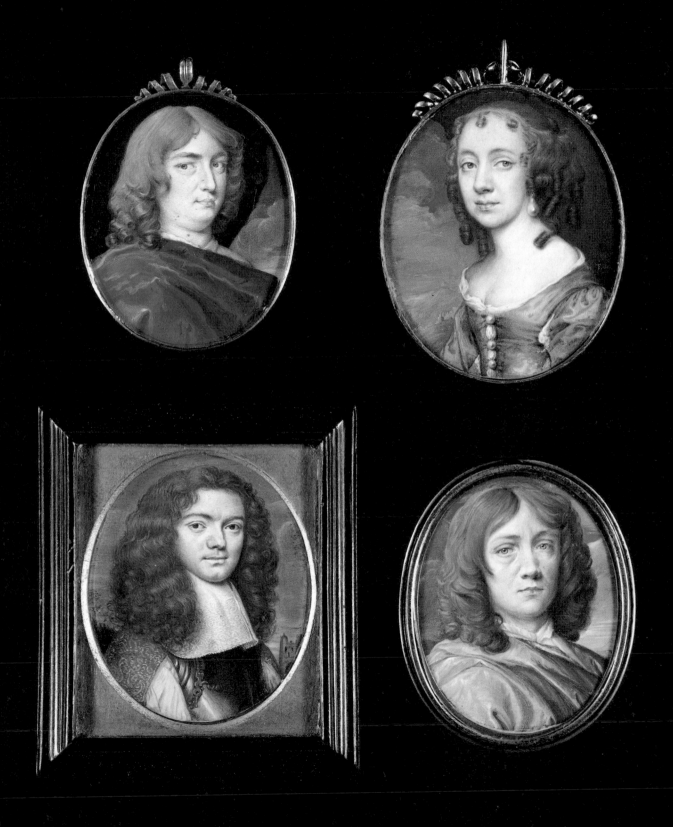

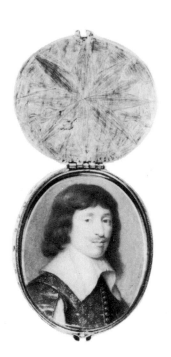

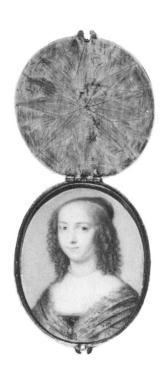

137–9. Alexander Cooper, Enamel locket containing *Unknown Man and Woman*, *c*. 1645, about 40 × 33 mm. Sotheby's, 5 July 1976, lot 13.

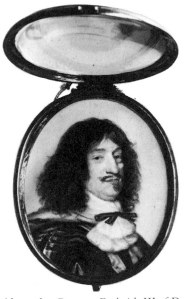

140. Alexander Cooper, *Frederick III of Denmark*, 1656, about 51 × 38 mm. Rosenborg Castle.

tures still in the collection of the Queen of the Netherlands and, as a copy, is analogous to the sort of work the English miniaturists were having to do at the same time. As other miniatures turn up and are attributed plausibly to Alexander Cooper, his commitment to the Netherlands seems to be confirmed. The beautiful double enamel locket containing portraits of an unknown man and woman, initialled in cypher *LvA*, must be Dutch and must date from the mid-1640s – the time in fact when Prince Frederick Henry of Orange ordered that he be paid 100 florins for a commissioned picture. Houbraken states that after living in Amsterdam for some years he went to Sweden, and was in residence in Stockholm by 31 May 1647 as official limner to Queen Christina, and from 1654 to Charles X.[80] His salary of 1200 daler was unreliable, as was usually the case with royal pensions and retainers in seventeenth-century Europe, and in 1653/4 he was urgently petitioning for payment of long arrears. In 1655 or 1656 he managed to supplement his earnings with a commission from the King of Denmark, and six miniatures of members of the Danish royal house accordingly survive at Rosenborg Castle. Their enamel lockets are dated 1656 and they constitute the last material or documentary evidence that we have of Cooper. He is said, believably but without evidence, to have died in Stockholm in 1660.[81]

He is also said to have been a friend of Descartes, a relationship which, resting on the near-contemporary record of John Aubrey,[82] seems quite credible. It is consistent with their common residence in The Hague, their contact with Elizabeth of Bohemia, and later on their common employment by Queen Christina of Sweden. If Cooper did know Descartes, as his brother knew Hobbes, it places him as securely in close association with the specifically intellectual and philosophical aspects of the Bohemian saga, at the point of the change-over from the animistic to the

mechanistic world view within the culture that the limners thrived in and helped to form.

Cooper's oeuvre, as can be deduced from this account, should have been very distinguished indeed. A graduate, as it were, of the school of Oliver in London, he seems to have taken up the particular connection between the Olivers and the Anne of Denmark–Elizabeth of Bohemia continuity, and to have become virtually the representative of the English limning tradition in the courts of Northern Europe that made up the Protestant anti-Hapsburg alliances. We have seen how the miniature itself had a specific cultural and political significance as the typical art of the legitimate Protestant monarchy in England, and there was Alexander Cooper carrying its practice into exactly those states whose political, religious and intellectual character disposed them to accept and understand it.

There is, however, one problem with this hypothesis of Cooper's consistent attachment to the opponents of the Hapsburg empire. It has been suggested that the portrait (col. pl. 19c), previously unidentified, contained in a divided 'mule' thaler could be of Ferdinand III, who succeeded his father as Holy Roman Emperor in 1637.[83] The case for this identification rests purely on a resemblance between the portrait and the images of Ferdinand III on his coinage; as such it has force but is not proved. Against it is the lack of any evidence that Cooper worked in Vienna, or for any other patron on the side of the Imperialists in the Thirty Years' War. The portrait, if it were of Ferdinand, would be by itself, an anomaly in a career that otherwise has a rational and intelligible outline.

The portrait is very beautiful and is in some ways the most serious and humane study of a mature sitter that survives from Alexander Cooper's hand. From the portraiture I personally find the face as compatible with that of Frederick III of Denmark as with that of the emperor, and the whole presentation of the image, with its blue background, in tune with the prevailing northern court style of Wuchters and van Mander. The circular format was archaic – or more probably archaizing – by *c.* 1640,[84] but its precise iconographic significance, perhaps suggestive of the complex of ideas around circularity, oneness, the sun and kingship, is lost along with what must have been its original setting. The miniature, which has an uncut gold margin, was certainly designed as a round, but was probably intended to be set in a golden jewel rather than in silver. The fact that the miniature is scratched and rubbed also suggests that it has spent some part of its history out of a protective setting, the gold presumably, as so often with court miniatures, having been melted down. Coin settings are not uncommon on seventeenth-century miniatures, so the present mule mount could have been substituted within a generation or two of the date of the portrait, the double headed coin being used as a rarity specially suitable for a cabinet miniature. In that case, the fact that the two heads were of important Protestant princes may have been significant. John George I of Saxony had been the ally of Gustavus

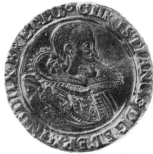

141. John George of Saxony and Christian of Brunswick from a double-headed ('mule') thaler, hollowed and threaded to form a box for colour plate 19c.

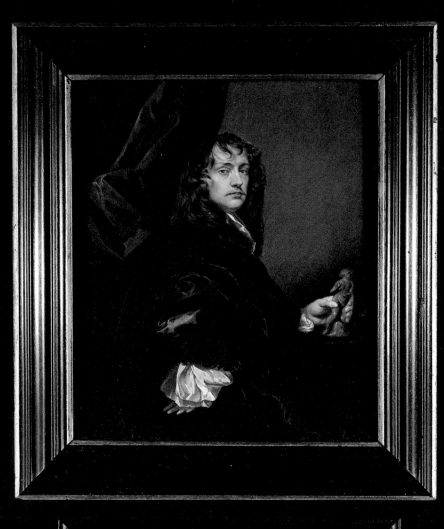

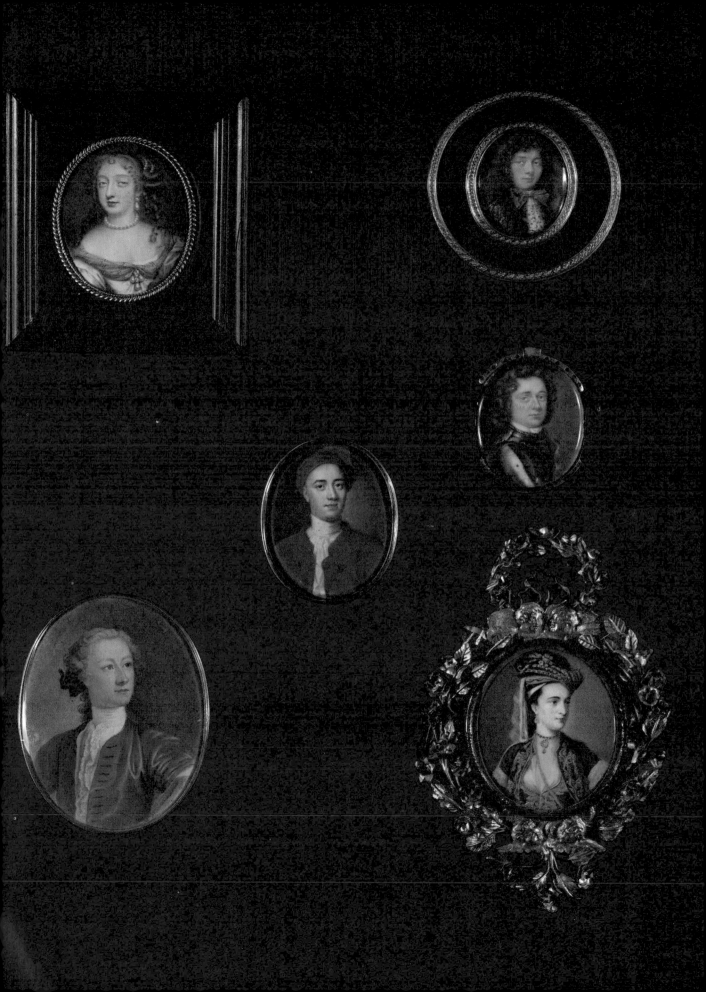

COLOUR PLATE 28 (preceding page)

a. (top left) Jean Petitot, *Frances Teresa Stuart, Duchess of Richmond*, 1669, 43 × 34 mm. V&A P64–1924.

b. (top right) Jean Petitot the younger, *Self-Portrait*, 1679, 31 × 27 mm. V&A P52–1941.

c. (middle left) Christian Zincke, *Charles Fitzroy, second Duke of Grafton*, *c.* 1706–10, 46 × 37 mm. V&A Evans 320.

d. (middle right) Charles Boit, *Unknown Man*, *c.* 1690–1700, 36 × 31 mm. V&A P33–1926.

e. (bottom left) William Prewett, *Mr Newsham*, 1736, 67 × 54 mm. V&A P4–1946.

f. (bottom right) Gervase Spencer, *A Woman in Turkish Costume*, 1755, 48 × 41 mm. V&A P4–1943.

Adolphus, a moderating Lutheran who swung against the Swedes and the French to preserve the balance of power after Gustavus Adolphus's death. Christian of Brunswick, 'the mad Halberstadter', was a chivalrous champion of Protestantism in the dark days following the Bohemian catastrophe. He wore the glove of his cousin Elizabeth of Bohemia in his hat, and went to war in alliance with Christian IV of Denmark swearing to restore her to the Palatinate.[85] If there was any political point to the mule it may have recalled the ambiguities of the Danish position as a Lutheran power with interests in the empire, but traditionally hostile to Swedish expansionism.

The archaizing format of the *Unknown Man,* and its clear stylistic relationship in the dark stipple of the hair lines to Peter Oliver, represented in these circles a politically acceptable language of portraiture. Its probable original setting would also have emphasized the status of the miniature within the craft tradition, historically related to the technical and metallurgical expertise of the goldsmiths. Mobilizing traditions of this sort was one of the springs of progress in the politico-cultural environment that the limners lived in; in Alexander Cooper's Europe his craft and expertise brought him close to the new Geneva and Paris-based technology of the enamel, and he responded accordingly. The English miniature on the continent thus made a loop in about 1630 away from the mainstream metropolitan development of the art, before converging on it again in the early 1650s.

What happened was that the London school of limners moved strongly in the second quarter of the century away from the craft tradition of their art, away from the interpretation of the miniature as an iconic emblem enclosed in a jewelled setting. With the portrait painters in large they developed a more naturalistic baroque iconography, and their techniques evolved away from the most specialized skills of the jeweller/limner and became much closer to those of the painter and graphic artist. They adopted, as in the works of Samuel Cooper and the Hoskinses, backgrounds of curtain, column, sky or landscape against which the sitter appeared as it were in life, implicitly mobile, a character of energy with the dignity of self-confidence and achievement. Alexander Cooper on the other hand, leaving England before the full impact of the van Dyckian baroque, and the most direct inheritor from Peter Oliver of the older tradition, came to maturity in the continental school which was affirming and developing the values of miniature portraiture as jewellery. The whole thrust of the miniature portrait on the continent at this time was towards the condition of the enamel, small in scale, on gold and set in a precious surround, painted softly in fine stipples of bright vitreous colour. The art is typically that of Petitot, and it had all the excitement of great technological advance, high fashion and extreme prettiness. Unsurprisingly Alexander Cooper was influenced in this direction. The relatively small ovals that he used, the gentle and minute touch in the flesh painting, the plain coloured and non-naturalistic backgrounds, and the simplification of tonal values in order to achieve brightness of local

colour, emulated in effect the advanced enamel of the Franco-Swiss tradition. It was from that fresh impetus, rather than from a purely conservative attachment to his own native tradition, that the characteristic features of Cooper's style came.

Petitot (col. pl. 28a), born in 1607, and Cooper were very close in age, and it is probably wrong to impute too firmly to Petitot the originating influence, but it is surely right to see Cooper as a successful competitor alongside Petitot and Jacques Bordier, a vigorous participant in and contributor to the court art of the continent rather than as an alienated member of the English metropolitan school. It is worth noting also that the enamellists' influence was felt in much the same way in England, not only at the time of Petitot's residence in London *c*. 1637. During the 1650s Samuel Cooper offered as an option the small format and bright, softly blended surface associated with the enamel; and after 1660 the plain coloured background in blue, together with an unconventionally bright palette and small scale, reappeared in work of artists close to the court and responding to patrons whose taste had been affected by continental practice – Richard Gibson and Nicholas Dixon would come into this category. It was in works of this kind, rather than in the naïve attempts of English artisans to achieve the technical excellence of the French enamellists, that the influence of the enamel was felt in seventeenth-century England. Enamel painting in England was mainly an immigrant art with its own technical and social history, essentially separate from that of the native limning.

RICHARD GIBSON (?1605–1690)

One of the more curious muddles of orthodox art history in the last fifty years has been the appearance, and now the disappearance, of the miniaturist D. Gibson. The result has been the establishment of Richard Gibson as a prolific and interesting artist of roughly the third quarter of the seventeenth century, not one of the great oracular masters of his civilization, but none the less providing important insights into that civilization, its attitude to the arts and patronage.[86]

When miniatures with a *DG* signature, or with inscriptions referring to a 'Mr Gibsone', started appearing in the early 1930s, they were assumed to be by a new artist, perhaps the father, uncle or brother of the already well-known miniaturist Richard Gibson. The two artists were assumed to be related because their styles were indistinguishably similar, a state of affairs that became known among the cognoscenti of the sale rooms as 'the Gibson problem'. Attempts were made to construct family trees to accommodate D. Gibson, and there were attempts to establish criteria for distinguishing his style from that of Richard Gibson. As time passed, the originally tentative hypothesis of D. Gibson's existence gathered certainty and further elaboration as each new unsigned miniature

COLOUR PLATE 29 (following page)

a. (top left) Bernard Lens, *Richard Whitmore*, 1718, 76 × 63 mm. V&A P14–1971.
b. (top right) Bernard Lens, *Katherine Whitmore*, 1724, 76 × 63 mm. V&A P13–1971.
c. (bottom left) Samuel Finney, *Queen Charlotte*, *c*. 1760, 46 × 39 mm. V&A Evans 114.
d. (middle) Peter Paul Lens, *Unknown Woman*, 1744, 44 × 34 mm. V&A Evans 159.
e. (bottom centre) Thomas Redmond, *A Boy*, *c*. 1760, 38 × 31 mm. V&A Evans 194.
f. (bottom right) Andrew Benjamin Lens, *A Woman, said to be Peg Woffington*, 1744, 43 × 35 mm. V&A Evans 154.

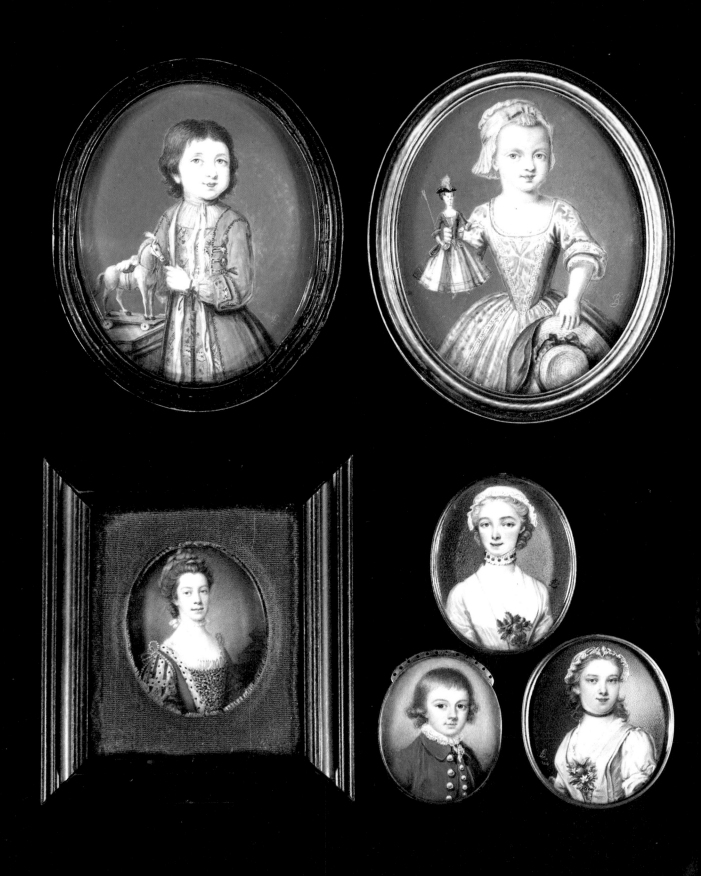

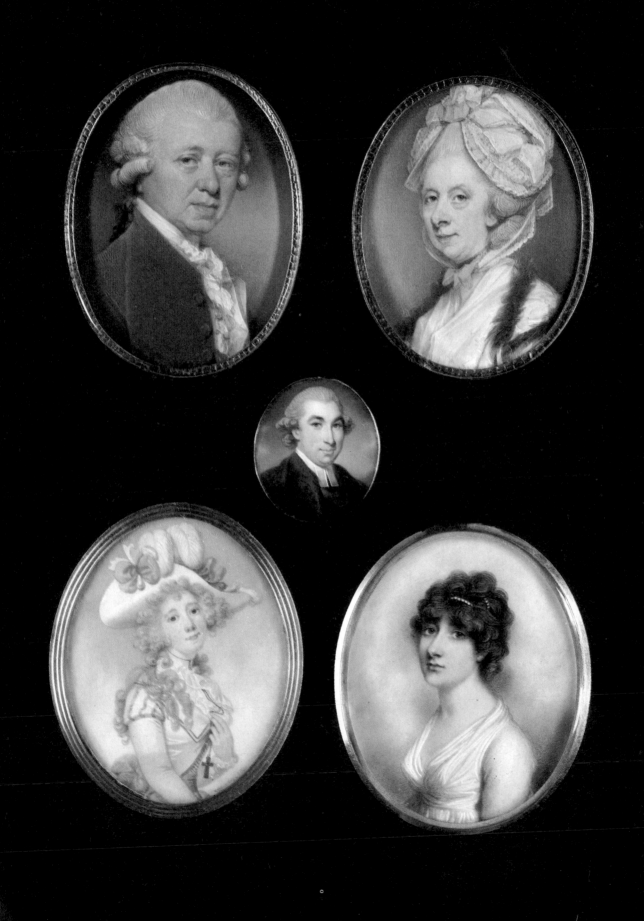

in the Gibson style appeared at auction and was attributed with apparent confidence to one or the other artist.

The abolition of D. Gibson rested on three main areas of research. The first and in a sense the easiest was the documentary: all the references in van der Doort,[87] in the Dutch royal archives,[88] in private correspondence and elsewhere, were to a single Gibson. There was no attempt to differentiate Richard from a putative rival of the same name. The references to a D. Gibson in Vertue could have seemed confusing, but in context it was usually clear that he was abbreviating the commonly used nicknames for Richard Gibson, Dick or Dwarf. The matter was clinched by the entry which transcribed the *DG* monogram and stated unmistakably 'the Mark of Dwarf Gibson as on a limning of his doing'.[89]

The second area of investigation was the miniatures themselves. Microscopic analysis of the brushwork in the signed or firmly attributable works confirmed the impressionistic judgment of connoisseurs that all the miniatures were by the same hand. In particular, the directional hatching across the face and exposed flesh of the bosom on female portraits, first distinguished by Goulding,[90] emerged as a primary characteristic of both groups. Other characteristics emerged strongly from studies under special lighting: tangential light revealed the exceptionally thick and laborious impasto of the flesh painting; ultra-violet and X-ray revealed the peculiar patterns of fluorescence and perviousness created by the unconventional choice of pigments for carnation grounds. By simply turning the miniatures over, the use of unprepared secondary supports, long after the metropolitan professionals had adopted gessoed cards, was revealed. Comparison of the handwriting on the backs of miniatures signed *DG* and inscribed with the remarkably full details of sitter, date and place, with those signed *RG* and similarly inscribed, also pointed conclusively to the artists being the same person.

The third area was the patronage. It proved possible to construct a reasonably coherent account of Richard Gibson's career that included the group of works previously attributed to D. Gibson. The so-called D. Gibsons indeed fitted with irresistible aptness into the pattern of his patronage. Thus, in the late 1630s, Gibson was attached to Philip Herbert, Earl of Pembroke, under whose aegis he, like des Granges, probably began as a miniature copyist of paintings in the Pembroke collection. He, however, unlike des Granges, learned to paint miniatures in a very dense painterly manner, a style which he may have picked up from Peter Lely, also from his earliest years in England a protégé of Pembroke, and a life-long friend of Gibson. Pembroke, as Lord Chamberlain and a member of the circle of aristocratic connoisseur collectors around the throne, introduced Gibson to the royal patronage, and Gibson accordingly worked in the limners' boom decade of the 1630s on copying paintings like the Titian *Venus and Adonis* in the Royal Collection.[91]

When Pembroke and the Noble Defectors broke with the king in 1641, Gibson stayed with his master in London rather than

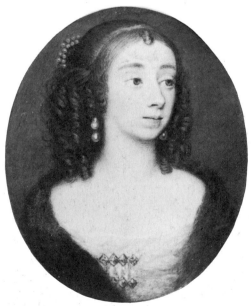

142. Richard Gibson, *Elizabeth Capell, Countess of Carnarvon*, 1657, about 80 × 68 mm. Formerly Lord Wharncliffe.

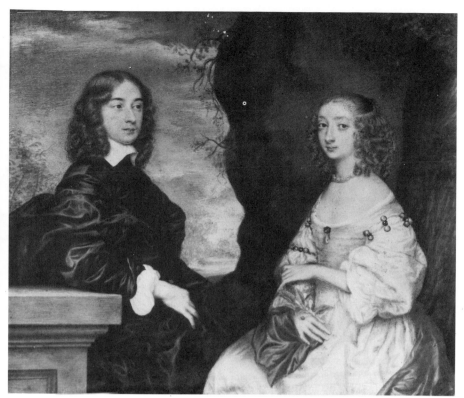

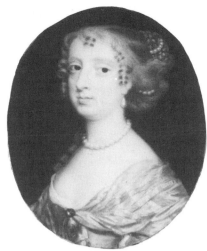

144. Richard Gibson, *Elizabeth Wriothesley, Countess of Northumberland*, c. 1662. Duke of Buccleuch.

143. (left) Richard Gibson, *Arthur Capell, Earl of Essex, and his wife Elizabeth, born Percy*, c. 1657. Duke of Buccleuch.

following the king to Oxford. What he did in the 1640s and early 1650s is obscure, but it is reasonable to assume that he was with Pembroke until the latter's death in 1649, because it was probably at about that time that Pembroke commissioned from Lely the double portrait of Richard and Anne Gibson for Wilton,[92] and set up an annuity for their future to be paid from his estate. After his death, Pembroke's role was taken over by his grandson Charles, second Earl of Carnarvon: Carnarvon became Lely's main patron in about 1650, and he presumably took on Gibson at the same time, recognizing no doubt that his talents and peculiar stature would be an ornament to Ascot as they had been to Wilton. The miniatures that Gibson painted in the Carnarvon connection form a remarkable group, stylistically uniform and describing a set of men and women linked by intermarriage and political interest.[93]

Traces of the connection are discernible perhaps in rumour and coincidence over a wide area. Sir William Portman (col. pl. 25b) was a Somersetshire magnate of the Restoration, richly connected in the City of London, a Fellow of the Royal Society, and a supporter of William of Orange in 1688 – precisely a member of the class of enlightened Anglican aristocrats who motivated the constitutional settlements after 1660. Significantly, the frame of the portrait of *Elizabeth Capell* (col. pl. 24a) has the name Henry Portman and the date 1714 inscribed on the backboard: Henry Seymour, scion of another great Somerset family, succeeded William Portman and changed his name in 1690. By inference the Portmans and Carnarvons were in contact, using miniatures as emblems of familial or political relationship. Sir Richard Anderson,[94] from a family of soldiers and lawyers, lived at Penley near Ascot and was

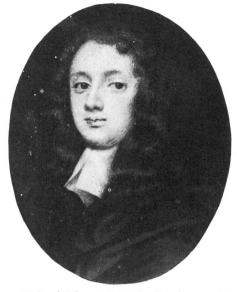

145. Richard Gibson, *Sir Richard Anderson*, 1658, about 75 × 59 mm. Formerly Captain Pearce.

presumably within the social orbit of the Carnarvons. Sir Harry Capell lived at Kew, near Mortlake, and near Ham House one of the crucial centres of the Sealed Knot organization in the late 1650s. Gibson had a connection there through Francis Cleyn, designer to the royal tapestry works and decorator of Ham. Lely too, who painted a double portrait of Gibson and Cleyn as archers, was involved in the wide connection, and drew his most regular patronage through the Interregnum from the Carnarvons, Dysarts and Tollemaches. In the nature of things, we cannot know what was happening amongst these people, their alliances and secluded activities, but their broad identity of interest as a group is reasonably clear. For them portraiture was a means of keeping in touch with family relations by keeping and exchanging likenesses. It was a means of maintaining communications and of expressing personal and political identity while filling the house, whether Wilton or Ham, with objects of aesthetic admiration.

It was in that uniquely potent combination that the richness of their culture lay. The images that Gibson invented for them were actually a fairly simple derivation from the sad-coloured portraiture of the early war years, and although he was capable of endowing his sitters with an austere dignity that must have been their aspiration both publicly and in their private lives, the imagery was incomplete without its context. It depended on the ensemble of portraits of the family, of the relations who were political friends, and of the king and queen. The iconography was thus completed in the context where the aesthetic judgment of the owner was coterminous with his political and social position, whereby the one defined the other, identified and proclaimed it. Arranged hierarchically in the appropriate rooms, as recommended by Sanderson, a family's portraiture became a compendium of its allegiances, alliances and dependencies. Microcosmically it recorded the household in its relation to the wider world.[95]

After the Restoration, Gibson's patrons came back to court and he took up the existence of a professional limner in London. There are glimpses of him pressed to attend to a commission from the first Viscount Ingram in 1664,[96] going with Lely in 1672 to call on Mary Beale and see her work,[97] and living prosperously in Long Acre.[98] He was clearly copying for the royal patronage – the Ingram reference has him copying portraits of Lady Castlemaine, and he must, on the evidence of Sanderson's reference to him as among the most eminent miniaturists of the time,[99] have been in the running to succeed Cooper as king's limner. The job he actually got was drawing master to the two daughters of the Duke of York, perhaps a disappointment to him and symptomatic of the view among the élite that he was not first rate.

Some time in the 1660s he changed his signature to *RG*, changing at the same time his persona of Dwarf Gibson or little Dick for that of the artist praised by Sanderson, the father of four grown up children, and respected participant in the artists' and intellectuals'

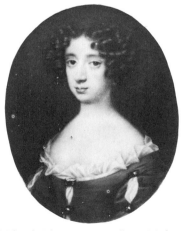

146. Richard Gibson, *Anne Villiers, Madame Bentinck, c.* 1678, 57 × 46 mm. Welbeck Abbey.

society of Covent Garden and Long Acre. The work of his later years was by no means inferior in quality. In many ways it was

more professional, lighter in handling, brighter in palette, prettier in effect (col. pl. 24d). The portraits of Anne Villiers and of Lady Frances Howard at Welbeck are fine portraits by any standards, unmistakably the work of a characterful artist capable of inventing an attractive 'look' for his clients, even if they are not much differentiated as individuals. The portrait of the Princess Mary from the later 1670s[100] is similarly a competent professional piece, reassuringly recognizable to the eye of the connoisseur then as now as the work of Gibson. Yet such portraits are nothing more than they individually seem. Gibson was not engaged with the cult of authenticity, of the documentary *ad vivum* sketch as was Cooper, or even with the high finish and high fashion of the early Dixon manner. Invention and the profound understanding of the civilization he lived in were not present in his later work. The moment, his presence in the interstices of a great aristocratic culture as it discovered itself and asserted its predominance in the life of the nation, was over.

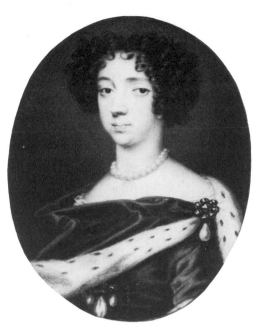

147. Richard Gibson, *Lady Frances Howard*, c. 1675, 79 × 62 mm. Welbeck Abbey,

DAVID DES GRANGES (1611–1671/2)

David des Granges's parents were Samson des Granges and Marie (born Bouvier), who were married 2 November 1609 at the French church in Threadneedle Street in London. Samson des Granges was from a family originating in Guernsey. He and his wife settled in the miniaturists' parish of St Anne Blackfriars, where just over a year later their first child David was born.[101] He was baptized both at the French church and at St Anne's on 24 March 1611. His aunt Esther, who witnessed the ceremony, was a Silkwoman to Anne of Denmark; other connections of the family, who witnessed this and subsequent baptisms, included the Scotsmen David Drummond and the king's goldsmith and jeweller George Heriot, both of whom had accompanied James to London in 1603. These Scottish connections may suggest that the family had already been established in royal employment in Edinburgh. David des Granges was married on 7 January 1635/6 at the church of St Martin-in-the-Fields. His bride was Judith Hoskins, one of the complicated Hoskins clan, a cousin presumably of the limner's household in Bedford Street, and connected thus to Samuel and Alexander Cooper. David and Judith des Granges set up house in the parish of St Martin-in-the-Fields and had several children born, baptized and buried either there or in the more recently established St Paul's Covent Garden. During the wars and Interregnum des Granges was out of London for much of his business, but he continued to live prosperously in the parish, in Elm Street by Long Acre, and was assessed for Poor Rate on and off until 1672, when it was recorded that he was 'poore' himself. There is no record of his death or burial, but since he was not mentioned in Samuel Cooper's will while other des Granges relations were, he probably died between the date of his petition to the king for money in 1671 and Cooper's death in 1672.

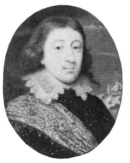

148. David des Granges, *Unknown Man*, c. 1620–30, 40 × 32 mm. V&A P5–1950.

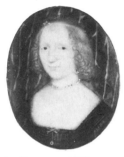

149. David des Granges, *A Woman with the initials EM*, c. 1630, 38 × 33 mm. V&A Evans 27.

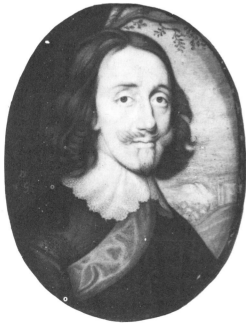

150. David des Granges, *Charles I*, c. 1635, 83 × 64 mm. National Portrait Gallery.

On this basis his career as a miniaturist seems to follow quite naturally, and the persistent notion that he was an oil painter, started by Sanderson's inclusion of him amongst the 'rare Artizans' of full-scale portraiture,[102] is implausible. Certain pictures have been attributed to him at various times, including the famous *Saltonstall Family*, the large oil on panel from Wroxton Abbey now in the Tate Gallery.[103] On costume and content it is dateable to the later 1630s, and is therefore especially difficult to accept as by des Granges. It is a curious mixture of technical assurance and structural naïveté, highly competent in the handling of opaque paint and in the development of effects over a large area, but naïve in the disrupted treatment of perspective and scale. Stylistically its associations are with the native provincial art of England in the period – John Souch's *Sir Thomas Aston*[104] is closely comparable – and by the time of the portrait des Granges had been for ten years, as we know from his engraving of *St George and the Dragon* after Raphael,[105] a practised exponent of rational renaissance composition. The existence of this print has led to the suggestion that des Granges was actually trained as an engraver,[106] and that could be right. The historic link between the trades of engraving, goldsmithing and limning could have eased des Granges's entry into his main career. The owner of the *St George*, furthermore, was William Herbert, Earl of Pembroke, the patron of Peter Oliver, and it is reasonable to suppose that, although the earl died in 1630, the relationship formed with the elder brother would have continued with the younger, Philip, who succeeded him and helped to transmit the courtly tradition of patronage of limning through the Interregnum. On that hypothesis, we find des Granges entirely in the right ambience for a miniaturist: a family and trade background conducive to the art, residence in the heart of the limners' London, and early contact with at least one of the great connoisseurs and collectors whose family were important patrons of limning. It leads on reasonably that des Granges should have become an expert copyist of old master paintings and modern master portraits (both necessary accomplishments for the successful miniaturist of the 1630s) and that he took on what must have seemed almost a hereditary patronage as he worked for the king and for the wider circle of connoisseurs at court. His portrait of the Duchess of Buckingham, signed and dated 1639,[107] and his copy of the king's *Marchese del Vasto* after Titian of 1640 (col. pl. 21), are the monuments of this phase of his career.

The latter raises the question of des Granges's style, its characteristics, antecedents and development. The earliest miniatures that have been closely examined are the *Unknown Man* probably of the 1620s, and the *Woman with the Initials EM* of c. 1630. The *Unknown Man* is in good condition and is finely worked in red and brown in fairly long strokes that tend to follow the curves and contours of the features, and which could show some residual influence from the technique taught by the engravers for suggesting relief. Basically, however, relief is created by tonal shading in grey, the colour applied in very short, almost stippled strokes making an effect

of considerable softness and subtlety. The rest of the miniature follows the normal professional practice of the period, the hair worked from a pale wash to the darker tones and finally heightened with the appropriate opaque colour for the lights, and the collar similarly brought up from the basic pale grey wash with pure white lights and lace detail. For the studs in the armour des Granges adopted the 'advanced' painterly method of representation, with ochre paint rather than powdered gold, but it is clear from the *Woman EM* that he knew the techniques of using powdered metal, in this case the use of silver for the pearls. In both these miniatures the technique is basically orthodox, recognizably part of the Hilliard–Oliver–Hoskins tradition, but, like that tradition, capable of innovation and individuality. Thus the *Woman EM* uses a gesso prepared card as a secondary support only a year or two after the practice apparently originated in the studio of Peter Oliver. The impression is that des Granges was a product of this close and mutually co-operative professional group in the Covent Garden area, his early style poised between the fine tonal hatching of Peter Oliver and the soft stipple manner that the elder Hoskins was beginning to make his own. Clearly on both the biographical and the stylistic evidence, des Granges belonged in this group, with Hoskins as his main point of attachment. Apart from the technical minutiae, it is Hoskins's work that des Granges's most resembles in general, the *Woman EM* being distinctly similar to the *Lady Catherine Erskine*[108] of about the same date, and the *Unknown Man* using a landscape for the background, as early an example of this as anything in the main Hoskins oeuvre.

It was on this connection that des Granges's career seems to have flourished, but his style did not develop in the same direction as Hoskins's. While Hoskins and his circle produced miniatures in an increasingly colourful stippled manner or in the ostentatiously dashing red-brown style, des Granges's hand became smoother, creamier and more blended, the style exemplified in work of the mid-1630s such as the *Charles I* in the National Portrait Gallery,[109] the *Duchess of Buckingham* and the *Marchese del Vasto*. The modelling of the features is softer, the sanguine blended with the carnation ground virtually as a transparent wash. The effect is extraordinarily delicate and quite unorthodox among the limners, though the rest of the technique remains conventional. Throughout the 1640s des Granges worked steadily in this manner, emphasizing the transparency of the flesh painting in the female portraits such as the *Unknown Woman*[110] and the *Lady Christiana Lindsey*, both signed and dated 1648. For the male portraits, as in the so-called *James Hamilton* of the same period, a dark stipple is used for the facial hair and bristle, the ruggedness of the masculine countenance being suggested by fine hatching of grey in the relief. For the masterpiece of *c.* 1648–51, the portrait of Charles II (col. pl. 19e), the modelling is very soft, in red and brown on an exceptionally rich brown-yellow carnation ground, with grey shadow adding apparent depths of tone rather than delineating explicitly the shadows. For the *Charles II* and for other portraits of the early 1650s, such as the

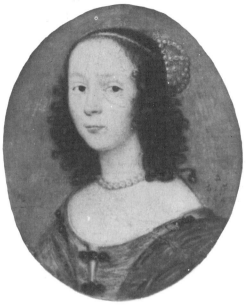

151. David des Granges, *Lady Christiana Lindsey*, 1648. Formerly Lady Binning.

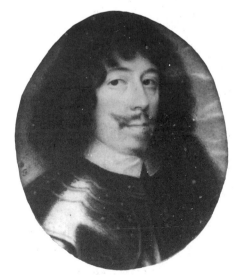

152. David des Granges, *A Man, said to be James Hamilton*, *c.* 1648, about 70 × 57 mm. Formerly Lady Binning.

153. David des Granges, *Lady Dacre*, c. 1650. Formerly C. L. Chute.

154. David des Granges, *Brian Duppa, Bishop of Winchester*, 1657, 59 × 49 mm. V&A Evans 26.

155. David des Granges, *Charles II*, c. 1651–5, about 68 × 57 mm. Formerly Newdegate Collection.

Lady Dacre, des Granges adopted the smaller scale fashionable at that time in response to the enamel portraiture of the European courts.

Thereafter the problems start. There are some stiff doughy productions that bear his initials – an *Unknown Man* of 1652 at Windsor, the *Bishop Duppa* or the *Unknown Man* of 1657,[111] or the *Walter Bockland* also of 1657.[112] The flesh painting in these is transparent, soft and wash-like, but the deterioration in portrait sense, in the ability to construct an image with some vitality and chic, is very apparent. From this period also come the images of Charles II that followed that of 1648, the group around the Hartwell House portrait which is signed and dated 1651,[113] and the subsequent group that remained current probably until Cooper's Restoration portrait, typified by the miniature at Ham.[114] There is no pleasure in looking at portraits such as these, and the puzzle is why des Granges should quite suddenly have slipped into producing them. The puzzle is compounded by the appearance of a work like the *Unknown Woman* that was in the Pfungst collection: on costume it should date from *c.* 1660 but in style and portrait sense it recalls the work of the 1640s. Des Granges, on the evidence of this and of the *Catherine of Braganza*, responded to the Restoration with some of the vigour conspicuous by its absence in the previous decade.

A background of patronage and professional association can be cautiously inferred. Des Granges probably began earning a living as a miniaturist in the 1630s, in the booming market created by connoisseurs' demands for copies of subject pictures and portraits, and by royal demand for images of the king. Hoskins had cornered much of this market and was under pressure from it, and I think he shared or farmed it out in the small community of inter-related miniaturists who lived in Covent Garden and who had a common interest in the welfare of their trade. Commissions in this fiercely commercial decade came from the circle of nobles and connoisseurs around the king, whose enthusiastic patronage thus ironically produced works that flouted the values asserted by their connoisseurship. The market broke at the end of the decade with the deteriorating political situation, and the limners followed their instinct for survival: Hoskins opted for London, Gibson for Wilton and des Granges for the king, perhaps in 1641 but certainly by the end of the 1640s when he began his series of 'official' likenesses of Charles II in exile. At this time he must have been closely associated with Charles and was probably at The Hague in the circle of the Bohemian exiles at the time when Peter Oliver's death and Alexander Cooper's departure for the northern Protestant kingdoms left open the English limning business in the Netherlands. The 1648 image of Charles after Hanneman (col. pl. 19e), of which there is an exact equivalent by Thach still in the Mauritshuis, epitomizes this connection. By showing Charles with his Garter ribbon, the portrait emphasizes his role as the legitimate head of the Elizabethan chivalry, entitled thus to the loyalty of those, whether abroad or still in England, who counted them-

selves members of this Protestant–parliamentary–monarchical culture.

He was with the king in Scotland in 1651 and in his Petition of 1671 he himself claimed to have been a faithful and diligent servant of the Crown.[115] Possibly his service, if it extended into the Civil War, was not mainly that of a limner: certainly there is a dearth of surviving miniatures from the war years and maybe, if Sanderson was right to list des Granges among the 'rare Artizans' of oil portraiture, he had spent the war as a full-scale painter – except of course there are no surviving oil paintings either. Whatever the truth of that, the changeless nature of the limner's work at court, wherever the court, was copying, and des Granges in Scotland can have done very little else. The Petition gives a detailed account both of the distribution of thirteen royal images, at a moment of political tension when loyalty images were obviously very important, and of the economics of the business. The original of all these copies was charged at 10 guineas and was not apparently included in the distribution. Mr Chiffinch, acting for the king, paid des Granges for it and commissioned the other thirteen at £6 each. Typically for the royal patronage none of them was paid for, until des Granges had twenty years later and after the Restoration petitioned the Treasury.[116]

He evidently lived for the rest of the Interregnum by producing the poorer images of Charles, and those of his immediate circle such as the loyal Brian Duppa. Des Granges's work for Duppa suggests the possibility of a more sustained connection with the Laudian Anglo-Catholics of Charles's exile court. He copied Huysmans's portrait of Catherine of Braganza dressed as a shepherdess,[117] which helps to substantiate the possibility, and shows des Granges co-operating in the attempt to endow the queen, and through her possibly the whole Francophile and Catholicizing wing of the court party with the imagery of a legitimate aristocracy. The 1664 Huysmans images of the queen, either as shepherdess with the Paschal Lamb, or as St Catherine, helped to define the iconography of the consequent portraits of court ladies on which Cooper worked, and which des Granges thus evidently had some part in establishing. He may in the atmosphere of religious sectarianism after the Restoration have become increasingly identified with the Catholics, without, however, being in any sense a Catholic himself.[118] There is no evidence that he was anything but a loyal parishioner of St Martin-in-the-Fields. But des Granges's last years are obscure and his patronage must have been fragmentary. Though the king was capable of 'well remembring [his] antient & acceptable Services', there was no question of a salaried appointment for him. Patronage went to those, Cooper and to a lesser extent Gibson, who had stayed in London or maintained in effect their membership of the genuine Protestant–parliamentary culture of the metropolis. In quality and content des Granges's work was no longer part of that vivid 'Elizabethan' tradition, and beside the very patent authority and originality within that tradition, des Granges had nothing to offer.

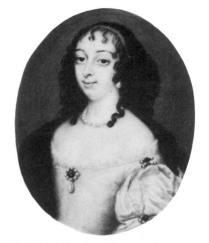

156. David des Granges, *Unknown Woman, c.* 1660. Formerly H. J. Pfungst Collection.

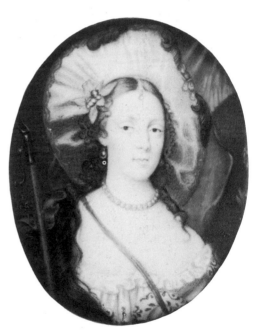

157. David des Granges, *Catherine of Braganza as a Shepherdess, c.* 1665, about 80 mm high. Daphne Foskett.

NATHANIEL THACH (1617–AFTER 1652)

Nathaniel Thach has emerged gradually from obscurity.[119] Thach's mother Priscilla was the sister of John Cradock, rector of Barrow in Suffolk, who was the father of Mary Beale. His father, Richard Thach, was a chandler and lived in the parish of St Martin-in-the-Fields in London. Nathaniel was baptized in his uncle's church of All Saints' at Barrow on 4 July 1617.

John Cradock seems to have been an amateur painter. In recognition probably of political services to Parliament he was made free of the Company of Painter-Stainers on 7 July 1648, and he presented to the company on that occasion a fruit and flower painting 'of his owne makeinge'. Four years earlier (2 April 1644) he had made a will leaving to his nephew 'late of London Picture Drawer all my empastered rounds as wee call them' – the terms used thus leading to the inference that Cradock as well as Thach thought of himself as a limner, referring thus familiarly to the gesso-prepared cards conventionally used by the limners at this date. As far as Cradock is concerned, although we know little of him beyond the fact that he was a Cambridge scholar and active parliamentarian, we may suppose that his interests coalesced in a world view something similar to that of other artist-intellectuals of the epoch. Bury St Edmunds, the nearest town to Barrow, was possibly the centre for a group of painters working there,[120] an outpost perhaps of the metropolitan culture, with a connection through the Thach–Cradock marriage into Covent Garden and the limners' London. The importance of limning in the connection is further suggested by the presence as a young man in the nearby parish of Horringer of Matthew Snelling. He, like Cradock, emerged with rather special intellectual interests from this local matrix, and became part of the set of experimentalist natural philosophers and connoisseurs in London that included the Beales, Flatman and Sanderson. Nathaniel Thach was evidently a product of the same background, but he did not emerge into the relative clarity of the later scene because he was by 1644, as his uncle said, 'late of London'. He had gone abroad and it is in the complicated political environment of Europe at the end of the Thirty Years' War that we have to place his activity.

Thach's surviving oeuvre is extremely small, but it is striking that of the five accepted works by him all are of sitters intimately connected with the court of Elizabeth of Bohemia in The Hague.[121] Of the five indeed four of the sitters were children or children-in-law of Elizabeth. Anne of Gonzaga (col. pl. 19f) and Princess Louise both wear dress that recalls the special cult of masque and symbolic entertainment in the Palatine court. Prince Maurice wears armour with a curious and unconventionally classicizing drape of cloak across his chest: the effect is to cast him as *dux* or *imperator*, a modern Roman imperialist. Charles II, still prince when this portrait type originated (col. pl. 19e), wears the Garter ribbon and thus proclaims his membership of an order of knights which, especially in a Palatine context, was associated with mili-

tant Protestant legitimacy.[122] This part of Charles's political persona, his relation to his Protestant aunt who drew funds from the English Parliament all through the war years and Interregnum, helped to attach to him, as potential sovereign, the loyalties of the parliamentary aristocracy and to ease ultimately his restoration. Maybe one should not attempt to read too much into these portraits, yet their context is important and they do as a group seem to speak an iconographical language distinct from that of the English school in the Civil War. This small group of portraits represents the survival in exile at The Hague of the special ethos of the Bohemian adventure, and represents one of the streams of continuity linking the Elizabethan–Jacobean culture of pre-1620 to the restored monarchy of 1660. Peter Oliver seems to have been an important figure in this connection, and Thach seems to have taken over the role of limner to the Palatine court that Peter Oliver must either formally or informally have had.

Isaac Oliver had a special relationship with Anne of Denmark and Prince Henry as their limner, dealer and artistic factotum.[123] When Prince Henry died in 1612, in the run-up to the marriage of his sister Elizabeth to the Protestant Lion, Frederick Elector of the Rhine Palatinate, part of Henry's significance as a future champion of Reformation Europe was transferred to Frederick and Elizabeth, who became for the next few years the brightest exponents of an enlightened northern renaissance in their castle at Heidelburg. Isaac Oliver painted miniatures of Elizabeth at the time of her marriage, but thereafter the portraits of her, and of the members of her suite when she left for Heidelburg, were by Peter Oliver. Elizabeth would have paid no salaries; any payments would have been strictly for work done, yet Peter Oliver kept on painting her even in the midst, during the 1620s and 1630s, of apparently heavy commissions from Charles. Probably through Peter Oliver first Alexander Cooper, then des Granges and Nathaniel Thach were drawn into the Bohemian circle at The Hague. What gave the latter two their entrée in practice was the death in 1647 of Oliver and the departure the same year from The Hague of Alexander Cooper for Sweden. The necessity of portraiture to the exiles was peremptory: thus des Granges's first portraits of Charles with his Garter ribbon, the copy after Hanneman, dated from 1648 (col. pl. 19e), and Thach's version of the same portrait from soon after.

The central importance of Peter Oliver and the potency with which he enforced the sense of continuity between the golden past of Protestant legitimacy and the hope of its future restoration, is reflected in factors of style and technique. Even without the theory of his patronage outlined above, one would deduce a relationship between Peter Oliver and Thach on grounds of style. Thach drew the features of his sitters with very fine grey strokes mingled with the sanguine, and he modelled the relief with shadows, as in the neck and chin or around the hair lines, with a strictly-disciplined grey-blue stipple strongly reminiscent of Peter Oliver's. The 'granular' effect of Oliver's stipple was softened by Thach's hand and some of the sharpness of Oliver's vision was lost, but the

relationship is none the less clear. Perhaps even more significantly, Thach used powdered metal and resin in the jewel painting for the *Anne of Gonzaga* (col. pl. 19f), a usage so specialized that it must have been learnt in the direct line of tuition and technical inheritance from the Hilliard–Oliver tradition. By 1649 the usage was archaic and had ceased to exist in the metropolitan English school. Its continuity, or its reappearance, in the circle of the last representatives of the Protestant monarchy makes a strong political point: the civilization of Elizabeth, expressed in the continuity of art and technology, lived on. Nathaniel Thach, working for Elizabeth of Bohemia, became like his employer an exponent of the authentic Tudor and Jacobean tradition.

At this point information and possible inference about Thach come to an end. The last mention of him is in his father's will, made on 2 December 1652, in which he was left £10.[124] He probably stayed on the continent, like Alexander Cooper, and he may have been dead by the Restoration since there is nothing to suggest that he attempted to benefit from his service to the exiled Stuarts, claiming many years of faithful service, as des Granges did. Certainly, if he did die or live abroad, he must have been a loss to the group of artist-intellectuals that he grew up with, and who were themselves, as experimentalists and artists, representative of the enlightenment. Had he returned to London, he would surely have turned up somewhere in the Beale connection.

MATTHEW SNELLING (1621–1678)

This account of Matthew Snelling is necessarily fragmentary, intended to be suggestive of the way he fitted into the pattern, rather than fully resolved. The indications are that Snelling was a serious artist and as much a member of the distinctive intellectual limners' culture as any of his professional colleagues. From the surviving works it is clear that he was working from about the mid-1640s until the mid-1670s, a career of some thirty years and on those grounds alone evidently serious and sustained. Contemporary references describe him firmly as a limner, and he probably knew Samuel Cooper as early as 1644, the date of a lost chalk drawing of him said to have been done by Cooper. There was also a miniature portrait of him by Cooper in the Michael Rosse sale, described as 'Mr Snelling the Limner'.[125] His own early works, a *Charles I* after van Dyck, signed and dated 1647, and a *Henrietta Maria as St Catherine*, signed and dated 1649,[126] suggest an orthodox beginning as a limner, copying portraits and attached perhaps to a patron in the royal interest. From the 1650s there are an *Unknown Man*, signed and dated 1652,[127] the *Countess of Dorchester* also of 1652,[128] the *Countess of Dorset* of August 1654 and the *Earl* of June 1655.[129] From the 1660s there are the *Unknown Man*, signed and dated 1661,[130] and another *Unknown Man* (col. pl. 26c), signed and dated 1663. From the 1670s there are the *Sir John*

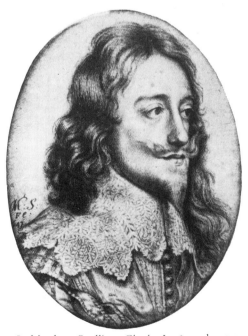

158. Matthew Snelling, *Charles I*, 1647, about 95 mm high. Denys Bower, Chiddingstone Castle.

(col. pl. 25d) and *Lady Dormer* (col. pl. 25c), the first of which is signed and dated 1674. On the slender evidence of the named sitters here, Snelling was working close to that same central group of Anglican aristocrats who provided the main patronage of limning and who divided during the wars between those who stayed with the king and those who temporarily sided with Parliament. The Dorsets had been with the king in the 1640s, and the fourth earl had attempted to join him at Hampton Court in 1647 as a member of his council, the same year as Snelling's portrait of the king. The fifth earl represented the court interest in Parliament until 1646, and came back to fortune with Charles II in 1660. He had been an early patron of Samuel Cooper, and was from 1665 a Fellow of the Royal Society. He seems to have been one of the central figures of that legitimate Anglican monarchical enlightened culture to which the limners were particularly attached. With Sir John and Lady Dormer of Lee Grange, Snelling was in touch with the great Pembroke–Carnarvon connection in Buckinghamshire, the parliamentarian nobles and patrons of Gibson; the Dormers were MPs and barristers, active in the part of professional London after 1660 of which Snelling, Thomas Flatman and the Beales were denizens.

Snelling's original access to these circles probably arose in some way from his background.[131] He was brought up at Horringer near Bury St Edmunds, the neighbourhood of the Beales and of Nathaniel Thach. His father Thomas Snelling, sometime mayor of King's Lynn, had died in 1623, and his mother remarried on 21 July 1625 a widower called Ambrose Blagge, who had a son, Thomas, later to be a colonel in the army and Groom of the Bedchamber to Charles II. From these circumstances it is fair to deduce that Snelling's family was genteel and, despite the setback in fortune following the death of his father, of rising status. Matthew did not go to either of the universities, though others of his name from the same part of the country did, and the reason was probably one of cost. Perhaps Snelling was a little better off than the orphaned Coopers, but like them he evidently needed a way to earn a living that did not have a high tariff on entry. Unlike Flatman or Charles Beale, he could not become a scholar or enter one of the learned professions. Given graphic talent, the choice of limning was sensible.

It is usually suggested that Snelling learned the craft of limning from Hoskins, in much the same way as it has been thought that Flatman probably did; they had, indeed, rather similar styles. The objection to Hoskins as the source is that in the later 1630s, when Snelling would have been learning, Hoskins was developing the polychrome stipple manner for his autograph work, and his studio as far as we can tell was working in a softer and more blended version of the red-brown hatching style probably adopted originally by Cooper. There is no connection between either of these styles and that of Snelling, except in so far as Snelling, like every other miniaturist in the mid-seventeenth century, sought to emulate Cooper's graphic brilliance and willingly received his influence. Basically, Snelling's style was quite different.

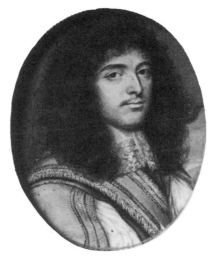

159. Matthew Snelling, *Richard Sackville, fifth Earl of Dorset*, 1655, about 64 × 51 mm. Countess Beauchamp, Madresfield Court.

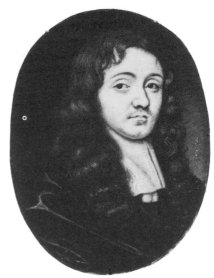

160. Matthew Snelling, *Unknown Man*, 1661, about 70 × 53 mm. Formerly Rev. C. A. Parr.

161. Anonymous, *George Gordon, second Marquis Huntly, c.* 1635, 123 × 88 mm. V&A P200–1929.

His earliest extant work, the *Charles I* of 1647, suggests a possible source. It resembles in style and technique the group of portraits that were in the old royal collection at Kensington Palace, of which five are in the Victoria and Albert Museum and others pass from time to time through the sale room.[132] They are painted with the brush point in monochrome (some have added colour) directly on to gesso-prepared cards. Relief is achieved by a system of cross-contour hatching, and the drawings have on this and other grounds been variously associated with the school of Isaac Oliver and with Crispin de Passe.[133] One of the series, as described by Vertue, was 'Charles Premier de la Grande Bretagne' originally framed with 'Henrietta-Maria Royne de la Grande Bretagne'. Perhaps the extant *Charles I* was the first of these, and perhaps the whole group was by Matthew Snelling – close side-by-side comparison would be needed to decide the point – but either way the similarity is sufficient to place the signed Snelling in the same stylistic descent as the Kensington Palace set. The descent was from the Anglo-Netherlandish school of draughtsmen and engravers, which included the Olivers and the de Passes, but not as represented in the naturalized London form of Peter Oliver. Had Snelling learned from Peter Oliver, he would surely have used gesso-prepared cards as secondary supports for vellum; he actually used them, as the European draughtsmen had for many years, as the drawing surface itself. This factor, together with the basic dissimilarity of the work from the orthodox miniature of the period, separates Snelling's style as it first appears decisively from the central London tradition.

A little later, his style seems more familiar. The *Henrietta Maria*[134] has much in common with des Granges's portraits, and perhaps even more with those of Alexander Marshall,[135] so that one can almost discern in this group an 'alternative' tradition of limning, aiming at a soft, creamy tanned rendering of flesh, a delicate method of blending the brushwork into the carnation so that it resembles a transparent wash, filling in the space between rather firmly drawn outlines. The format of miniatures in this style by all three of these draughtsmen was often an enlarged rectangle, influenced in that no doubt, as in the flair with which landscape backgrounds were used, by the example of Hoskins, absorbed as it were from outside, after the basic personal style had been learned elsewhere. The evidence of the 1650s is that Snelling did not share the common aspiration of the decade towards smallness and high blended finish: perhaps for him these qualities did not seem progressive. He seems to have developed firmly towards the bravura graphic style, visible for example in the *Earl of Dorset* where the features are drawn with the same kind of long wiry lines and almost coarse hatching that those who admired Cooper and who believed in showing the palpable marks of the artist's hand similarly aspired to. For Snelling, with his putative background training as a draughtsman or engraver, the development seems in some respects like a return to his first manner, but by the 1660s it was becoming the dominant mode, profoundly congruent with the taste for honesty and simplicity in the London élite. At the same

time, the brightening palette of the Restoration made Snelling, whose surviving work of the 1650s is by no means as sad-coloured as for example Gibson's, seem particularly modern. His brightness, his use of sky backgrounds and his aggressive draughtsmanship, may well in fact have influenced Flatman, who must have been looking for tuition and whose social circle had considerable overlap with that of Snelling. But Snelling, it seems clear, was not one of the leading 'official' miniaturists of the Restoration, at least not as Cooper or Gibson were. His reputation as we can discern it was as a generalist, current at the fringes of court or aristocratic circles, and the closely associated intellectuals.

Thus Vertue picked up the idea that he was not just a limner, and wondered whether the 'Mr Snelling' of whom he heard was not identical with Thomas Snelling, poet and scholar of Oxford during the wars, Commonwealth and Restoration:[136] perhaps the echoes of Matthew Snelling's reputation suggested some literary connection. Vertue also noted the unfounded gossip that Snelling used only to paint the portraits of women so that he could flirt with them,[137] and in a similar vein he recorded that 'Mr Snelling limner contrivd or furtherd the match between the Duke of Norfolk . . . & his second Lady who was mother of George. & Frederic Howard –.'[138] The duke's second wife was his former mistress Jane Bickerton, the daughter of the keeper of the king's wine cellar; his legitimate sons raised a petition on 24 March 1676/7 against the offspring of this liaison, denying the existence of a marriage.[139] Vertue was undoubtedly referring to this juicy scandal, and whether it was true or not that Snelling had acted as pander, the occurrence of his name, as limner, in a context of aristocratic household politics, mixed up with the daughters of court officials, helps to place Snelling in society roughly where from his background and family connections one would expect to find him.

His connection with Charles Beale was more straightforward, and was similar consistent with his family background in the neighbourhood of Bury St Edmunds. Charles Beale's references to him were as to a close acquaintance. He lived in Long Acre[140] and it is fair to assume that he was either a regular member of the Beale circle or a frequent enough visitor to be party to its interests. The documentation of their relationship, though slight, at least suggests that they had in common the painter's expertise in 'art history' and a consciously commercial attitude to the cult of collecting and connoisseurship. Again the reference comes via Vertue: '4[th.] March 167$\frac{1}{2}$ M[r] Matthew Snelling . . . offerd me for my Venus & Cupid of Rottenhamer – 30 guineas. (at 18 pence above value) I refusd it. and would have 40 guineas. I reckon it worth 50.'[141] Snelling on this evidence was either a dealer or collector, interested in vertu and in the masterpieces of the history of art. The coincidence of such activities with limning goes back to Isaac Oliver and the beginnings of the English cult of vertu in the circle of Anne of Denmark and Prince Henry. The suggestion is that the limner, as the most intellectualized sort of painter, was apt to be an adviser and agent for the magnate in his dealings with the market. In the

later seventeenth century this association between limners and expertise in art had issue in those, presumably including Snelling, who were *marchands amateurs*, and those like Dixon who developed the speculative production of miniatures for the market and tried to devise new ways of selling.

Beale was also intensely interested in painting (col. pl. 27a), in its materials and technology, especially in the chemistry of colours. He was very much an intellectual, a Fellow-Commoner of Trinity, Cambridge (admitted 20 May 1656),[142] and an intimate of the founding Royal Society clerics, administrators and professional men. The evidence, again slight, is that Snelling was in some way a party to his researches into the composition and preparation of dyes and pigments. It comes from Vertue's transcription of the lost 1672 volume of Charles Beale's notebook, and it tantalisingly omits the context in which Beale, at least twelve years after the event, should have been recalling Snelling's gift of some colour: 'a parcell of Pink made by Mr Snelling of the weed before it flowerd. & sent my wife 7 July 1658. a small parcell sent by Mr Snelling. 13 Sept 1654'.[143] Why should Beale have dwelt on this apparently trivial incident? And why should the exact dates have been recorded so carefully? On the face of it Beale and Snelling were experimenting with sources of 'pink', which in seventeenth-century usage was the term for colours in the yellow-brown range derived from the plant Genista Tinctorum, a variety of broom.[144] The date 7 July, in relation to the usual flowering period of brooms and the necessary duration of harvesting and preparation of the 'pink', is obviously significant, and contrasts with the 13 September date for the batch prepared presumably in the ordinary way from the plant after flowering. We can deduce that Snelling was, like Beale, an intellectual and natural philosopher experimenting in the chemistry of colour, that he was one of the professionals whom Beale, in accordance with the respect in which all the natural philosophers held the crafts, was consulting. At the very least, Snelling must have been like the otherwise unknown painters Manby, Henny and Comer,[145] but the fact that Snelling was evidently of the same social background as Beale probably indicates that he was more closely a party to his enquiries than the other painters. The fact also that he was limner, and hence within the mystery of the craft described by Hilliard and Norgate, would have helped to characterize his expertise as intellectual rather than simply of the artisan. The evidence by itself may be slight, but in the context of what we know of the links between limning and the seventeenth-century traditions of chemical experiment, it is surely significant that one of the very few pieces of information about Snelling to survive – to be carefully preserved indeed – bears precisely on this point.

Other fragments of information similarly suggest that Snelling was close to the natural philosophers, perhaps especially close to the physicians who carried on the chemistry-based medicine of Mayerne, and contributed their expertise in observational science to the Royal Society. Thus there is a note in the diary of Robert

Hooke for 8 December 1674: 'Saw Brouncker's picture at Snelling's'; and for 8 March 1674/5: 'Lord Brouncker sent in picture'.[146] Brouncker (1620–84) was a distinguished mathematician and the first president of the Royal Society. That Snelling was acquainted with him and Robert Hooke, who had in his youth been a pupil of Lely, and whose early Royal Society experiments were physiological, helps to suggest the significant overlapping of interests in these circles. Snelling also painted in large Baldwin Hamey the younger (1600–76), one of the school of English physicians who had been at Montpellier and who were proponents of the most practical and observational approach to disease. For a man of wealth and vertu, his choice of portrait painter – for the picture in the College of Physicians – would have been odd if there had not been some particular connection between him and Snelling or between Snelling and the college. Through Charles Beale if not on his own account he probably knew Dr William Croone (1633–84), one of the promoters of the Royal Society and a close friend of the Beales; and John Lorymer the apothecary, who was Croone's father-in-law.[147]

The evidence is admittedly slight, but it does seem plausible that an important area of Snelling's patronage was thus amongst the scientists and physicians, close to, in other words, but not the same as Flatman's, and different too in that Flatman was, as we shall see, a full member of the intellectual life of the Society, whereas Snelling's attachment to it could seem, to Vertue at least, ambiguous. Nevertheless, the evidence is that Snelling was interested in the chemistry of colours, that his approach was experimental, that he knew physicians whose discipline was both philosophically and practically allied to that of the painter, and that he was by background and acquaintance a member of Charles Beale's intellectual circle.

On this basis the characteristics of his style, as they are visible in newly available works like the *Unknown Man* of 1663 (col. pl. 26c), are richly expressive. The brightness of the palette – the brightness indeed and directness of the light which causes no deep shadow and gives a clear view of the sitter's features – tends to de-mystify the sitter and place him as it were in the clear light of reason. The long wiry drawing stroke and the system of creating relief in the features by contour-following strokes and cross-hatching emphasize the character of the image as a drawing or limning by the honest patency of technique. But the similarity in the result to that achieved by Flatman is not just a matter of handling, nor indeed is it importantly a matter of common debt to the drawing handbooks or to the influence of Faithorne. It lies more deeply in their radical predisposition to the Society ethos which made them both in some sense members, and whose aesthetic precepts they both adopted and helped to realize in practice. On the record Snelling emerges as a slight figure in this culture, but it seems to be where he belongs, and his presence can thus help us to piece out a little more of the intellectual and artistic history of the later seventeenth century.

Thomas Flatman (1637–1688)

In a wordly sense Flatman was easily the most distinguished of the men about town in the late seventeenth century who painted miniatures. It was in him that the whole long trend, from Hilliard to Sanderson, for the arts to be incorporated in the life of the complete gentleman was most conspicuously realized. Among his friends, and particularly in the Beale circle, the same aspirations were evident, and these, of which we now know quite a lot,[148] help to validate the sense acquired less directly from the careers of the other limners of a special political and intellectual culture enfolding and motivating their lives.

Flatman was born into the class that had access, via the universities, to education and the learned professions. He was the son of a clerk in Chancery and was born evidently in London, according to his own conflicting testimony either in Red Cross Street or Aldersgate Street.[149] He entered Winchester as a scholar on 22 September 1649, and proceeded on 11 September 1654, also as a scholar, to New College, Oxford. He was entered as a Fellow of New College in 1656, but had been since 31 May 1655 also entered at the Inner Temple from where he was called to the Bar, describing himself as 'of London, a gent.' on 11 May 1662. He took his MA at St Catherine's Hall, Cambridge, on 11 December 1666, being entered in the register as a BA of Oxford, though no documentary evidence of his Oxford degree survives. He was elected a Fellow of the Royal Society on 30 April 1668. He is said to have owned, or to have been the scion of, an estate at Tishton near Diss in Norfolk; or perhaps he acquired the estate through his marriage on 26 November 1672 to a lady said by Anthony à Wood to have been of fortune. In London he lived in Three Leg Alley in the parish of St Bride, and died there on 8 December 1688.

He was an active man of letters. His publications cover the end of his Oxford period, from 1658, and culminate in his Pindaric ode 'on the Death of the Right Honourable the Duke of Ormonde' of 1688. His major publication, in which his other works were progressively incorporated in four editions to 1686, was *Poems and Songs* (1674). He contributed to the important edition of *Ovid's Epistles translated by several hands*, published originally by Tonson in 1680 and in subsequent editions including prefatory verses by Dryden. Between 1 February 1681 and 22 August 1682 he brought out anonymously eighty-two numbers of the weekly *Heraclitus Ridens or A Discourse between Jest and Earnest . . . in opposition to all Libellers against the Government*. On this showing it is hardly possible to see Flatman as a poetaster, nor merely as an amateur writing gratuitous occasional pieces and melancholy songs. His literary work has attracted no recent scholarship, but the neglect is unjust. In both quantity and quality the oeuvre is that of a hard-working Restoration professional.

It is the more impressive as only one-half (or perhaps one-third if he were practising as a barrister) of his career. In a sense his literary work followed on more naturally from his education than his

painting, and the question is how a scholar and literary intellectual such as Flatman became a limner at all. In fact the connection between his literary work and his painting goes back at least as far as the verses he wrote to commend the publication of Sanderson's *Graphice* in 1658. There is hardly a hint in his lines that he himself was a practitioner of the 'noble art', but the fact that he knew Sanderson at this time suggests that he must have begun limning when he returned to London from Oxford in about 1657. His early work is dependent on Samuel Cooper,[150] and it is possible that he may have studied Cooper's manner of working, as the Beales used to watch Lely and as Susanna Gibson watched Cooper, during sittings. Technically, Flatman was a limner of the red-brown hatching school and thus securely within Cooper's orbit, but it is perhaps odd that, since he would have seen Cooper's work in its most blended phase of the 1650s and early 1660s, Flatman's brush-work is so little resolved, and each stroke so wiry and insistent on its own graphic value. The explanation may partly lie in Flatman's acquaintance with William Faithorne, for whom also he wrote a valedictory verse to the *Art of Graveing and Etching* of 1662. Flatman's line is metallic in quality like that of an engraver, and his mode of suggesting relief or recession by strokes of varied frequency, is similar to that recommended by Faithorne in his treatise. The technique is a specialized variant of that put forward in all graphic handbooks and could well have been learned by Flatman from one of the editions of Peacham's *Complete Gentleman*. Whatever the source, it is likely to have been literary and Flatman's hand was in that respect strikingly different from that of the regular professionals. It was more insistently individual, more conscious of technique than a well-taught apprentice professional would have studied to achieve. The impression is of a very gifted man reading himself into a subject, consulting those of his acquaintance who knew something of it, and going along to watch the greatest exponents.

Why should Flatman, already a learned man, a barrister and poet, have sought also to become a limner and to be known as a master of that art? The answer bears closely on the whole position of limning in the late seventeenth century and is particularly clear in Flatman's case because we know more about his intellectual life and affiliations than we do of any other artist.

The circle of his friends included for certain the Protestant-Episcopalean part of the original Royal Society membership. His connections with this group probably sprang from his time at Oxford in the mid-1650s when the meetings of the natural philosophers were still going on in Wadham College, in the rooms of John Wilkins, the Warden. Members of this Oxford group, according to Thomas Sprat, went to London in about 1658 (about the time of Flatman's move)[151] and continued their meetings in rooms at Gresham's College, extending their membership, until in 1660 they were formally incorporated as the Royal Society. Sprat makes clear the basic importance to the group's ideas of a firm Anglicanism, guaranteed by the presence of those founding Fellows like

Wilkins and Seth Ward who gained preferment as bishops in the Restoration, and by those such as Flatman and his close friend Samuel Woodforde among the later Fellows, who lived an intensely pious but secular life in the City as lawyers and men of letters. This inclination to place their intellectual interests in a framework of settled, tolerant, anti-controversialist religious belief was one of the key characteristics of the Society, providing a leadership which took in those of the university educated but non-Society members like Charles Beale who came in contact with it. Anglicanism was not in these circles merely a means of avoiding religious dispute: as Sprat made clear, it provided the basic rationale of the Society's activities, inculcating in the philosophers a sense of reverence for the 'admirable order and workmanship of [God's] creatures'.[152] The Society, in Sprat's account, was a house with many mansions, and the only requirements were tolerance, an open-minded readiness to experiment, and a recognition that knowledge was a common property for the public good. 'Thus they have form'd that *Society*, which intends a *Philosophy*, for the use of *Cities,* and not for the retirments of *Schools,* to resemble the *Cities* themselves; which are compounded of all sorts of men, of the Gown, of the Sword, of the Shop, of the Field, of the Court, of the Sea; all mutually assisting each other.'[153]

This side of the Society's work probably attached Flatman, both as a man of strong religious outlook, and as a citizen-scholar and lawyer. The Society also had the explicit intention of drawing to itself artists and craftsmen. It embraced all assistance

> which is the more remarkable, in that [the members] diligently search out, and join to them, all extraordinary men, though but of ordinary Trades. And . . . they are likely to continue this comprehensive temper hereafter . . . [since his Majesty] has engaged them to have [careful regard] for all sorts of Mechanick Artists.[154]

> They intend the perfection of *Graving, Statuary, Limning, Coining,* and all the work of Smiths, in Iron, or Steel, or Silver: And the most excellent *Artists* of these kinds, have provisions made for their practice, even in the Chambers and Galleries of [the king's] *Court*.[155]

As a limner, Flatman was probably the only Fellow of the Society who could rightfully have occupied one of the chambers in the palace allocated to artists and craftsmen. In his own mind he showed that 'comprehensive temper' which brought philosophy closely into contact with the real business of life. Such a passion for practicality, such a marked respect for the craftsman and his instruments, whereby things were made and experiments for progress became possible, extended into a respect for the language of artisans. 'They have exacted from all their members, a close, naked, natural way of speaking; positive expressions; clear senses; a native easiness: bringing all things as near the Mathematical plainness, as they can: and preferring the language of Artizans,

Countrymen, and Merchants, before that, of Wits, or Scholars.'[156]

With this dictum many of the developments in the arts in the seventeenth century seem more richly comprehensible. In Flatman's case, as in that of Abraham Cowley, association with the Royal Society was clearly related to the simplification and quickening of their literary language. More to the point, the peculiarity of Flatman's style as a limner, though it can be described in terms of influences or sources, emerges as a similar effort towards simplicity and naturalness. Thus his style does not try to lose the modelling strokes in a rich blended effect, but stresses the nature of the portrait as the product of the techniques and materials that have gone to its making.

The same aspiration may be evident in the other limners of the Restoration, especially in the later Dixon, but in Flatman when he painted the members of his own circle, it seems to achieve its most apt expression. In these portraits, in the *Unknown Woman* (col. pl. 26b), the *Samuel Woodforde*[157] and the *Charles Beale,* there is a calculated moral symmetry between the sitter and the style. It is the portraiture of a distinct social group, showing the sitter in ordinary dress, tidy as for the metropolitan round of business and society, or in undress as for the house. It is a portraiture that eschews the elaborate amplifications and 'swellings of style' in traditional iconography, and expresses in its graphic honesty the aspiration towards the 'close, naked, and natural'[158] way of life. The style has even more bite and point in the self-portrait of 1673 (col. pl. 26d), where the intentional coarsening of the touch and the extremity of wiry unresolved lines in the face were certainly designed to avoid the lingering narcissistic vanity of finish in a self-portrait. Here, the iconography was the technique, intended to address the kind of man for whom self-examination was a function of the conscience and the intellect in the service of religion; whose purpose was not to look good or grand but to remind himself of his minimal corporeal reality. Sprat discussed the acute difficulty of studying Man 'because the Reason, the Understanding, the Tempers, the Will, the Passions of Men, are so hard to be reduced to any certain observation of the senses'.[159] The risk, as Sprat saw it, was one of prolixity, and Flatman, sharing the stylistic ethic of the Society, countered it in his painting by a style that was similarly 'close, naked, and natural'. Because portraiture was a form of discourse on Man, the style, for a member of the Society, had to be reductive.

How far these portraits were characteristic of his oeuvre is another matter, and it raises the question of whether or not he was in any useful sense an amateur. To show that he was an amateur presumably requires an indication that his clientele came to him as to a friend or acquaintance rather than as to a professional painting portraits for money; it requires an indication that most of his portraits were of members of his own circle. The question is obscured by the fact that many of the identifications of his sitters for the surviving portraits are extremely dubious. Thus a portrait such as the *Abraham Cowley* (col. pl. 26a) which ought to show

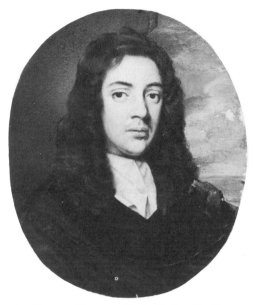

162. Thomas Flatman, *Charles Beale*, 1664, 82 × 70 mm. V&A P13–1941.

Flatman painting one of the key progenitors of the Royal Society, and a man of letters working in the same stylistic genre as himself, may be incorrectly identified. Objections extend also to the portrait of Sir Thomas Henshaw,[160] one of the original twenty-one Fellows of the Society: the portrait has not been seen for over fifty years and the reasons for its identification are not recorded. The so-called *Sir Geoffrey Palmer*[161] could be a case of the identification being transferred to the well-known but aged Attorney General, from the less well-known but younger and perhaps more likely Dudley Palmer, another early FRS. With sitters like Sir Geoffrey Palmer it is tempting to suppose that Flatman painted his legal colleagues, as for example Sir Robert Hyde, Chief Justice of the King's Bench,[162] or Sir John Maynard, Solicitor General.[163] With sitters like Thomas Gregory,[164] said to have been Clerk of the Cheque at Chatham, or indeed with Charles Beale himself, it is possible to see Flatman as working for that class of officials and placemen amongst whom he certainly found some of his closest friends. Clearly, unless all these traditional identifications are wrong, a significant number of Flatman's sitters were connected to him either intellectually, professionally or socially. To see the matter in this light is, however, somewhat misleading. As a member of the Royal Society, he lived so much at the centre of the Protestant–monarchical culture that all his friends and colleagues were likely to have been members of the metropolitan élite that anyway patronized portrait painters. There is thus no useful distinction that can be made between customers and friends because for him, even more than for the other limners, customers were friends and were treated with varying but essentially similar directness, vigour and vernacular honesty.

Uncritical and inadequate as existing lists of Flatman's work may be,[165] it seems reasonably clear that he was painting some of the high magnates of the Stuart court. There are portraits identified as of Clarendon, Shaftesbury, Lauderdale, Argyll, Bridgewater, Denbigh, Ossory and Ormonde. It hardly makes sense, though some of the men like Bridgewater, one of the Royal Society nobles, may have been familiar to Flatman, to think of them as friends. Though the portraiture is certainly direct and honest, it probably has a rather different iconographic point and requires a different context for understanding. The best way of seeing these aristocratic portraits – or rather that part of Flatman's work that was concerned with men in their aspect of power and virtue – is as a process of memorializing the great, as the visual counterpart of his Pindaric odes on the deaths of Champions. The verse-form helps us to understand the way in which style has a meaning.

Flatman's basic attitude to poetry is de-mystifying. He wrote about it in a characteristically urbane and ironical way, his vocabulary unmistakably borrowed from that current in Royal Society circles. Poetry for him was a sort of applied science, a mechanical invention or a kind of medicine intended to ease constrictions of communication and expression:

163. Thomas Flatman, *Thomas Gregory*, 1680, 63 × 51 mm. V&A Evans 24.

in my poor Opinion Poetry has a very near resemblance to the modern Experiment of the Ambling-Saddle; It's a good Invention for smoothing the Trott of Prose; That's the Mechanical use of it. But Physically it gives present Ease to the Pains of the Mind . . . 'tis an Innocent Help to Sham a Man's time when it lies on his hands and his Fancy can relish nothing else. I speak but my own Experience; when any Accident hath either pleas'd or vex'd me beyond my power of expressing either my Satisfaction or Indignation in downright Prose, I found it seasonable for Rhiming.[166]

The value that he puts on freedom and the primacy of sense over measure, is evident in his choice of verse form:

I always took a peculiar delight in the Pindarique strain, and that for two Reasons, First, it gave me a liberty now and then to correct the saucy forwardness of a Rhime, and to lay it aside till I had a mind to admit it; An secondly, if my Sense fell at any time too short for my Stanza (and it will often happen so in Versifying) I had the opportunity to fill it up with a Metaphor little to the purpose, and (upon occasion) to run that Metaphor stark mad into an Allegory.[167]

The Pindaric ode was the form that he used for his memorials to the great, exploiting the informality of the verse and its conversational demotic effect to address the subject in his fleshly mortal humanity. The mocking remarks about metaphor may have been aimed at the Miltonics, and certainly there seems to be an implicit reference to *Lycidas*, built on images of a sympathetic Nature responding to human calamity, in the lines on Ossory:

> Celestial Powers! how unconcern'd you are!
> No black Eclipse, or Blazing-Star
> Presaged the death of this Illustrious Man,
> No Deluge, no, nor Hurricane;
> In her old wonted course Nature went on,
> As if some common thing were done.[168]

There is a kind of brisk good sense in this, and the cheerful tonic manner treats the eminence and illustriousness of the subject not as a matter for obsequious awe but respectful and grateful note.

For Flatman, the memorializing poet and portrait painter, the problem is one of style, of achieving a sensible non-adulatory approach to the great man. The analogy between the poetic and the painterly serves to emphasize the essential sameness of the problem, and the general applicability of a plain and natural style to achieve a one-to-one representation. In his poetry the correct style is found in the Pindaric measure, in his limnings it is located in the frank graphic vigour of brushwork – both deeply consistent in representational directness with the Royal Society prescription of that 'shortness [whereby] men deliver'd so many *things*, almost in an equal number of *words*'.[169]

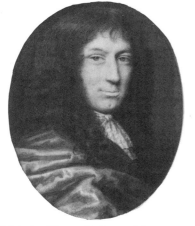

164. Nicholas Dixon, *Unknown Man*, c. 1660, 44 ×33 mm. V&A Evans 34.

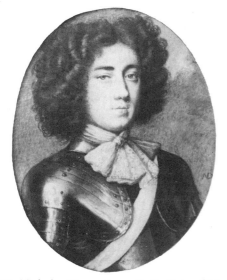

165. Nicholas Dixon, *Unknown Man*, c. 1665, 60 ×48 mm. V&A 803–1904.

166. Nicholas Dixon, *James Scott, Duke of Monmouth*, c. 1670. Duke of Buccleuch.

NICHOLAS DIXON (*c.* 1645–AFTER 1708)

Few facts are known about Nicholas Dixon. He must have been born about 1645 and died after 1708, his working life being thus nearly coincident with that of Peter Cross. It has been suggested that he was a pupil of John Hoskins, and brought to his office of king's limner in succession to Samuel Cooper much of the 'shy intimacy' of the Hoskins manner.[170] All historians have followed Vertue[171] in detecting a decline in the quality of Dixon's work in his later years, a decline associated with his floating of a lottery in 1698 and the subsequent financial embarrassments. Vertue recorded that he died in the King's Bench Walks, a refugee from prosecution for debt.[172] The date 1708, a terminus post quem for his death, appears on the document transferring seventy of his limnings, already mortgaged in 1700, to the Duke of Newcastle. The thirty of these which have remained at Welbeck Abbey, together with the three signed portraits of possibly separate provenance, constitute the largest single body of his work.[173] They indicate the extent to which, in his later years at least, Dixon's industry was devoted to the traditional business of court miniaturists, that of copying subject pictures by the old and modern masters. On the face of it, therefore, his career seems to have failed to develop in the same way as the rest of the miniaturists: rather than responding to the demand that a painting, especially a portrait, should be original and painted from nature, he remained it seems a less self-conscious artist, content to reproduce commercially the authentic statements of other men.

Dixon was, it is true, in some ways a very conventional miniaturist. He belonged solidly and centrally in the metropolitan school of the later seventeenth century, and his practice, both technically and iconographically, was typical. Thus he used gesso-prepared card supports for his vellum, he increased the size of his miniatures to the three inch oval around 1670; he used the standard range of pigments, the same balance between transparent and opaque colour, as had become established usage since the 1630s. Certain specialized usages such as his use of metallic gold in a literal and non-illusionistic manner, emphasized the technical lineage of his craftsmanship from Nicholas Hilliard. The conventionality of Dixon was actually the expression of the continuity of the art form from its origins in the legitimate Anglican Elizabethan monarchy into the revived monarchy of Charles II. The restored court used limning more or less consciously as an evocation of this Protestant legitimacy, so that in Dixon's conventionality and 'conservatism', there was a distinct political value.

Despite their common presence in the apostolic descent from Hilliard, Dixon could not have been a pupil of Hoskins. Simple chronology rules this out since Dixon, if he was born in the mid-1640s, would have been seeking tuition or apprenticeship shortly before 1660 by which time Hoskins had been inactive for many years.[174] I do not see in Dixon's miniatures either shyness or intimacy, but a definitively bold court style, analogous in that to

the Hoskins of the late 1620s, though not similar in technique or presentation. Hoskins, furthermore, had evolved from the hard grey stipple manner of the 1620s towards the softer polychrome stipple of the 1630s and early 1640s, and if there were any direct tutorial relationship between him and Dixon, some indication would surely have survived in the pupil's practice. Dixon, how-ever, from his earliest works of the 1660s used the red-brown hatching method of face-painting, with the harsher lines carefully blended with gouache into the orthodox carnation base. It was that style, in the small format adopted by Cooper in the 1650s in emulation of the enamel, that produced the 'soft undramatic modelling' noticed by Graham Reynolds.[175] Cooper's most smooth and blended phase developed out of this for the finished court miniatures of the 1660s, and it was in parallel to those that Dixon's style emerged as a positive and mature presence around 1670. On the technical evidence, therefore, Cooper was Dixon's master, and that was why Dixon succeeded to the king's limner-ship. He belonged unmistakeably in the tradition. He had the flair to produce a distinctive 'look' and the technical skill to be instantly recognizable as an initiate in the mystery of the art. Rather than the laborious and painterly Gibson or the brilliant Cross, he must have been the natural choice to succeed Cooper.

His development thereafter is difficult to describe with cer-tainty. Most of his dated works were from the two decades 1660–80.[176] Costume evidence for the late seventeenth century is also difficult to interpret, so there is no sense of temporal rhythm to the few works that can be assigned on other evidence to the period 1680–1700. Taking the oeuvre as a whole, however, it is possible to see some general direction of change in his style, other than a simple deterioration. Thus, Dixon was launched as the inheritor of Cooper's highly finished 'blended' style of the 1660s; he main-tained it through the 1670s, but responded increasingly to the movement towards larger ovals and a more sketchy instantaneous technique as the decade wore on (col. pl. 24b). The development was not, as it was in Cross's case, towards a more transparent, diaphanous treatment, but towards the scratchy graphic manner, the hatching strokes elongated and wiry like pen lines. It was the same tendency as in Flatman and Snelling, who seem to have been the progressives in this style, and Dixon's emulation of it probably marked his consciousness of the aesthetic prescriptions emerging in the culture of his peers and patrons. It is interesting that even as they developed a direct 'improviste' face painting technique, they maintained the lavish use of powdered gold as though consciously emphasizing the roots of the new style in the older tradition. In the 1690s, if the date of the *Unknown Man* supports the inference, Dixon's style became even coarser and more exaggerated, the whole tendency being towards a breakdown of harmony and propriety in the finished work, to stress presumably the creative passion of the artist. The risk, of course, of working quickly rather than slowly, carelessly rather than painstakingly, and broadly rather than finely – the risk in fact of presenting oneself as a genius

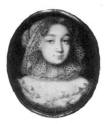

167. Nicholas Dixon, *A Woman wearing a Lace Head-Dress*, c. 1665, 28 × 23 mm. V&A P42–1941.

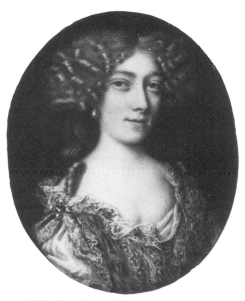

168. Nicholas Dixon, *Unknown Woman*, c. 1670, about 75 × 61 mm. Duke of Buccleuch.

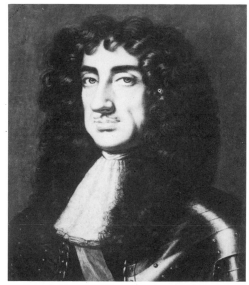

169. Nicholas Dixon, *Charles II* (detail), c. 1672, 256 × 204 mm. Formerly H. J. Pfungst Collection.

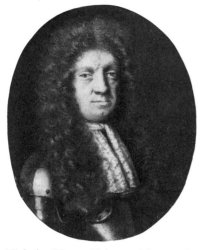

170. Nicholas Dixon, *Unknown Man, c.* 1690, 63 × 51 mm. V&A P24–1929.

rather than a conscientious craftsman – is a risk of obvious failure. This may be what happened to Dixon, and the 'incompetence' noticed by Vertue in the *Lady Henrietta Cavendish*, 'done by Dixon whose feeble work shows him aged then',[177] shows the effect of ambition rather than senile degeneration.

Dixon was striving towards that raw authentic discourse of genius that in one context crops up as the Royal Society style and in another as the 'violent driving on of the passion' of creativity. Though connected inseparably to one another within the culture of the Restoration élite, these manifestations of genius drew on distinct traditions. Thus Dixon reached the sense of himself as a creative being by relating his work to that of the masters, by seeing himself as the present representative of a whole long line of genius. He was, as well as king's limner, the keeper of the King's Picture Closet, and was thus engaged officially in the care and study of works of art. He was the custodian of the tradition, responsible for the transmission and renewal of the example of the Masters for the benefit of the present. A way of accomplishing this was through copying, an activity prescribed for all students of painting as a means to understanding and excellence in the art. The copies he made, moreover, were of the kind not only conducive to increased respect for the original, but which had been since the time of the Olivers treasured in cabinets as precious works of art in their own right. From the terms of his lottery it is clear that he did not share the prevailing view that a copy was not a 'proper' work of art: 'a collection of Pictures in limning not to be equalled anywhere if this collection falls into the hands of any person that don't understand them or will part with them they shall receive for them £2000 in Money of the Proposer'.[178] Clearly also he shared the fundamental respect for art as something that demanded understanding as a matter of intellect and intelligent appreciation in the consumer as well as the producer. The difference was that Dixon expressed his sense of the dignity of art by rehearsing the triumphs of the masters and implicitly thereby linking the present to the past. He was helping to build the frame of mind in which the modern artist achieved status by inheriting the prestige of the old master.

What is especially interesting about Dixon's later work is not only that it included a relatively large number of historical copies, but that they were marketed through a lottery. It is interesting in that it shows how close, even at the outset, art history (defining the self-consciousness of the artist) was to the art market (which assigned places and values to the work). Dixon's own statement gave an equivalent in money for the essentially non-monetary value that he claimed to distinguish in the works, and it implied that in a certain context the one could be expressed by the other. To us this is familiar enough because we understand that in our civilization there is a more or less regular correlation between 'importance' and money value in the arts, but in the late seventeenth century this potentially powerful economic reinforcement of the artist's position was not generally felt. Dixon of course failed to make his coup, and the lottery was just one more of the bubbles

floated on the vigorously expansive financial markets of the period. Strictly, the commercial analogies of Dixon's enterprise were the subscription lists of books and printsellers, and he was thus presumably trying to bring some of the market wisdom of the publishers – Tonson for example or Faithorne – to the apparently promising but under-developed picture business. He was breaking the link that had, since the renaissance, bound the painter to his patron, as he himself tried to pass from salaried dependence on the Crown to speculative production for a generalized and impersonal market.[179] And that afforded another reason for turning more towards subject pictures than to portraits. The portraits pre-eminently implied a commission and a peculiarly close, literally face-to-face relationship between artist and patron. Given the right environment, a sufficiently disseminated knowledge of art and its hierarchy of values, subject pictures, especially those images guaranteed by association with great names could open a new market. Thus copies gave the painter some control over his own economic future, while incidentally reassuring him in his relatively exposed commercial position with the sense of belonging in a profession. Dixon may have been trying to do too much, and the scale of the enterprise may have been too big, but there was judgment and enlightened self-interest in it.

For rather subtle reasons, therefore, I think that the ordinary perception of a link between Dixon's 'decline' and his commercial operations, was after all correct. Emphatically, however, the loosening of his style was not because of a corrupting influence from the market nor from pressure – as Hoskins had experienced within the commission system in the 1630s – to reduce quality to meet demand. The loosening of his style was most immediately caused by aesthetic factors, by the aspiration towards a recognizably brilliant and easy draughtsmanship and by commitment to values that were not intended to be commercial. Yet, as we have seen, Dixon occupied that very point in his society where those values found expression in commerce and drew on the power of money to confirm the prestige of art. There was, in other words, a profound sympathy between the market and the rising self-consciousness of the artist who was historically aware and who presented himself as a modern master; a profound sympathy between the market that put a price on expert status and the artist who expressed himself with that undisciplined and loose spontaneity that denoted the passionate authenticity of genius. What happened to Dixon may indeed have been a decline according to the connoisseur's judgment, but it shows how exceptionally responsive he was to the aesthetic–economic environment.

PETER CROSS (*c.* 1645–1724)

Although we now know very much more about Peter Cross than we did, and the chimerical Lawrence Crosse has, like D. Gibson, been laid to rest,[180] we still have an unclear idea of how he fitted

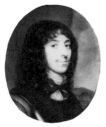

171. Anonymous, *Unknown Man*, c. 1665, 34 × 29 mm. V&A 637–1882.

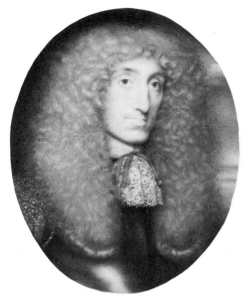

172. Peter Cross, *Robert Kerr, fourth Earl of Lothian*, 1667, about 75 mm high. Sotheby's, 11 July 1977, lot 140.

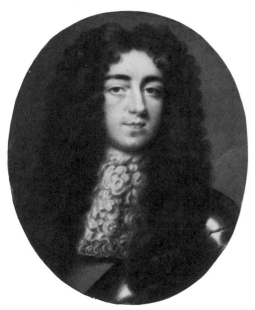

173. Peter Cross, *James Scott, Duke of Monmouth*, 1683, 78 × 64 mm. Welbeck Abbey.

into the world of the limners, and for whom he worked. Answers to these questions are inferential, but they seem plausible and consistent with what we know of the developing intellectual, social and political culture of the seventeenth century.

Cross's background is now firmly placed in the prosperous trading class, his father Anthony being a freeman of the Drapers, and his three elder brothers following in the same business. Peter was no older than six when his father died in 1651/2 leaving a substantial estate and making provision for his youngest son to be put into some suitable trade when the time came. Mary Edmond has suggested that he was put into Samuel Cooper's studio, a placement facilitated by the fact that Christiana Cooper, Samuel's wife, was also from a family of Drapers. She postulates close social relations between the households in Covent Garden.

This circumstantially is very plausible but should perhaps be qualified in at least one way. The first miniatures that we have by Cross, such as the *Unknown Man*[181] or the *Unknown Woman* (col. pl. 24c) of the mid-1660s, do not look like works influenced either directly or technically by Samuel Cooper. The polychrome stipple in the modelling of the faces is actually reminiscent of the elder Hoskins in the late 1630s and 1640s. Graham Reynolds[182] made this point forcibly in discerning the roots of the extreme stipple manner of Cross's maturity in works by Hoskins such as the *Catherine Bruce* (col. pl. 20), and it would be reasonable to suppose that there had been some contact. Furthermore, Cross's use of a landscape background in the *Unknown Woman* (col. pl. 24c) suggests that his idea of what a miniature should look like was formed to some extent by the example of Hoskins. On the other hand, as far as we can tell, Hoskins was not an active miniaturist around 1660, the time when Cross should have been learning the art. He could have been teaching without accepting or performing commissions for himself, but that is unlikely. What is possible is that Cross was taught abroad. The polychrome stipple manner occurs in French miniatures of the period and there is indeed an overall similarity in conception as well as in scale and colouring between the *Unkown Woman* and say the *Unknown Man*.[183] Vertue had a confused idea that Cross, or his name 'Le Croix', as Vertue gives it, had origins in France:[184] the hypothesis is that Cross may have spent part of his childhood or adolescence in France or the Francophone Netherlands, and picked up a style of limning which, on his return to England, fitted easily into the London profession, of which Hoskins was the elder statesman. The relative openness of taste in the Restoration court towards continental and particularly French models would have been especially favourable to him.

Cross was like Cooper a lifelong dedicated professional and his oeuvre alone rivals Cooper's in size and sustained vigour. He was extremely prolific and from the first he seems to have attracted good business. The *Lord Kerr* shows him working even at this early date for rising political stars, and no doubt other portraits by him as they are identified will confirm the eminence of his patronage. By the 1680s and 1690s he seems to have been easily the most impor-

tant miniaturist working in London, and to have cornered practi-
cally the best part of the market. The list of his sitters amounts to a
gallery of the social and political élite of the late Stuart monarchy.
The identified portraits by him at Welbeck, for example, include
the Duke of Monmouth, the Duke of Newcastle and the Duchess
of Albemarle;[185] he seems to have worked for the Duke of Lauder-
dale[186] and for the Duke of York who may have given to Lauder-
dale the portrait of Mary of Modena at Ham.[187] It was probably
through the household of the Duke of York that Cross gained
entry to the royal patronage. Gibson left London in 1677, and it
may be more than coincidence that the portrait by Cross in the
Fitzwilliam said to be of Mary of Modena is dated the same year.
Vertue saw a portrait of James when he was king,[188] so the
connection, if it was begun before Charles's death, bore fruit later.
In these years it was Dixon who was nominally the king's limner,
and the fact that Cross was actually picking up most of the business
probably reflects the fact that Dixon was putting his energies into
subject limnings rather than portraits.[189] In a special sense, Cross
not only continued Cooper's role of producing the finest court
images with a reliability and professionalism not attained by
Dixon, but under James and William III he virtually took on the
official mantle.

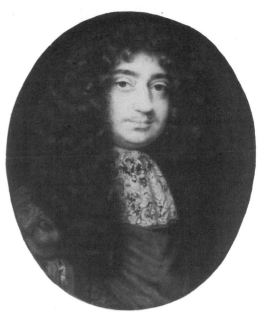

174. Peter Cross, *John Maitland, Earl of Lauderdale*, *c.* 1698, 80 × 65 mm. Ashmolean Museum.

In these later works Cross was clearly influenced by Cooper, and
there are cases where the effort to emulate him is almost palpable.
Significantly, however, even then Cross did not use the Cooper
technique to produce a Cooper-like effect. He used his own stipple
as in the *Lord Kerr* of 1667,[190] where the effect of bright blended
colour and strong lighting was built up in minutely careful poly-
chrome touches. It resembles and rivals Cooper's work without
imitating it. He seems to know the effect he is aiming at, but he
seems not to have been taught the original means of achieving it: he
seems to know his Cooper from the outside, rather than from
inside the workroom. The contrast is with Susanna Penelope Rosse
whose technique, although she learned her first manner from her
father Richard Gibson, became assimilated to Cooper's by direct
study. Cross was a formed artist it seems when he encountered
Cooper, and was evidently fitting himself to compete in a market
where the standards were set by Cooper. He evidently looked
carefully at the other successful miniaturists of the 1660s, at Gibson
and Dixon, but the *Lord Kerr* stands out as the epitome of the
inspirational influence that Cooper could have on a young artist
with the technical equipment and self-confidence not merely to be
an imitator.[191]

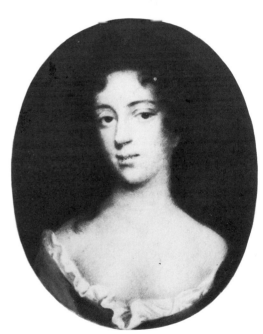

175. Peter Cross, *Mary Beatrice d'Este, c.* 1685, 85 × 68 mm. Ham House.

Cross's admiration for Cooper is evident from the number of
works by him that were sold with the rest of Cross's goods in
December 1722.[192] According to Vertue there were twelve, in-
cluding the portrait of Christiana, the presence of which in his
possession goes a long way to support the suggestion of close social
relations between the Crosses and Coopers. Perhaps Cross owned
works by Cooper for family reasons rather than as a collector and
connoisseur. Yet although from Vertue's account there was little

else in the sale to justify the normal view that Cross was a sub-stantial collector, he does refer to the objects as a collection, and, without giving an exhaustive account, he mentions a Holbein drawing as well as one or two other things of interest to connoisseurs. Cross's will furthermore refers to 'all my Shells and Rarityes whatsoever in my Cabinett standing in my Dineing Room',[193] and he must thus have thought of himself as the proprietor of important objects.

By the time Vertue met him he was an old man, probably too weak to live by himself, but he was the source of important information for Vertue. He gave the crucial information about the early history of Cooper's portrait of Cromwell.[194] Cross was the expert who had been charged with the task of cutting the sketch into an oval, and it was he who had to repair the portrait that was believed to be an original image of Mary Queen of Scots.[195] Putting these glimpses together, I think we can infer that Cross was, if not a collector in the grand contemporary sense applicable to a few artists, at least engaged in the same field. We can infer that he was a custodian of the traditions of art both as history and in knowledge of materials.

This side of him takes on a much greater significance in the light of another of his early portraits, the *William Gore* of 1670. It is extremely interesting that he should have known Gore, a distinguished historian and ecclesiologist of Middelburg and Amsterdam, or at least to have been close enough to him to have painted his portrait. It brings the world of Cross, the artists and connoisseurs, right up against the traditions of scholarship, partly arcane, that sought to uncover and exploit the harmonies of a unified animistic universe – into contact, in other words, with one of the intellectual traditions that underpinned the 'scientific' revolution of the period. Gore's interests, as they can be deduced from the titles of his publications, touch precisely the fields at issue here and show implicitly how art, in its potency of design and mystical richness of technique, could, within the broad intellectual landscape of later seventeenth-century natural philosophy, have a particularly important status. His books fall into three groups: drawing and painting; Jewish history and lore; and architecture.[196]

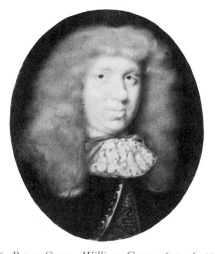

176. Peter Cross, *William Gore*, 1670, 62 × 51 mm. V&A P55–1935.

Gore must almost certainly have been a mason. The masonic myths draw heavily on the cabalistic traditions of Jewish scholarship, and identify the Temple of Solomon as enshrining in its geometry the comprehensive wisdom of elder days. Architecture, both conceptually and practically, was transmitted through the guilds of medieval masons who built the cathedrals. 'At some point, operative masonry, or the actual craft of building, turned into speculative masonry, or the moral and mystical interpretation of building.'[197] Similarly in these circles there was a readiness to allow the principles and practice of painting to have a moral and mystical value, to claim for the art of drawing in particular, if not quite the same compendious relation to all other knowledge that geometry and architecture possessed, at least a role as originator: Thus Gore wrote:

> The Art of Drawing . . . may justly be called a bearing Mother
> of all Arts and Sciences whatever . . . the Art of Drawing is the
> Beginning and End, or Finisher of all things imaginable, where-
> fore she may be called a Sense of Poesie, a Second Nature, a
> Living Book of all things past. She is called a Poesie, because that
> she thorow falshoods and masked faces, represents unto the
> Beholder the Truth of all things present and past . . . A Second
> Nature she is called, because she teacheth thorow Drawings to
> imitate and to set forth all the Works of the Creation. A Living
> Book she is called, of things present and past; because that she
> brings into remembrance to the beholder of her, things long
> since past . . . and more than this, she brings to remembrance the
> deeds of People and Nations, dead long since; and the features
> and resemblance of our Fathers, Grandfathers, and great Grand-
> fathers, she represents as living in dead shades long after their
> time.
>
> The Art of Drawing doth consist in this . . . that she . . . doth
> express in plain, as if they were really those things which they
> only represent.[198]

Such sentiments were, by the late seventeenth century, fairly
well established as the conventional wisdom, present in Peacham,
Norgate or Sanderson as much as in the masonic ideology of Gore.
What is important about the case of Gore is that it shows how
much a part of the intellectual landscape of scholars and philos-
ophers the art of painting was. We have seen how the empiricist
natural philosophers respected craftsmen for their plain speech and
technical know-how, and how the passion for practicality lay thus
close to the intellectual origins of the Royal Society.[199] The case of
Gore shows how there was a separate (or not quite separate) strain
leading to the same result among speculative and mystical in-
tellectuals whose habitual thinking attributed symbolic values to
the tools and productions of craftsmen. For them it followed easily
to extend the significance of the architect, with some qualification,
to the artist, and by mobilizing the renaissance idea of drawing as
the fundamental tool of all the arts and sciences, they gave to the
artist a vital role in their world view. They helped, by a purely
mystical attitude to his powers, to establish the artist as a leading
exponent of the modern intellectual culture.

Possibly Cross was a mason himself, but not, like Gore, one of
the basic theoreticians and scholars of the movement. Given that he
was a practical man, and respected for that within his culture, his
interests in the history and expertise of art were unlikely to have led
him far from the rationalist mainstream of London thinking.
Given also the dependence of limners on the Royal Society culture,
their similar historical antecedents and their stylistic convergence
with its aesthetic precepts, Cross would have found conformity
inevitable. Especially his putative connection with freemasonry, or
with those who thought in a comprehensive masonic style, would
have strengthened his sense of belonging to the dominant culture,
since there was a significant overlap between the early masons and

177. Peter Cross, *Mr Carter*, 1716, about 77 × 63 mm. Daphne Foskett.

178. Bernard Lens, *Robert Dudley, Earl of Leicester*, 1723. Welbeck Abbey.

the founders of the Royal Society, both groups drawing on the same intellectual traditions and aspiring to a similar definition of the public good.[200] Anti-speculative doctrine in the Royal Society did not shut out Robert Moray or Elias Ashmole, and within the 'broad church' attitudes of these people a powerful sense of cultural homogeneity was evidently fostered.

Economically, it was his participation in this culture that provided the continuity in Cross's career, as in that of other professional artists, scientists and scholars, across the changes in regime from the 1650s through 1688. Cross was living in Henrietta Street, the heart of intellectual London, and during the years of his main output he must have been building up his presence as a connoisseur, collector and creative artist in his relations with his clients. He must have been perceived as solidly and prosperously a member of the metropolitan élite, an apt servant of the aristocratic parliamentary culture in the metropolis which had brought back the monarchy and could change the regime at need. Thus Cross's early connection with the Duke of York led on smoothly after 1688 to work for William of Orange. The flow of patronage from the ruling magnates did not falter because the fundamental identity of the ruling élite, Anglican and enlightened in the Elizabethan tradition, did not change. As in 1641 or 1660, the important thing was to be in London where the culture was and where the money remained.

Cross died at the beginning of 1724.[201] It is hard to date the costume of the late seventeenth and early eighteenth centuries, and Cross's style after about 1680 remained almost constant, so one cannot speak confidently of stylistic development or decline. It is impossible to be sure that some of the works traditionally or intuitively assigned to the decades 1680–1700 are not rather later. The *Lady Katherine Tufton* (col. pl. 24f) is known to be of 1707 merely on the strength of Cross's inscription, and on style alone it might otherwise have been assigned to *c.* 1685. Probably after about 1710 his activity declined. Maybe since he was in his sixties, his hand had lost some of the delicacy and precision fundamental to the stipple style, but the *Mr Carter* of 1716 is not actually inferior to his best work and could surely have maintained a place in the market. By this date, however, his work must have seemed sophisticated and degenerately unfocussed by comparison with the bright hardness of the historicizing naïve school of Lens, the formation of which was due quite largely to the cult of art history in which Cross had been a leader. Cross presumably retired slowly, declining into weakness and ill health around 1720. When he made his will on 9 June 1721 he was 'weake in body', but he was not, like the limners who had relied on the payment of official salaries, impoverished. His sale was probably occasioned by his giving up Henrietta Street and going to live with his youngest daughter Elizabeth. While there, Vertue caught up with him, an old man reminiscing about Cooper and Cromwell, himself the historian displaced ironically by the historicizing Young Turks of the new generation.

4

———••€]-(3••——

Miniatures on the Market

THE EIGHTEENTH CENTURY

THE EIGHTEENTH-CENTURY began rather auspiciously. Internal
disruptions caused by political disaffections were momentarily
abated by the death of James II in France in 1700. The decisive
early victories of the Anglo-Austrian alliance in the War of the
Spanish Succession signalled the end of French hegemony on the
continent. England and Scotland united to form Great Britain and
a constitutional monarchy began to cohere. The first decade of the
new century also witnessed the birth of Samuel Johnson and the
publication of Alexander Pope's *Pastorals*, the first volume of Sir
Hans Sloane's monumental natural history of the West Indies, and
the first English encyclopaedia. Sir Godfrey Kneller and Michael
Dahl were at the height of their popularity as portrait painters,
while the finest cycles of English baroque history painting were
begun by Antonio Verrio, Louis Cheron and Sir James Thornhill.

Foreign artists dominated the visual arts in England, and minia-
ture painting ceased to be an exception to this pattern. The native
artists who had sustained the tradition of Nicholas Hilliard into the
last quarter of the seventeenth century gradually disappeared from
the scene: Gibson died in 1690; and Nicholas Dixon, who had
mortgaged his collection of miniatures in 1700, eased into retire-
ment.[1] Of the English miniaturists whose careers antedated the
reign of Queen Anne, only Peter Cross continued to flourish. The
demand for miniatures burgeoned, however, and while Cross
obtained a substantial portion of this business, an even larger share
went to foreign artists recently moved to London. Many of these
foreign miniaturists took advantage of connections made with the
English aristocracy during the war years, others were encouraged
to immigrate by the Hanoverian court or by the reported success
of fellow artists and countrymen, such as Dahl. It is difficult to
determine if the activity of foreign miniaturists in London actually
suppressed the emergence of indigenous talent or whether shifts in
aristocratic taste, such as the increasing predilection for enamel
painting, caught the native school unprepared; in contrast to the
rest of Europe, England produced no enamelists of note in the late
seventeenth century. Regardless of the exact reasons for the pre-
dominance of foreign artists, these miniaturists brought with them
new technical skills, and an international court style that well
suited the cosmopolitan airs of their new clients.

Much of the literature on the subject has treated the first four decades of the eighteenth century as a low point in the history of English miniature painting. Even an astute critic of the period felt justified in claiming that its miniaturists 'degenerated into little Knellers, Jervases, and Hudsons, insipid and characterless'.[2] Recent exhibitions have helped greatly to dispel a long-standing prejudice against English late baroque portraiture in oil, although condescending generalizations and a marked lack of documentation still obscure the brilliant achievements, both aesthetic and technical, of many miniaturists of this period. In this age of Augustan formalism, conformity of manners, dress and appearance were more important than probing character studies; the expressionless ovoid masks of the baroque portrait were the norm, and naturalistic detail was decried as caricature.[3] In assessing the achievements of this period, a tolerance for the stylistic preferences of the day is required. Other factors, such as an ever increasing demand for miniature replicas of large-scale portraits and an expanding base of patronage, must also be taken into account. Miniature painters had always executed replicas among their work, but in the early eighteenth century this practice became an industry. Some artists, like Louis (d. 1747) and Joseph (c. 1680–c. 1768) Goupy, specialized in this type of work, while almost every miniaturist divided his time equally between *ad vivum* portraiture and copies after other painters.

Like mezzotint engraving, which also flourished at this time, enamel painting was a laborious and methodical technique perfectly suited for reproducing the fixed design of a painted portrait. Replicas are often spiritless affairs, however, and it is very difficult to appraise fairly an artist's talent as a portrait painter when the nature of his model is uncertain.[4] Furthermore, miniaturists of this and later periods as well were admittedly guilty at times of uninspired performances as a result of increased demands for their services. The foremost enamelist of the period, Christian Frederick Zincke, was occasionally criticized by his contemporaries for making his sitters resemble each other or, more precisely, a stereotype based on a socially accepted pictorial form. Even his staunchest defender was compelled to admit that he had 'that bad habit, which painters call *manner*; but it is a common defect with artists who work quick, to be over greedy of money, and too desirous of being single in their profession'.[5] Since most miniaturists could, and did, produce more portraits in their careers than most oil painters, such 'bad habits' were inevitable, and almost every fashionable miniaturist from this point onward would be similarly accused. But setting aside the replicas and the hurried studio productions that are endemic to eighteenth-century practice, there remains a substantial corpus of superlative work that deserves recognition.

With the exception of Cross, the foremost painter of portraits in little active in London at the turn of the century was the enamelist Charles Boit (1662–1727), who migrated from Stockholm to England in the late 1680s with the help of a fellow Swede, Michael Dahl.

His earliest identified enamels of English sitters, dated 1693, portray Captain Gervase Scrope of Cockerington, Lincoln, and his wife.[6] They are conventional portrayals in the international style of the Petitots. Another miniature of 1693, painted at Coventry, confirms that his initial practice was not confined to London.[7] Boit rose quickly to prominence and by 1696 was court enameler to William III. After a brief return to the continent, from which he was driven back to London by the wars, he resumed his most favoured status in the court. Queen Anne, perhaps at the suggestion of Robert Harley, first Earl of Oxford, commissioned from Boit an enamel of monstrous proportions (24 × 16 inches) to commemorate the Blenheim victory. Although Boit had managed a successful (10 inch) enamel portrait of Prince George of Denmark and Queen Anne in 1706 (Windsor), an enamel the size of the Blenheim allegory was virtually impossible technically. It was never completed, and the progress of the charade and duplicity of the artist in prolonging royal payments for the commission is fully recounted by Vertue.[8] Eventually his creditors demanded recompense and Boit fled to Paris where he died. Technically of a very high quality, his English work (col. pl. 28c) is characterized by soft modelling with a minute blue and green stipple and the use of a slightly hot range of browns for the linear accentuation of facial features. His approach to character appears analogous to that of Dahl, although after his flight to France he assimilated the more flamboyant court style of Rigaud and Largillière. Despite his personal failings, Boit succeeded, primarily through the patronage of the court and the Earl of Oxford, in establishing in England a taste for enamel painting that would be further advanced by the Hanoverian court and copiously gratified by his principal student, C. F. Zincke.

Boit was probably responsible for persuading another Swede, Christian Richter (1678–1732), to move to London in 1702. Although trained as a goldsmith, as was Boit, Richter specialized in watercolour and body-colour miniatures painted on vellum. He had considerable business in copying the works of Kneller and Dahl, and, as this was the great age of collecting ancestral and historical portraits of all types, in replicating seventeenth-century pictures. His manner was consistent throughout his career, although the size of his miniatures generally increased toward the end of his life. His early portrait of Eleanor Brownlow (col. pl. 25e) of 1709 shows the influence of Dahl in the disposition of the figure and, as Walpole noted, in its strong coloration.[9] In painting the features, Richter began with a pale carnation over which he laid a cluster of blue dots and small hatches in the areas of deepest shadow. The lips and the lines and creases of the flesh were painted with a rich reddish-brown. This colour was also used, in fine regular lines mixed with touches of yellowish-green, to enrich much of the complexion. On the scale of the Brownlow portrait, the overall effect of this coloration is very natural. A later portrait, of Dr John Radcliffe,[10] is much larger, and, although copied from a Kneller painting, owes little to that artist in the crispness of its

179. Charles Boit, *Captain Gervase Scrope and his Wife*, 1693, 45 mm high. Sotheby's, 17 May 1976, lot 71.

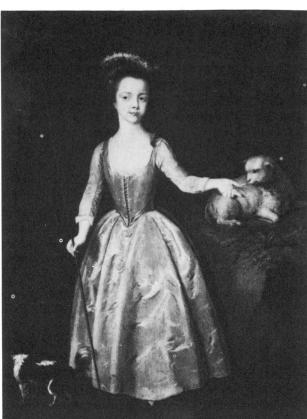

180. Christian Richter, *Dr John Radcliffe*, 1719, 115 × 94 mm. V&A 478–07.

181. Christian Richter, *Lady Margaret Cavendish Harley*, c. 1721, 153 × 115 mm. Welbeck Abbey.

drawing and the flush of its tints. In this later example, Richter employed a more elaborate technique of blue, yellow and green stipple, mixed with thin, evenly spaced lines of blue and reddish-brown. This more developed technique undoubtedly owes something to the increased size of this piece and perhaps to the example of Peter Cross, although, as Vertue noted, Richter's 'manner was peculiar to himself'.[11] His neat, regular drawing Vertue attributed to his earliest training as a metal engraver. It is an interesting correlation, for a number of artists at this time were enjoying financial success with plumbago (black lead) portraits on vellum, a medium also clearly influenced by and deriving authority from engravings.

According to Vertue, Richter suffered towards the end of his life from 'venereal distemper' which disfigured his face and consequently diminished his practice in *ad vivum* portraiture. A number of full-length copies after Dahl and Kneller, including his portraits of Lady Margaret Cavendish Harley of *c.* 1721 and Mrs Eliot of 1726,[12] suggest that he increasingly devoted his time to copying, although, like other artists of the period, the 1720s in particular, he painted these large cabinet miniatures to satisfy an obviously widespread demand. The Earl of Shaftesbury's opinion that miniaturists should confine themselves to heads alone – 'for bodies would be mere puppets and ridiculous'[13] – was not the public consensus.

Another foreign artist who worked exclusively in watercolour and body-colour on vellum and might be said to rival Cross and

Richter at their best was Benjamin Arlaud (fl. 1701–17). The younger brother of the miniaturist J. A. Arlaud (1668–1746), Benjamin (or Benoit) is said to have died in London in 1719. Little is known of this Genevan and the exact date of his arrival in London is disputed. His earliest dated work is a portrait of William III of 1701, but there is no evidence to confirm that this was painted in London or from life. His portrait in miniature of Poncette de la Vivrais (1703)[14] was probably executed on the continent. His last miniature is said to depict the Duke of Rutland and is dated 1717. On the basis of signed examples, Arlaud in all likelihood arrived in London between 1704 and 1707, and most of his identified miniatures are dated, or can be dated, to the next ten years. That he travelled back and forth between London and the continent is almost certain. He was well patronized by the Duke of Portland and the Earl of Oxford, and the Blenheim victory of 1704 brought him commissions for a series of martial portraits of Marlborough, Prince Eugene of Savoy, and a number of their principal English officers. Five identical miniatures of Prince Eugene and three of Marlborough have survived. Of the same type are his portraits of Baron North (Yale) and the Duke of Kingston-upon-Hull (col. pl. 25g); the latter miniature is dated 1704. Two pendant portraits of the Duke and Duchess of Portland by Arlaud are dated 1709, and the rubbed miniature of a lady, said to be Elizabeth Knight (Yale), can be dated to approximately the same year on the basis of costume.[15]

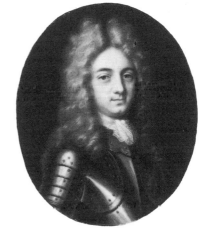

182. Benjamin Arlaud, *Henry Bentinck, first Duke of Portland*, 1709, 58 × 46 mm. Welbeck Abbey.

These, and other surviving examples, evidence a genuine and highly accomplished master. With his crisp, tight delineation of a sitter's features, he approaches the style of Richter, but his free massing of the hair and textured treatment of the backdrop for the head exhibit painterly qualities alien to the more fastidious Swede. He modelled his faces with an elaborate technique of hatchings applied in short, regular strokes: green, yellow and blue for the shadows, pale red over a delicate carnation for the lighter areas. He occasionally left an exposed patch of vellum for the highest lights. Although easily recognized, it is likely that many of his works today masquerade as the productions of Richter. In his portraits of women, Arlaud too frequently adopted the baroque formulae made popular by Dahl, but in his male portraits there is generally a directness and simplicity of presentation that is both ennobling and engaging. Perhaps more than any other miniaturist of the epoch, he successfully unites the gracious decorum of the continental school with a literal transcription of character that is an essentially English inclination.

The most influential foreign artist active in England for a protracted period was Christian Frederick Zincke (1683/4–1767). The son and apprentice of a Dresden goldsmith, he was brought to London in 1706 supposedly to help Boit. He studied with Boit and probably set up on his own as an enamelist after Boit's hasty departure in 1714. He was certainly one of the finest enamelists to work in England since Petitot, whose works he avidly collected, and he dominated the field of portraiture in miniature well into the

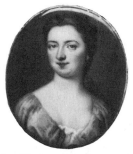

183. Christian Zincke, *A Woman, perhaps Arabella Fermor*, 1716, 38 × 33 mm. V&A P106–1922.

1750s, thus providing an important link between the ages of Kneller and Reynolds. Zincke was an extremely prolific artist and a good portion of his later portraits are from life. Two early enamels, the *Grafton* (col. pl. 28c) and the so-called *Arabella Fermor*[16] of 1716, are both modest in scale. The flesh tones are cooler than those of Boit and there is little discernable stippling, the red, yellow, and blue tints being well blended. The lips are painted in two different, but closely related, shades of red, and as is common in his early practice, he left a crescent of white enamel ground exposed under the eyes for highlights. A bold facture in the draperies nicely animates the small oval surfaces. His earliest works are in the baroque idiom, but as he progressed into the century his interpretation of character became more casual under the influence of Mercier and Highmore. His range of colours remained essentially the same, although in his later works he suppressed his highlights with a purplish tint and aimed at an even smoother surface.

In the late 1720s Zincke's eyesight began to deteriorate, and although he limited his practice after 1737 he remained active until his death. Possibly as a result of his affliction, his later miniatures often exhibit an obtrusive red stippling over the face. In 1732 he was made enamel painter to George II, which effected an immense increase in his business and also attracted the antagonism of Mercier. That he could maintain his pre-eminent position at court indicates the high esteem that was accorded both his talents and the type of portraiture which he practised.[17] His contemporary André Rouquet (1701–58) claimed that he had no pupils, but it is improbable that many of the native enamelists active in the second quarter of the century, and Rouquet himself, did not at some point assist in his studio. It is certain that he instructed Jeremiah Meyer in enamelling after 1755. Like most miniaturists of the period he benefitted from the generous patronage of the Portland–Oxford families.[18] Some of his finest extant pieces are the family portraits executed in the late 1730s and early 1740s for William Bentinck, second Duke of Portland (1709–62). The quality of Zincke's enamels is uneven, owing to his prodigious output, his likely use of studio assistants, and probably his eye ailments; it is hazardous to attribute unequivocally to his hand even signed examples. At his best, however, he is a conservative but estimable portrayer of character, a fine draughtsman, and an excellent technician in a frequently intractable medium.

If Zincke and his foreign colleagues monopolized the trade in portraits in little during the first forty years of the century, they were not without some competition from native-born artists. William Prewett (fl. 1733–50), an enamelist of obscure origin but said to have been a pupil of Zincke, painted some excellent portraits in the 1730s. A portrait of George Keate, reportedly signed and dated 1733, was exhibited at South Kensington in 1865. His portrait of Horace Walpole of 1735 exists in numerous versions[19] and there is an impressive group portrait by him after Vanderbank in the Victoria and Albert Museum. His enamel portrait of Mr

Newsham (col. pl. 28e), one of the sitters in the group portrait, is dated 1736. In this example, his colouring is more naturalistic than Zincke's and he simulates a very accurate flesh tint. The strident pose, if not borrowed from a lost Vanderbank oil, demonstrates a daring and original talent, as does his candid portrayal of an unidentified gentleman that was on the London art market in 1977.[20]

Two other enamelists of note who worked closely in Zincke's style in the 1720s were Abraham and Noah Seaman, the former's enamels distinguished by his excessive enlargement of his sitter's eyes, the latter's by his somewhat blocky modelling of the head and his skill in subtly differentiating the textures of garments. Vertue informs us that the enamelist Johann Zurich (*c.* 1685–1735) was driven from the field in the 1730s by Zincke's meteoric rise in popularity; the relative scarcity of the Seamans' works after about 1730 suggests a similar fate.[21]

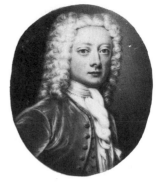

184. Noah Seaman, *Unknown Man, c.* 1730, 48 × 38 mm. V&A P17–1934.

During the second quarter of the eighteenth century, when Zincke was at the apex of his popularity, the aesthetics of English portraiture were gradually changing. Shifts in taste, brought on by an ever broadening spectrum of potential patrons and the gradual assimilation of new foreign styles, eventually humbled the impersonal Augustan manner. Formal portraiture in all media was becoming the art of a whole society and not the prerogative of a court, a development that encouraged a more genial intimacy and an unaffected interpretation of character. The miniature, the most intimate of all portrait types, inevitably gained from this progression. Miniature portraits painted from life began to outnumber noticeably those copied from oil paintings, and the less stilted vision of Hogarth, Highmore and Hayman is evident to some degree in the works of all the miniaturists active toward midcentury, including Zincke. The new sentiment, insofar as it dictated the approach that was to be taken in the portrayal of women, was assessed by one miniaturist: 'If [artists] were able to paint character as well as form, they would draw an excessive decency in manners, in discourse and in dress; a modesty delicate, tempting, and witty, and sometimes an air of innocence extremely engaging.'[22]

The miniatures painted during the decades 1740–60 are distinguished not only by the unpretentiousness of their styles but also by the modesty of their scale. Measuring on the average one to two inches in height, they are not uniformly smaller than many painted in the preceding decades, but there are conspicuously fewer attempts to work on a large scale at this time. In George Vertue's self-portrait with his wife of 1720,[23] the walls behind are covered with large, framed miniatures and engraved heads, a profuse public display of social and political affiliations that, for the generation nurtured on the sentimental prose of Richardson and the rational taste of Allan Ramsay, must have seemed excessive. The discreet wrist bracelet, the small, easily cached locket, and the inner lids of snuff boxes now became the preferred settings for miniatures.

It was during this period that the domination by foreign minia-

turists ebbed. The native tradition re-asserted itself, and water-colour painting on ivory gradually supplanted enamel painting in the public's favour. The most notable artists of this period were almost all native-born, and those who practised enamel painting did not do so exclusively, but rather were equally proficient with watercolours. One of the most successful artists to emerge at the beginning of this period was Gervase Spencer (d. 1763). Little is known of Spencer's early career, except that he began it rather inauspiciously as a footman. According to Vertue, he was self-taught, but it is unlikely that the technical expertise required of enamel painters could have been acquired unassisted. His earliest enamels, which date from 1740, are so similar in style and execution to those of the French artist Rouquet that it is reasonable to assume he learned from him. As an enamelist, Spencer did not alter his technique throughout his career. In contrast to the mannered red stippling frequently encountered in Zincke's late works, Spencer, like Rouquet, painted with a neat stipple technique that blends smoothly and almost imperceptibly the facial tints – primarily pastel pinks and yellows with discreet accents of blue.[24] Spencer employed a similar touch in his contemporary watercolour miniatures. His characterizations, especially those of the 1750s, are often tender, and of the miniaturists of this period, he approximates most nearly Allan Ramsay's delicate sensitivity to feminine grace. His pastel range of colours is ultimately French in origin, and he had his principles of colouring confirmed in the works of Jean-Antoine Liotard. Liotard's pastel portraits, executed during his first visit to England in 1753, created a sensation in London, especially those of women in Turkish costumes. Spencer both copied and borrowed poses and costumes from these portraits (col. pl. 28f), although the dramatic lighting favoured by Liotard and his inexorable realism are only infrequently encountered in Spencer's enamels.[25]

The second major enamelist of this period was Nathaniel Hone (1718–84), one of the earliest of a rapidly emerging school of Dublin miniaturists. Hone began painting in enamel shortly after settling in London about 1742, and for about a decade produced his best work in this medium. Although he painted portraits in enamel and watercolour until 1770, it is apparent that after he trained his attention on oil painting around 1760, miniature painting became a matter of aversion to him. At the outset of his career, his enamels were neatly and crisply drawn, his modelling of the face achieved by a minute and attentive stipple, and his colouring strong but well balanced. He had less poetry than Spencer, but his frank characterizations are convincing, and, at his best, he graced his sitters with a natural ease. By the 1760s Hone had introduced in his technique a deep brown for shading and a blotchy stippling method comparable to that employed by fellow Dubliner Rupert Barber (fl. 1736–72) and the elusive enamelist James Macpherson (fl. 1740s). Much of this later work has a coarseness and riotous colouring that detracts from an otherwise genuine talent for portraiture. In a letter to her husband of 9 May 1769, Dorothy, Duchess of Portland, reported: 'Dr. Hinchliffe . . . says he does not

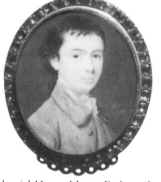

185. Nathaniel Hone, *Master Earle aged 15*, 1758, 38 × 32 mm. V&A P4–1958.

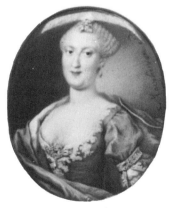

186. James Macpherson, *Unknown Woman*, 1750, 51 × 42 mm. V&A P154–1929.

know anybody that enamels well. Hone he thinks the best, but cannot recommend him as a capitol one by any means. It was Hone who did the picture of my brother which I wear on a bracelet, and surely that is a most shocking thing.'[26] Hone's inattention to the rigours of enamel painting signal his waning interest in this medium, a weariness shared by the public as well. Although Jeremiah Meyer, Edward Shiercliffe (fl. 1765–86), J. H. Hurter (1734–99), and Henry Spicer (1743–1804), a Spencer pupil, produced enamels of exceptional quality during the last decades of the eighteenth century, the enamel became increasingly less popular after mid-century for *ad vivum* portraits. When enamel painting was revived in the nineteenth century, impressive technical innovations were introduced, but the medium was reserved almost exclusively for copying paintings in oil.

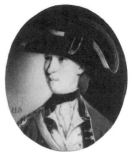

187. Henry Spicer, *A Captain of the Grenadier Guards*, c. 1775, 40 × 33 mm. V&A Evans 299.

Although English artists were not terribly competitive in the field of enamel painting before 1740, and although enamel painting threatened to annihilate the indigenous tradition of miniature painting in watercolours at the beginning of the century, one native artist sustained the school's vitality by radically altering its techniques and direction. This artist was Bernard Lens III (1682–1740), the son and grandson of artists of the same name. He probably learned the rudiments of miniature painting from his father, although his earliest works exhibit a remarkable facility that cannot be credited to that tuition. His earliest surviving work, a portrait of the Rev. Dr Harris, is dated 1707 and was painted from life. This example is of particular importance as it is the earliest known miniature by an English artist painted in watercolour on ivory.[27] The introduction of ivory as a support for miniature painting, one of the most important technical innovations in the history of the art, has been traced to the practice of the Venetian miniaturist Rosalba Carriera (1675–1758), who, just prior to the turn of the century, merged her miniaturist painting technique with an existing tradition of ivory snuff box decoration.[28] The standard early Rosalba portrait is a half or three-quarter length figure in a slightly elongated oval. Backgrounds are often, but not invariably, solid grey and the face is sparingly modelled in grey and blue applied in transparent hatches over the ivory. The hair and drapery are freely and boldly treated in bodycolour, and baskets of colourful flowers are occasionally introduced for decorative effect. The contrast between the thinly painted flesh areas and the opacity of the remaining surface gives a seductive warmth and presence to the countenance that is not found in the highly wrought miniatures on vellum by Arlaud and Richter.

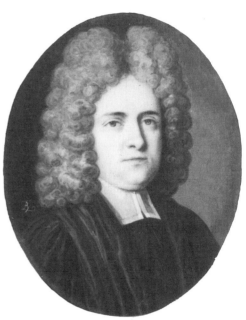

188. Bernard Lens, *The Rev. Dr Harris*, 1707, 81 × 64 mm. Yale Center for British Art.

Lens's technique of painting on ivory is frequently so close to that of Rosalba as to preclude any notion that he was not initially inspired in this direction by examples of her work. One miniature of an unidentified lady is so reminiscent of the Rosalba type that it might be a copy after her. What is significant in Lens's first work on ivory, which is also his first dated miniature – *The Rev. Dr Harris* – is that, while it aims at the general effects of Rosalba's new manner, it differs from her work in a number of salient respects.

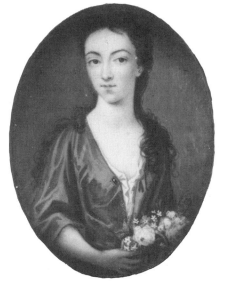

189. Bernard Lens, *Unknown Woman*, c. 1715, 76 × 56 mm. V&A Evans 156.

COLOUR PLATE 31 (following colour page)

Richard Crosse, *Mrs Siddons*, 1783, 174 × 133 mm. V&A P146-1929.

The face of the sitter, for instance, is more extensively modelled with transparent colours applied in short hatches and by stippling; furthermore, these tints are flesh coloured, in reds and browns, with blue and green only sparingly touched to the deepest shadows. This more naturalistic colour range and descriptive definition suggest that Lens was, at this early stage, equally interested in the work of Cross. It is this merging of an essentially English style with technical importations that set in motion the next two hundred years of development in English miniature painting.

As Lens's career progressed, his style became more mannered. The robust coloration of his earliest work was eschewed in favour of Rosalba's cooler blues and greens. His connection, through his father, to the Earls of Oxford assured him regular employment,[29] and he was especially prolific as a copyist of old master paintings. In addition to copying miniatures by Holbein and Hilliard, he also adopted, in some of his portraits, their solid ultramarine backgrounds. This conscious archaizing was certainly calculated to appeal to his connoisseur patrons (col. pl. 29a&b). Since he was not an accomplished figure draughtsman, it is unfortunate that he succumbed so frequently to the temptation, or the pressure from clients, to paint on a large scale.[30] In disposing his figures, he continued to borrow attitudes from Kneller well beyond an excusable point in time, yet in his late self-portraits and portraits of his family, he was extremely sensitive to individual character, producing works of exceptional quality and appeal.

As miniature painter to George I and George II, Bernard Lens received no salary, 'having nothing but the bare title', but his appointment certainly enhanced his practice both as a miniaturist and as a drawing master. He taught drawing to Horace Walpole as well as to members of the royal family and the daughters of the nobility. One close imitator of his miniature style, who deserves passing mention as a likely student, was Sarah Stanley (c. 1697–1753). The daughter of Sir Hans Sloane, the king's physician, she excelled, from the mid-teens, in copying Rosalba, Hilliard, and such popular Dutch-Italianate landscape and allegorical painters as Poelenburgh.[31]

Lens's most important disciples were his two sons, Andrew Benjamin (c. 1713–after 1779) and Peter Paul (1714–after 1750).[32] Though christened to honour Rubens, Peter Paul is remembered for his roguish exploits, utter lack of diplomacy, and prowess at self-advertisement. His earliest surviving work, a pen drawing of a human head with canine features (1728), suggests a sinister and malevolent character.[33] Peter disappears from the scene about 1750, while his older brother enjoyed success as a miniaturist well into the 1770s. Both artists practised a variety of styles, more or less within the orbit of their father's. Both occasionally employed vellum, but were at their best in the 1740s when painting on small ivories.

Andrew's *Peg Woffington* (col. pl. 29f) of 1744 is perhaps his finest work with its muted silvery radiance, controlled stippling and natural flesh colouring. Compared to Peter's *Unknown Woman*

(col. pl. 29d) of the same year, Andrew's example exhibits a more acute instinct for the placement of the bust in the oval and a more accomplished technique in the modelling of the features and in the simulation of fabrics. Although Peter often lapsed in his structuring of a head – to the extent that many of his sitters appear to suffer a cranial deformity – his modelling of female features, particularly when he painted on ivory, is softer and more delicate than his brother's. Both artists preferred to set the head against a dark background hatched in a peculiar manner that can best be described as resembling a large-grained aquatint, a mannerism adopted from their father. Andrew often surpassed both of his relations in his ability to graduate tones in these backgrounds and consequently to increase the illusion of plasticity.

The 1750s was a critical decade in the history of the English ivory miniature. Hone, Spencer and Andrew Lens had established practices. Samuel Collins, Penelope Carwardine (*c.* 1730–1801), Luke Sullivan and Gustavus Hamilton (*c.* 1739–75) made their first appearances while the foremost practitioners of the next half-century were all students. One sees in this formative decade the re-establishment of a truly national school acting in concert with a singleness of perspective that had been lacking since the late seventeenth century; the remarkable consistency of style during this period has made the attribution of unsigned miniatures difficult. Hogarth's assistant, Luke Sullivan (1705–71), most thoroughly assimilated the French rococo figural style then being disseminated by Gravelot and his English pupils. Most of his colleagues embraced the Lens style, but imbued it with greater eloquence and naturalism. One of the more attractive performers of this period was Samuel Finney, who sacrificed a law career in the late 1740s to practise miniature painting. He exhibited with the Society of Artists from 1761 to 1766, and he was appointed miniature painter to Queen Charlotte in 1763. His portrait of the queen (col. pl. 29c), the face modelled with a minute blue stipple and the overall coloration a cool silvery-blue, manifests clearly the refinement which these artists brought to the Lens manner. Samuel Collins (*c.* 1735–68) began painting miniatures about 1750, passing much of his career at Bath, which was becoming a provincial centre for portraiture in miniature and pastel. The habitually vituperative critic Anthony Pasquin, in a rare show of sympathy, described Collins as 'one of the most perfect miniature painters that ever existed in the realm'.[34] Collins's miniatures often resemble those of Spencer who, in the 1750s, developed a manner of painting in watercolours on ivory that was more consistent with the demands of this medium and totally distinct from the decorative style that he employed in enamelling. Both artists allowed a considerable amount of ivory to show in the face, shading with vigorous hatches of greyish-brown, pale blue and a modicum of red. Both utilized a new technique of scratching through, or scraping out, areas of paint in the hair or shadows to strengthen the definition of the smallish heads. The quality of Spencer's watercolour miniatures is more variable than that of his enamels, but Collins was an

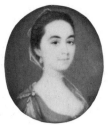

190. Penelope Carwardine, *Unknown Woman, c.* 1760, 32 × 28 mm. V&A 412–1907.

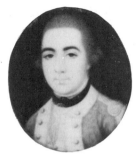

191. Gustavus Hamilton, *Unknown Man*, 1769, 38 × 32 mm. V&A P4–1971.

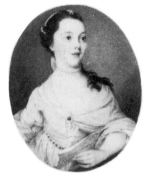

192. Luke Sullivan, *Unknown Woman*, 1760, 44 × 35 mm. V&A P30–1941.

193. Samuel Collins, *Captain Bury*, 1763, 35 × 30 mm. V&A P59–1927.

COLOUR PLATE 32 (preceding page)

a. (top left) John Cooke, *An Officer, c.* 1800, 63 × 47
mm. V&A P24–1949.
b. (top centre) James Scouler, *Unknown Man,* 1781,
51 × 39 mm. V&A Evans 210.
c. (top right) John Barry, *Unknown Woman, c.*
1790, 51 × 38 mm. V&A P70–1931.
d. (middle) John Smart, *Dorothy Capper,* 1778,
36 × 30 mm. V&A P66–1920.
e. (bottom left) Diana Hill, *A Girl, c.* 1800, 92 × 70
mm. V&A P139–1929.
f. (bottom right) John Smart, *Self-Portrait,* 1797,
87 × 70 mm. V&A P11–1940.

exceptionally gifted artist whose breadth of handling and lightness of touch anticipates the major stylistic advances of the succeeding generation.

The acknowledged masters of the incomparable school of late eighteenth-century English miniature painting – Jeremiah Meyer, Richard Cosway, John Smart, Richard Crosse, Samuel Cotes, James Scouler and Ozias Humphry – make their first appearances in the late 1750s, and their backgrounds are strikingly similar. Crosse, Humphry, Smart and Cosway were all born in the same year. Cotes and Meyer were slightly senior, although both began their training at a more advanced age. The artistic climate of the 1750s was optimistic and efforts were constantly being made to upgrade the training of younger talent and to bring art to the attention of a much broader public. An important figure in this movement was William Shipley, whose drawing academy provided the initial training for Cosway, Crosse, Smart and Scouler. Other aspirant draughtsmen and painters profited from admission to the Duke of Richmond's gallery of casts from antique statuary, which was opened to serious students in 1758. Cotes benefitted from the tutelage of his older brother Nathaniel, who by 1760 was an established portrait painter, while Meyer plumbed the mysteries of enamel painting with the aid of the retired but still active Zincke, and Humphry apprenticed to the irascible Collins. The opportunities for sound, academic instruction, not readily available to the previous generation, account significantly for the uniformly excellent performances of the miniaturists who rose to prominence after 1760. Increased encouragement was also forthcoming in the form of cash premiums annually awarded by the Society of Artists, founded in 1753, and by the opportunity, from 1760 on, to exhibit regularly in public for the first time in England. Equally important to the promotion of these artists was George III's ascendance to the throne in 1760. He was the first monarch of the century seriously to cultivate native talent, and both he and his family were especially generous with miniaturists; most of the artists previously mentioned were eventually beneficiaries of direct royal patronage or positions in the royal household. For the young artist electing a career in miniature portraiture, this was a propitious moment.

These artists followed a similar pattern of development. All began painting in the conservative mode of the 1750s: a subdued palette, small ivory support, and a restrained application of transparent colours. By 1770 they had increased the average size of their ivories and were using more of this highly reflective surface to advantage. Their modelling was more forceful, their colours were naturalistic and rich, and their use of opaque colours generally discreet. The progress of this stylistic evolution can be gauged in the works of two artists whose earliest miniatures appear just prior to 1760: Samuel Cotes (1734–1818) and James Scouler (1717–79). Cotes's miniatures exhibit the reticent handling and naïveté of Peter Lens. By the middle of the next decade, when he produced much of his best work, his style was refined to an amazing degree.

His poses often imitate the dignified ease of Reynold's more intimate portraits of the period (col. pl. 25f), and he became increasingly concerned with his backgrounds, which at this point, are often nicely modulated and partially transparent. As can be seen also in contemporary works by Collins, Carwardine and Finney, he rapidly progressed from a more monochrome treatment of the face to a more emphatic and vivid coloration and a higher degree of finish, delicately interlining hatches of blue and red watercolour that blend subtly when viewed at the proper distance. Scouler's early work is characterized by its cool Reynoldsian colours. Like Finney, he preferred a blue stipple, extensively employed in modelling the figure and background. His poses, however, are often more sophisticated than those of either Finney or Spencer at the same time, and there is every indication that he too was carefully studying Reynolds, whose works were readily accessible in the annual exhibitions. By the late 1760s, his coloration is more true to the cast of real flesh and his technique very close to that of John Smart's in its minutely detailed elaboration.

The stylistic evolution of English miniature painting in the second half of the century has often been described as an inevitable consequence of the gradual sophistication of the techniques for painting in watercolour on a difficult ivory surface. The presupposition underscoring this argument is that innovations in technique constituted a positive and consciously pursued advance over earlier painting methods. Certainly, the increased proficiency in painting with watercolours on ivory allowed for many of the stylistic changes taking place at this time, but it does not in itself entirely explain the reasons for these developments. The impact of the public exhibition on the miniature painter's art in the 1760s has never been thoroughly investigated, yet it must have been tangible and immediate. All of the miniaturists who were pupils just prior to 1760 became regular contributors to the Society of Artists exhibitions almost from their inception in that year – John Smart was eventually director of that Society. Cosway and Meyer were made Royal Academicians at an early date, and any miniaturist of merit from the late 1760s onwards exhibited regularly at one or the other London institution. If the inauguration of public exhibitions meant that artists could display their talents to a larger audience, it also meant that they had to vie in a competitive arena with their colleagues for their share of the public's approbation and patronage. Such a contentious situation encouraged the rapid development of highly individual styles. Furthermore, the miniaturists had to exhibit in close proximity to life-sized paintings in oil. Although miniatures were exhibited as a group and given every advantage in the hang in the galleries, miniature painters must have felt slightly overwhelmed at first by this uneasy juxtaposition. It might be argued, therefore, that these new concerns contributed as much as any other factor to the rapid sophistication of techniques and the diversification of styles that so distinctly separates the works of the Modest School from those of their immediate followers.

From the 1760s onwards, the size of the oval miniature steadily

COLOUR PLATE 33 (following page)

John Smart, *The Misses Harriet and Elizabeth Binney*, 1806, 225 × 245 mm. V&A P20–1978.

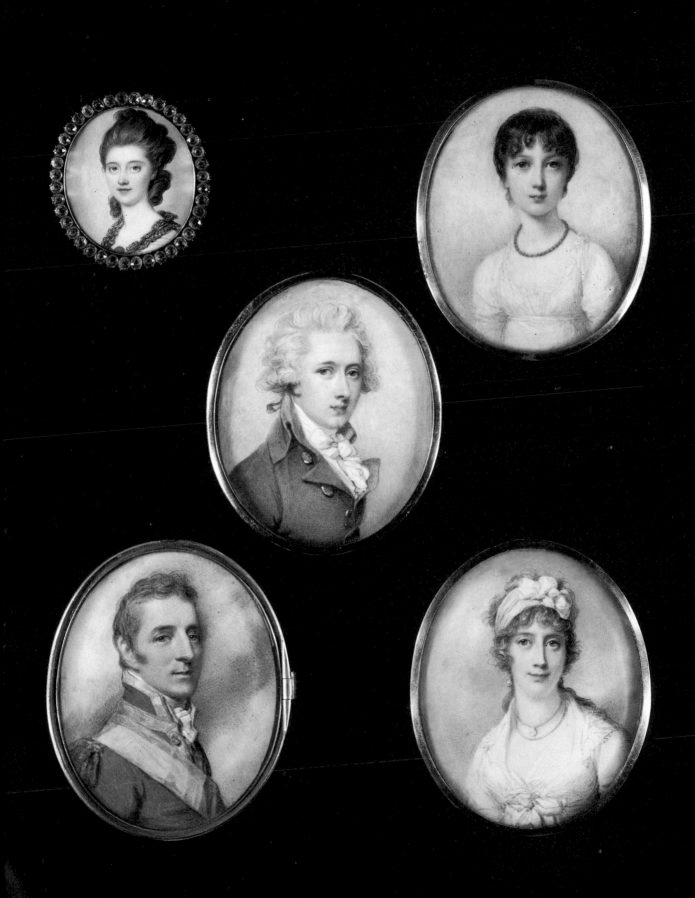

increased until it reached, in the 1780s, the average of three inches. A concise explanation of this phenomenon is difficult to frame. Certainly, an adeptness at controlling the effects of watercolour on ivory emboldened artists. Changes in fashion, especially women's wear around 1770, to the high coiffure and large ribboned and plumed hats also made a larger ivory not only appropriate but necessary. There was a growing predilection for the grand and ostentatious, and this is reflected perhaps in the manner in which miniatures were worn after 1760. If one can rely on contemporary representations of women wearing miniatures in the eighteenth century, those prior to 1760 show a preference for the bracelet type; a showy necklace variety appears more frequently later in the century. This development, in turn, parallels a new fondness for antique cameos and medallions as personal adornments. It can be ascertained with some certainty that the prospect of exhibiting publicly prompted artists like Cotes and Scouler to attempt unusually large pieces in the 1760s. Cotes's *Mrs Yates as Electra*, for instance, was painted for, and exhibited at, the first exhibition held at the Royal Academy in 1769. Walpole described this six inch vertical portrait as 'pretty well', presumably referring to the fidelity of the likeness, as it is not a totally agreeable piece of miniature painting. It is more confidently painted than many of Bernard Lens's comparably sized copies after oil paintings, but it suffers many of the same defects, in that large areas of the surface are thickly painted with relentlessly dull, opaque colours. The face, however, is subtly treated with watercolour and has a radiance that sets it off noticeably from the background and drapery, but the visual effect as a whole is disquieting because of this fragmentation of parts.[35] Nevertheless, it is an interesting piece, both as a harbinger of things to come and as a summation of the problems confronting artists as their works increased in size. From 1760, the innovations in miniature painting were solutions to these problems, and the numerous styles evolved in meeting this challenge are surely one of the oustanding accomplishments in the history of English painting.

Jeremiah Meyer (1735–89), miniature painter to the queen and painter in enamel to the king (1764), was one of the principal miniaturists of the century. A native of Tübingen, he moved to London at an early age. The exquisite design of his portraits after 1770 may ultimately owe something to his earliest training under Zincke, but his mature watercolour style is not indebted to earlier masters. As one critic noted in 1774: '[His] Miniatures excell all others in pleasing Expression, Variety of Tints, and Freedom of Execution, being performed by *hatching* and not by *stipling* as most Miniatures are.'[36] Meyer developed a linear style (col. pl. 30a&b) consisting almost entirely of fine, long strokes of watercolour, regularly and often widely spaced, but crisscrossing in areas of densest shadow. Opaque colours were used sparingly, primarily to accent clothing. His method allowed a maximum exploitation of the luminous ivory surface, and this, together with his delicate and precise touch, accounts for the soft lustre of his pictures. The importance

of the medium in achieving these effects is made apparent by a comparison of his watercolour miniatures with his contemporary portraits in enamel in which he employs the same drawing style. In the enamels, the effect is more crisp and the images, fine as they are, want the seductive atmospheric attributes of his ivories. Within the bounds of his oval format, Meyer was a master at suggesting grace in his portrayals of women and cultivated refinement in those of men. In his later works he adopted the prevailing fashion for elongating the exposed necks and shoulders of his female sitters, but the attitudes he managed are elegant to a degree usually beyond the skill of others. Preciosity is a quality generally considered prejudicial to portrait painting; only rarely does an artist of Meyer's sensitivity make a positive virtue of this trait.

The basic formula of Meyer's style, if not always his delicacy and consummate draughtsmanship, became the currency of the period. Richard Crosse (1742–1810) employed a tighter, more controlled version of Meyer's linear style together with a predominantly greenish-grey palette. His works became increasingly transparent in the 1770s and 1780s; and on a large scale, as in his *Self-Portrait* or the *Mrs Siddons* (col. pl. 31), he resolved successfully with this technique the problems encountered earlier by Cotes in his *Mrs Yates*.

Competing with Meyer for the accolade of society portraitist in miniature was Richard Cosway (1742–1821). He began his career contemporaneously with Meyer, but his initial inclination was to pursue oil painting. His miniatures of the 1760s are typically small in scale but painted with a surplus of paint that can be dark and

194. (above left) Samuel Cotes, *Mrs Yates as Electra in Voltaire's 'Orestes'*, 1769, 152 × 127 mm. V&A P1–1951.

195. (above right) Richard Crosse, *Self-Portrait, c.* 1780, 152 × 117 mm. V&A P147–1929.

COLOUR PLATE 35 (following page)

a. (top left) George Engleheart, *Sir Thomas Stepney, c.* 1775–80, 51 × 38 mm. V&A P44–1953.
b. (top centre) George Engleheart, *A Woman, said to be Mrs Dicksee, c.* 1780, 38 × 32 mm. V&A P22–1937.
c. (top right) George Engleheart, *Mr William Aiton*, 1793, 64 × 51 mm. V&A Evans 108.
d. (middle) Anonymous, *An Eye, c.* 1810, dia. 30 mm. V&A P43–1929.
e. (bottom left) George Engleheart, *Unknown Woman*, 1804, 83 × 65 mm. V&A P58–1910.
f. (bottom right) John Cox Dillman Engleheart, *A Girl*, 1807, 67 × 54 mm. V&A 413–1907.

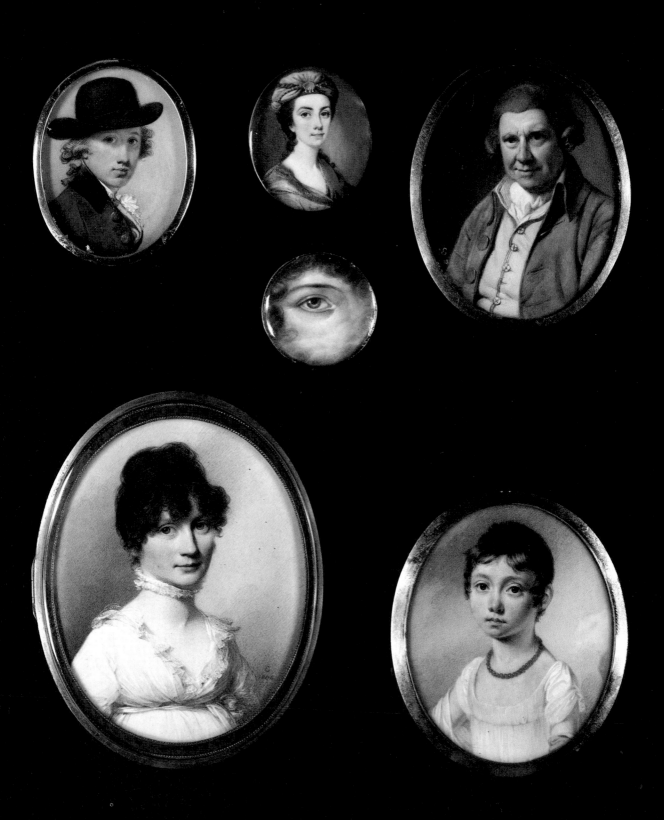

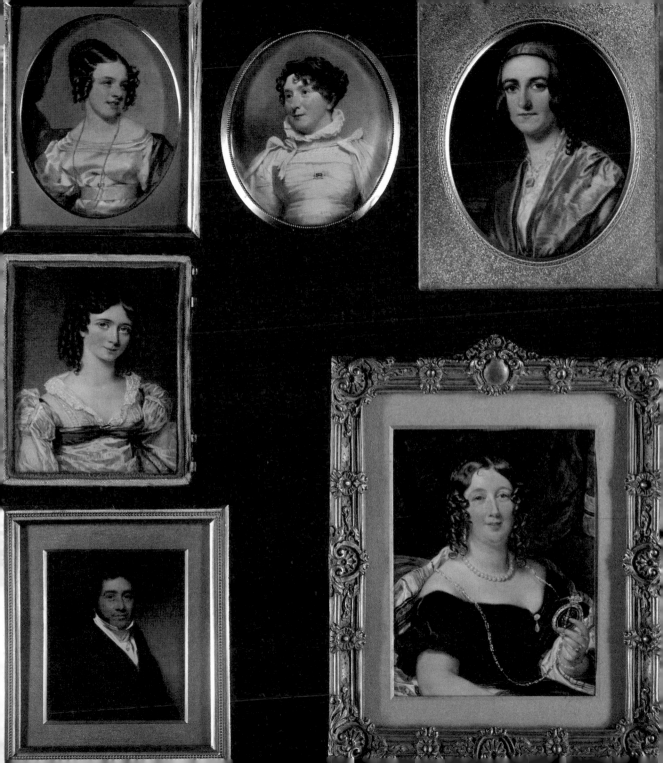

heavily impasted in his backgrounds. Inspired by contemporary portraiture in oil, he aimed in such works at creating a dramatic ambience for his sitters that would intimate a complex and noble personality. His characteristic method of modelling the face with vigorous hatchings and large dots of watercolour is already in evidence in his first essays, and, like a number of his contemporaries, he initially favoured a greyish-brown tint for shading. After studying briefly in the Royal Academy schools, Cosway was made an Academician in 1771, a rare honour for a miniaturist of the period and a testament to his talents both as a painter and as a politician. In 1781 he married the attractive and talented amateur Maria Hadfield. Taking up residence shortly afterwards at Schomberg House, Pall Mall, he began a campaign of personal aggrandizement that culminated in his appointment as painter in miniature to the Prince of Wales. By the end of the decade, with Meyer recently deceased and John Smart in India, he was the undisputed master of the portrait in miniature in London, and, because of his foppish behaviour and personal idiosyncrasies, also the artist most ridiculed by the popular press. He may not have painted as many portraits in one year as Crosse or Smart, but by the late 1780s he had the best of London society flocking to his studio. His residence, richly adorned with *objets de vertu* and splendid collections of old master paintings and drawings, also became a weekly gathering place for the élite and the fashionable of the moment. Tiberius Cavallo, the scientist, attended one such soirée in 1788, the year of the Regency crisis, and described the event to the artist and theorist Prince Hoare:

> Mrs. Cosway, alias Mary Cosway, alias Lady Mary Cosway, alias the Goddess of Pall-Mall, alias la decima Musa, alias the Magnetic Muse, and her sister Charlotte were very glad to hear something of you, and desire their compliments – Magnitism is, at least apparently, out of fashion there. Two evenings in the week, viz: on Monday and Thursday, Mary the great sits in state; but at other times she is not at home. On Monday last amongst a great variety of people she had Mr. de Cologne and the French Ambassador, persons peculiarly remarkable for being in one room at the same time. The performance in these stated evenings consists of music, flattery, scraping, bowing, puffing, shamming, back biting, sneering, drinking tea, etc.[37]

Cavallo describes an extremely lively but artificial society, and in many respects, Cosway's mature style is the consummate analogue to the artificiality, but also the sparkle, of this ebullient period of English history. If the social connections that Cosway cultivated with lavish abandon assured him a steady and lucrative practice, and secured for him a status envied not only by miniaturists but by artists of every persuasion, it was, nevertheless, his considerable talent as a portraitist that sustained his unrivaled popularity into the nineteenth century.

During the late 1780s, Cosway's handling was at its most fluid and unrestrained. His powers of invention and his appreciation of

the miniature's innate decorative potential were most acute. He may have idealized and flattered his sitters, but he rarely sacrificed their individuality entirely to a preconceived notion of style. In his own peculiar fashion, he faithfully adhered to Reynolds's dictum that: 'in portraits, the grace, and we may add, the likeness, consists more in taking the general air, than observing the exact similitude of every feature'. Reynolds made this statement in his Fourth Discourse to the students of the Royal Academy in 1771, the year of Cosway's election to membership. He broadened the implications of that observation when he employed it, almost verbatim, in a discussion of Gainsborough's portraits in the Fourteenth Discourse of 1788. Although the training and professional ambitions of Gainsborough and Cosway diverged radically, they shared comparable aesthetic viewpoints, and it is the 'undetermined manner' of Gainsborough's later portraits, with its appeal to the viewer's imagination in perceiving the likeness within the freely treated features, that best serves as a point of reference for Cosway's mature style.

In this classic phase of his development, Cosway restricted his palette severely, keying off from his sketchy sky backgrounds in which clear, precious blues are often floated in and allowed to settle in random decorative patches. In his portrayals of women, he frequently cocked the head at a slight angle, but generally escaped the suggestion of insipidness that so commonly results from this mannerism when employed by other artists of the period, in particular, Samuel Shelley, Richard Crosse and Andrew Plimer. Another of his clever inventions was to distort the structure of a head painted in three-quarter profile by extending it laterally along an oblique axis emanating from the chin. The resulting subtle tension within the oval format is extremely effective in engaging and fixing the spectator's attention on the sitter's features.

Cosway maintained this style into the nineteenth century, although like other miniaturists of the period he began to tighten his handling, to layer his tints, and to intensify his hues in the mid-1790s. His late works tend to be overlooked, yet among them are some of his finest interpretive studies of character. The fanatic mysticism to which he succumbed in his last years must be held accountable to an extent for the cynicism and the introspection that often lingers behind the feeble smiles of these later images.

Before leaving Cosway, mention must be made of his portrait drawings. In the 1780s, Cosway introduced the practice of supplementing his miniature trade by offering small full-length graphite portraits with the face alone touched with watercolour. Cosway was a precocious draughtsman, having won numerous premiums from the Society of Artists when still apprenticed to Shipley. An increasing demand for his services at this time perhaps persuaded him to capitalize on his talent by marketing this type of portrait. It should be noted, however, that the substitution of paper for ivory also provided a support large enough for full-length or group portraits without increasing proportionately the labour required

COLOUR PLATE 37 (following page)

a. (left) Ozias Humphry, *Warren Hastings*, c. 1785–90, 155 × 110 mm. V&A 996–1897.
b. (right) George Chinnery, *Mrs Robert Sherson*, 1803, 155 × 122 mm. V&A P27–1922.

COLOUR PLATE 38 (preceding page)

a. (left) William Egley, *Mrs Parker*, 1849, 187 × 138 mm. V&A P83–1922.
b. (right) Alfred Tidey, *A Boy with White Mice*, *c.* 1845, 193 × 137 mm. V&A P85–1935.

in their production. The pencil portrait thus enlarged the potential clientele of the miniaturist by providing both formal and, presumably, less costly alternatives to miniatures on ivory, and Cosway's example was followed by such artists as Henry Edridge, George Chinnery, Alexander Pope, John Smart and George Engleheart. Although for Cosway the portrait drawing was probably more a source of amusement than of income, it would become within a short time a popular option, and a serious commercial threat, to the miniature.

No two miniaturists were more dissimilar in temperament and ambition than Cosway and John Smart (1742/3–1811). Smart, like his colleague, studied at Shipley's academy and won several premiums for drawing from the Society of Artists. He achieved considerable status among London artists and was one of the best and most successful of eighteenth-century miniaturists. Perhaps to avoid competition with Cosway and Meyer, he remained loyal to the Incorporated Society of Artists when a rival faction withdrew to form the Royal Academy. He exhibited annually with the Society from 1761 and between 1773 and 1785 held the offices of director, vice-president and president. If Cosway was the darling of the aristocracy, Smart was the flatterer of the burgeoning, affluent and solid middle class. Although he portrayed his share of peers, his patrons were mostly the military, the entrepreneurs and merchants, and the bureaucrats engaged in shaping a future empire. It was a conservative clientele, less interested in notions of a grand style or innovative techniques than in direct, honest facsimiles of their features. His achievement is vivid testimony that an artist could flourish in the eighteenth century without the support of royalty or distinguished society.

In contrast to Cosway and Meyer, Smart's style underwent little appreciable change from his earliest work, which in accuracy of drawing, strength of colouring, and proficiency of technique surpassed that of most of his contemporaries in the 1760s. He painted with bright, clear colours, attending meticulously to every detail of the features and dress, and there is little invention or 'style' in the posing of his sitters. When many artists were decreasing the amount of opaque colour employed in painting accessories and clothing, gravitating toward the more buoyant styles of Cosway and Meyer, Smart remained true to his earliest manner, painting his sitters' costumes with flat, matt colours. In typical fashion, he gradually increased the size of his ivories to the requisite three inches favoured at the end of the century, and consequently he was required to model the features with short, dense hatches instead of relying entirely on a microscopic stipple, and to modulate the depth of his backgrounds. Smart exerted a strong influence on Scouler (col. pl. 32b) and Thomas Day (*c.* 1732–*c.* 1807),[38] and, together with John Bogle (*c.* 1746–1803), championed a more highly finished, softly stippled style in opposition to the freer manner of Cosway. His removal, for eight years, to India in 1785 in pursuit of the patronage of the wealthy merchants of the East India Company perhaps contributed to the unusual constancy of

his style, the sparseness of his aristocratic commissions, and the paucity of his imitators.

From an early date, Smart made small watercolour portraits on paper. It is possible that his elaborate technique on ivory required such preliminary sketches. On the other hand, these watercolour studies may represent rough copies of finished portraits on ivory intended to serve as models for future replicas or patterns for prospective clients. Late in his career he did execute on commission delicate pencil portraits and highly finished watercolour portraits on card, including an immense sheet portraying the entire family of Sir Robert Wigram.[39] One of his most sophisticated compositions on card is his portrait of the Binney daughters (col. pl. 33). The duller finish of paper, and the larger figure size which this substitution permitted, alone differentiate this work from his ivory portraits. In the 1780s, at the same time that Cosway was introducing his pencil portraits and John Robert Cozens was demonstrating the poetic potential of landscape painting in watercolours, the full-length watercolour portrait on paper emerged as a distinct type of presentation drawing, and like the pencil portrait offered miniaturists greater latitude in format and scale. Most of the originators of this type of portraiture – Thomas Rowlandson (1756–1827), John James Barralet (c. 1747–1815), Robert Dighton (1752–1814), Francis Wheatley (1747–1801), to cite but a few – were not miniaturists by profession, and their similar styles have a common ancestry in the tradition of topographical staffage. By the end of the century, however, it was the miniaturists, or artists connected with this business through family or early training, who captured the field, bringing to it their delicate techniques and gum-saturated colours. Such cabinet pictures by Smart, Adam Buck (1759–1833), William Wood (1764–1810), John Wright (d. 1820) and Samuel Shelley (1750–1808) evince in their popular reception a pervasive taste, and it was only a short time before methods of cutting comparably large ivories were invented for the miniaturists.

While most major miniaturists of the late eighteenth century provide biographies replete with achievements, that of Ozias Humphry (1742–1810) borders on tragedy. His early style manifests the sound influence of his teacher Samuel Collins, but his career was marked, even at this early date, by unfortunate circumstances. Collins was a talented artist but a derelict personality, and he stranded his apprentice in 1762 after fleeing to Ireland to escape his creditors. At the suggestion of Reynolds, Humphry set up as a miniaturist in London in 1764. Aspiring to become a history painter and having been refused the hand of the daughter of James Paine the architect, he travelled to Italy in 1773 to further his education. Returning to London, he continued to paint miniatures, but also applied himself with diligence to oil painting. His oils were not well received, and in an effort to improve his finances he went to India from 1784 to 1786 only to be upstaged by Smart, frustrated in his engagement to Alderman Boydell's niece, and swindled by the natives. As a result of encroaching blindness, which he attributed to the mundane task of copying in miniature the Duke of

COLOUR PLATE 39 (following page)

Simon Jacques Rochard, *Miss Mary and Master Patrick Stirling*, 1826, 238 × 151 mm. V&A P106–1931.

COLOUR PLATE 40 (facing following page)

a. (top left) Charles Hervé, *Monsieur Tussaud*, 1854, 130 × 91 mm. V&A P34–1937.
b. (top right) John Simpson, *Sarah Simpson aged 12*, 1849, 64 × 41 mm. V&A P23–1953.
c. (middle) May Hart Partridge, *A Child*, c. 1910, 64 × 48 mm. V&A P42–1975.
d. (bottom left) Janet Robertson, *Miss Marjorie Webb*, 1913, 85 × 66 mm. V&A P13–1966.
e. (bottom right) Nellie Hepburn-Edmunds, *Eileen Marshall*, 1912, 127 × 95 mm. V&A P71–1924.

196. Charles Shirreff, *Miss Catherine Taylor, later Mrs Robert Sherson*, 1797, 72 × 57 mm. V&A P69–1910.

197. (below) Horace Hone, *Colonel Marston as a Boy*, 1785, 49 × 41 mm. V&A P97–1910.

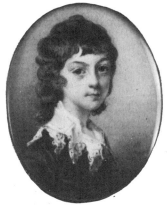

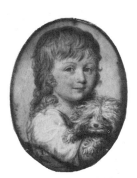

198. Philip Jean, *A Child*, 1787, 41 × 31 mm. V&A P95–1910.

Dorset's collection of ancestral portraits for a fee of £1,448, 'independent of the loss of my eyes',[40] he virtually ceased to paint in the late 1790s. His main contribution to English art after this date was the encouragement that he gave William Blake and the young Andrew Robertson. Humphry's ambition to become an oil painter asserted a strong influence on his development as a miniaturist. He was an early exponent of the rectangular format and the half and full-length figure set against an elaborate backdrop. He favoured sobriety in his selection of colours and in his representation of character, hinting at intellectual strengths that, more often than not, were probably lacking in his sitters. If he successfully emulated Reynolds in this respect, he did so in an original manner, and in his posing of larger figures he exhibits a range of inventive skills that is unusual for a miniaturist at this date. His late, unfinished miniature of the shattered Warren Hastings is one of the most poignant and dignified portraits of that sitter (col. pl. 37a).

The great flourishing of English miniature painting in the last quarter of the century was a phenomenon fueled by an insatiable public demand for this type of portrait and remarkable for its stylistic diversity. London remained the centre for the school, but it was no longer the sole training ground or the locus of activity for miniaturists, and all the large cities could boast competent native practitioners. Although the most important artists eventually settled in the capital, they often did so after training in regional centres. This diversity of background strengthened the school as a

199. Edward Miles, *An Officer*, c. 1790, 70 × 57 mm. V&A P99–1962.

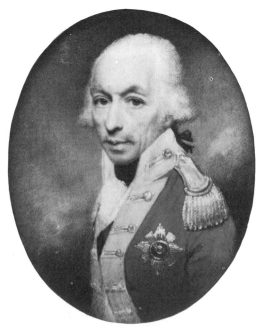

200. George Place, *Alexander Gordon, fourth Duke of Gordon*, 1796, 86 × 64 mm. V&A 542–1903.

whole and encouraged stylistic variety. A plethora of first-rate miniaturists were active in the last quarter of the century, and, as has been observed often, no other period produced such a large number of individually outstanding works. In this context, it is only possible to touch upon a few of the more prominent artists, beyond those already discussed.

George Engleheart (1750/3–1829) began his career slightly later than Cosway and Meyer, but he rapidly advanced to their level of proficiency and popularity. The son of a German emigré plaster modeller, he was befriended by Meyer, and through him introduced to George Romney and William Hayley. Like many miniaturists who enrolled in the Royal Academy schools, he benefitted from the tutelage of Reynolds, whose work he copied in miniature.[41] His style into the 1780s has affinities with Meyer's, although his palette is cooler and his linear painting technique less flexible. His characterizations can be masterful, but also, as one contemporary complained, a bit too stiff.[42] By the mid-1790s he had increased the size of his ivories and introduced a stylized 'sky' background. His facial tones became hotter, but it is a full-blooded, richer colouring that is in keeping with the preference of the period.

Andrew Plimer (1763–1837), of Shropshire, became Cosway's manservant about 1781. It is somehow perversely appropriate that Cosway's most successful student should commence his career in so obsequious a relationship to his mentor, but it is much to Cosway's credit that he recognized Plimer's talent and encouraged a potential rival to set up on his own about 1785. Plimer's early works are imitative of Cosway. He exploited the obvious mannerisms – washed-in skies, enlarged eyes, staccato hatch and dot modelling, etc. – but he lacked Cosway's sure touch, and his interpretation of Cosway's poses is frequently flaccid. His tendency to regularize the pattern of his brushstrokes and his preference for brown in the final delineation and shading of the face became more pronounced as he matured (col. pl. 30e). The more successful miniaturists were painting hundreds of portraits annually, and it was inevitable that one portrait frequently resembled another, but of all the artists accused of stereotyping their sitters, Plimer is probably the most deserving of the criticism. It is not surprising that a flourishing trade in forgeries of his methodical style developed in the late nineteenth century.

Other artists who developed individual styles from the Cosway–Meyer mode, and who warrant passing notice were Nathaniel Hone's son Horace (1754/6–1825), Philip Jean (1755–1802), Edward Miles (1752–1828), George Place (d. 1805), Thomas Richmond (1771–1837), John Comerford (c. 1770–1832), the talented but utterly unpredictable Mrs Anna Mee (c. 1770–1851), and the steady, if rarely surprising, William Wood.

More original than many of these artists was the London-born Samuel Shelley (1756–1808), who was supposedly self-taught, but had some training in the Royal Academy schools in the mid-1770s. He also benefitted greatly from the privilege of copying in minia-

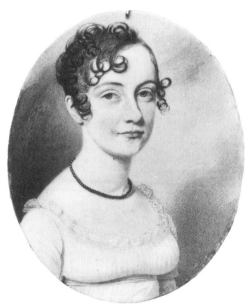

201. Thomas Richmond, *A Girl*, c. 1810, 77 × 62 mm. V&A P92–1937.

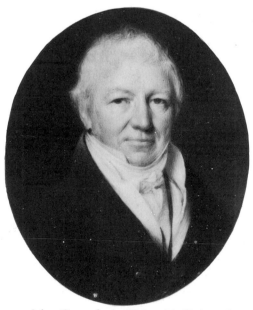

202. John Comerford, *Walter MccGwire*, 1818, 84 × 68 mm. V&A, lent by Mrs J. E. MccGwire.

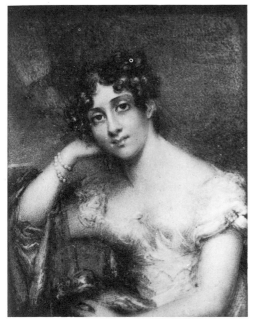

203. Anne Mee, *Miss Elliott*, c. 1825, 108 × 82 mm. V&A P43–1931.

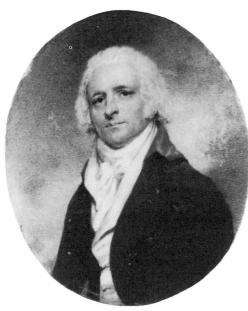

204. William Wood, *A Man with the initials NAM*, c. 1795, 84 × 70 mm. V&A P91–1931.

ture the works of Reynolds, and he applied himself with some success to painting in oils and in watercolour on paper. He painted history and figurative subjects on ivory in the 1780s, but was not encouraged to continue in this vein, although one contemporary argued that Shelley was 'among the few who do not consider the profession in a mercenary point of view; and he has raised himself above the character of a mere miniature painter, by his historical pictures'.[43] Shelley is of some importance in the history of English miniature painting, as he was one of the first to work with frequency on a large ivory and to load his watercolours with gum arabic. By so doing, and by painting his draperies and detailed backgrounds fluently, he simulated the richness and depth of oil paints without completely foreifeiting the transparency of watercolour. His successful larger works in this manner include his portraits of Mrs Delaney (1784)[44] and of Misses Annabella and Mary Crawford, which he exhibited at the Royal Academy in 1782. As Alexander Robertson's teacher, and perhaps Richard Westall's (1765–1836), he indirectly influenced Andrew Robertson, and he might have instructed Edridge who worked in a manner very close to that of Shelley's in the 1790s. Shelley was a founding member of the Society of Painters in Water-Colours in 1804, but he soon resigned his office as treasurer after a dispute arising from the distribution of the Society's earnings. Each exhibitor at the Society's annual show was to receive a portion of the gate in proportion to the number of works exhibited. According to Roget, the prolific representation of Shelley's portrait miniatures and drawings at the first exhibition was not considered by the other members 'to promote the Society's objects, [and] did not justly entitle him to a share of the profits'.[45] The Society had been founded to advance the interests of watercolour painters against the stiff opposition and supposedly bad treatment they encountered at the Royal Academy. Miniatures had always been given preferential treatment at the Academy exhibitions, and it is likely that many of the watercolourists specializing in landscape and genre resented their presence on the Society's walls.

Though we possess less biographical information on John Barry (fl. 1784–1827) than on most of his contemporaries, his surviving works show exceptional ability. He exhibited miniatures of a fashionable London clientele at the Royal Academy from 1784 to 1827. His early portraits of women evince passing admiration for Romney, but like many of his colleagues he had difficulty with anatomical proportions and definition when working on a more ambitious scale than the bust-length oval of two and a half to three inches. Within the latter format, however, he was capable of striking originality, and his best works of the 1790s are easily recognized by their idiosyncratic style. Except for grey hatching near the shoulders, his backgrounds are frequently only palely lined with neat, almost imperceptible striations of blue or blue-grey. Against this blanched surface, he modelled the sitter's face and costume with receding tints of brown, grey and blue that are delicately drawn in unfused, but tightly intervaled and rigidly

vertical strokes of medium length. He enlivened this system by imparting an angularity to the drawing of hairlines, eyebrows and jabots. This restraint in handling and in colouring produced a chaste, neoclassical gravity somewhat removed from the decorative frippery of much late eighteenth-century work (col. pl. 32c). Two artists approximating Barry's manner were Thomas Hazelhurst (*c.* 1740–*c.* 1821) of Liverpool and Charles Robertson (*c.* 1760–1821) of Dublin. Robertson arrived in London about the time that Barry began exhibiting publicly and it is likely that works by these two artists are frequently confused. Robertson also favoured a near-white background at times, but in his modelling of the face he was more fastidious, and in his colouring less ashen, than Barry.

At his best, John Bogle (*c.* 1746–1803) can be ranked with any of the late eighteenth-century masters. A native of Scotland, he settled in London about 1770 and exhibited there annually until 1794. He was conscientious in his naturalism, employing a free, dense stipple technique that smoothly rounds the contours of the face. He carried into the 1790s his early preference for opaque colours in painting the clothing of his sitters. He applied these colours in a thick and often painterly fashion, but used the finest, controlled hatchings of diluted white for highlighting darker garments. His backgrounds are often applied in layers of dark, saturated watercolour. This sophisticated and balanced application of transparent and opaque colours gives his miniatures the substantiality of oil paintings, and has affinities to contemporary continental miniature painting.

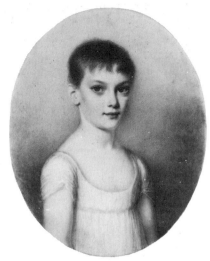

205. Thomas Hazelhurst, *The Rt Honourable J. A. Plantagenet Stewart*, *c.* 1800, 76 × 63 mm. V&A Evans 133.

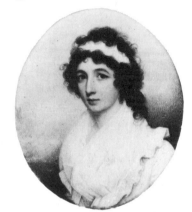

206. Charles Robertson, *Unknown Woman*, *c.* 1796, 64 × 51 mm. V&A P98–1962.

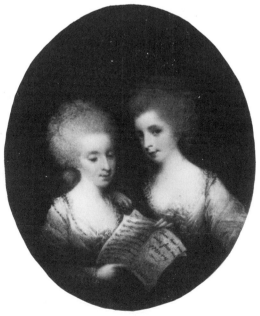

207. Samuel Shelley, *The Misses Annabella and Mary Crawford*, 1782, 81 × 65 mm. V&A P7–1925.

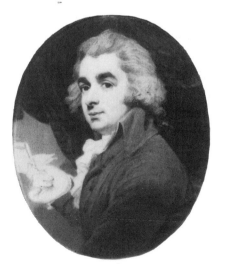

208. Henry Edridge, *John Bannister*, *c.* 1795, 65 × 54 mm. Yale Center for British Art.

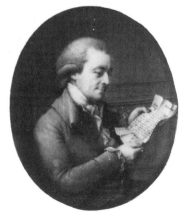

209. John Bogle, *The Dutch Governor of Trincomalee*, 1780, 53 × 44 mm. V&A P83–1910.

THE NINETEENTH CENTURY

From the time of Hilliard, miniature portraits were intended ordinarily to be worn or carried on one's person. Certainly, large miniatures not suited to this purpose were always made, and for a variety of reasons, but the traditional appreciation of miniatures as jewellery or objects of personal adornment and private emotions held for the better part of two centuries. The preference for the oval shape, the placement of bits of hair, often elaborately arranged or plaited, in the backs of late eighteenth-century frames, and the miniature depiction of single human eyes – a curious fad of the period but one that primarily catered to amative or simple fraternal sentiments (col. pl. 35d) – all reflect in their fashion this long-standing conception of the miniature's special function and value. By 1800 this conception was being critically scrutinized. As one miniaturist remarked in 1803: 'Oval miniatures [are], at best, but *toys*: I should like to aspire to paint *pictures*, and in the exhibition this year, oval miniatures have disappeared, as they are not so much worn. Most of them are square.'[46] In this sweeping condemnation, the creations of the preceding generation were viewed as frivolous baubles whereas it was the miniaturist's duty to paint pictures. As the functional distinction between the miniature portrait and other forms of portraiture blurred, the styles and techniques previously employed by miniature painters also experienced a reassessment. In the last decades of the eighteenth century, miniaturists painted with the conviction that their medium offered certain unique effects that could not be imitated by any other medium of painting. In general, they developed techniques and styles that exploited these effects in a manner consistent with their understanding of the miniature's purpose. From 1800 they purposefully modified their techniques to accommodate a growing desire, as much a product of their own professional ambitions as of fluctuations in popular taste, to have miniatures imitate the finish, the chromatic depth and range, the surface gloss, the compositional complexity, and the scale of portraiture in oils. The new generation can be said to have exploited the unique properties of their medium as inventively as their predecessors, but they did so toward a different end.

The most extreme exponent of the prevailing late eighteenth-century manner of miniature painting that was under attack was Richard Cosway, who simplified his technique to such an extent that one might classify his mature works as miniature drawings. For Cosway, and in varying degrees for Meyer, Engleheart and their like-minded colleagues, the visibility of the brushstroke and the ivory surface assumed considerable importance in the overall effect that they sought to convey. Their immediate disciples blended and merged these brushstrokes until their individual character was suppressed. Cosway could boast as many as twelve sitters a day because of his facility, but for the next generation such facility would be seen as morally corrupt[47] and six or more sittings for one portrait as barely adequate. The change in attitude is clearly traced

in the works of George Chinnery (1774–1852) or of one of the more prosperous miniaturists to straddle the two centuries, John Cox Dillman Engleheart (1784–1862), a nephew and pupil of George Engleheart. After initial training with his uncle, the younger Engleheart entered the Royal Academy schools in 1800 and commenced exhibiting the next year. In a portrait of an unidentified lady of 1803, he faithfully imitates his uncle's style of the 1790s, which, although characterized by a fairly laboured finish in the head, retains much of the lightness and calligraphic emphasis of this earlier period. Both John Cox Dillman and George Engleheart began to paint on a larger rectangular ivory before 1810. One can follow in the younger Engleheart's development the gradual suppression of ornamental blues and greys in the modelling of the face and backgrounds, a more minute definition, and a pronounced tendency to cover as much of the ivory as possible, especially in the hair, clothing and backgrounds, with sonorous, thickly layered and gummed pigments that bear out with force (col. pl. 35f). Cosway's style was fashionable, but like any fashion it was also evanescent. The antithesis of his manner and philosophy was that of John Smart, and it was the latter's highly polished naturalism that was, broadly speaking, the path into the next century. Had Smart, Bogle, Humphry or Peter Paillou been of the succeeding generation, they would probably have embraced its desire to 'paint pictures' and the new technical criteria and discipline that it demanded. The same stimulus, ever present in the late eighteenth century, that prompted Cotes to attempt his portrait of Mrs Yates, prompted an entire generation to reject the Cosway aesthetic and to endeavour to compete with oil painting on its own terms. In retrospect, one observes that from the moment miniatures and oils were juxtaposed in public exhibitions, the miniaturists experimented with techniques and styles that gradually either dissociated their productions completely from those of the competition, or moved closer to spanning the gap that separated them. By 1800 the numerous options had been clearly set out, and the final choice was resounding.

Contributing to this shift in attitude was the miniaturists' concern for their status as artists, which was being challenged by an increasing number of reputable critics. The incredible proliferation of miniature portraits at this time tended to reinforce such opinions as that previously quoted in the discussion of Shelley – miniaturists were, on the whole, a mercenary corps more interested in personal gain than in the loftier aims of high art. This negative view was certainly encouraged by some portrait painters in the Royal Academy whose income was most threatened by the ever increasing popularity of the miniature. In 1805 Martin Archer Shee, future president of the Academy, viciously attacked the profession in his *Rhymes on Art, or the Remonstrance of a Painter*, which consisted of approximately one thousand lines of verse, well annotated, extolling the virtues of the English school and flogging the public for their inattention to living artists and their misapplied patronage. His treatment of miniaturists was brief but particularly abusive:

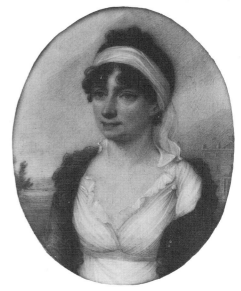

210. John Cox Dillman Engleheart, *Unknown Woman*, 1803, 78 × 60 mm. V&A P21–1930.

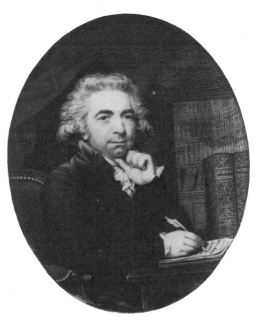

211. Peter Paillou, *William Rowley*, 1789, 104 × 84 mm. V&A P73–1935.

> Alas, how many cast of meaner mould,
> Life's common clods, we every day behold,
> In evil moment to the Muse aspire,
> Degrade the pencil and abuse the lyre,
> .
> Blockheads pursu'd through every nobler shape,
> In miniature take refuge, and escape.

As if this passage were not sufficiently explicit, Shee appended to it the following comment on his final couplet:

> From the prompt means of subsistence which miniature-painting affords to every manufacturer of a face, it will always be the refuge of imbecility; a receptacle for the poor and disappointed in art; where all who want vigour that impels to higher game, or the means to support a larger pursuit, will sit down with humbled expectations, consoled by the reflection, that if their fame be more confined, their profit is less precarious.[48]

Shee's attack did not pass unchallenged, and in 1806 the miniaturist and critic W. H. Watts (1776–1842), with the support of his professional colleagues, issued a forty-page pamphlet, *The Remonstrancer Remonstrated With*. It is a trenchant defence of miniature painting, that makes short work of Shee's somewhat biased and overgeneralized argument. Watts also noted that although miniaturists had previously been accorded the respect of the Royal Academy, of late they had been systematically excluded from official honours and this invidious slight had forced them to ally themselves in spirit, if not by contract, with the artists who had only recently formed their own Society of Painters in Water-Colours. 'By following this example,' he claimed, 'the painters in miniature will add more proofs to the many already before the world, that there is not anything in their own minds, or in the materials with which they work, that disqualifies them from entering into a generous rivalry with the painters in oil colours.'[49]

The leading figure in this new rivalry was Andrew Robertson (1777–1845), born in Aberdeen, the son of an architect and the brother of two miniature painters, Archibald and Alexander, both of whom practised their art with distinction in America. In 1801 Andrew travelled to London to enter the Royal Academy schools. His brothers recommended that he study the full-bodied water-colour drawings of Richard Westall, and upon arriving in London he appears to have cultivated the friendship of influential Academicians, including Westall, West, Shee and Northcote. He was already on good terms with fellow countryman Raeburn. He also introduced himself to Shelley and Cosway and made copies of their miniatures, but decided that neither offered a satisfactory model to emulate. Rising quickly in fame, he was appointed miniature painter to the Duke of Sussex in 1805, and in 1807 he took an active role as secretary in organizing the Associated Artists in Water-Colours, a society intended to promote the aims of all watercolourists. Half of the initial membership were miniaturists, including Wood (president), Watts, A. E. Chalon (1780–1860),

Henry Pierce Bone (1779–1885), François Hüet-Villiers (1772–1813), James Green (1771–1834; treasurer) and his little-known but accomplished wife Mary, whose best miniatures are reminiscent of Robertson's work. One probable reason for the emergence of this second watercolour society was the antipathy recently experienced by Shelley at the rival institution. The original minutes of the newer society featured the resolution that it would be composed of painters in miniature as well as artists practising other forms of watercolour painting, thus, as their title implies, acknowledging differences in technique and philosophy but allowing an equality of status. After a few successful exhibitions, the Associated Artists disbanded; nevertheless, the favourable public response that greeted their concerted effort did serve as a potent warning to the Academy.

From the moment he arrived in London, Robertson worked zealously to introduce a new style of miniature painting. Eventually, he was abetted in this endeavour by the leading portrait painters in oil, perhaps because they feared that this precocious artist might apply his talents to life-sized oil portraiture, perhaps because they entertained the hope that he might confine his activity to copying in little their larger works. His first essay in this 'great style', as West called it, was a faithful eight by seven inch student copy of an oil portrait by van Dyck. So elaborate was the technique and so forceful the colouring that Cosway is said not to have recognized the piece as a miniature on ivory. Robertson abhorred the lighter, more decorative coloration of his predecessors: 'Modern paintings, placed besides Rubens, etc. are like drawings, from their blueness and cold tone . . .' and 'Most miniatures are too much like china. Ivory must be brought down very much to give it the softness of flesh . . . I must have two styles, one for connoisseurs and one for the world, who do not like warmth [and] say it is yellow.'[50] He decided, therefore, to found his style on the example of the best old master paintings. With regard to finish and characterization in miniature painting, he again focussed his criticism on Cosway, who was still the most popular miniaturist of the day: 'They are pretty things but not pictures. No nature, colouring, or force. They are too much like each other to be like the originals and if a man has courage to deviate from the model, we all know how easy it is to paint pretty things, when he can paint smooth without torturing it into a likeness of a bad subject; but young artists dare not deviate, it is likeness which must recommend them.'[51]

In general, Robertson did not flatter his sitters through idealization, preferring to articulate their features in strong chiaroscuro. In female portraiture especially, he avoided the coy imbecility or the slick neoclassical idealization that appears all too frequently in the keepsake portraits of the period. If Robertson endeavoured to compete with oil painting, this aspiration had its drawbacks, for the time and expense required in painting a large and elaborate miniature were more than many sitters were willing to invest. For those who preferred a 'lesser' form of likeness, he developed a less

212. Andrew Robertson, *Princess Amelia*, 1811. Royal Collection.

highly finished manner, reserving his new style for his aristocratic clientele and his own edification when exhibiting at the Royal Academy.[52]

Robertson's most important followers were Frederick Cruik-shank (1800–68), a fellow Aberdonian who exhibited regularly at the Royal Academy from 1822 to 1860, and Sir William Charles Ross (1794/5–1860), who was distantly related to Robertson. Both artists evolved individual styles, with Cruikshank using a broader touch than either his teacher or colleague (col. pl. 36a). Ross was the more influential, and it is his achievement against which must be measured that of every other miniaturist of the period. Ross standardized the use of large formats for three-quarter and full-length portraits in elaborately furnished interiors, increasing the average size of the miniature from the four or five inch rectangle favoured in the first quarter of the century to often twice that size. His colouring was rich, drawn from an appreciation of Rubens and Lawrence, his drawing of the figure impeccable, and his likenesses convincing and refined. As one critic wrote as late as 1855: 'Sir William Ross goes on in his luxury of colour; he must continually be surrounded by a train of Albano's little boys, strewing flowers in his path.'[53] His delicate blend of yellow, blue, and pink flesh tones can often recall the decorative enamel heads of the mid-eighteenth century, but he was uncommonly versatile in varying his painting technique and palette to gain a specific visual effect. A precocious artist, Ross apprenticed to Robertson in 1814 as his painter of backgrounds. He became an Associate of the Royal Academy in 1838 and Academician in 1842, in which year he was also knighted. A favourite of Queen Victoria, he achieved an international reputation and was described in his obituary as 'a courtier in the best sense of the term'.[54] He ranks as one of the better portrait painters of the epoch, rarely failing to evoke a charming appearance with supreme grace and delicacy.

Spanning the better part of the half century, Ross's works reflect the various stylistic currents in formal portraiture at the time. More compromising than Robertson, he could flatter his sitters in Lawrentian terms, although he rarely attempted Lawrence's scrutiny of feminine intellect or his probing of complex personalities. His later portraits echo the unheroic domesticity, the elegant blandness of the aristocracy at ease, that typifies the oil portraits of Sir Francis Grant or F. X. Winterhalter. With equal tact, he delineated the fleshy pulchritude of aging countesses (col. pl. 36f) and the sprightly charm of their children. As veracity in portraiture became an issue at mid-century, Ross, like George Richmond, was a painter who could justifiably argue through his work that truth and artistic interpretation were not contradictory. John Ruskin, in his voluminous critical writings, was generally silent on miniature painting, although he apparently admired the artists of the contemporary school. He might have marvelled at the ability of Ross, as he did that of certain other watercolour painters, to mould a profusion of minutely observed detail into a unified expression of greater breadth. In his 1851 defense of the Pre-

213. (facing page) William Charles Ross, *Baroness Bardett-Coutts*, c. 1847, 420 × 290 mm. National Portrait Gallery.

214. William Newton, *Unknown Woman*, 1816, 76 × 60 mm. V&A 995–1901.

Raphaelites in *The Times*, he did pay Ross a double-edged compliment when he compared the 'perfect truth, power, and finish' of his drapery painting with that of John Everett Millais and William Holman Hunt, whose concern for the minute transcription of detail might well be compared to that of certain miniaturists, but whose literal realism was essentially incompatible with the ingratiating naturalism required of a society portraitist.

Ross may have achieved supremacy in the second quarter of the century, but he was not without estimable rivals. William Egley (1798–1870) was a popular artist who exhibited at the Royal Academy from 1824 to 1869. Self-taught, he mastered a tight, neat style slightly harder and less mellifluous than Ross's (col. pl. 38a). Ross's main competition, however, was from Sir William Newton (1785–1869), who trained as an engraver and at the Royal Academy schools in 1807. He exhibited at the Academy from 1808 to 1863. He was appointed miniature painter to William IV in 1833 and, as painter to Queen Victoria, was knighted in 1837. Like Egley, he promoted a slightly tighter and drier variant of Ross's style, and he also specialized in large contemporary histories in the 1840s, using the impractical support of joined sheets of ivory. His more mechanical handling does not approach Ross's suggestion of breadth and animation, and often his portraits of women are weakly drawn. Also competing with Ross were a number of Anglicized foreigners, among them Alfred Edward Chalon (1780–1860) and Simon Jacques Rochard (1794–1874). Chalon (col. pl. 36d), a Genevan by birth, entered the Royal Academy schools in 1797; he was eventually made Academician in 1816, and he held the appointment of painter in watercolour to Queen Victoria until his death. In 1815, the slightly younger Parisian, Rochard, was residing in exile in Brussels, where he made important connections with Wellington's officers that resulted in his relocation to London the next year. He remained active in London for three decades. Both artists used heavily gummed colours for the darker passages in their portraits, but they applied them with a wide brush in fluid strokes and dapples. Of the two, Chalon was more comfortable with the outlandish dress styles of the 1820s and 1830s and, in most instances, was a better draughtsman. Rochard's excellent portrait of the Stirling children (col. pl. 39), however, was painted with complete assurance and freedom; it betrays in its ambitious composition and its treatment of the faces the artist's admiration for Lawrence's contemporary group portraits of children. In this example, he modelled the faces broadly, although when the heads of his sitters covered a larger portion of the ivory surface, he usually worked the flesh tones to a high finish with a layered stipple technique that he favoured throughout his career. Upon close examination, Chalon's soft modelling of the flesh is actually achieved by a scratchy and irregular application of short hatches. By a more systematic application of darker broken lines, especially along the profile that is in shadow, he frequently created the novel illusion of the head in motion. Both of these stylistic traits descend ultimately from Cosway through such artists as William Wood.

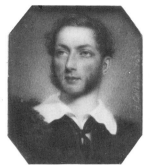

216. Henry Collen, *Captain Octavius Vernon Harcourt*, 1838, 43 × 35 mm. V&A P26–1932.

215. Reginald Easton, *Everilda MacAlister*, *c*. 1880, 73 × 60 mm. V&A P5–1956.

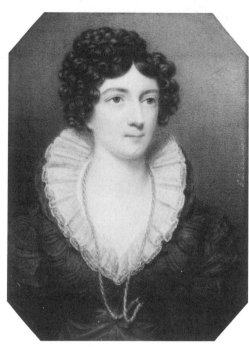

217. George Lethbridge Saunders, *Mrs Ferguson*, *c*. 1838, 118 × 93 mm. V&A Evans 296.

During the first year of Victoria's reign, the seventieth Royal Academy exhibition included over two hundred miniatures by as many as thirty competent professionals. In addition to works by the miniaturists already mentioned, there were contributions from a number of fine painters of the second rank – George Lethbridge Saunders (1807–63), George Raphael Ward (1801–78), William Barclay (1797–1859), François Rochard (1798–1858) and Henry Collen (1798–after 1872), for example – who produced a steady stream of agreeable miniatures in the manners of Ross or Newton or Chalon. Fresh talent continued to appear on the scene in the 1840s, and the miniature tradition seemed to thrive with the same vitality that had sustained it in previous epochs. Among the more prominent newcomers were Reginald Easton (1807–93) and Thomas Carrick (1802–75), whose success was phenomenal when one pauses to consider that they were essentially self-taught, Alfred Tidey (1808–92), who studied at the Royal Academy, Robert Thorburn (1818–85), yet another of the many Scots who distinguished themselves in London after 1800, and Annie Dixon (1817–1901). The last was a pupil of Ross upon whose manner her early romantic style is fashioned (col. pl. 36c). By the 1870s she had mastered a more direct psychological penetration of character, and she was highly successful with a bust-length format in a four inch oval. Dixon continued to paint into the 1890s and was one of the few miniaturists who can be said to have maintained standards of high originality after 1870. Thorburn was another artist of considerable promise when he arrived in London in 1836, his abilities as a portraitist already in evidence. He favoured very large ivories, a chaste coloration and hard, clear outlines that were recognized at the time as distinctly Germanic in derivation. He portrayed his sitters with uncommon earnestness and little glamour. Patronized by the Prince Consort, Thorburn reflects in such miniature pictures as the portraits of Selina Charlotte, Viscountess Milton, and her daughter,[55] and Charlotte, Countess Canning, with her sister Louisa, Marchioness of Waterford,[56] the German style which the

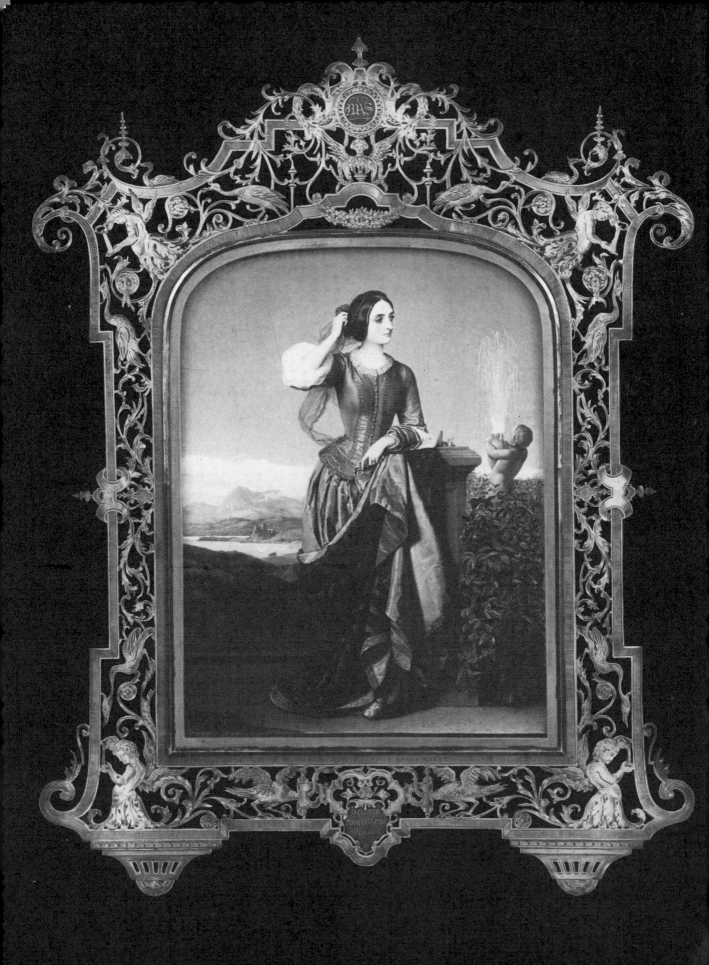

Prince promoted through his principal oil painter, William Dyce. With his painterly technique and palette and his predilection for large, often complex, multi-figured compositions, it was only logical that Thorburn abandoned miniature painting in the late 1850s to paint in oils.

Carrick and Tidey evolved styles of minute finish that nevertheless aimed at the luminous breadth of Ross.[57] Carrick was also an early proponent of miniature painting on thin sheets of marble. As a support, marble was marketed in France and England in the 1840s when the gargantuan proportions of miniatures required a sturdy surface that could be cut to almost any size and that would not suffer from yellowing, warping or cracking.[58] The flatness of tone that resulted from its use, however, was not appreciated and the material never really found favour with English painters.

In the seventeenth and eighteenth centuries, miniaturists had frequently used their medium for the depiction of genre or landscape subjects, either copying works in oil or inventing their own figural designs. In England, miniature painting was more narrowly restricted to portraiture than in France, but English miniaturists did attempt on occasion genre and history subjects. Another concerted effort in this direction was made in the nineteenth century by J. C. D. Engleheart and others, but with little more success than had greeted Shelley's efforts earlier. Alfred Tidey's *Boy with White Mice* (col. pl. 38b), exhibited at the Royal Academy in 1845, is a Victorian example of this application of miniature painting, and in spite of its enchanting luminosity and arch subject, the artist was unable to sell his work, observing of contemporary taste, that 'apart from portraits, painting on ivory would not be remunerative'.[59] By mid-century, the public had become accustomed to adorning their walls with genre subjects by a host of watercolour painters who worked on paper and whose virtuoso techniques combined the best aspects of both traditions. Finished watercolours the size of Tidey's miniature and larger, by such artists as William Henry Hunt, Myles Birket Foster, and Sir William Frederick Burton, were the most popular entries in the annual Water-Colour Society exhibitions. Their methods of juxtaposing energetic strokes and a minute stipple or hatch of watercolour on paper or on a bright ground of Chinese white created scintillating lights and textured surfaces that sparkled and carried better at a distance than the delicate ivories of Tidey and his colleagues.

Describing the state of miniature painting during the decade of the 1850s, Tidey later reminisced, 'About this time the sun of the miniature painters was setting in all its glory, for then the work of Ross and Thorburn, Carrick and others were at their best and the thickest of the crowd of visitors to the Royal Academy was usually found in the miniature room.'[60]

By 1860, a particularly bleak year for the miniature in England as elsewhere, the sun had set. In that year, the centennial of the first Society of Artists exhibition, a critic for the *Art Journal* lamented, 'A little longer and we shall have outlived the art of miniature painting.'[61] The previous year, in its review of the annual Royal

218. (facing page) Robert Thorburn, *Lady Scott*, 1854–6, 451 × 354 mm. Birmingham City Art Gallery.

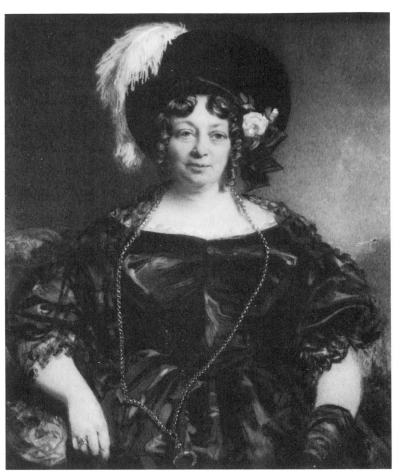

219. Thomas Carrick, *Unknown Woman, c.* 1845,
142 × 123 mm. V&A P101–1929.

Academy exhibition, the same journal failed, for the first time, to
mention the miniaturists' contribution, and simply informed its
public that 'photography has scattered the miniaturists'. In its 1862
review it noted: 'The miniatures now occupy but a small portion
of the wall of what used to be called the "miniature room." They
are not placed in the most advantageous light . . . that is, the south
side, which, ten years ago, and even less, used to be hung with the
most valuable works of Sir William Ross, Thorburn and others,
before the art was all but superseded by photography.'[62]

Both Ross and Chalon died in 1860. By that year, Egley,
Cruikshank and Newton were of advanced age, Rochard had been
abroad for some time, Tidey was also on the continent, and
Thorburn had all but forsaken the miniature. As critical as the loss
of these masters, was the relative scarcity of new stars after mid-
century. Photography might be blamed for having dealt a disabl-
ing blow, but it is this absence of innovative newcomers that, more
than anything else, precipitated in the 1860s the hiatus from which
the miniature never fully recovered. The reasons for this dearth of
new talent might be traced directly to the practice and aims of the
miniaturists themselves as redefined much earlier in the century.

From the middle of the eighteenth century, the ranks of minia-
ture painters were occasionally diminished by the loss of a first-rate
painter, such as Hone, to the more prestigious medium of oil on
canvas. Many miniaturists, from Cosway to Ross, painted in oils,
but what contrasts the two centuries most decisively is that in the

later period the attrition rate from one discipline to the other was much higher. As miniatures increased in size and elaboration, artists began to find it more advantageous to paint in oils. John Linnell (1792–1882), George Richmond (1809–96), George Patten (1801–65) (col. pl. 36e), John Jackson (1778–1831), the Hayter brothers, Sir George (1792–1871) and John (1800–95), and Robert Thorburn, began their careers as miniaturists but gravitated early on to other media, thus depriving the school of some noteworthy portraitists. Furthermore, the cabinet-sized portrait drawing and watercolour on paper had been a secondary source of income for miniaturists throughout the century, but as interest in watercolour painting and chalk drawing increased, the large drawn portrait on paper became a decidedly popular alternative to miniatures on ivory. As one amateur miniaturist observed in 1843: 'Water-Colour drawings of a larger size frequently take the place which miniatures once exclusively occupied in household decoration.'[63] This popularity allowed some miniaturists – Henry Edridge, Adam Buck, Thomas Heaphy, Octavious Oakley, Chalon, Linnell and Richmond – to curtail their practice severely, or to abandon miniature painting entirely.

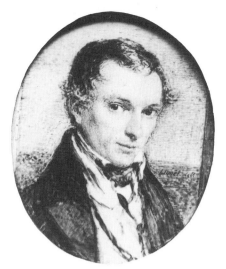

220. John Linnell, *Unknown Man*, c. 1820, 69 × 55 mm. V&A P11–1937.

At mid-century, the value of labouring to master the painstaking techniques of miniature painting then in favour must have appeared dubious to many potential miniaturists when a good livelihood was available through less rigorous avenues of training and practice. As the taste for laboured and embellished watercolours intensified, it was not only miniature painters who were confronted with this dilemma, but also the painters of landscape and genre scenes.[64] One French critic, commenting on the English watercolours exhibited at the International Exhibition of 1855, affirmed the obvious: 'Artists who give themselves so much trouble to do in water what they might easily do in oils are like romantic lovers who come in down the chimney when the door would be opened at the second knock.'[65]

Finally, it would have occurred to anyone contemplating a career in miniature painting in 1850 that photography, after a decade of startling improvements, was not a passing fad, but a genuine threat to the future of all forms of portrait painting. The sophistication of photographic processes in England and their impact on the miniature trade is well documented in contemporary literature. In the 1840s and 1850s, the still expensive daguerreotype and the albumen print were viewed with interest, primarily as scientific aids to proper portrait painting. As one observer confidently claimed, 'the sun will continue to be a very bad painter, too liberal in his details, and at the same time too false in his proportions'. Artistic genius was still required to rectify 'the deficiencies in truth, in life, and in spirit'.[66] This is the expiring gasp of the theoretical principles that had guided English portraiture from the time of van Dyck. Within a decade, hand-tinted portrait photographs were being praised as 'truthful beyond the artist's power'. The relentless pursuit of realism was underway, and in one announcement concerning the invention of a projector that would

enlarge the *carte de visite*, introduced in 1857, to any size, it was jubilantly proclaimed that the artist could now 'paint upon the very face itself'.[67]

During the initial phases of development, portrait photographers constantly introduced new methods and materials intended to attract a share of the miniature market. A. F. Claudet, for instance, employed watercolour painters to finish, in a miniaturist's technique, his monochrome plates. Such amalgams, as noted by one impartial judge, 'can scarcely be distinguished from the most highly finished miniatures for delicacy and effect . . . they are works of art . . . [that] may be equalled, but we scarcely think they can be surpassed.'[68] In the late 1850s J. E. Mayall patented his ivorytypes, hand-coloured photographs printed on a special white surface, meant to simulate ivory portraits but sold at '1/5 the cost of miniatures'.[69] At the same time, some established miniaturists made their own overtures to the new science of 'sun portraiture'. Charles Hervé's (1834–1910) portrait of 1854 (col. pl. 40a) evinces in its granular surface texture, the pose of the sitter, and the evaporating contours, the direct influence of the photographic image. John Simpson (1811–after 1871) frequently made enamels from photographs (col. pl. 40b), while Thomas Carrick began painting on a photographic base and eventually abandoned miniature painting in the 1860s for a more lucrative practice as a studio photographer.

Because of its traditional prestige value and the talent it attracted, portraiture in oil, after a brief setback, survived the onslaught of photography. Following the example of Andrew Robertson, miniaturists had strained to attain this elusive prestige for their own productions. Through aristocratic patronage, many in the nineteenth century succeeded, but in so doing they sacrificed the portability and devalued the intimacy that had in the enlarged popular market been the miniature's primary attractions. Smaller oval portraits were continuously painted in the first half of the nineteenth century, but the main creative thrust was toward framed wall hangings. It was a simple matter for the more accurate and novel photograph to decimate the ranks of the lesser talents who specialized in ornamental keepsakes. With the corps of brilliant miniaturists depleted in the 1860s, there was little of artistic excellence in the field for even the prestige-conscious patron to support. What had been a professional industry ever since Nicholas Hilliard's financial embarrassments was rapidly becoming the province of amateurs.

In the third quarter of the century, beleaguered by the incursions of photography and the drawn portrait, and suffering the loss of its best representatives, the miniature tradition in England had reached a virtual standstill in its development. In this moribund state, the miniature seems to have lost even its intrinsic sentimental value. The Keepsakes of the 1830s and 1840s with their maudlin romances were often illustrated with scenes of women clutching, crying upon, or gazing dreamily at miniature pendants. In 1857, Flaubert could still use this device to stigmatize Emma Bovary's

growing bourgeois attachment to her lover Rodolphe: 'She was becoming quite sentimental. They had had to exchange miniatures and locks of hair and now she wanted a ring, an actual marriage band as a sign of eternal union.'[70] But in 1871, it was a *carte de visite* that the arch-sentimentalist of the age, Sir John Everett Millais, chose to place in the hand of his pensive heroine in a painting on a courtship theme ambiguously titled *Yes or No* (Yale).

In 1865 the largest and most comprehensive retrospective of English miniature painting yet assembled opened at South Kensington. Claiming a state of crisis in the apparent collapse of the tradition before the soaring popularity of photography, its organizers professed the hope that the display would revive public interest in the art. But the continuity of the tradition as a practical art had been severed, and it is indicative of the extent of this break that the exhibition's organizers were unable to arrive at a clear definition of what constituted a miniature. In the end, they set aside questions of medium and function and used as their sole criterion size, thus including small-scale portraits in crayon, oil, pencil and watercolour. Although one critic praised the exhibition as an event 'particularly grateful to eyes wearied with the utter veracity – the "justice without mercy" – of photography',[71] this effort was largely unsuccessful in its primary aim.

In 1860 only sixty-three miniatures were exhibited at the Royal Academy; in 1870 the number had fallen by half and most of these, excluding the enamels of Simpson, the Bones and William Essex (1784–1869)[72], were the contributions of four artists: Annie Dixon, Reginald Easton, Edward Taylor (1828–1906) and Edward Moira (1817–87). The last two miniaturists were of modest talent but achieved some success through the support of the patrician class and the absence of any substantial competition. Henry Tanworth Wells (1828–1903), an able miniaturist who had exhibited from the 1840s, was represented by a few examples, but within a year he appears to have given up miniature painting for portraiture in crayons and in oils. Newton, Chalon and Cruikshank were represented by watercolour portraits on paper. By 1880 the number of miniatures had increased, but over half were again submitted by the same four artists. An attempt to bolster the profession came with the foundation of the Royal Society of Miniaturists, Sculptors, and Engravers, and Queen Victoria remained a staunch patron of the miniature painters who persisted; but belated recognition and spotty patronage did not revive the lost momentum. Toward the end of the century, Charles James Turrell (1846–1932), Nellie Hepburn-Edmunds (fl. 1895–1914; col. pl. 40e), and Edith Crapper (*c.* 1900–79), with their sensitive interpretations of character and their fluid, individual styles, provided a welcome alternative to the spate of amateur/professionals – Rosa Carter (fl. 1889–1910), Edith Fortunée de Lisle (1866–1911) and Mrs W. Lee Hanky (fl. 1889–1914), for instance – who seemed content to have their painting styles counterfeit photographic effects. Instances of original achievement (col. pl. 40c–d) were infrequent, but they stand as effulgent reminders of a great and enduring artistic legacy.

221. Charles Turrell, *Princess Mary, Princess Royal*, 1912, 80 × 63 mm. V&A P20–1934.

222. Edith Crapper, *Bertha Crapper aged 70*, 1925, 54 × 42 mm. V&A P16–1979.

Abbreviations

Auerbach 1954	E. Auerbach, *Tudor Artists: A Study of Painters in the Royal Service and of Portraiture on Illuminated Documents . . .*, 1954.
Auerbach 1961	E. Auerbach, *Nicholas Hilliard*, 1961.
Colding	T. H. Colding, *Aspects of Miniature Painting*, Copenhagen 1953.
Edmond	Mary Edmond, 'Limners and Picturemakers: New Light on the Lives of Miniaturists and Large-Scale Portrait-Painters working in London in the Sixteenth and Seventeenth Centuries', *Walpole Society*, XLVII, 1978–80, 60–241.
Foskett 1972	D. Foskett, *A Dictionary of British Miniature Painters*, 2 vols., 1972.
Foskett 1974	D. Foskett, *Samuel Cooper, 1609–1672*, 1974.
Foskett 1979	D. Foskett, *Collecting Miniatures*, The Antique Collectors' Club, Woodbridge 1979.
Foster	J. J. Foster, *A List Alphabetically Arranged of Works of English Miniature Painters of the XVII Century . . .* Supplementary to *Samuel Cooper and the English Miniature Painters of the XVII Century*, 1914–16.
Goulding	R. W. Goulding, 'The Welbeck Abbey Miniatures', *Walpole Society*, IV, 1916.
Hilliard	Nicholas Hilliard, 'A Treatise concerning the Arte of Limning', MS. Laing III 174, Edinburgh University; ed. R. K. R. Thornton and T. G. S. Cain, *'The Arte of Limning'*, Mid-Northumberland Arts Group, 1981.
Hilliard and Oliver 1947	Graham Reynolds, *Nicholas Hilliard and Isaac Oliver*, exhibition catalogue, Victoria and Albert Museum, 1947; revised and expanded 1971.
Limning 1573	*A Very Proper Treatise, wherein is briefly set forth the arte of limning . . .*, 1573
Long	B. S. Long, *British Miniaturists*, 1929.
Murdoch	John Murdoch, 'Hoskins' and Crosses: Work in Progress', *Burlington Magazine*, CXXXX, May 1978, 284–90.
Murdoch and Murrell	John Murdoch and V. J. Murrell, 'The Monogramist DG: Dwarf Gibson and his Patrons', *Burlington Magazine*, CXXIII, May 1981, 282–9.
NPG 1974	D. Foskett, *Samuel Cooper and his Contemporaries*, exhibition catalogue, National Portrait Gallery, 1974.
Noon	Patrick Noon, *English Portrait Drawings and Miniatures*, exhibition catalogue, Yale Center for British Art, 1979.
Norgate, BL	Edward Norgate, British Library MS. Harley 6000 (*c.* 1620).
Norgate, Bodleian	Edward Norgate, Bodleian Library MS. Tann. 326; ed. Martin Hardie as *Miniatura, or the Art of Limning*, Oxford 1919.
Princely Magnificence	*Princely Magnificence: Court Jewels of the Renaissance, 1500–1630*, exhibition catalogue, Victoria and Albert Museum, 1980.
Reynolds 1952	G. Reynolds, *English Portrait Miniatures*, 1952.
Reynolds 1961	G. Reynolds, 'Samuel Cooper: Some Hallmarks of his Ability', *Connoisseur*, CXLVII, February 1961, 17–21.
Sanderson	William Sanderson, *Graphice. The Use of the Pen and Pensil. Or, the Most Excellent Art of Painting*, 1658.
Sprat	Thomas Sprat, *The History of the Royal Society of London for the Improving of Natural Knowledge*, 1667.
Strong 1963	Roy Strong, *The Portraits of Queen Elizabeth I*, Oxford 1963.
Strong, *Icon*	Roy Strong, *The English Icon: Elizabethan and Jacobean Portraiture*, Studies in British Art, Paul Mellon Foundation, 1969.

Strong, *Portraits* Roy Strong, *Tudor and Jacobean Portraits* . . ., catalogue of the portraits in the
 National Portrait Gallery, 2 vols., 1969.

Van der Doort 'Abraham Van der Doort's Catalogue of the Collections of Charles I', ed. Oliver
 Millar, *Walpole Society,* XXXVII, 1958–60.

Vertue 'Vertue Note Books', I–VI, *Walpole Society,* XVIII/XXX, 1929–30/1951–2.

Walsh and Jeffree E. Walsh and R. Jeffree, '*The Excellent Mrs Mary Beale',* exhibition catalogue,
 Geffrye Museum and the Towner Art Gallery, Eastbourne 1975–6.

Yates 1972 Frances Yates, *The Rosicrucian Enlightenment,* 1972, edn. 1975.

Notes to the Text

Notes to Chapter One

1. Richard Haydocke, *A Tracte containing the Artes of Curious Paintings, Carvings & Buildings,* Oxford 1598, translation of G. P. Lomazzo, *Trattato dell'arte de la pittura.*
2. *Ibid.,* vi.
3. Norgate, BL.
4. Norgate, Bodleian.
5. Hilliard, 62.
6. It is only ten years since the systematic study of the history of miniature painting techniques was commenced at the Victoria and Albert Museum. Because of the size and frailty of portrait miniatures it has been impossible to subject them to the destructive, but objective, analytical techniques which are frequently employed in the study of less susceptible works of art. Therefore, the information on the subject has been derived from a limited number of non-destructive methods of examination, and from the study of contemporary and near contemporary documents.

 Although much of the research has been directed towards the collation of information which has a purely utilitarian value, such as bringing an objective aid to the problems of attribution, making clear distinctions (based on the study of materials and methods) between original works and later copies or forgeries, disclosing new additions of restorers and the depredations of time and ill-usage, and improving our approach to the conservation of the works, there is one other benefit which results from these studies which cannot be measured in practical terms, but which can greatly enhance the pleasure we derive from the miniatures, and our understanding of them and of the artists who created them. It has always been particularly true of miniature painting that art and craft cannot be separated, and it is because of that perception that we amplify in the pages that follow our sense of history with information which will contribute to the understanding of the appearance of the miniatures, of the means by which artists overcame the severe limitations imposed by their materials, and the way in which artists' everyday lives were tempered by the demands of their craft. I have omitted the 'cookery of art' – the endless recipes for pigments and other materials – but I hope to have made it clear that this traditional and oc-

casionally experimental science underpins all its perceived results.
7. *Limning* 1573.
8. The techniques of microscopy at magnifications ranging from x7 to x200 provide valuable evidence of the original structure of the miniatures, as well as accentuating the additions of earlier restorers and revealing losses in the original paint layers due to physical damage. Inspections using ultra-violet and infra-red reflectance have also been of great value: the former is capable of producing patterns which can be connected with particular artists; the latter, in addition to its value in revealing underpainting and accentuating indistinct inscriptions, is also capable of discriminating between the two important blues in use during the early period (the blue bice produced from azurite and the ultramarine made from lapis lazuli). X-radiographs are of great importance in the study of miniatures because they tend (like ultra-violet examinations) to produce a pattern of pigment usage which can enable us to identify the work of individual artists.
9. British Library MS. Harley 6376, 37–9.
10. G. C. Williamson, one of the earlier modern writers on miniature painting, suggested in *The Art of the Miniature Painter* (1905, 84–6) a further uncertainty over the medium used for binding pigments: that Holbein may have used the yolk or the white of egg as a binder, or a combination of the two. The author claimed that 'an eminent foreign chemist who experimented in Bavaria . . . said that he had obtained on analysis, distinct evidence of Holbein's use of albumen'. This statement should be treated with reserve: the author gave no particulars of the analysis, the chemist, or the painting on which the analysis was carried out. We are not even told that the subject of the test was a miniature. It may well have been an easel painting, in which case one would expect to find passages carried out with egg tempera. It seems unlikely that the destructive sampling which would have been necessary for a chemical analysis at the turn of the century would have been permitted in the case of a rare miniature of some 50 millimetres in diameter.
11. D. V. Thompson, Jnr, *The Materials of Mediaeval Painting,* 1936, 55–7; and *Limning* 1573, *passim.*
12. *Limning* 1573, f.12.
13. Norgate, Bodleian, 20.
14. Karel van Mander, *Schilderboek,* 1604; trans. Constant van der Wall, New York 1936, 89.

15. For example, the Grimani Breviary, Biblioteca Marciana, Venice.
16. Hilliard, 68.
17. The majority of the drawings, which constitute the largest corpus of work from Holbein's hand, are now in the Royal Library at Windsor. Many were exhibited in *Holbein and the Court of Henry VIII,* Queen's Gallery, Buckingham Palace, 1978–9.
18. Hilliard, 80.
19. *Ibid.,* 100.
20. *Ibid.,* 94.
21. *Ibid.,* 98.
22. Norgate, BL, f.9.
23. Sanderson, 68.
24. Norgate, Bodleian, 41–2.
25. British Library MS. Harley 6376, p. 60. The author of this manuscript gives directions for making a number of stones which are not mentioned by Norgate.
26. Two of Mayerne's notebooks on artists' techniques are preserved in the British Library: MSS. Sloane 1990 and 2052.
27. British Library MS. Sloane 1394, f.139v.
28. Goulding, no. 10. It is interesting that the diamond has been set into the vellum with pitch: Hilliard commented in his Treatise that the diamond was the only stone which, being set in pitch, 'changeth not in his bright pure whiteness'.
29. Norgate, BL, f.8.
30. *Ibid.*
31. British Library MS. Harley 6376, 50–1.
32. Norgate, *Bodleian,* 90.
33. *Ibid.,* 20.
34. Norgate, BL, f.5.
35. *Ibid.,* f.7. For many years pointed brushes were described as 'pencils'.
36. *Ibid.*
37. *Ibid.,* f.5.
38. *Ibid.,* f.7.
39. British Library MS. Harley 6376, 33.
40. *Ibid.,* 25–6.
41. *Ibid.,* 25.
42. *Ibid.,* 27.
43. See Mayerne, British Library MS. Sloane 2052, f. 29v, and Basil Long, 'Miniaturists, their Desks and Boxes', *Connoisseur,* LXXXIII, 1929, 323–7.
44. Sugar candy was a solid refined from cane sugar. Sugar cane was grown in Spain and Southern France, and for many years Venice was the sugar-refining centre for Europe. In 1544 two sugar refineries were opened in London, reducing the cost of importing the product. There is a recipe for making sugar candy in the British Library MS. Sloane 122, f.99. From the author's script, vocabulary and usage this manuscript cannot be dated much later than 1500.
45. Hilliard, 36. Earwax (cerumen) probably turned the watercolour paint into an emulsion. Cerumen is largely composed of phospholipids, which are good emulsifiers. Medical experiments have shown that the best agent for dispersing cerumen is pure water. See B. Senturia, *Diseases of the External Ear,* Illinois 1957, 125–38.
46. A type of squirrel hair imported from the con-

tinent; originally from a species of squirrel native to Calabria. The medieval Latin word for this animal was *calabre.*
47. British Library MS. Harley 6376, 12–16. This manuscript contains a detailed account of brush-making.
48. Long, 'Desks and Boxes', *op. cit., passim.*
49. Norgate, Bodleian, 25; and British Library MS. Harley 6376, 40.
50. British Library MS. Harley 6376, 8.
51. Hilliard, 22.
52. British Library MS. Harley 6376, 8–9.
53. Norgate, BL, f.6.
54. *Ibid.,* f.7.
55. *Ibid.,* f.8.
56. *Ibid.,* f.9.
57. Norgate, Bodleian, 3.
58. *Ibid.,* 3–5.
59. V. J. Murrell, 'Cooper's painting technique' in NPG 1974, xix–xxi; also V. J. Murrell, 'Some notes on the painting materials and methods used by Samuel Cooper', in Foskett 1974, 131–8.
60. Graham Reynolds, *Samuel Cooper's Pocket-Book,* Victoria and Albert Museum Brochure no. 8, 1975. Miniatures at various stages of completion are illustrated.
61. Murdoch and Murrell; also Jim Murrell, 'Examination of Portrait Miniatures: The Collaboration of Curator and Conservator', forthcoming, *Conservator,* VI, 1982.
62. Murdoch, 288–90.
63. See Reynolds 1952, 105: also Colding, 127–37. These writers leave us with little doubt that the portrait miniature on ivory was invented by Rosalba Carriera, the Venetian pastelist. The rapid spread of the new method was probably due to her international reputation. Colding's assertion, however, that ivory is an easier surface than vellum upon which to work with watercolour is wrong.
64. Reynolds 1952, 105.
65. See John Payne, *The Art of Painting in Miniature,* 1788, 21–6; Constant de Massoul, *Treatise on the Art of Painting,* 1795, 86–7; William Wood, 'Memoranda of Miniatures Painted 1790–1814', Victoria and Albert Museum Library MS., entry numbers 5384, 5421 (1796).
66. *The Art of Painting in Miniature,* translated from the French of Claude Boutet, 1729, 13. This treatise also mentions eel and carp gall, but these are not mentioned by later writers, presumably because ox gall was more easily obtained.
67. Quoted by Long, 293–4.
68. Nathaniel Whittock, *The Miniature Painter's Manual,* 1844, 63.
69. Wood, *op. cit.,* entry number 5035 (1790).
70. Payne, *op. cit.* 33–5.
71. Gilbert Russell, *The Art of Miniature Painting,* 1824, 27.
72. Andrew Robertson, *Letters and Papers of Andrew Robertson . . .,* ed. E. Robertson, 1897, 61–2.
73. *Ibid.,* 99.
74. *Ibid.,* 85.
75. *Ibid.,* 164.
76. *Ibid.*
77. *Ibid.;* also Alfred Tidey, *Diary,* 1844.

78. Charles Holtzapffel, *Turning and Mechanical Manipulation*, 1843, I, 154.
79. Robertson, *op. cit.*, 183–4.

NOTES TO CHAPTER TWO

1. This essay is based on research in progress towards a complete catalogue raisonné of all surviving English miniatures from *c.* 1520–1620 to be published in 1983. Many of the arguments and conclusions advanced here were worked out jointly with Jim Murrell during a period of eight years in which several hundred miniatures were examined out of their frames in the Conservation Department of the Victoria and Albert Museum. An incalculable debt is owed to owners who have allowed their miniatures to be examined in this way.
2. Hilliard, 63.
3. *Ibid.*, 91.
4. *Ibid.*, 97.
5. For what follows I am indebted to Gordon Kipling, *Triumph of Honour: Burgundian Origins of the Elizabethan Renaissance*, Sir Thomas Browne Institute, University of Leiden, 1977.
6. See S. Anglo, *The Great Tournament Roll of Westminster*, Oxford 1968.
7. For the documentation on painters, see the pioneer work of Auerbach 1954.
8. For an account of the Royal Library, see Kipling, *op. cit.*, 30–40.
9. J. B. Trapp and H. S. Herbruggen, '*The King's Good Servant*', *Sir Thomas More*, exhibition catalogue, National Portrait Gallery, 1977–8, no. 37.
10. *Ibid.*, no. 38.
11. Most of what follows is based on a detailed examination of the miniatures at the Victoria and Albert Museum. For the Horneboltes, see: Colding, 55ff; Auerbach 1954, 50–1, 171–2; Hugh Paget, 'Gerard and Lucas Hornebolte in England', *Burlington Magazine*, CI, 1959, 400–1; Graham Reynolds, *Connoisseur's Complete Period Guides*, ed. R. Edwards and L. G. G. Ramsey, 1968, 190–1; *Holbein and the Court of Henry VIII*, exhibition catalogue, Queen's Gallery, Buckingham Palace, 1978–9, nos. 89–90.
12. Trapp and Herbruggen, *op. cit.*, no. 43.
13. Strong, *Portraits*, I, 159 (Type VI). I would in the light of new evidence date these somewhat earlier.
14. Auerbach 1954, 50.
15. E.g., Colding, pl. 102.
16. Van der Doort, 114, no. 47. The miniature is now in the collection of the Duke of Buccleuch.
17. *Ibid.*, 115, no. 48. The miniature is still in the Royal Collection.
18. *Ibid.*, 114, no. 46.
19. Trapp and Herbruggen, *op. cit.*, no. 36; also Foskett 1979, pl. 4c.
20. Duke of Buccleuch.
21. Strong, *Portraits*, I, 40.
22. Foskett 1979, pl. 4a.
23. *Exhibition Illustrative of Early English Portraiture*, Burlington Fine Arts Club, 1909, pl. XXXII (case B, no. 2).
24. What follows is based on a study of the actual miniatures at the Victoria and Albert Museum. The relevant previous literature is: A. B. Chamberlain, *Hans Holbein the Younger*, 1913, II, 217–42; Long, 214; P. Ganz, *Holbein*, 1950, pls. 172–91, 258–60, 432–510; Reynolds, *Connoisseur's, op. cit.*, 191–225.
25. All reproduced in Ganz, *op. cit.*
26. Duke of Buccleuch; repro. *ibid.*, pl. 189.
27. Private Collection; repro. *ibid.*, pl. 190.
28. For the biographical facts on the Bennincks and Levina Teerlinc, see Auerbach 1954, 51, 75, 103–5; Reynolds, *Connoisseur's, op. cit.*, 225; Auerbach 1961.
29. For sources, see my forthcoming book.
30. Auerbach 1961, 54, suggests the *Elizabethan Maundy*.
31. Strong, *Icon*, 76, no. 12.
32. *Ibid.*, 92–3, nos. 32–3.
33. Royal Collection.
34. *British Portraits*, Royal Academy, 1956, no. 598.
35. Strong 1963, 5.
36. For Hilliard the standard monograph remains Auerbach 1961. Pages 336–8 contain a bibliography of literature up to 1961. Since then, the following have appeared: Leslie Hotson, 'Queen Elizabeth's Master Painter', *Sunday Times Colour Magazine*, 22 March 1970, 46–53; Graham Reynolds, 'The Painter plays Spider', *Apollo*, LXXIX, 1964, 279–84; Roy Strong, *Nicholas Hilliard*, 1975; Edmond; Hilliard (Thornton and Cain edn).
37. Hilliard, 69.
38. Auerbach 1961, 288, nos. 11–12.
39. *Ibid.*, 11.
40. *Ibid.*, pl. 186.
41. See a listing in Strong 1963, 89–95.
42. Auerbach 1961, pls. 30–5.
43. Hilliard, 77.
44. Auerbach 1961, pl. 68.
45. Strong 1963, 60, nos. 23–4, pl. VII.
46. See Strong, *Icon*, 13ff.
47. Auerbach 1961. pl. 87.
48. *Ibid.*, pls. 88, 93, 98.
49. *Ibid.*, pl. 177.
50. *Ibid.*, 326.
51. *Ibid.*, 29.
52. *Ibid.*, 6–7.
53. *Ibid.*, pl. 56.
54. Graham Reynolds, 'Portraits by Nicholas Hilliard and his Assistants of King James I and his Family', *Walpole Society*, XXXIV, 1959, 14–26.
55. *Ibid.*, pl. 159.
56. On Lockey, see Otto Kurz, 'Rowland Locky', *Burlington Magazine*, XCIX, 1957, 13–16; Auerbach 1961, 254–62; Edmond, 95–7.
57. E.g. Auerbach 1961, pl. 154.
58. Royal Collection, Recent Acquisitions 11.
59. Auerbach 1961, pl. 194, as attributed to Laurence Hilliard.
60. There is one other painter who has been pushed to the fore as a possible miniaturist who should

be disposed of. William Segar (fl. 1580–5, d. 1633) was a pursuivant and subsequently a herald and enjoyed a long career in this capacity ending up as Garter King of Arms (Auerbach 1961, 271–81). He certainly painted portraits on panel. A documented one survives and others can be related to it. No fewer than six are listed in the inventory of the Lumley collection in 1590. Naturally as a herald he belonged to a quite different tradition, that of illuminating grants of arms, and one certain work has so far emerged, a portrait of Dean Colet, but it bears no relation in style or format to Hilliard. In his large-scale painting he was certainly influenced by Hilliard's calligraphic manner, as was Robert Peake; but this does not turn them into practising portrait miniaturists. Auerbach's attribution of a full-length of Robert Dudley, Earl of Leicester, in the Buccleuch collection cannot in any way be sustained (established in 1979 by scientific examination). It is early nineteenth century in date and likely to be by G. P. Harding. Segar may be placed safely to one side.

61. Auerbach 1961, 224–32.
62. Foskett 1979, pls. 11a, 11b.
63. The literature on Oliver is surprisingly scanty: *Nicholas Hilliard and Isaac Oliver*, exhibition catalogue, Victoria and Albert Museum, 1947, 11–12, nos. 121–205; Auerbach 1961, 232–54; Edmond, 72–95.
64. Auerbach 1961, pl. 195.
65. Edmond, 73, suggests a relative of Gilbert Talbot, seventh Earl of Shrewsbury, who took the Order of the Garter to Henry IV in the autumn of that year.
66. Van der Doort, 123, no. 1.
67. Auerbach 1961, 235.
68. For drawings by Oliver, see *The Age of Shakespeare*, exhibition catalogue, Whitworth Art Gallery, Manchester, 1964, nos. 48–63.
69. Auerbach 1961, 234.
70. Strong, *Icon*, 151–7.
71. *Ibid.*, 269–304.
72. *Ibid.*, 289, no. 285; 297, no. 300.
73. Peter and Ann MacTaggart, 'The Rich Wearing Apparel of Richard, 3rd Earl of Dorset', *Costume*, XIV, 1980, 41–55.
74. Strong, *Icon*, 313–35, esp. 321, no. 336; 323, no. 341.
75. Strong, *Portraits*, II, pl. 324.
76. Repro. *Hilliard and Oliver* 1947, no. 190.
77. William Camden, *Remaines . . . concerning Britaine*, edn. 1870, 366–7.
78. What follows summarizes Roy Strong, *The Cult of Elizabeth*, 1977, 56–83.
79. George Peele, *The Honour of the Garter* in *Works*, ed. A. H. Bullen, 1888, 316–20.
80. See Frances A. Yates, *Giordano Bruno and the Hermetic Tradition*, edn. 1978, 296–7.
81. G. P. V. Bolzani, *Les Hieroglyphes*, trans. I. de Montyard, Lyon 1615, 518.
82. See Roy Strong, 'The Elizabethan Malady: Melancholy in Elizabethan and Jacobean Portraiture', *Apollo*, LXXIX, 1964, 264–9.
83. *The Complete Poems of Sir John Davies*, ed. A. B. Grosart, London 1876, 43.
84. *The Miscellaneous Works in Prose and Verse of Sir Thomas Overbury*, 1856, 73.
85. Act I, sc. i; III, sc. i.
86. Lost; Auerbach 1961, no. 220.
87. For suggested wilder (and I find unacceptable) ramifications, see L. Hotson, *Shakespeare by Hilliard*, 1977.
88. Ham House Collection, Victoria and Albert Museum.
89. Strong, *Cult, op. cit.*, 156.
90. *Ibid.*, 64–5, 156.
91. For a listing of the Mask of Youth miniatures, see Strong 1963, 94–7, nos. 13–22.
92. *Ibid.*, 97, no. 21; *Princely Magnificence, Court Jewels of the Renaissance*, exhibition catalogue, Victoria and Albert Museum, 1980, no. 36.
93. *Princely Magnificence*, no. 38, for bibliography. The miniature bears a false date and depicts the queen *c.* 1600 with the additional chin-ruff that appears only in the very last portraits of her. The date 1585–90 given in *Princely Magnificence* is a decade too early.
94. *Poems of Davies, op. cit.*, 135. On the image of the queen in these years, see Strong, *Cult, op. cit.*, 46ff.
95. *The Memoirs of Sir James Melvil*, ed. George Scot, 1752, 96–7.
96. See Countess of Radnor and W. B. Squire, *Catalogue of the Collection of the Earl of Radnor*, 1909, II, 109; Roy Strong, 'The Radnor Miniatures', in *Christie's Review of the Season 1974*, ed. John Herbert, 1974, 254–7.
97. Strong, *Icon*, 171, no. 114.
98. *Princely Magnificence*, no. 46.
99. *Ibid.*, no. 40. The present date reads 1575. Beneath can be seen the indentation for 1586 and not 1588 as stated in *Princely Magnificence*.
100. Strong 1963, 28.
101. Auerbach 1961, 167–8, pl. 165; 318, no. 179; Strong, *Nicholas Hilliard*, 1975, 15.
102. P. K. Thornton and M. Tomlin, *The Furnishing and Decoration of Ham House*, Furniture History Society, 1980, 25–6, 127–32.
103. Van der Doort, 102–23.
104. *Ibid.*, 113.

Notes to Chapter Three

1. As, for example, Strong, *Icon*, 27, 57.
2. The concept of this enlightenment, and much else here, is derived from Yates 1972.
3. Sprat, 82–3.
4. Edmond, 73, suggests that Oliver could have been born from about 1589. My account here relies on Edmond for all documentary references.
5. *Ibid.*, 76.
6. In his will, *ibid.*, 75.
7. Wicander collection, Nationalmuseum, Stockholm.
8. V&A P3-1950.
9. E.g., formerly in the Pierpont Morgan collection, and another last recorded in the collection of S. Wingfield Digby; photos V&A.

10. At Welbeck, undated but close to *Nethersole*. Another dated example was an *Unknown Man* of 1620 in the Wyndham Cook collection; photo V&A.

11. Now National Gallery, Washington. The picture was profoundly associated with the Garter cult, having been presented by Duke Guidobaldo of Urbino to Henry VIII in return for the Order of the Garter, conferred on him in 1504 (C. H. Clough, 'The Relations between the English and Urbino Courts, 1474–1508', *Studies in the Renaissance*, XIV, 1967, 207).

12. Now National Gallery, London; the miniature, signed and dated 1634, is at Windsor.

13. Now Louvre; the miniature, signed and dated 1633, is also at Windsor.

14. Norgate, Bodleian; quoted by Long, 321.

15. Quoted in *DNB*.

16. See sections on Samuel Cooper and Snelling.

17. Joseph Meder, *The Mastery of Drawing*, trans. W. Ames, 2 vols., New York 1978, 72–4, 135–9 *et passim*. This is useful but incoherent. Meder did not know of the various techniques for preparing vellum, and did not know of the use of gesso-prepared cards by limners. On graphite, and the opening of the Borrowdale plumbago mines in 1664, see 114–15.

18. See p. 89. The *editio princeps* is the large rectangle by Isaac Oliver at Windsor (pl. 90). The classicizing profile type derives similarly from Isaac (pl. 79).

19. As a boy, formerly Solly collection (Sotheby's, 27 June 1940), with apparently updated versions at Windsor and in the Rijksmuseum/Mauritshuis; a portrait of 1621 also in the Rijksmuseum/Mauritshuis; one of 1626 formerly in the Pierpont Morgan collection (Christie's, 24 June 1935, lot 185); and an undated but probably later image in the Cecil Higgins collection; photos V&A.

20. E.g. *c.* 1613–14 in the Buccleuch collection, and *c.* 1620 in the Rijksmuseum/Mauritshuis; photos V&A.

21. Viz. the profile portrait in the Dutch royal collection, adapting the idiom of the Fitzwilliam *Prince Henry*.

22. No fewer than three have ended up from separate sources at the Victoria and Albert Museum.

23. Edmond, 113–23.

24. *Ibid.*, 200, note 244.

25. Windsor.

26. Mauritshuis.

27. See p. 44.

28. Basil Long (1929, 224) admitted this possibility by speculating that Hoskins and his son both worked on the same miniatures, and Graham Reynolds (1952, 43), though he has been largely responsible since for the disappearance of the younger Hoskins from the historian's reckoning, also allowed for possible collaboration between father and son.

29. The case is argued at greater length in Murdoch 1978.

30. Compare also a version sold at Christie's, 2 November 1971, lot 42, repro.

31. The following list is a possible oeuvre for the younger Hoskins:

Princess Elizabeth, IH/1645 (Beauchamp collection)

Sir Charles Lucas of Colchester, IH/1645 (Christie's, 24 June 1935, lot 139)

A Woman, IH/1646 (formerly Mrs Ashcroft)

General Davison, IH/1646 (Buccleuch collection)

A Soldier aged 27, IH/1646 (Beauchamp collection)

A Man, no signature or date, but *c.* 1647 (Christie's, 28 October 1970, lot 114)

Sir Thomas Peyton aged 35, no signature or date, but *c.* 1647 (Sotheby's, 9 June 1969, lot 69)

Sir John Wildman, IH/1647 (V&A)

Second Duke of Hamilton, IH/1647 (formerly Lady Binning)

Jane Stanhope, IH/1648 (Christie's, 16 December 1975, lot 45)

Lady Glenham, 1648/IH (formerly Pfungst collection)

Unknown Woman, 1649/IH (formerly Pfungst collection)

Unknown Woman, 1650/IH (Marquess of Crewe)

First Earl of Shaftsbury, 1652/IH (Christie's, 24 June 1935, lot 140)

Unknown Woman, no signature or date, but *c.* 1653 (Christie's, 18 June 1974, lot 66)

Ann Rich, 1653/IH (Buccleuch collection)

Unknown Woman, 1653/IH (Christie's, 29 June 1932, lot 144)

Edward, first Earl of Conway, 1655/IH (Wallace Collection)

Viscountess Mansfield, 1665/IH (Portland collection)

A Youth, 1657/IH (Windsor)

Sir John Maynard, 1657/IH (Metropolitan Museum, New York)

Unknown Man aged 67, 1658/IH (formerly Pfungst collection)

32. Edmond, 114–15.

33. *Ibid.*, 118.

34. *Ibid.*, 121.

35. Quoted by Reynolds 1952, 46.

36. *DNB*.

37. Walsh and Jeffree; also E. Walsh, 'Mary Beale Paintress', *Connoisseur*, CXXXI, 1953, 3–8; and E. Walsh, 'Charles Beale 3rd Book 1680', *Connoisseur*, CXLIX, 1962, 248–52.

38. Lugt Collection, Institut Néerlandais, Paris.

39. Reynolds 1952, 59.

40. Edmond, chapters on the Hoskinses and Coopers. Cooper's maternal grandfather, however, was buried from the Fleet prison on 3 May 1610 (*ibid.*, 99), so it would be wrong to suppose that either of the two families could have felt secure socially.

41. Mary Edmond has raised the question as to whether Samuel or Alexander Cooper was the elder. She points out that a possible reading of the inscription on Samuel's burial monument, 'Obijt quinto die Maii Anno MDCLXXII Aetatis Suae 63', was that he had attained the age of sixty-three – a natural interpretation – and could therefore have been born in the latter part of 1608, about a year after his parents' marriage and a year before Alexander's birth (Edmond, 99–100).

42. Richard Graham in *du Fresnoy's Art of Painting, translated into English by Mr Dryden*, 1695, appendix 338–9.
43. *Ibid.*; quoted in Long, 81.
44. B. Buckeridge, in *The Art of Painting and the Lives of the Painters, done from the French of Monsieur de Piles*, 1706, 409–12; quoted by Long, 83.
45. Murdoch, 287–8.
46. 'I must confess I do think the colouring of the flesh to be a little forced' (quoted by Foskett, 1974, 49).
47. An idea first mooted by Oliver Millar in the *Burlington Magazine*, CXVI, 1974, 346.
48. Long, 82.
49. Reynolds 1952, 51–2.
50. *Ibid.*, 56. Aubrey said that the auction price of a Cooper was twenty guineas.
51. Quoted by Long, 86.
52. Quoted by Foskett 1974, 50–1.
53. 'On the Noble Art of Painting' for Sanderson's *Graphice*, 1658.
54. As so often the best account and fullest transcription of this is Mary Edmond's, 100–1.
55. Thus anticipating the practice of the Royal Society: 'This freedom therefore, which they use, in embracing all assistance, is most advantageous to them: which is the more remarkable, in that they diligently search out, and join to them, all extraordinary men, though but of ordinary Trades. And that they are likely to continue this comprehensive temper hereafter . . .' (Sprat, 67).
56. Sanderson, 32.
57. Yates 1972, chapter I.
58. Cleveland Museum of Art.
59. See pp. 151–2.
60. Reynolds 1952, 51.
61. G. Reynolds, 'Was Samuel Cooper influenced by Rembrandt?' *Victoria and Albert Museum Bulletin*, II, July 1966, no. 3, 97–103.
62. Fitzwilliam Museum.
63. See, for example, the instances quoted by Long, 85. The courts with which Cromwell was corresponding were to a great extent those that Alexander Cooper was involved with, and which were the background to his assimilation to the enamel cult. Samuel Cooper's Cromwell portraiture also shows this trend, and it may therefore have been a conscious adaptation of the English style to suit the potential recipients. An image, for example, went off to Queen Christina of Sweden probably in the early 1650s with verses by Milton – 'Bellipotens Virgo, Septem regina trionum,/ Christina, Arctoi lucida stella poli' (quoted from Reynolds 1952, 52) – alluding to her role in the firmament of Northern Protestant powers.
64. For a posthumous portrait the painter obviously makes use of what sources he can. See O. Millar, 'Painting in the Age of Charles II', *Connoisseur*, CXLVII, 1961, 3.
65. Earl Spencer, repro. NPG 1974, no. 107.
66. Fitzwilliam, repro. NPG 1974, no. 116.
67. See pl. 127.
68. Goulding, no. 62.
69. Version also at the Mauritshuis.
70. The *Lauderdale*, signed and dated 1664, probably existed as a multiple; there is an unsigned version in the Buccleuch collection. The *Clifford* is one of Cooper's latest works, signed and dated 1672 (collection of the Lord Clifford of Chudleigh, repro. NPG 1974, no. 135).
71. Pepys specifically mentioned portraits of Arlington and Ashley (quoted by Foskett 1974, 49; see also pls. 46, 74). Part of the wit and aptness of the name Cabal, as applied to the supposed leaders of Charles's Foreign Affairs committee, was to tar its members with the brush of witchery and the discredited magico-cabalistic tradition.
72. G. Reynolds, *Wallace Collection Catalogue of Miniatures*, 1980, p. 53.
73. A. M. Crino, 'The Relations between Samuel Cooper and the Court of Cosimo III', *Burlington Magazine*, XCIX, 1957, 16; An account of the correspondence and of the entries from the records of expenditure in the royal household is accessible in excellent summary in Foskett 1974, 59–69.
74. Reynolds 1952, 65–6.
75. Long, 79.
76. On these portraits and their basis in work attributed to Honthorst, see A. Staring, 'Vraagstukken der Oranje-Iconographie', *Oud-Holland*, I, 1953, 12–24. There appears to have been confusion between Frederick V of Bohemia and Prince Frederick Henry of Orange, but the Craven miniatures seem to have settled the identification as Frederick and Elizabeth of Bohemia. Either way, however, the appearance of these portraits, classicizing and evocative of imperial Rome, was characteristic of the culture that the Bohemians fostered and which harboured them. Portraits in this idiom run from Anne of Denmark (profile at Windsor, 'Servo per regnare', by Isaac Oliver), the profiles of Prince Henry (*Hilliard and Oliver* 1947, nos. 180, 190; Sotheby's, 5 July 1976, lot 14), to the Thach–Honthorst images of Elizabeth of Bohemia's children. They help attach heroic and mystic associations to the sitters' political personae.
77. J. von Sandrart, *Academia Nobilissimae Artis Pictoriae*, 1683, 312; quoted by Long, 78–9.
78. *William Duke of Hamilton* (V&A P140–1910); *John Digby, Earl of Bristol* (V&A P132–1910); *Robert Dormer, first Earl of Carnarvon* (collection of Lord Glenconner; a version is in the V&A, Evans 51). The first two were attributed to Alexander Cooper by Reynolds, and the third (with alternative suggestion of Peter Oliver) by Carl Winter – notes in V&A files.
79. Apart from those already referred to, there is a larger version in the Buccleuch collection.
80. A. Houbraken, *De Groote Schouburgh der Nederlandsche Konstschilders an Schilderessen*, 1753, II, 87; quoted by Long, 79.
81. G. C. Williamson, *History of Portrait Miniatures*, 1904, I, 78ff; quoted by Long, 79.
82. Quoted by Reynolds 1952, 65.
83. By Peter Barber, a verbal opinion; recognition was instantaneous.
84. Colding, 109.

85. E. A. Beller, 'The Thirty Years' War', in *The Decline of Spain and the Thirty Years' War*, New Cambridge Modern History, IV, ed. J. Cooper, Cambridge 1970, 316.

86. See Murdoch and Murrell, summarized in the following pages.

87. Van der Doort, 104, 214.

88. Transcribed by Dr A. Staring in the course of correspondence with Graham Reynolds in October 1952; quoted by Murdoch and Murrell.

89. Vertue, VI, 10.

90. Goulding, 28.

91. 'Tis pis auff ardonis was te noffember 1639 bij mi diliffert tu da kings hands inde kabint and bij mis Magen diliffert tu dick melort chamerlings dwarff vor tu kopit and den tu ristorit agn vorda kings us tu de kabint' (Van der Doort, 114).

92. Kimbell Art Museum, Fort Worth, Texas.

93. *Charles Dormer, second Earl of Carnarvon*, signed DG (Duke of Beaufort); repro. NPG 1974, no. 200

 Elizabeth Capell, Countess of Carnarvon, signed DG, (Duke of Beaufort); repro. *ibid.*, no. 199

 Elizabeth Capell, signed, inscribed and dated Ascot Janu 31 1657 (Lord Wharncliffe in 1865); photo. V&A

 Elizabeth Capell (probably) signed DG (V&A P15–1926); until 1980 exhibited as an example of du Guernier

 Elizabeth Capell, authoritatively inscribed as by Richard Gibson (Yale Center for British Art)

 Lady Katherine Dormer, authoritatively inscribed as by 'Mr Gibsone' (V&A P77–1935)

 Lady Isabella Dormer, signed RG, inscribed and dated 1671 (V&A P4–1966)

 Peregrine Bertie (T. Cottrell-Dormer Esq.); repro. NPG 1974, no. 202

 Sir Harry Capell (Lord Wharncliffe in 1865); photo. V&A

 Arthur Capell, Earl of Essex, and his Wife (Duke of Buccleuch); photo. V&A

 Elizabeth Countess of Essex (two versions: Castle Howard; Mrs Foskett); repro. NPG 1974, no. 203

 Elizabeth Wriothesley, Countess of Northumberland (Duke of Buccleuch); photo. V&A

 Elizabeth Capell was the sister of Arthur Capell, Earl of Essex, and of Sir Harry Capell, afterwards Lord Capell of Tewkesbury. The Countess of Essex was Elizabeth Percy, daughter of the tenth Earl of Northumberland; the Northumberlands had been political allies of the Pembrokes in the 1640s and then swung with the Capells and the rest of the group back to a form of qualified monarchism in the 1650s. Lady Katherine Dormer was the half-sister of the Earl of Carnarvon's second wife Mary; she married Robert Dormer and lived quite near Ascot at Dorton in Buckinghamshire. Katherine and Mary were daughters of Montague Bertie, second Earl of Lindsey, and sisters of Peregrine. Lady Isabella Dormer was the daughter of Charles, second Earl of Carnarvon, by Elizabeth Capell.

94. Collection of Captain Pearce in 1935; photo. V&A. Pearce was the correspondent of Long largely responsible for raising the issue of a miniaturist called D. Gibson.

95. Sanderson, 15.

96. Quoted by Reynolds 1952, 78.

97. Vertue, IV, 168.

98. Edmond, 108.

99. Sanderson, 20.

100. Collection of Mrs Foskett.

101. Edmond, 123–4, has established his basic circumstances.

102. Sanderson, 20.

103. E. Waterhouse, *Painting in Britain, 1530–1790*, 1953, edn. 1969, pl. 37.

104. Manchester, City Art Gallery; repro. *ibid.*, pl. 36.

105. Long, 123.

106. Foskett 1972, 242.

107. Windsor.

108. Earl of Haddington, repro. NPG 1974, no. 149.

109. Dated by D. Piper, *Catalogue of the Seventeenth-Century Portraits in the National Portrait Gallery*, Cambridge 1963, 63, to *c.* 1645, but on costume certainly ten years earlier.

110. Buccleuch collection.

111. V&A Evans 28.

112. Foskett 1972, II, fig. 224.

113. Goulding, 30. The group following this Hartwell House version of 1651 includes examples formerly in the Newdegate collection (photo V&A), at Welbeck (repro. Goulding, pl. xv, no. 89), Earl of Ancaster, Earl Spencer at Althorp (repro. NPG 1974, no. 209), Earl Bathurst, Messrs Duveen.

114. HH381; versions are widespread; a photograph of one that was in the collection of L. Twiston-Davies is in the Victoria and Albert Museum.

115. Summarized and quoted by Goulding, 29.

116. *Ibid.*

117. About 1664 at Windsor, see O. Millar, *The Tudor, Stuart and Early Georgian Pictures in the Collection of Her Majesty the Queen*, 1963, I, 131, no. 289, pl. 124; the miniature is in the collection of Mrs Foskett; repro. Foskett 1979, pl. 23d.

118. Long, 123, states that he was associated with the French Dominicans; and Reynolds 1952, 70, that he became a Roman Catholic.

119. Long; Walsh and Jeffree, 50–2, from which the following details and quotations are taken; see also the account by Foskett 1979, 116–17.

120. Walsh and Jeffree.

121. *Charles II*, probably as prince, after Hanneman, signed and dated 1651 (Mauritshuis); it is practically identical – indistinguishable stylistically at least in a photograph – from des Granges's version

 Anne of Gonzaga, signed and dated 1649 (V&A), after a portrait attributed to Louise Hollandine in the style of Honthorst, in the Museum Wasserburg, Anholt, West Germany

 Prince Maurice, signed (Windsor); repro. Walsh and Jeffree, no. 57

 Princess Louise Hollandine (Musée Carnavalet), after a self-portrait (?) in the style of Honthorst; attributed to Thach by Walsh and Jeffree, no. 58, repro.

Princess Sophia, signed and dated 1651, after Honthorst (Sotheby's, 29 March 1965, lot 41); repro. Foskett, 1979, II, pl. 899

122. The Palatine takeover of the Elizabethan Garter cult is described, with a bibliography of earlier studies, by Yates 1972, 29–30.
123. See p. 64.
124. Walsh and Jeffree, 50.
125. Quoted by Foskett 1974, Appendix III, 101.
126. Duke of Northumberland.
127. In November 1936 in the possession of Mr A. G. Tite.
128. Liverpool, referred to by Long, 415.
129. Earl Beauchamp; photo V&A.
130. In 1933 in the possession of the Rev. G. A. Parr.
131. For the greatly increased information on Snelling we are mainly indebted to Walsh and Jeffree; some of Jeffree's additional information was published in Foskett 1979, 117–19.
132. The following are in the V&A:
La Duchesse de Croy P77-1929
Demoiselle de Londres P78-1929
Countess of Buchan P79-1929
Marquess of Gordon }
Mrs Killigrew } P200-1929
 Henry Prince of Wales, originally paired with *La Duchesse de Croy,* was sold at Sotheby's, 5 July 1976, lot 14.
133. Even Alexander Cooper has been suggested. Graham Reynolds in correspondence with David Piper in 1954 mentioned that Carl Winter had compared the group with drawings by de Passe. This insight helps greatly towards distinguishing the important school of Anglo-Netherland portrait and figure draughtsmen around Isaac Oliver and the de Passe workshop. In the English connection Faithorne seems to have been its most distinct product.
134. Repro. Foskett 1979, 117, pl. 22d.
135. The Victoria and Albert Museum has recently acquired for Ham House the copy by Marshall of the *Catherine Bruce* (HH274), but this example, being in bad condition, gives a poor account of his style. The most impressive of his works that I have seen are in an extra illustrated volume of Walpole's *Anecdotes of Painting in England* (1765) in the Rare Book department of the Yale Center for British Art.
136. Vertue, I, 116.
137. *Ibid.*
138. *Ibid.,* II, 69.
139. *Complete Peerage . . .,* ed. G. E. Cokayne, 1895, VI, 55 and note c.
140. Vertue, I, 116.
141. *Ibid.,* IV, 168.
142. Information supplied by my colleague Ronald Lightbown.
143. Vertue, IV, 168.
144. Information supplied by Jim Murrell.
145. Walsh and Jeffree, 14.
146. *Diary of Robert Hooke, 1672–1680,* ed. Robinson and Adams, 1935, 134, 153; quoted from a manuscript note by C. F. Bell in his copy of Long, 415.
147. Walsh and Jeffree, 38.
148. Walsh and Jeffree.
149. *DNB,* deriving information from registration

details given by him to the academic authorities.
150. Reynolds 1952, 75.
151. Sprat, 57.
152. *Ibid.,* 82.
153. *Ibid.,* 76.
154. *Ibid.,* 67.
155. *Ibid.,* 149.
156. *Ibid.,* 113.
157. Fitzwilliam Museum.
158. Sprat, 113.
159. *Ibid.,* 82.
160. Foster, no. 26.
161. *Ibid.,* no. 39.
162. V&A P118-1910.
163. V&A P122-1910.
164. V&A Evans 24.
165. Foster's list is still the most comprehensive available.
166. T. Flatman, *Poems and Songs,* edn. 1686, introductory address 'To the Reader', unnumbered pages.
167. *Ibid.*
168. 'On the Death of the Right Honourable Thomas Earl of Ossory. Pindaric Ode', stanza II.
169. Sprat, 113.
170. Reynolds 1952, 87.
171. Vertue, IV, 193.
172. *Ibid.,* IV, 50.
173. Goulding, 25–6.
174. See p. 96.
175. Reynolds 1952, 87.
176. Foster, 94–104. All of Dixon's works included in Foster's list were pre-1680.
177. Quoted by Goulding, no. 362.
178. Vertue, IV, 144.
179. Some details of Dixon's salary and its payment are transcribed by Goulding, 25.
180. Murdoch, 288–90; Mary Edmond, 'Peter Cross, Limner: Died 1724', *Burlington Magazine,* CXXI, September 1979, 585–6. He still walks occasionally, however, as in Foskett, 1979, 149–52.
181. V&A P11-1955.
182. Reynolds 1952, 94.
183. It is painted with a curiously neat brushwork and sugary colours directly on to a gesso-grounded card with no vellum. The Cross, of course, is painted on vellum in the conventional English way, but otherwise the relationship is striking.
184. Vertue, VI, 19.
185. *Monmouth,* Goulding, no. 91; *Newcastle,* Goulding, nos. 111, 116; *Albemarle,* Goulding, no. 165.
186. *Lauderdale* (Ashmolean Museum).
187. HH377.
188. Vertue, I, 78.
189. See p. 156.
190. Formerly Heckett collection, sold Sotheby's, 11 July 1977, lot 140, repro. in colour; also repro. Foskett 1979, pl. 34c.
191. There is room for further research here. I suspect that the interface between the two artists in the late 1660s includes many instances of fraudulent transfer from Cross to Cooper.

Thus the signature SC/1669 on the so-called *First Earl of Sandwich*, V&A D93, seems to be a forgery, and the style of the miniature in polychrome stipple is much closer to that of Cross at this time.

192. Vertue, I, 107.
193. Edmond, 'Peter Cross', *op. cit.*, 586.
194. Vertue, I, 109, 118.
195. *Ibid.*, V, 40.
196. *Nieuw Nederlandsch Biografisch Woordenboek*, ed. P. C. Molhuysen and P. J. Blok, Leiden 1911, VII, 479.
197. Yates 1972, 253.
198. *An Introduction to the General Art of Drawing . . . Formerly set out by that Excellent Limner Mr Gerhard of Brugge . . . augmented and amended by W. Gore. Truly translated into English by J.L.*, 1674, 1–2. Gore's use of 'Gerhard of Bruges' suggests consciousness of the importance of the Ghent–Bruges tradition for the early English school.
199. See p. 150.
200. Yates 1972, 254.
201. Edmond, 'Peter Cross', *op. cit.*, 586.
202. *Ibid.*

NOTES TO CHAPTER FOUR

1. The primary source of information concerning the artists of the next four decades remains the notebooks of George Vertue, whose connection to the Earls of Oxford brought him in close contact with the leading miniaturists of the period. With regard to Dixon, he recalled in 1742: 'I have not seen of his works in Queen Anne's time' (IV, 193).
2. See David Piper, *The English Face*, 1957, 148. Carl Winter, in an otherwise sympathetic essay on the subject of the English miniature, virtually passed over the entire first half of the century; see also Carl Winter, 'The British School of Miniature Portrait Painters', in *Proceedings of the British Academy*, XXXIV, 1948.
3. Arthur Pond's naturalistic etched portrait of Dr Mead (1739) so embarrassed the doctor that he asked to have the plate destroyed. As Vertue noted with respect to this incident: 'such kinds of work will give pleasure to Virtuoso but not to the public eye . . . and modish people' (III, 126). The mere notion of appearing in public without a wig 'debassed the Idea of a polite person'.
4. With Kneller's death in 1723, the quality of large-scale portraiture in oil declined to such an extent that even engravers, whose function it was to replicate these images and who could not be held accountable for the painter's deficient inspiration, were afraid for their reputations. The distinguished mezzotint engraver George White was apparently so mortified by prevalent standards that he abandoned his profession in the 1730s to 'draw pictures from life on vellum' (Vertue, III, 60).
5. Andre Rouquet, *The Present State of the Arts in England*, 1754, 56.

6. Sotheby's, 17 May 1976, lot 71, repro.
7. See Foskett, 1972, I, 170. It was at Coventry that Boit instructed Humphry Wanley, future librarian to the Earls of Oxford who were the most important patrons of miniature painting during this period. Vertue's (IV, 192) 1741 inventory of Lord Oxford's collection listed 532 pictures of which many were miniatures.
8. Vertue, III, *passim*.
9. Horace Walpole, *Anecdotes of Painting in England*, ed. J. Dallaway and R. N. Wornum, 1849, II, 682.
10. Inscribed in graphite, verso, "C Richter/ 1719."
11. Vertue, III, 63.
12. The portrait of Lady Margaret Harley is in the collection of the Duke of Portland; see Goulding, no. 185, and Foskett, 1972, II, pl. 290, no. 726. The *Mrs Eliot* is repro., pl. 289.
13. Quoted from Piper, *Face, op. cit.*, 158.
14. Sotheby's, 13 February 1978, lot 57, repro.
15. For a discussion of the date of Arlaud's death see Foskett, 1972, I, 139. Dated works by Arlaud at Welbeck Abbey are Goulding, nos. 129, 137–8. Miniatures of Marlborough and Prince Eugene are Goulding, nos. 130–1. Goulding also lists three miniatures dated 1706: *Christian V of Denmark* (Rijksmuseum); *Johann Wilhelm, Kurfürst von der Pfalz* and its pendant *Maria Anna Louisa* (Munich). Another replica of the Prince Eugene was in the Heckett collection: Sotheby's, 24 April 1978, lot 476, repro. For the Yale miniatures, see Noon, nos. 20, 429. Two signed pendants of a gentleman and his wife, closer in style to the works of his brother, were sold at Sotheby's, 7 June 1971, lot 84, repro.
16. V&A P34-1941 and P106-1922; both signed and dated.
17. According to Vertue, III, 60, the king had more respect for Zincke as a draughtsman and portraitist in the 1730s than he had for any other artist in England.
18. Goulding, *passim*, listed over twenty enamels by Zincke in the Portland collection. Those dating before 1720 are mostly copies after oil paintings, while those dating later are generally portraits from life.
19. The example in the Buccleuch collection is signed and dated 1735; see H. A. Kennedy, *Early English Portrait Miniatures in the Collection of the Duke of Buccleuch*, 1917, pl. LXVII.
20. Sotheby's, 28 March 1977, lot 52, repro.
21. Foskett, 1972. A portrait of an unidentified gentleman by Abraham Seaman, signed and dated 1725, was in the Heckett collection; Sotheby's, 11 July 1977, lot 165, repro.
22. Rouquet, *op. cit.*, 47.
23. Repro. Ellen D'Oench, *The Conversation Piece: Arthur Devis and his Contemporaries*, exhibition catalogue, Yale Center for British Art, 1980, fig. 2.
24. Spencer occasionally deviated from this softer range of colours when he intensified the rouge of the cheeks, perhaps in compliance with the growing fad at mid-century for cosmetics; cf. Rouquet, *op. cit.*, 48–9.
25. An example demonstrating Liotard's influence on Spencer's chiaroscuro is the latter's enamel

portrait of an unidentified gentleman, signed and dated 1753, that was sold at Christie's, 13 November 1973, lot 23.

26. Quoted from Goulding, with no. 227.

27. Long, 356, reported the existence of a miniature on ivory after an old master painting by D. Rawdon, signed and dated 1705. Goulding, 42, argued that Peter Cross might have known about ivory as a support at an early date; however, he did not use ivory and he might have learned of its potential in miniature painting from Lens, rather than vice versa. There is no evidence to support J. L. Propert's contention (*Miniature Art*, 1897, 90) that a miniature on ivory depicting the Duke of Schomberg is the earliest known example on this support; nor is there any reason to assume that it was painted by an English artist or before the duke's death in 1690.

28. Colding, 129ff.

29. Goulding, 41, claimed that Bernard Lens III was appointed drawing master to the future second earl in 1707, an assertion repeated in subsequent literature. The Lens family member who was appointed was described to the first earl as 'the best master we have in London', hardly an appropriate description for an artist whose earliest known work dates to the same year. In 1707 Bernard Lens II was the foremost drawing master in London, and it was certainly he, and not his son, who received this appointment.

30. A noteworthy exception to this rule is Lens's *Sarah Churchill, Duchess of Marlborough* (V&A 627-1882) which was painted from life in 1720 according to Lens's inscription of the verso; see Basil Long, *Catalogue of the Jones Collection*, 1923, III, no. 610, pl. 46.

31. A miniature by this artist, signed and dated 1716, which appears to be based on a Rosalba, was sold at Sotheby's, 5 June 1972, lot 65. Two large cabinet paintings in body-colour on vellum after Poelenburgh, signed and dated 1724 and 1727, are in the Victoria and Albert Museum (P50-1955). They are not painted in a miniaturist's technique, but rather in the perfunctory gouache manner of Goupy, that can be traced to such precedents by continental artists as the 'Verrio Workshop' replica of *James II receiving the Mathematical Scholars of Christ's Hospital* at Yale (Noon, no. 17). In a copy after Hilliard's *Man clutching a Hand in the Clouds* she was more attentive to the technique of the model (see Heckett sale, II, Sotheby's, 11 July 1977, lot 120).

32. A miniature of a child by B. Lens III in the Portland collection (Goulding, no. 123), is inscribed on the verso in the artist's hand: 'aged 2 years 5 months. 1716/ Pe[ter] : bo[rn] 1714.' It is highly likely that this child is Peter Lens.

33. The drawing is in the collection of the Yale Center for British Art, B1977.14.5691. Vertue, III, 106, described Peter Lens as a 'votary of the devil'.

34. Anthony Pasquin [John Williams], *An Authentic History of the Artists of Ireland and Royal Academicians*, 1794, 28.

35. The same observations apply to Scouler's miniature, *Garrick and his Wife*, of 1768 in the Victoria

and Albert Museum (P5-1951), which is probably identifiable with no. 150, Society of Artists exhibition, 1768.

36. Quoted by Long, 293–4.

37. MS. letter, dated 8 February 1788, Beinecke Rare Book and Manuscript Library, Yale University. This letter is published with the kind permission of Stephen Parks, curator of the Osborn Collection, Beinecke Library. Other manuscript letters in the Osborn Collection relating to Cosway include: an undated note to Maria Cosway from Lady Ailesbury requesting permission to visit Maria; an undated letter from Caleb Whitefoord to Richard Cosway thanking the artist for his part in encouraging the Prince of Wales to become a patron of the Society of Arts; a note dated 2 March 1788 from Charles Burney to Maria Cosway acknowledging an invitation to visit on Monday or Wednesday next; a letter dated 24 February 1781 from Giuseppe Plura in Venice to Prince Hoare in London, with the comment 'the public papers announce *la Maria* to be now Madame Cosway', and a letter dated 24 July 1806 from Joseph Bonomi to Prince Hoare which mentions that Mrs Cosway is living in Lyons.

Tiberius Cavallo (1749–1809) was a natural philosopher who spent most of his life in London. He published numerous scientific volumes, including works on electricity and magnetism. He was made Fellow of the Royal Society in 1779. Cosway is believed to have been a fanatic devotee of Franz Anton Mesmer and the philosophy of 'animal magnetism'; see 'Recollections of Richard Cosway', *Library of the Fine Arts*, IV, July 1832, 187.

38. This artist is often confused with others of the same name. He supposedly studied under Ozias Humphrey or D. Dodd, and he exhibited at the Royal Academy from 1773 to 1788. His works are not well known, but on the basis of two portraits of unidentified women dated 1783 (Foskett, 1972, II, pl. 212, and Yale Center for British Art, B1974.2.31 [Noon, 450]), there is little doubt that he imitated John Smart very closely. His structuring of the head is identical to that of Smart, and he favoured the same terracotta hues for the face. His brush-work is woolier than Smart's and he used less stipple. His method of painting the hair is the most individual aspect of his work. After applying an even grey wash of middle tint to these areas, he scraped through this wash to expose crescents of white highlight, alternating these with thin wiry lines of deeper grey paint.

39. The original portrait is untraced, but an engraving after it is known, as well as a number of preliminary studies in pencil; see Noon, no. 61.

40. J. Agnew, *Report on the Papers of Ozias Humphrey, RA (1743–1810) in the Custody of the Royal Academy of Arts*, Royal Commission on Historical Manuscripts, 1972, 74 (HU/4/65).

41. Two excellent, rectangular (7¼ inch) copies after Reynolds of Sir William and Master Lumley Skeffington (c. 1777) were sold at Christie's, 18 December 1974, lot 76–7, repro.

42. William Hickey, the diarist, recorded in 1781: 'I

was desirous of possessing a good portrait of my dearest Charlotte. She had presented me with one painted by Engleheart, which I thought did not do her justice, besides being a stiff, formal picture. This made me wish to have one by Cosway' (*Memoirs of William Hickey*, ed. Alfred Spencer, 1918, II, 362). The subsequent account by Hickey of the painting of this Cosway miniature provides an interesting record of Cosway's studio practice.

43. Edward Dayes, *The Works of the Late Edward Dayes*, 1805, 348. The sale of Shelley's studio (Peter Coxe, Spring Gardens, 22 March 1809) contained over forty lots of miniatures in 'rich carved and gilt frames' with such titles as *Seneca going to the Bath, Laura Sleeping, Fancy Subject, Bellisarius*, etc.

44. This miniature, a five inch vertical oval signed and dated 1784, was sold at Christie's, 14 December 1971, lot 51.

45. J. L. Roget, *A History of the 'Old Water-Colour' Society*, 1891, I, 216.

46. Andrew Robertson, *Letters and Papers of Andrew Robertson, miniature painter; also a treatise on the art by his eldest brother, Archibald Robertson*, 2nd edn, ed. E. Robertson, 1897, 99. In the nineteenth century methods of framing became a critical concern for both miniaturists and other artists painting in watercolours. As the century progressed, exhibitors introduced more ornate gilded frames for their pictures. On one level, the wide gilded frame increased the visual presence of the work and imparted to it, through association, some of the status value of oil paintings. Of greater significance, however, is that as watercolour paintings and miniatures became more highly finished and richly coloured, their pictorial success often depended on such enhancement. This factor can be appreciated by anyone who has seen a late watercolour composition by George Fennel Robson, for instance, improperly framed in a stained wooden or ebony frame. In the eighteenth century, large miniatures were generally displayed in narrow wooden frames, such as those made of stained pearwood by Bernard Lens III for the Earl of Oxford. Such frames were simple, with no ornate carving or gilding. At the Royal Academy exhibitions, miniatures could be presented as a group in a large frame, but for individual works, the width of the frame could not exceed one inch. Andrew Robertson was the first to challenge this tradition in 1803, claiming that his larger frames were 'essential to give [miniatures] their proper effect' (*ibid.*, 96). He was not rebuked for his challenge and within a short time the Academy modified its rule to allow for individual gold frames two and a half inches wide for miniatures with a maximum dimension of six inches.

47. For instance, see Andrew Robertson's opinion: '[Cosway's] price is 25 & 30 guineas, he ought to make good things. He has so much to do that he may use any liberty' (*op. cit.*, 62). For a general discussion of the prices paid for portraits in different media during the period under discussion, see Noon, vii–viii; Goulding, *passim*,

documents many of the prices paid for early eighteenth-century miniatures in the Portland collection.

48. Martin Archer Shee, *Rhymes on Art, or the Remonstrance of a Painter*, 1805, 30–1.

49. *Ibid.*, 36.

50. Robertson, *op. cit.*, 49, 55, 63.

51. *Ibid.*, 61–2.

52. *Ibid.*, 151, where Robertson wrote in 1807: 'Pictures of that large size take so much time to paint, that I should starve, were my employment altogether in these. They are what have gained me my reputation, but small miniatures are what one must live by.'

53. *Art Journal*, N.S., I, June 1855, 183.

54. *Art Journal*, N.S., VI, March 1860, 72.

55. See *Catalogue of Portraits, Miniatures, etc. in the Possession of Cecil George Savile, 4th Earl of Liverpool*, privately printed, 1905, no. 288, pl. XLIX; and Sotheby's, 25 March 1981, lot 8.

56. Foskett, 1972, II, pl. 371.

57. *Art Union Journal*, IV, June 1842, 126. In describing Carrick's contributions to the Royal Academy exhibition of 1842, one reviewer wrote: 'We find in the works of this artist a new and original style of miniature painting, the value of which does not lie in what is understood by "finish" although the finish of his miniatures is equal to the most tedious elaboration. The force of his work consists in their luminous breadth; and the clear definition and prominency of their parts, without any cutting up or diminution of the main effects of the heads.'

58. *Ibid.*, 166.

59. Attached to the frame backing is an account of this miniature written by Tidey in 1885: 'Samuel Rogers preferred receiving his friends at Breakfast, I called on him early one morning and found him with two gentlemen (strangers to me) to whom he was showing my picture "The White Mice," one of them observed it is like a reduced Murillo, on which Rogers said it is better than Murillo there is more force in it, of course I took this for what it was worth, his warm approbation of the work, and which was very gratifying.

'When alone with him afterwards he strongly advised me to continue to work in the same style, but I told him I could not do so, on which he said, "What is to hinder you," but I had not the courage to tell him, that tho many admired the work no one had offered to Buy it, in fact – I had discovered that apart from Portraits, Painting on Ivory would not be remunerative, and at this very time the dawn of Photography was threatening to annihilate Miniature Painting as an art.

'About this time the sun of the Miniature Painters was setting in all its glory, for then the works of Ross and Thorburn, Carrick and others were at their best and the thickest of the crowd of visitors to the Royal Academy was usually found in the miniature room.

'Efforts are being made to recover this "Art of the past," but the great perfection to which photography has attained goes so far to satisfy the never ceasing and most cherished feelings

of humanity, and which the miniature painter alone could formerly supply (viz) *likeness in little*, that I fear it will be but a vain struggle.'

A. H. Tidey Nov.1885

60. *Ibid.*

61. *Art Journal*, N.S. VI, June 1860, 183.

62. *Art Journal*, N.S., I, June 1862, 137.

63. Mrs S. C. Hall, 'Memories of Pictures', *Art Union Journal*, V, June 1843, 141–2.

64. Most frequently cited is the case of John Frederick Lewis who resigned his membership in the Old Water-Colour Society with a note to its secretary stating: 'I felt that work was destroying me. And for what? To get by watercolour art 500L a year, and this too when I know that I could with less labour get my thousand' (Major-General Michael Lewis, *John Frederick Lewis*, Leigh-on-Sea 1978, 30).

65. Quoted from Marjorie Cohn, *Wash and Gouache*, exhibition catalogue, Fogg Art Museum, 1977, 13.

66. 'The Application of the Talbotype', *Art Union Journal*, VIII, July 1846, 195.

67. *Art Journal*, N.S., II, 1863, 138.

68. 'Daguerreotype Portraits', *Art Union Journal*, VIII, July 1846, 216. Claudet employed a miniaturist named Mansion, who might have been a relation of the miniaturist André Mansion (1785-*c*. 1834).

69. *Art Journal*, N.S., III, February 1857, 66. Mayall also attempted to undercut the crayon and pastel portraitists by developing and patenting in 1853 a type of vignette photograph called a 'crayon daguerreotype'. His intention was to imitate the portrait drawings of such popular draughtsmen as Samuel Laurence. Portrait drawings with the face of the sitter clearly delineated but the rest of the body simply sketched or rubbed in had gained a popularity at mid-century comparable to that of watercolour drawings.

70. Gustave Flaubert, *Madame Bovary*, Paris, 1857.

71. *Art Journal*, N.S., IV, 1865, 216.

72. Enamel painting experienced a renaissance in the nineteenth century, but almost exclusively as a reproductive medium, the virtue of which resided in the stability of its materials and its new, brilliant range of colours. The use of enamel primarily for copying oil paintings was defended by Essex in 1851: 'The most valuable service enamel painting can render to society, is to perpetuate the portraits of celebrated men, and the best works of the great masters of all times and countries' (*Art Journal*, NS., III, May 1851, 146). Enamel was considered by most nineteenth-century miniature painters a mechanical art.

Index

Photographic Acknowledgments

We are grateful to the following owners and institutions who have kindly allowed us to reproduce miniatures from their collections or who have supplied us with photographs: The Royal Collection, by gracious permission of Her Majesty the Queen; Aberdeen Art Gallery; Countess Beauchamp, Madresfield Court; Birmingham City Art Gallery; Denys Bower, Chiddingstone Castle; British Library, London; British Museum, by courtesy of the Trustees of the British Museum; Duke of Buccleuch; Christie's (photograph A. C. Cooper); Cleveland Museum of Art; Countess of Craven; Duke of Devonshire; Fitzwilliam Museum; Daphne Foskett; Collection José A. Gomis; Trustees of the Goodwood Collection; Ham House; Institut Néerlandais, Paris (Fondation Custodia – Coll. F. Lugt); Mauritshuis; Metropolitan Museum of Art, Rogers Fund, 1950; National Maritime Museum, Greenwich; National Portrait Gallery, London; Duke of Northumberland; Pennington-Mellor-Munthe Trust; Pierpont Morgan Library; Earl of Powis; Rijksmuseum; Duke of Rutland, Belvoir Castle; Marquess of Salisbury, Hatfield House; Sotheby's; Welbeck Abbey; Yale Center for British Art, Paul Mellon Collection.